THE STORY OF LOOKING

THE STORY OF LOOKING

MARK COUSINS

CANONGATE

Published in Great Britain in 2017 by Canongate Books Ltd,
14 High Street, Edinburgh EH1 1TE

canongate.co.uk

1

British Library Cataloguing-in-Publication Data
A catalogue record for this book is available on
request from the British Library

ISBN 978 1 78211 911 1

Text Design: Christopher Gale

Typeset in Bembo by Biblichor Ltd, Edinburgh

Printed and bound in Italy by LEGO SpA

CONTENTS

INTRODUCTION 1

PART 1 STARTING

CHAPTER 1 Starting to Look: *Focus, Space and Colour* 13

CHAPTER 2 Developing Looking: *Eye Contact, Movement, Landscape and Emotion* 37

CHAPTER 3 Looking, Self, Home and Design: *The Things Nearby* 59

CHAPTER 4 Growing Up Looking: *Desire, Abstraction and God* 73

CHAPTER 5 Looking and Cities: *Vicinity and Vista* 93

PART 2 EXPANDING

CHAPTER 6 Expanding Horizons from the Middle Ages Onwards: *Trade, Crusade, Empire and Conquest* 117

CHAPTER 7 Looking and Science: *Not Imposing a Story* 137

CHAPTER 8 Image War and the Power of Looking in the 1500s and 1600s: *Protestantism, the Baroque, the Ottomans and Versailles* 157

CHAPTER 9 What Lies Beneath: *Laughing and Tears* 171

CHAPTER 10 Looking and the 1700s: *Grand Tours, Enlightenment, Industry, Revolution and Flight* 187

PART 3 OVERLOADING

CHAPTER 11 Looking and the Early 1800s: *Romanticism, America, Railroads and Photography* 217

CHAPTER 12 The Transparent Eyeball; Looking and the Late 1800s: *Literature, Light Bulbs, Impressionism, Cinema and Sport* 249

CHAPTER 13 The Sliced Eyeball of the Early Twentieth Century, Part 1: *Microcosms, Time and Tutankhamun* 287

CHAPTER 14 The Sliced Eyeball of the Early Twentieth Century, Part 2: *Protest, Modernisms, Skyscrapers and Advertising* 305

CHAPTER 15 The Twentieth Century Losing Its Realness?:
 Motorways, War, TV, Celebrity and Want See 343

CHAPTER 16 The Twenty-first Century and Everywhere:
 Skype, Surveillance, Virtual and Augmented Realities 371

CHAPTER 17 The Unseen; Looking Back; Looking and Dying;
 Being Looked At 381

CONCLUSION 395

ACKNOWLEDGEMENTS 405

IMAGE CREDITS 406

INDEX 417

INTRODUCTION

SIX a.m. I wake. My bedroom's completely dark. I pull open the window blind and see this:

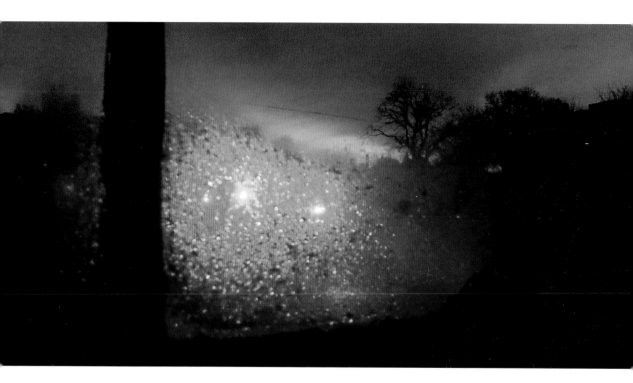

Condensation on my window, lit by the sodium street lights outside my flat. Beyond that, miles away, the dusty-pink glow of the coming morning. Navy above. A distant, leafless tree.

This watercolour, this smudged scene, comforts me. I will start writing a book today, a book about looking. Tens of thousands of words lie ahead in the coming months. Pages of words and paragraphs which will look nothing like the world, but which I will use to try to describe the world. I do not know precisely where the words will take me. I have planned this book in detail, but words have a mind of their own and can escape the plan. I will discover things as I go, I hope. Maybe you can share in the pleasure of discovery. For now, this alba, this moment before the day starts, before the book starts, I am happy just to look, to admire the navy-pink-orange, the softness of the light, the accidental elegance of the

composition, the black vertical, the shallowness of focus, the consolation. No one else is looking at this exactly as I am, and if I had had a lie-in and not seen this, it would have happened anyway. The sky would still have been Turneresque, the orange light would still have backlit the condensation.

In the twenty-first century it's valuable to think about looking, its history and impact. For more than a century now there has been an unprecedented escalation in what we see and how we see it. The visible world has been technologised. Photography, cinema, advertising, TV, the internet, Google Maps, smartphones, Skype, Facebook, satnavs, virtual reality and augmented reality constitute a deluge of new looking for our species – what, in later chapters in this book, I call the split eyeball. Back in the 1800s, photography seemed to rob places and people of some of their aura. When cinema came along, its rampant visuality was seen as trivial or debasing. Television was said to tranquillise people. About thirty billion selfie photographs are now posted online each year. At the funeral of Nelson Mandela in 2013, the then Danish prime minister Helle Thorning-Schmidt took a selfie of herself with Barack Obama and David Cameron, and excluding Michelle Obama. It is often said these days that Japanese tourists on a coach trip in Europe will quickly snap a photograph of a famous site then move on, or that British people abroad will similarly take a picture of something instead of actually looking at it. And parents regularly complain that their children are so glued to the multiple screens in their homes that they do not look up from them enough to enjoy the offline world. The escalation in quantity of visual information panics us. What is it doing to our brain wiring? Are we downloading our consciousnesses onto our smartphones? Are we looking too much, or in too fragmented a way? Is looking displacing thinking?

There is some basis to these digital-age anxieties, as there was to their equivalents in the nineteenth century. But the tour that you are about to take will provide some perspective on this looking panic. It will explore the role that looking has played in our emotional, social, political, scientific and cultural development. By considering the story so far, and noticing how we encounter the visible world, I hope to provide some perspective on the storm of looking that we find ourselves in.

Of course looking is only one thing that human beings do. Our lives are tapestries of thinking, hearing, moving, laughing, loving, fearing, touching, believing, reading, playing, remembering, creating, hurting, dreaming and much more. I find myself more moved by music than any other art form, and I like dancing with my eyes closed, as looking seems to inhibit my pleasure. I feel

excluded when my partner looks at Facebook when we are together and feel that smartphones have changed the eyelines in our relationship.

But these things do not prevent me from enjoying the visual storm, the wind in the trees and in my hair. In what follows I will endeavour to show the underlying richness of looking, its pleasures, discoveries and the empathy it can unlock. Helle Thorning-Schmidt's selfie story is more interesting than it first appears, for example. Her children had just taught her how to do selfies, so perhaps she was having fun at playing a teenager. The seating at the event was mostly unreserved, so she did not know she would be sitting next to Barack Obama until he and Michelle showed up. Her picture was posey, yes, and I am sure she had one eye on its PR potential, but she also did it on the spur of the moment. The 'look where I am!' impulse is universal, endearing even, and a human response to time passing and memories fading. Ditto the camera-toting tourists. They have spent a lot of hard-earned money to come halfway around the world. Whilst visiting two cities a day, their phone or digital cameras become a way of dealing with the anxiety of looking, the desire to make the money and time count. Yes, they will probably bore their friends back home with their pictures of Edinburgh Castle or the Eiffel Tower, but when they look at the photographs in ten years' time, there will be things in them – people on the same coach, a stop to have pizza and a beer, a youthful face that is now less so – that will move them and take them back to their trip. And as for the child sutured to her phone, yes it is tedious when she does that for hours, and yes, a lot of what she is looking at is rubbish, but that is not a reason for decrying screens or decrying looking. There is rubbish reading and thinking too. By looking at screens, especially if she is someone who is good at looking, a child will encounter things that will fire her thoughts. This book will not shy away from how looking can exploit, control or demean, but it is more interested in how looking has enhanced our lives.

It has certainly enhanced mine. When I was at school our English teacher made us read Charles Dickens's *Great Expectations* aloud in class, a common practice which aims to give a group of children the collective experience of enjoying a novel. Many of my classmates loved the opportunity, and read fluently, even using different voices for Pip, Joe, Miss Havisham and the book's other characters. The words seemed to leap off the page when they read. Not for me. When I looked at a page of words, they looked like this:

think he lacks ambition, others that he is playing a long game, working up to an audacious deal that will see him comfortable, somewhere far away, where it would be difficult for Victor Gilmartin to put his hands round Ferrie's neck and squeeze.

The gantry in Gilmartin's is twelve feet long, amber-stocked and glowing. Patrons gather round long wooden tables on pews and prayer seats. Oak, culled from churches Victor demolished in his previous incarnation, lines the walls. Barmen, in swinging kilts of mismatched tartan, glide from table to bar, floating silver trays of drinks above the heads of the crowd, without spilling a drop. If it were not for the girning faces in the portraits that line the walls, the illuminated, chipped porcelain and flawed glass, it would be a pleasant place. As things are, it is an aesthete's nightmare.

There was a buffalo head mounted at eye level on the far wall. A young girl stroked the sparse hair on its nose sadly. Time.

A hundred years ago this strange-looking beast had run across a green grass plain in a herd that shook the ground with the weight of their hooves. Alongside comes a train. Red cattle-guard pointing the way, grey smoke trailing behind. The stoker shovels coal into the boiler, the driver pulls the whistle from the sheer excitement of the chase. Midway, in the third carriage down, a man lifts his rifle to the open window, levels his sights, focuses, squeezes the trigger and bam, one buffalo to be sawed, scooped, stuffed and preserved.

Victor was behind the bar, avuncular as ever.

'What do you think, Rilke? I just bought it this afternoon. It took three thirsty men forty minutes to get it up there. I'm going to have a competition to see who comes up with the best name.'

A flat, monochrome block of granite, hard and impenetrable. I could dive into images like the photograph of the view from my bedroom window this morning. They were aqueous, inviting, seductive, layered and readable, whereas a page of text was none of these things. Looking has kept me happy, alert, informed and curious. When I am feeling down, I go out into the city where I live, and people-watch. When I am overwhelmed with work, I climb a mountain and look out to the horizon. When I am far from home, I look at photos on my phone of the person I live with, and feel better. When I have time off, I go to see art, buildings or landscapes. Looking is my consolation and calibration, and so I have built my working life on imagery. Most of my films are about looking. All of them could start with one word: 'look'. On completing my tenth film and realising that its main character is recovering from a tragic event by looking at the city, Stockholm, in which she lives, and on noticing that my eyesight is beginning to fade and that I now need glasses, I decided to write this book.

Our art schools are full of people like me, who are more at home with images than words, as are our physics and engineering courses, rock bands and football pitches. Some people are better at looking than reading. If you are one of them, this book is particularly for you. You could be in your late teens, or studying a humanities course, or a general reader of any age. If you know a lot about visual culture then some of what follows will be old hat, and you will spot what I have not dealt with. But that is fine. This book is not an encyclopedia, but rather deliberately personal.

In what follows I will not be the only tour guide. In each chapter, painters, photographers, filmmakers, scientists or writers will also show us the world through their eyes. They will be our surrogate lookers. They have a hotline to the visual world.

One such great looker in particular will tee us off. Consider these scribbled words:

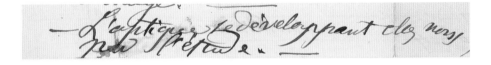

They are in a letter from the French painter Paul Cézanne to a fellow artist, Émile Bernard, written in 1905. The handwriting is swirly and a little shaky – Cézanne was coming to the end of his life – but we can just decipher it. Cézanne has written *L'optique, se développant chez nous par l'étude nous apprend à voir* – the optical experience which grows in us.

There is nothing unusual in a painter using the word optical, of course, given that part of their trade is looking, but Cézanne does not use the word as an objective, as in 'optic nerve', for example. He is implying that a person has an optical experience, and it develops over time.

What does he mean by that? I think he is saying that a human being develops a looking life. Just as we can say that our verbal vocabulary grows over the course of our life, so Cézanne means, I believe, that our visual vocabulary grows as we do. This will be the central idea in this book. Your *optique*, your looking, is all that you have seen: your mind's eye, your lifelong photo album. In his *Philosophical Dictionary*, the French writer Voltaire said that an idea is 'an image that paints itself in my brain. The most abstract ideas are the consequences of all the objects I have perceived.' You and I each have such a cache of images in our heads, and so did every seeing person in history.

Imagine, for example, this woman's:

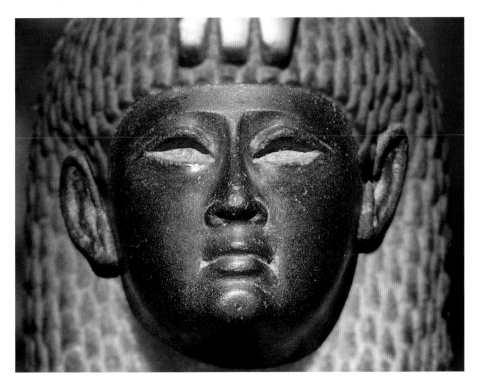

This basalt sculpture of Cleopatra from about 40 BCE, when she was still alive, has empty eyes, but hers were far from that. Of Greek origin, she was probably the most powerful woman of her time. Powerful people see inner sanctums, vistas, masses of people turned towards them and monumental cities designed to be best

seen from where they sit, and Cleopatra saw Alexandria recede into the horizon as she sailed her fleet along the coast of what is now Libya. She saw the Roman civil war, Mark Antony naked, her twins by him born, and the dying of the light as she committed suicide on 12 August 30 BCE. What a life those eyes saw, what amplitude. They were probably once filled with precious materials, but I like that they are vacant. This book will try to fill such eyes. Twenty centuries later, a famous dream factory in Southern California imagined her like this:

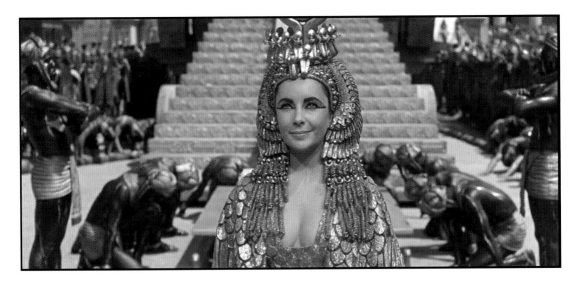

In focus where everything else is out of focus; centred; causing people to fall to their knees; encrusted with gold shaped like feathers, as if she is an eagle; confidently letting her cleavage be seen; as monumental as the staircase behind her. This image tells us more about the twentieth century's design and desire than it does about Cleopatra's, but her looking, and being looked at, was surely as intense. She was equally at the centre of a visual force field. If only we could see Cleopatra's looking life.

Add together my own visual experiences, and all those who, like me, are slow readers, as well as great lookers like Cézanne and powerful, elite ones like Cleopatra, and we start to get a sense of the richness of visual experience. Our guided tour begins. What will be its methods?

Let's start with what it will not do. In my research I have read academic books about the psychology of looking, vision in French philosophy, power and imagery and so forth. I have learnt from the content of each, but not their form. Too often, for me, such books are commentaries on other commentaries, debates within debates. They feel like gatherings of thinkers – Socrates, Descartes, Gilles

Deleuze, Maurice Merleau-Ponty, Susan Sontag, etc. – sitting at some grand dinner party or academic conference, or standing in Raphael's great fresco *The School of Athens*, debating. This book hopes to be less static and more mobile than that. It will be a road movie rather than a dinner party. On the way we will meet some of the people just mentioned, but rather than settle down with us in a 100-page *colloque*, they will give us advice and point us onwards. It is a book by an image-maker rather than a word-maker. It is about the act of looking: what, when and where we see, and the effects it has. In his book *The Living Eye*, Jean Starobinski captures the drama of this when he talks of the 'expectation, concern, watchfulness, consideration and safeguard' of looking.

This book will not be a comprehensive history of looking. It would take a thousand such volumes to describe all the looking we have done, the billions of glances, the aesthetics of those glances and their effect. Instead our story will zoom in on certain points in time, create a montage of moments in human looking, and hope that they can represent the rest. What happened visually when Mount Vesuvius erupted, or when that urban jewel Baghdad was destroyed in 1258, or when the modern Olympic Games took place, or when Pablo Picasso tried to imagine his response to the German and Italian bombing of the Basque town of Gernika on 26 April 1937? Such moments have left traces. They have watermarked our cultures.

Psychologists and neuroscientists had made great discoveries about child development and how looking takes place in the deep structure of our brains. I have gained a lot from such research, but have not attempted an account of it here. Instead, I dip into these disciplines where they substantially enlighten my theme. I start with the birth of a child, but join the dots with other things that seem revealing.

Most histories are still written by people like me – white, Western men – but, as in my previous work, I will try not to tell only a Western story or a male story or a white story. Combining the history of individual looking with that of our species' looking will mean that my story will shift between short and long timelines, between micro and macro.

Finally, I will follow another lead from Cézanne. His scribbled letter suggests that our looking is not just everything we have seen, it is how we have seen it and what we have done with that seeing. Looking is also apprehension of space; it is walking, detection, longing, dissection and learning. It is our visual shocks, the way our emotions are triggered by the visual world. It is the number of times we have looked at a child or partner or sibling, plus the feelings that looking caused us to have, plus how we stored those feelings, plus how we access them now.

For example, below is an old phone of mine. It no longer works, but I keep it because there is a photo on it of my granny lying dead in her coffin.

It is not the done thing to take photos of dead relatives at funerals, but I wanted to and, when I found myself alone in the chapel of rest, I took the picture. I looked at it once or twice, and then my phone died, and so I could do so no more. I have seen quite a few dead bodies in my time, and I have looked at Egyptian mummies, and the bodies of Lenin and Chairman Mao, and I have seen lots of dead animals. But I have only photographed one corpse, my granny's. This old phone, therefore, contains part of my looking life. The images are now for ever locked inside it, the way the images of all the dead things I have seen are locked inside me.

Not everyone can see of course. Two hundred and eighty-five million people are visually impaired, and of those thirty-nine million are blind. Ninety per cent of them have a low income, and eighty-two per cent are over fifty. If you are rich, white or young, you are more likely to see. Some who are blind, and whose sight is reparable, have rightly rejected the opportunity to see because they love their sensory engagement with the world as it is, and they do not want a new, outside, facility to intrude.

I hope they will not begrudge what follows: an affirmation of something that most of us take for granted, a complicated triangle whose points are the outside world, the eye and the brain. Let's start by saying how limited human sight is.

If this line represents the spectrum of electromagnetic waves that exist, of which visible light is a part,

here is how much we can see:

–

The rest

_____ _____

is invisible to the human eye. A cat sees far more, as do many devices: infrared cameras, X-ray machines, electron microscopes, etc.

Let's narrow life down to that small, glorious bit which is visible to the human eye. This

–

is a world.

The visible world. The world of Cézanne, Cleopatra, my dead granny, trees outside your bedroom window on a luminous morning, and everything you have seen.

Let's look at it.

PART 1

STARTING

CHAPTER 1

STARTING TO LOOK: *FOCUS, SPACE AND COLOUR*

'If I could alter the nature of my being and become a living eye,
I would voluntarily make that exchange.'

– *Jean-Jacques Rousseau*, Julie, or the New Heloise

FOCUS

We should start where everything started. The Big Bang did not bang. Initially at least, there was no medium through which the sound waves could travel. It could be seen, except there was no one to do the seeing. It was not the Big Bang, it was the Big Flash. The rapid expansion from quantum dimensions 13.8 billion years ago is likely to have produced so much light that the Big Flash was the brightest thing that has ever happened. It made looking possible. The seen began.

Billions of years after the Big Flash, human see-ers began too. They had missed the most visible event in history, but by the time of their arrival life had evolved to a dazzling degree. Humans looked out into the world via two swivelling, vulnerable, aqueous orbs. They were astonished, these eyeballs, and astonishing. In each, 120 million rods were able to assess brightness and darkness in five hundred gradients. Seven million cones would, in time, be able to register a million colour contrasts.

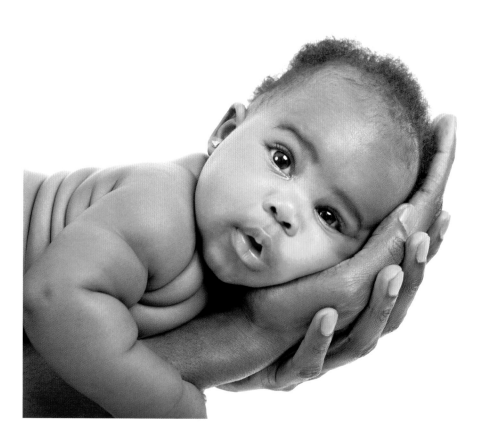

How does the photo album of our life begin? With blank pages. Let's imagine the birth of an early *Homo sapiens* in Africa about 200,000 years ago. She lies on her father's hand, looks out into the world and begins to lay down visual impressions. The baby's big, absorbent eyes start to live. The first things that register are incomplete. Where the optic nerve attaches to the retina at the back of the eye there is a blind spot, a hole in what it sees, which will be there throughout her life. She has no past, this baby, or so it seems. The baby quickly sees grey blurs. Shadows and outlines fall upon the blank pages. It takes time for life to come into sharp focus for a baby, and before it does, the world looks like this:

Soft-edged. Immaterial. As an adult we have multiple reactions to such an image. It is troubling in that, if we were to walk forward into this landscape above, we would be unable to see if there were holes in the ground, or branches that might stab us in the eye. Lack of focus makes us unsafe, uneasy. But that is not all. In the story of looking, visual softness, lack of focus, light rays meeting in front of or behind our retinas rather than on them, are not necessarily defects. These early impressions were types of imagery that would continue to play a part in how we fear, love, admire and think of ourselves.

To see how, let's start with this image from Swedish film-maker Ingmar Bergman's 1966 movie *Persona*.

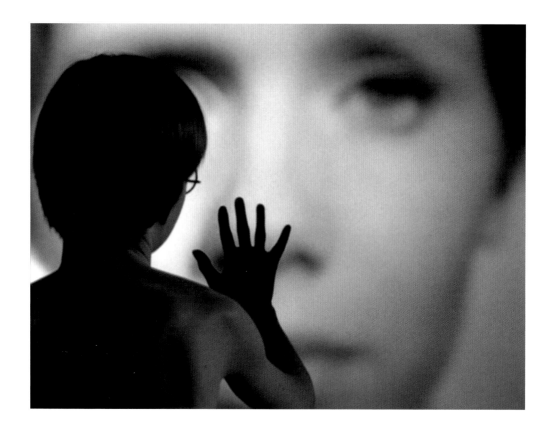

A boy looks at his mother. She is in black and white and out of focus, rather like a baby would see its mum. Within minutes of its birth, our early *Homo sapiens* baby stares at faces – its parents, animals or even simple graphic representations of two eyes, a nose and a mouth. Contained within its genetic information is the ability to discern the arrangement. Its blank pages have ghost images on them, ready to develop.

The boy in the film holds his hand up, to try to touch such a ghost image, or is he trying to wave? He is apart from his mother; locked out of her world, as if a pane of glass separates them. There is distance between them, but the focus seems to contradict that distance. It is as if she is so close that the lenses in our eyes are not strong enough to bend the rays from her face into sharpness. Most of us have experienced waking up in bed beside someone, their head so close to ours that they are a blur; at such short distances, the other person's two eyes can merge into one large one in the middle of their head, as if they are a Cyclops.

Bergman's image (filmed by his great cinematographer Sven Nykvist) and the black and white, blurred trees that the baby saw tell us something about the look of love. Lack of focus, especially in close-up, makes us feel adjacent,

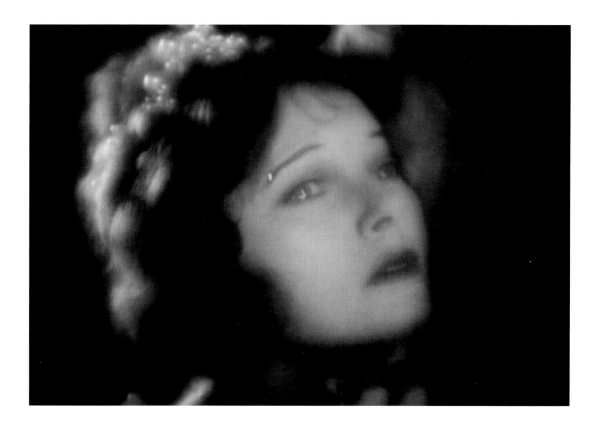

almost in a force field. It excludes background. This image from the 1929 film *The Divine Lady* shows how mainstream entertainment, in its desire to depict love, has pushed visual softness to an extreme.

It is as if actor Corinne Griffith is in the fog of love, or has been burnished. This could almost be what a baby sees. Visual softness reduces psychological distance; everything seems to have melted away. The image is not far from abstraction. The reverie of the unfocused. Like our earlier image of the forest, this one is also somewhat unsettling. There is trouble in her eyes, and tears are coming. The visual softness means that we have lost our bearings here, that we are in a realm where everything is close, felt and emotionally flooded. There is helplessness in the visually soft. We do not know which way is up. This image of Corinne Griffith was photographed by John F. Seitz, who would go on to film *Sunset Boulevard* and *Double Indemnity*.

And visual softness is not only about a baby's first glimpses of the world, our close encounters with a lover, or the visual strategies of romantically photo-graphed cinema. The eyes, smile and background in this next famous image show that painters have used the unfocused too.

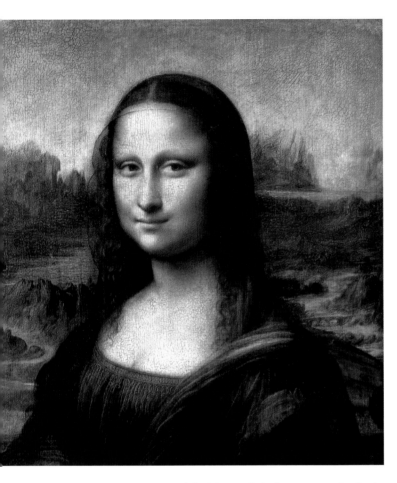

In Renaissance Italy, the technique was called *sfumato*, which its inventor, Leonardo da Vinci, described as the 'the manner of smoke, or beyond the focus plane'. The portrait was commissioned by the husband of the sitter, Lisa del Giocondo, so, like the picture of Corinne Griffith, it is a look of love image. But it is more than that. Leonardo's smokescreen reduced the amount of visual information in the landscape in order to leave space for us to imagine what is not there. The art historian and painter Giorgio Vasari wrote of such imagery 'hovering between the seen and the unseen', which gets close to the heart of the matter. The landscape in the *Mona Lisa* is emergent seeing. It is a kind of dawn, like the dawn we saw at the beginning of this book.

Lisa del Giocondo's famous smile is dawning, like the light is dawning, like a baby's vision dawns. And although we know that this is a real woman, born on 15 June 1479, and although her clothes and hairstyle are of their time and place, the *sfumato* clouds her and her place in the world. The unseen that Vasari mentions is the intangible, the numinous. Lisa looks like we dreamt her, like she is in a dreamscape. More than three centuries after Leonardo, the English painter J.M.W. Turner would take his idea of the defocused landscape to an extreme by painting using his peripheral vision, in other words turning his head away from his subject so that it became entirely soft edged. In Turner's *Seascape with a Sailing Boat and a Ship*, nothing is pin sharp. The sky, clouds, sea and vessels fuse into each other as if they are one amorphous visual entity.

Turner was using soft focus to show the visual occlusions of sea, weather and objects, but on the other side of the world, a century later, out-of-focus

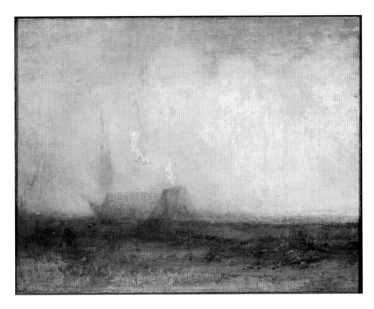

imagery that resembled his paintings was used to suggest something other than love, closeness, dream or tempest. Look at this similar image from the 1953 film *Ugetsu Monogatari*:

Here director Kenji Mizoguchi has the scene shot with a long lens, diffused light, a smoke machine, a diffusion filter and low contrast to coax us of out of our

hard-edged, three-dimensional, everyday life into a floating world. The setting is Lake Biwa in the late 1500s. Two peasants, who live modest, decent lives, want more. Their wives try to convince them not to be too ambitious, but hubris takes over. One of them, the potter Genjurō, falls for an aristocrat, Lady Wakasa, who admires his work. She seduces him and asks him to marry her. In this famous image, he seems to carry her on his back.

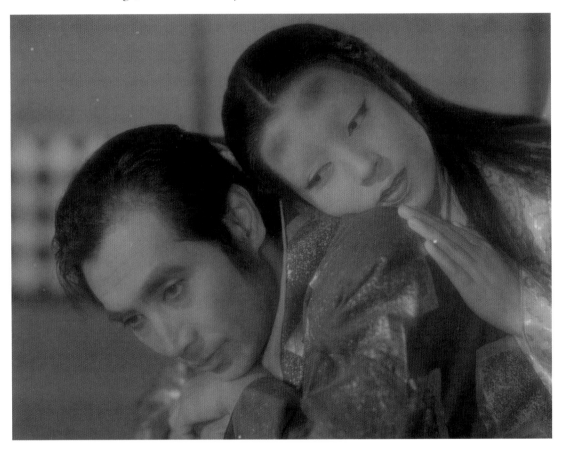

Cinematographer Kazuo Miyagawa's focus is again shallow, the contrast is low. There are no blacks or whites, just shades of grey, as if their world is fogged, or floating. It is, in a sense, floating, because it is revealed that Lady Wakasa is a ghost. Miyagawa uses soft focus as a ghostly thing, as a way of depicting a haunted, parallel world.

Artists have continued to be interested in this parallel world. In the twentieth and twenty-first centuries, the German artist Gerhard Richter regularly produced large, blurred images of faces and the sea that gave the sense of primal seeing. He said in an interview that he blurs 'to make

everything equal, everything equally important and equally unimportant'. He could be talking about the out-of-focus seeing of a newborn child in which most things, with the exception of faces, have equal weight. The very first impressions on the blank pages of a baby's inner eye are mysterious, ghostly and imprecise about place and space. They are the foundations of our future seeing.

LOOKING OUT AT THE WORLD

Let's think of our African baby from 200,000 years ago again. Once she learns how to focus, what she next sees, before colour, is space. The blank spaces start to acquire dimensions. Having two eyes allows her to see and judge distance, what is close and what is far. Unlike a horse or rabbit, whose eyes are on the sides of their head and who therefore see to their left and right, humans eyes are frontal, and so our looking is substantially forward. We have a greater sense of where we are going than where we are. As we grow up, we develop an aesthetic of near and far, an emotion. This man, in Caspar David Friedrich's painting *Wanderer Above the Sea of Fog* of 1818, looks out into a landscape not unlike Lisa del Giocondo's, but where she has her back to hers, he has his back to us.

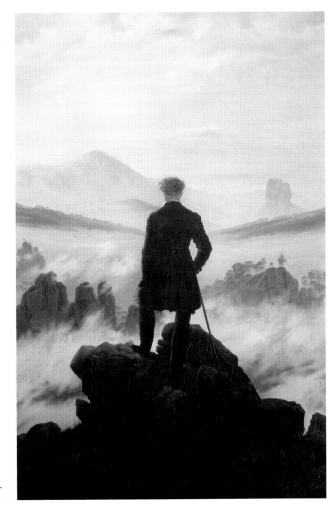

We are looking with him not so much at a landscape as into a vast space. The space makes him feel small, overwhelmed by the size of the world. The effect is consoling; it takes him out of

himself, what the anthropologist Joseph Campbell called 'the rapture of self-loss'.

We do not only perceive space when we climb mountains, of course. We want a room with a view. A house or flat with such a view will sell for more than one without. As we will see later in our story, the drive to invent hot air balloons and tall buildings comes, in part, from the desire to see space. Images are no longer things that appear on the blank pages. They appear in them. In terms of geometry, where an x-axis is left–right and a y-axis is up–down, in–out is the z-axis – that line in space that links us with everything in front of us.

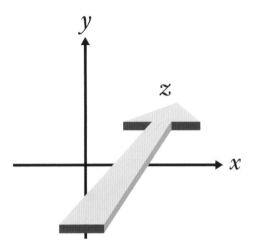

In southern Scotland, on raised moorland overlooking this

view, the artist Ian Hamilton Finlay built six small stone walls which carry the words

<div align="center">
LITTLE FIELDS LONG HORIZONS

LITTLE FIELDS LONG FOR HORIZONS

HORIZONS LONG FOR LITTLE FIELDS
</div>

The first line captures the smallness of the looker and the distance of the looked-at – the length of z. By moving the word 'long' in the second line, he doubles its meaning – far and wanted. We want the afar, that which stretches into the distance. The z-axis is implicated in desire; it is our sense of adventure, our wanderlust and the way that we visualise the future that lies ahead.

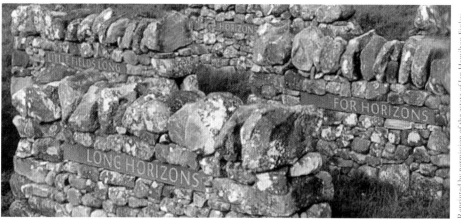

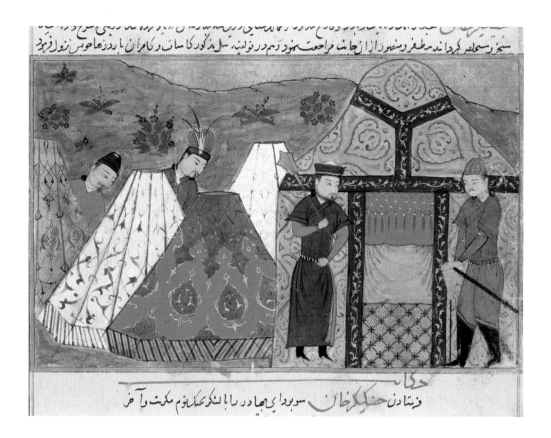

The story of z-ness, of the journey from in to out in the visual arts, has been shifting and dramatic. In this fourteenth-century Persian illustration, four military tents, four people and distant hills are all pushed up against the picture plane, distinct from each other because of their colour or pattern. There are no shadows, a frequent sign of z-lessness.

For much of the Middle Ages, Western artists followed suit, cramming their characters, stories, incidents and symbols into a shallow, almost z-less space. But a new movement – the Renaissance – became beguiled by z, depth. As early as 1278–1318, the painter Duccio tilted the top of this *Last Supper* table backwards, away from the picture surface, breaking the spell of flatness and inducing a kind of vertigo, a teetering visual drama in which, to our eyes, it looks as if the cutlery and plates will slide off, onto the apostles who are in front of – or is that below? – it.

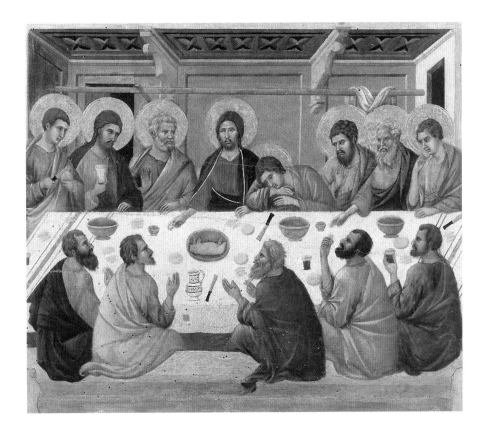

It looks as if the back wall is recessed, that the ceiling brackets are pointing towards us and that the artist has taken a step backwards out of the room, and that, as a result, he is viewing it through a window. Our child's perception of z is analogous to this growing visual separation.

From here onwards, z – the illusion of three-dimensional space – was one of the tricks and pleasures of Western painting. Northern European artists showed us rooms seen through rooms; Mantegna made us feel as if we were sitting at the feet of Jesus Christ; allegorical or religious scenes were set in architectural spaces to make them feel touchable, real, or similar to our own lives. Z had poetics, but politics too. In his television series and book *Ways of Seeing*, John Berger said that paintings with such an appearance of depth, with single vanishing-point perspective, arranged the visible world as if it is centred on the spectator, 'as the universe was once thought to be arranged for God'. He was right to draw attention to this assumption that Western lookers made that they were the centre of the universe, but the z-axis is political in another sense too. As we will see, the line from me – here – to you – there – is the line on which sympathy and empathy take place.

LOOKING AND COLOUR

Let's imagine that we have moved forward in history from the earliest days of *Homo sapiens*. We are in Egypt now, at the time of Cleopatra. Another baby is looking. After seeing blurs and space, like its ancestor, our new baby starts to see colour. Her pages become tinted and more complex. In nature, the recurrent colours are the green pigment chlorophyll, in plants and algae, and the skin pigment melanin, but the biggest sheet of colour that humans ever see is sky blue. Each of the colours has its own history, but let's focus on blue. The complexity of its story is mirrored in the stories of the other colours.

Looking at a cloudless sky is z–less. We have no sense of distance. The painter Yves Klein was born in Nice in the south of France, so in infancy would have often seen the blue-sheet sky. In his late teens, he lay on a beach and signed that sky. Will he have understood that the blueness comes from what is now called Rayleigh scattering, sunlight bouncing off particles in the atmosphere? Will he have noticed that if he dropped his eyes from the intense blue above him, to the horizon, it will have looked whiter? In Milan in 1957 he showed a series of paintings, each entirely ultramarine, mixed in a resin to make it more luminous, more intense. They echoed the infinite scale of his childhood sky-watching, the saturation of his field of vision.

Yet the story of looking at blue is not as direct as Klein's experience might suggest. It weaves in and out of human consciousness and culture. There is no blue in the 17,000-year-old Lascaux cave paintings, perhaps because no animals have blue fur. The semi-precious stone lapis lazuli, which gave Klein's ultramarine paint its intensity of colour, was probably first mined in Afghanistan in the seventh century BCE. In ancient Egypt, where our baby is, it was a symbol of daybreak. Women – perhaps Cleopatra amongst them – painted their lips blue-black. As it could not be mined in Europe, for example, lapis lazuli was as precious as gold in the ancient world, but from around 2000 BCE there was another blue, cobalt, which was lighter and less intense than lapis.

It was used to colour glass in the Middle East, and much later, in the 1300s, to tint the underglaze in Chinese pottery.

Given that these and other blue pigments existed, and that the Egyptians had a word for blue, and that the biggest visible things in the world were blue, it comes as a surprise to hear that not once is the sky or sea called blue in the writings of Homer, or in the Bible, or in the 10,000 lines of the Hindu Veda. Unlike Jewish culture which values the verbal more than the visual, Greece was a place where looking was prized – 'Knowledge is the state of being seen,' wrote Bruno Snell in *The Discovery of the Mind: The Greek Origins of European Thought* – so we would expect Homer to have a broad lexicon of looking. He describes the sea as bronze or 'wine dark' and writes of its sheen, but not what we would call its colour. As Homer and the Bible's authors lived around the Mediterranean, they will have seen it on many sunny days as it reflected the clear blue sky above.

Explaining this leads us into the subjectivity of colour, how it relates to our thinking and values. There was no word for blue in ancient Chinese, Japanese, Greek or Hebrew, so when the speakers of those languages looked at the sky they did not see something on the colour spectrum so much as the light spectrum, or the space spectrum, or the divine spectrum. Most languages had words for dark and light from their earliest times, and then came red, then green or yellow. The last principal colour was blue. Little that was solid was blue. When you looked to

the sky, you did not see something material; you saw where your god was. It is impossible to understand how Homer looked when he wrote *The Odyssey*, but he was writing about war and homecoming in a country that had no way of quarrying anything blue. Perhaps his themes favoured their own image systems. Tenebrous contrasts in tone occur throughout *The Odyssey*; his is a visual world of conflict. Blue is hard to fit into that paradigm.

We will return to how the cognitive aspects of colour influenced Mediterranean lookers when our story reaches the end of the nineteenth century, but let's continue to track the story of blueness. In the Middle Ages, woad, a broccoli-like brassica that was native to the Caucasus and steppe, was widely ground to create the textile dye woad blue.

More muted than lapis or cobalt, it was used as a body paint by early Britons (Julius Caesar saw it when the Romans invaded England), perhaps because it is a mild antiseptic. William Wallace is said to have used it, hence Mel Gibson's half-blue face in the film *Braveheart*. In India at the same time, the main textile dye was indigo, which is closer to purple than the others.

The development of the silk trade route between Asia and the Mediterranean led to the flourishing of indigo. It became so valued that less than five years after painting the *Mona Lisa*, Leonardo was contractually required to use it in his beautiful *The Virgin of the Rocks*. This London version of the painting is perhaps a copy, in part by his assistants, but it demonstrates well the use of blue.

The indigo was underpainted with another blue, azurite, this time derived from a copper carbonate. You could call the painting bichrome. Two colours, blue and gold, each precious, are embedded in each other. They seem to swirl like oil on water. The painting has a religious subject, of course, but at this early stage in the story of looking, it is the reduced colour palette, the way the Madonna's gown echoes the distant hills, that catches our attention.

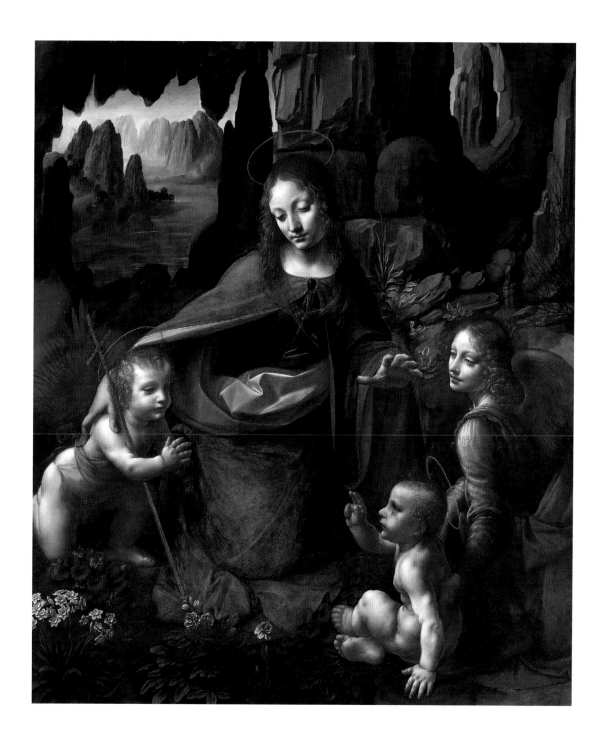

A century after Leonardo, Persian blue came to dominate the intricate tile work of the great mosques in Iran. Again the subject was religious, but even more than in *The Virgin of the Rocks*, the blue-gold combination gestures to abstraction.

When it is mined, azurite is veined with earth colours. It is hard not to see the colour scheme of the mosque, and maybe even the Madonna, in these naturally forming blue-brown combinations. They evoke earth and sky.

And so, as the word appeared in more languages, and more sources of blue were found in nature, and as our art and buildings became more blue, so did human life. As Alexander Theroux, who writes brilliantly on colour, describes:

> It is the symbol of baby boys in America, mourning in Borneo, tribulation to the American Indian, and the direction south in Tibet. Blue indicates mercy in the Kabbalah and carbon monoxide in gas canisters. Chinese emperors wore blue to worship the sky. To Egyptians it represented virtue, faith and truth. The colour was worn by slaves in Gaul . . . A blue spot painted behind the groom's ear in Morocco thwarts the power of evil, and in East Africa blue beads represent fertility.

He is telling the anthropological story of blue and how it shifts in appearance, meaning and effect.

LOOKING AND THE COLOUR WHEEL

But how does blue relate to all the other colours in life? In the late 1700s a Frankfurt-born artist, writer, lawyer, statesman, philosopher and collector had this question in mind. He travelled to Italy to see great art, and wrote about Leonardo da Vinci. What he saw in Italy led, in 1810, to his *Theory of Colours*, one of the most influential publications on the subject. It was a wayward work, contradicting the science of its day by emphasising not the optics of colour, but how we look at it, how it works on our imaginations. 'Search nothing beyond the phenomena, they themselves are the theory,' he wrote, a manifesto of looking. His name was Johann Wolfgang von Goethe.

Goethe sensed that colours tamper with each other, and with blackness. Of our colour, blue, he wrote 'it is darkness weakened by light'. To scientists this was nonsense, but Homer's descriptions of the sea in *The Odyssey* seem born of the same thought. Goethe's was an artist's account of light, and it influenced painters such as J.M.W. Turner. And Goethe's ideas can certainly help us understand why in Leonardo's *Virgin of the Rocks*, the Iranian mosque and the raw azurite, the colours seem so right for each other.

Here is an image of Goethe's from 1809:

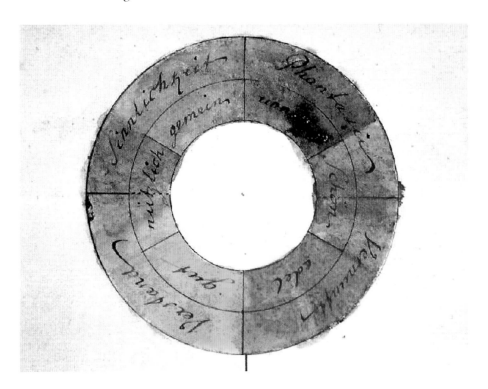

In his *Theory of Colours* he explained its significance.

> The chromatic circle . . . is arranged according to the natural order . . . The colours diametrically opposed to each other in this diagram are those which reciprocally evoke each other in the eye. Thus, yellow demands violet; orange [demands] blue; purple [demands] green; and vice versa.

Just as Goethe predicts, diametrically opposite our blues is the yellow-gold of Leonardo and the Iranian mosques. They reciprocally evoke and even demand each other. Though he had no scientific proof for this, Leonardo wrote that colours '*retto contrario*' – totally opposite – each other are the most harmonious. And in 1888, in a letter to his brother, painter Vincent Van Gogh wrote of the 'antithesis' of colours. His most famous painting, *The Starry Night*, is blue and yellow-gold. Stare at blue for half a minute, then look at something white, and what do you see? Yellow. After forcing blue upon your eye and brain, it is as if they – to use Goethe's word – demand the complementary after-image, yellow.

And Goethe helps us understand other aspects of looking at colour. Both the Leonardo paintings we have seen so far depict distance, z-ness, as blue. This moment from the 2002 Chinese film *Hero* does the same. Despite the cloud, the trees in the landscape on the left are somewhat green. In the distance, on the right, there is a noticeable indigo shift. The film-makers emphasise this by dressing the figure in the image in the same colour.

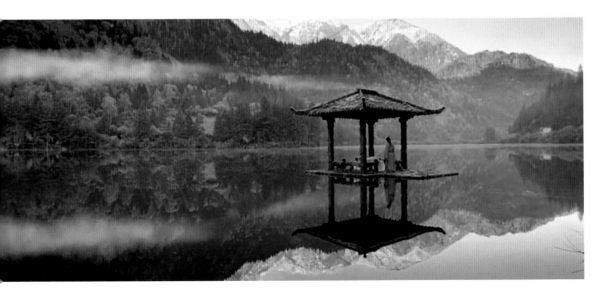

Goethe explains this blue shift. He did experiments to show that when light travels through the moisture and dust in the air (what he called turbid media) it becomes coloured. It had long been known that white light is split as it travels through a prism (or raindrops – hence rainbows), but in the *Theory of Colours* Goethe describes this refraction in a way that would have been useful to Leonardo, or Christopher Doyle, who filmed the above shot in *Hero*:

> If . . . darkness is seen through a semi-transparent medium, which is itself illumined by a light striking on it, a blue colour appears: this becomes lighter and paler as the density of the medium is increased, but on the contrary appears darker and deeper the more transparent the medium becomes: in the least degree of dimness short of absolute transparence . . . this deep blue approaches the most beautiful violet.

And as well as complementary colours, and distance, Goethe wrote about something else that opens our eyes. He said that all hues are coloured shadows, which is implied in his comment on blue. But it is the phrase 'coloured shadows' which is evocative.

In the image below, a man who has long wanted to see this woman this way, finally does so. It is from Alfred Hitchcock's film *Vertigo*. The man was in love with a woman who died (or seemed to), then met another woman who resembled her. He wanted to remake the second woman as the first, to pretend to himself that she had not died, or to gratify his erotic imagination. Hitchcock and his cinematographer Robert Burks film the scene as the man sees it, or rather, feels it.

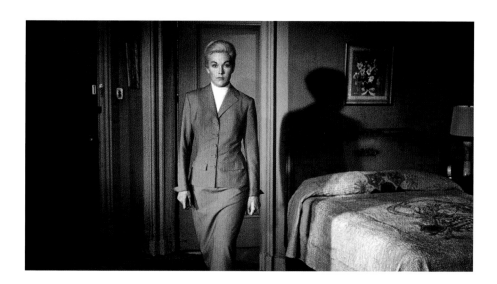

Look at her shadow, which falls across the bed and onto the wall. Is it grey, like shadows are supposed to be? No, it is plum coloured, like the lampshade, both of which, on the colour wheel, are the opposite of the green of her dress. We think of a shadow as an absence of light, but not for Goethe, and not here. A shadow is not necessarily just less, a reduction: here it is a contortion. The darkness is alive. Even it has something to say.

Then follow that thought to this image:

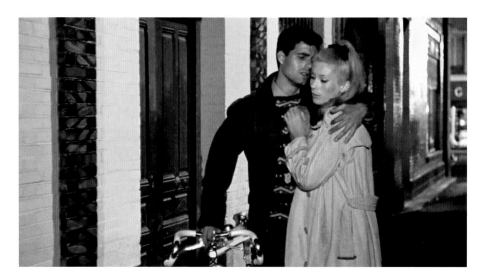

It is from another film, *Les Parapluies de Cherbourg*. The man and woman appear to be in love. They are young. Her hand is closed, his is open. It is 1964. France is at war with Algeria. The guy has to tell the girl that he will go to war. They cling to each other, deferring the moment when he must leave. They live in an ordinary working-class military and shipbuilding town in the north of France that was bombed in the Second World War, but is that what this image says? Director Jacques Demy, cinematographer Jean Rabier and production designer Bernard Evein have made it noticeably chromatic – flooded with colour. The only root colour is his brown jacket; otherwise the hues are wild: the light salmon of her coat, the darker pink flush of her cheeks, the turquoise of his shirt, the lemon of his bike. And then there is the Goethe shadow on the wall behind his right shoulder. A lilac shadow which helps transform real-world Cherbourg into a movie set, or a place or an externalised, heightened feeling. Her cheeks are flushed, and so is the street.

Colour is frequently discussed in the humanities. It is everywhere, like time is everywhere, and the role it plays in looking is hard to overstate. We will revisit it in this book, but for now let's zoom in on one moment: 4 p.m. one November day on the North Sea.

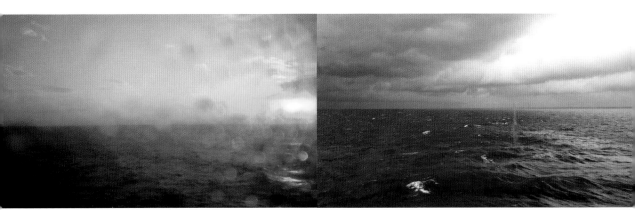

These two photographs were taken six minutes apart. There is not much blue in either. The bronze-orange in the first is the complementary colour of the green-slate in the second. The first is blurred, because of the rain. We see the horizon – there is plenty of z-axis here. The early stages of looking are all in these images.

Is it a push to say that this is how Homer might have seen the sea? He could have recognised the dark wine colour of the water on the right of the first image, or the silver on the second. Whether it is him looking, or Cleopatra or Goethe or Yves Klein or Ian Hamilton Finlay or us, we can say that seeing the unexpected colours here gives pleasure. Our eyes skim the churning sea, into the long distance, longing.

By seeing shadows, blurs, space and colour, our baby's eyes have started to come alive. They have laid down impressions, spaces, and contrasts on her blank pages which will be overlaid. They will always be formative, these first images. Shadows, expanses of blue and softness of focus will resonate for her throughout her life as archetypes resonate within stories. Soon, new elements will be added to such ancient, primitive looking. Movements, places and emotions will register for our baby and, as they do, she will begin to learn about the visual world.

CHAPTER 2

DEVELOPING LOOKING: *EYE CONTACT, MOVEMENT, LANDSCAPE AND EMOTION*

'Only connect! That was the whole of her sermon. Only connect the prose and the passion . . . Live in fragments no longer. Only connect, and the beast and the monk, robbed of the isolation that is life to either, will die.'

– *E.M. Forster,* Howards End

WE began by looking through the eyes of an early African *Homo sapiens* baby, then we imagined an ancient Egyptian infant. The first visual impressions of each were new, fast and impactful. Though such impressions are only traces and glances, their freshness and lack of precedent give them ballast. It is not long in our looking lives, however, before something more complicated than shadows or skies begins to draw our attention.

That thing is connection. We begin to see, in simple ways at first, how things relate to us and to each other.

Moving forward in history, let's imagine a baby in, say, Australia in 1050 BCE. If she covers her eyes with her hands, she will see the world or a person disappear then appear again. She is disconnecting, then connecting. Connection will be a key theme throughout the story of looking, seeing, studying, staring, viewing and watching, but in this chapter we will consider four specific aspects of connected looking: how our eyes lock with the eyes of another; how we see something that has been in one place move to another, the two places becoming connected; how we look at landscape and, in doing so, see something of ourselves in it; and how we connect to others' emotions. Each of these associations extends looking outwards. It creates an affinity.

Eyelines first. One of the artist René Magritte's most revealing paintings is a close-up of an eye in which is reflected a blue sky with white clouds. It could be the eye of Yves Klein on that day on the beach when he looked upwards to sign the sky. But the title of Magritte's painting – *The False Mirror* – sounds an alert.

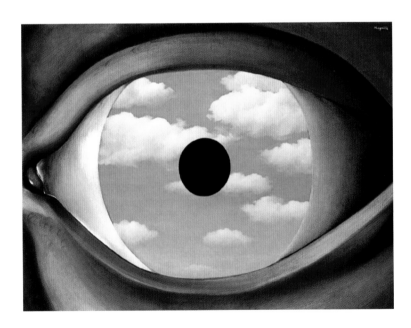

As neuroscience can now show, there is something false in our understanding of how looking works. When we look, we do not objectively see what is out in the world. The art historian E.H. Gombrich tells a story to illustrate this. During the Second World War he was employed to listen to German radio frequencies to try to discover the Nazis' military plans and tactics. The signals were crackly and weak, so he was not able to hear all the words in a sentence. From the ones he could hear, however, he was able to infer the rest. The sense allowed him to fill in the gaps, to make connections. It is now clear that from childhood onwards, we look in a similar way. Our eyes provide pieces of visual information to the visual cortex in the back of our brain, but we infer the rest from our experience of seeing. We learn how to complete the picture with the other seeing we have done. In fact, as neuroscientist David Eagleman describes, the amount of information flowing out of the visual cortex when we see is ten times the amount that goes in. So we are not just filling in small gaps, we are filling in most of the picture. We are projectors as much as absorbers. We see through knowing. People who have been blind for a long time, and then have surgery to make them see, report that although their eyes are now fully functioning, it takes a long time before their brain is able to make sense of all the visual data with which it is suddenly flooded. Looking really is a story, the story we tell ourselves based on what we see in one moment combined with what we know from all the looking we have done.

Our Australian Aboriginal baby, who saw the blurs, then space, then colour, very quickly starts making eye contact. She stares into the eyes of other people. In the faces of those she looks at most, she bonds. Recognising their eyes reduces uncertainty for the child, and in their smiles she intuits safety and,

eventually, joy. She comes to delight in them. Novelist George Eliot called this 'the meeting eyes of love'. In this Mexican clay sculpture, also from 1050 BCE, a much older child leans towards the adult, turns his head and looks up into his eyes. The man mirrors the gestures.

The youth perhaps once held something in his left hand, but whatever it was, it did not distract either from looking directly at the other. We are drawn to their eye-lock. It is as if there is a line between their eyes. The line was made three thousand years ago, yet it is still alive with inquisition, with example. The man's hand on the youth's shoulder adds

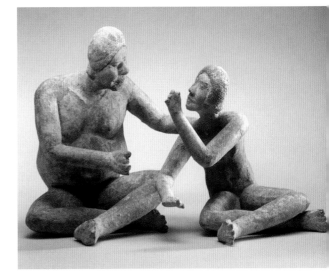

to the feeling that the latter is being guided into some sort of understanding. The boy is learning through the connection his eyes make.

The 1962 Soviet film *Ivan's Childhood* is about a twelve-year-old boy looking at, and learning about, the brutal world of war. It starts with Ivan looking through a cobweb; then he goes into a field, turns his head, and the director, Andrei Tarkovsky, has his film cut to this image: square-on, symmetrical, filling the frame, no sideways glance.

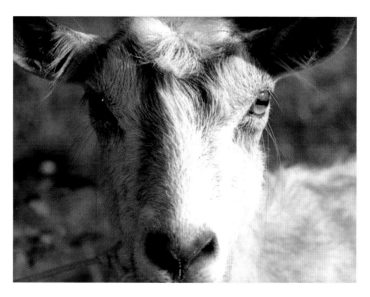

It lasts only a moment, but startles. The boy looks into the eyes of a goat; the film-makers put the camera where the boy's eyes are so that we look into the eyes of the goat too. We are the boy's surrogate. It is often a shock to lock eyes. Children play a game to see how long they can look into each other's eyes before one looks away, breaks the spell. Tarkovsky did not want his films to take place only in social realms. He wanted his characters to connect with nature and something eternal or metaphysical. The boy – and the film – looking at the goat immediately opens a portal into the natural world, and another type of subjectivity unexpected in war movies, which more usually deal with soldiers, commanders, tactics, heroics or suffering.

Looking at the eyes of this goat helps us see how the earliest humans saw. There were more animals a million years ago, and far fewer humans – in the African grassland savannah there were just two people per square mile – so those there lived much closer to animals than most of us do today. The first humans would have recognised this goat picture. They would stare into an animal's eyes as a preface to killing it, perhaps, or to see if it was about to flee. Another kind of looking game. Do we see fear in the goat's eyes? Does it see fear in us?

Does it look like a beast, or like me? Is it possible to say that the first humans respected animals? Understood them? When they looked into their eyes, did they wish that they were them? Or is the stare too intense, embarrassing or short to allow such reflection? Maybe the thinking you do, if you do any, happens after the look has finished. Maybe the goat's eyes are a false mirror. The moment is fleeting, but in his poem 'Two Look at Two', Robert Frost suggests the opposite, that it is rock-like:

> A doe from round a spruce stood looking at them
> Across the wall, as near the wall as they.
> She saw them in their field, they her in hers.
> The difficulty of seeing what stood still,
> Like some up-ended boulder split in two,
> Was in her clouded eyes: they saw no fear there.

The intensity, startle and portal of eye contact electrify our looking lives because they give us the sense of seeing into another consciousness. Artists have long understood this eye-lock voltage. It is often said that a painting's eyes follow us around a room. As with the Mexican clay sculpture, the intensity of eyelines in paintings makes them seem present tense.

In 2010, the Serbian artist Marina Abramović turned the eyeline lock into a Homerian epic. For 736 hours, she sat in New York's Museum of Modern Art, staring into the eyes of anyone who chose to sit in the chair opposite her.

In a public place, in the bustling modernist city of New York, where to hold someone's stare on the subway can be seen as a threat or a come-on, Abramović stared into the eyes of other people the way Tarkovsky's goat looked at Ivan, the way the early humans might have held the gaze of an animal. Her looking cancelled out the fleetingness of city life. Though the event was always observed, many people felt that she and they were the only two in the room, that their surroundings blurred. Some cried. In the documentary *Marina Abramović: The Artist Is Present*, we see that she cried too. Close-ups show how exhausted she was, and how

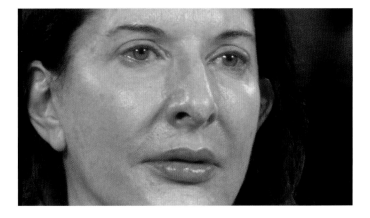

moved. The relevance of the clay sculpture, the Soviet film or Abramović's artwork to our story is not how they are depicted, but what they show. The sculptor, the film-maker and the performance artist are our surrogate lookers. They are drawing our attention to one of the earliest and most powerful aspects of the looking lives of an individual and of our species.

LOOKING AND MOVEMENT

Blur, depth, colour, eye contact: the child is learning to look, the species is learning to look. They are tuning into the visual world. It is a world that is not static, of course. What happens when the zebra or antelope we have been staring at on the savannah moves, or when the baby's mother's face moves away from her, into the world, so that it becomes part of a fuller picture? Looking becomes dynamic. It connects one place with another. It draws an imaginary line between the former place and the new place. Let's imagine that the child or the hunter is static, and that they are surveying a scene. Their eyes have a lot to respond to: faces, colours, depth, brightness, movement. Muscles around the eyeball pull and push it in all directions.

In the next image, three young women are walking towards us.

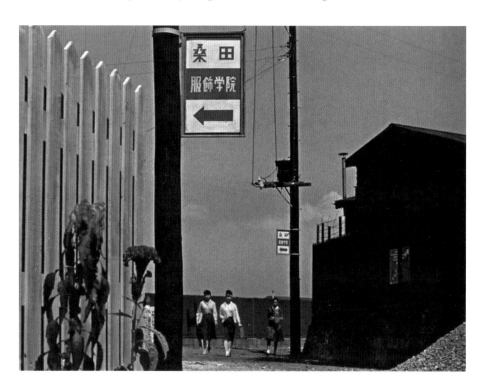

That is what is happening, that is the action. But it is not all that is happening or even the main thing that is happening. It takes up no more than a twentieth of the overall scene. Instead, other things catch our eye. They dart to the red flowers on the left, up to the red of the large sign, and then to the red of the smaller, distant sign which is perhaps ten metres away but which looks as if it is on the same visual plane as the large sign. There is no 'distant' red here. All the reds are red, and so our eyes skip between them, connecting them, as if z-ness does not exist.

From the signs, our eyes then spiral down to the girls' reds – the dress of the one on the right and the satchel of the one in the middle. Thence we are back at the flowers. A clockwise, spiralling, visual journey in red. The girls walk in this image, but the colour takes our eyes for a walk, a different kind of walk, a walk on the surface that undermines, or rather, counterbalances, the girls' walk. The other colours help corral our looking, like sheepdogs corral sheep. The pale-green fence blocks the left flank, and the dark building on the right ensures that our looking does not get lost on the other side. The black verticals of the telegraph poles trisect the scene, almost as if it is a triptych: as if the flowers, the girls and the enshadowed building are three separated scenes, three different times, combined. Yet the light reassures us that it is not – the shadows in all three fall leftwards. The image is from a film by Yasujiro Ozu, one of the great lookers. He understood that, from the earliest times, our eyes have seen things as surfaces, patterns, as well as actions in depth. In doing so, they are searching. Looking is always searching, just as Gombrich listening to German radio signals was searching.

In this image, taken eighty years ago, a woman is eating a crisp, or some kind of snack. It is an everyday event, and yet engaging. Her lips are so perfect – a sheared heart. They and the moment of eating are caught in what almost seems like a search-light, as if she is someplace where eating crisps is illegal and she is doing so illicitly and has just been spotted. Or maybe she is in a cinema, near the back, and she has been crunching on crisps and someone's complained and the light is the light of an usher's

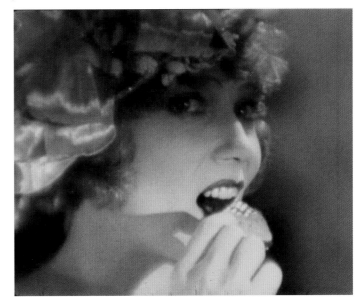

torch, accusing her of breaking the spell of the movie? It is her eyes that make us imagine that what she is doing is not quite right. The light has not quite caught them yet, but they have flicked rightwards, alerted by some observer. They are not relaxed the way they would be if she was going to eat uninterrupted. If the light is from an usher's torch, she would surely be looking at its direction. But she is not, so it is either not an usher or she is insouciant, which quickens the heart, gives her a spark, a hint of personality. She looks caught in a moment, but someone with an eye for such eyes and skin and such a mouth has worked hard to make this image so appealing.

That someone was film-maker E.A. Dupont, and the woman in the image is Gilda Gray, who was born in Poland, married at fourteen, became famous for her shimmy dance move, lost her savings in the stock market crash in 1929, and raised money for her fellow Poles during the Second World War. We can see none of this in the image, of course. Looking can seldom tell us such things. Instead, by gathering visual clues and connecting the dots, as it were, looking asks us to imagine what is not in the image. She bites the crisp, but then what? Is she caught? Does she skip onwards? We do not know. What kind of looking are we doing as we have these thoughts? We are doing detection looking. We are like police looking for clues. As we look at Gray, we are bringing our own knowledge, or our desires perhaps, to the scene, to make it come to life in space and time, to set it in a place, a building, and to extend it backwards and forwards in time, to the before and after.

The visual world has got an innate mystery. It is begging us to know it more, to flesh it out. Just as when we see old photos, archaeological sites such as Pompeii or a crime scene, looking on, we become Sherlock Holmes. We detect.

Let's detect this moving image.

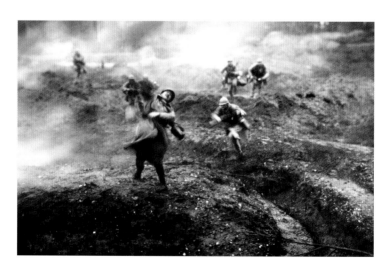

Instantly, we can tell that it is a moment. This is not an image that tries to present to us a season, or a week, or a day, or a morning. If we looked only at the muddy foreground, we might be able to think of such lengthy time frames, but as soon as our eyes clock the man with the gun running, just to the right of centre, we know we are seeing a second, or a split second. His left leg is moving so fast that it is blurred. In an instant it will be in a different place. As we look, we connect where it is coming from and where it is going to. His weight is forward, out with the only part of him that is on the ground, his right leg. If both do not move forward, he will fall.

And yet it is not he who really catches our eye; it is the man in front of him, who seems to be stopped, or twisting, or falling backwards – a ricochet man, as if Francis Bacon had painted him. The foremost man has been stopped in his tracks by something so forceful – we presume a bullet – that, as his body reels backwards, his clothes have yet to get the message that the advance is over. The man's body is dying, but his clothes are still living. We connect the body and the clothes. We notice the difference between them.

As we look at this image we look into movement, into time and death. The man is a French soldier. We are in Verdun in the northeast of the country, in 1916, during a 303-day battle in which an estimated 714,231 men died, as our man seems to be dying. Even his moment seems to defy gravity or space – that contortion, that blur. We look into his face in this image, and what do we see there? The pity of war distilled? Or a guy in his twenties, with a moustache, who had a life back home, but which is expiring as we look at him?

This image sucks us in. It is easier to look at it when we hear that, despite often being published as a photograph of a real soldier dying in Verdun, it is actually from a re-enacted movie, *Verdun, souvenirs d'histoire*, released fifteen years later. So much about the image convinces us that it is not fifteen years later, that it is from 1916, and a split second in 1916. More than anything, what convinces us is the motion blur, which is the shot's relevance here. If we had been in Verdun, our eyes would have been darting all over the place, to look for safety, to try to get a sense of the atrocity. And yet it is unlikely that, as a result of such rapid, zigzagging looking, we would have experienced motion sickness.

Look up from this book, and then around you. Connect your reading world with the world that immediately surrounds you as you read. Let your eyes dart about. In doing so you will take in several visual moments per second, yet this will not disorient you. When we first film moving imagery, with a video camera or mobile phone, we tend to pan the camera in a similar way, quickly and from one moment to the next, but when we look back at it we are struck by how wobbly it seems, how uncomfortable it is to watch such movement. The camera

is right; everyday looking is jerky, it is an accumulation of rapid visual impressions that should overwhelm us. And yet they do not, because our brain learns to compensate for the motion blur. It is a great image stabiliser. On the savannah grasslands, our hunting ancestors might have seen a zebra they have speared suddenly reel and die, the way the Verdun soldier reels. Their brains would have stabilised the image.

Perhaps our brains are too good at this. There is nothing stable about a man dying from a gunshot on one of history's worst battlefields, so the image overleaf is right to be unstable, blurred. And in the twentieth century, painters sought new ways of depicting motion seen by a static observer. Life was speeding up, especially in cities, so in this painting, *The Cyclist*, completed three years before Verdun, Russian Futurist Natalia Goncharova gave the front wheel three visual echoes, the back wheel four and the man's back four.

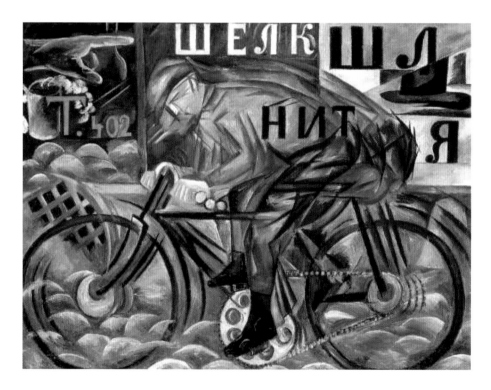

Things this fast, she is saying, would be in more than one place at once in the painting. They connect several spaces. We see where the cyclist is, but also where he was. The composite image, the layered looking, allows us to see movement.

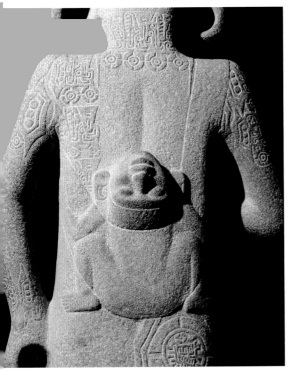

Our baby grows up. History moves on. Imagine, now, that we are looking through the eyes of this child strapped to her father's back in a Mexican sculpture from CE 900. She looks up and smiles.

As her father walks, she sees movement. She has seen a lot, this kid. The world has pulled into focus for her, and become chromatic. She can easily track her parents' movements now, and has seen distance and looked into the eyes of animals. Her brain has learnt how to stabilise movement. Her looking life is well under way. Next we should consider her encounter with the visual world of emotions, but before we do so, let's have an interlude, as journeys have interludes. Let's imagine her seeing the natural world's tableaux, what we call landscapes. As she is jogged along on her father's back, or around his shoulders, she will see such tableaux, this girl – growing spaces that have form. She will be on a guided tour of the visible world. At first she might see like this:

Beneath growing things, which will give her a sense that these yellow flowers are reaching. When she sees this . . .

. . . she will feel that everything –
the thistles, the trees – is reaching that
upwardness in nature that we will see
all our lives.

She will notice gradation in colour
and space. She will begin to feel
extended by these landscapes.

And that snow, when she first
sees it, is like a beach in that it reflects
light upwards, under her chin.

She will see that in nature there
are accidents of positioning and
colour, which you could call form.

In her life, she will sometimes
encounter form in nature that will
astonish her because of its symmetry or
fanning, its design and display.

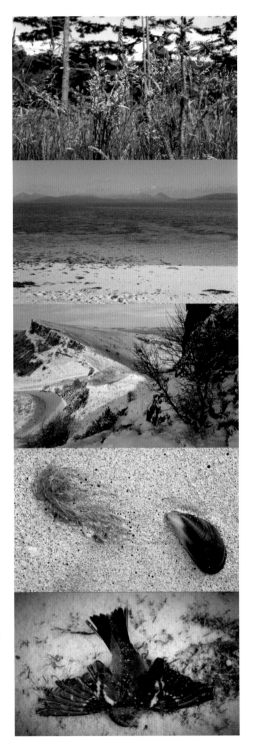

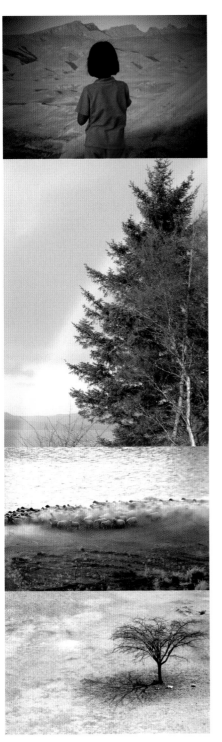

She will start to notice how colour and space combine with form and light.

And will perhaps think that she is in the most splendid place in the world.

But there will be more. She will happen upon sheep by a river, which kick up dust in a way that will remind her of all sorts of looking – into a goat's eyes, Leonardo's *sfumato*, Goethe's colour wheel.

And, on that savannah, she might glimpse her future solitude.

In doing so, in seeing her emotions symbolised or reflected in things outside herself which are, in reality, indifferent to those emotions, she will be projecting. She will be connecting to the tableaux of the natural world. Throwing a line from our inner world onto the outer world, like a boat throws a line onto the dock as it arrives in harbour, is something people will always do. It is what E.M. Forster meant when he wrote 'only connect'.

If we do not grow up in a city, and are alert whilst looking at the natural world, we will come to learn how to read a landscape, its habits and revelations: the green flash at sunset; the fact that if you lie on your belly to watch the sun dip below the horizon, then jump up exactly as it does so and you see another moment of it, you are proving that the Earth curves; a holly bush is less prickly at the top because its grazers cannot reach up there; hydrangeas change colour, from blue in acid soil to pink if the ground becomes more alkaline; if you see a secondary rainbow, its colour sequence will be the opposite of the first one; shadows are always slightly blue because they are gently lit by the blue light from the sky; when the Moon is a crescent and if we can see the pale remainder of it, we do so because it is being lit by the Sun's light reflecting from the Earth, so called 'earthshine'.

Seeing each of these things will help us understand the natural world and feel part of it. Such looking changed as human culture underwent a series of revolutions. For nomadic people, an expanse of desert or grassland was something you moved through according to the seasons, in search of pasture or animals to hunt. Come the agricultural revolution, land was what you settled on, cultivated and marked off as yours. The space you saw was the thing you worked and, if you were lucky, owned. Then landowners began to think of land and landscape, not to be worked but to be admired. It was art, it was picturesque. Come industrialisation and capitalism, further and ongoing detachments took place: workers crammed into cities, and what was outside cities – the countryside – was seen from a distance. Landscape became estranged, it was no longer readable as nomads or farmers would read it. It caught the eye as before, but had become an object of desire.

LOOKING AND EMOTION

The most affecting looking connections a child makes as it develops are to the emotions of others. It enters the world of visible emotion. In New York, people were moved by Marina Abramović's simple stare, but what happens early in our lives when people who are clearly feeling something stray into our field of vision? Maybe they are far away and their back is turned:

In this painting Pablo Picasso does not show us the woman's face, but we can read her body language. Her head tilts left, on top of the child, and her left shoulder drops to create a scoop in which to hold it. Her body language is inward; she is hugging the child so tightly that we see nothing of her arms. The mood is blue, the pain is blue. The background, what is in front of her, is empty or obscured. As we look at her we might imagine that she has closed her eyes. She seems to cast a shadow on the ground, but also up the wall on the right, as if she is in a prison cell.

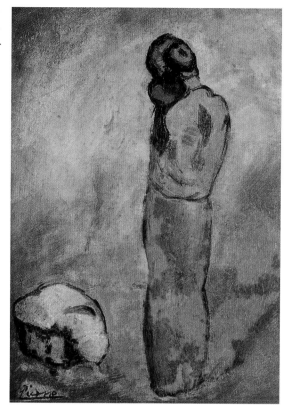

Which perhaps she was. Picasso had been visiting the Saint-Lazare women's hospital-prison in Paris in the period before he painted this, and a close friend had, a year previously, committed suicide. It is hard not to read solitude and despair in this picture, and, by not showing the woman's face, the painter leaves room for us to project emotions and scenarios onto it, to connect what we feel to what she feels.

Kenji Mizoguchi, whose misty lake scene we encountered earlier, understood this. Like Picasso, he portrayed women in his work more than men. In one of his best early films, *Osaka Elegy*, the woman, Ayako, has family problems so is forced into having an affair with her boss. In this scene, like the mother in Picasso's painting, she turns her back to us to hide her pain, but stands upright, holding herself together.

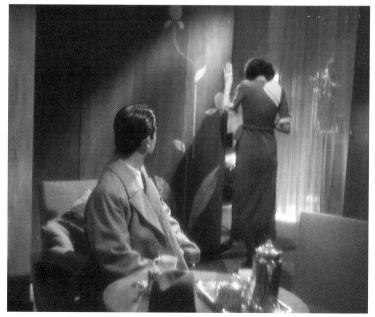

We see this and are moved. We are not confronted with

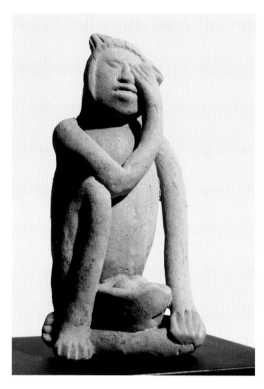

her sadness head-on, and so there is room for ours. But what if the suffering person turns around to face us? In this Mayan figurine from CE 600–900, the crying woman seems lost in herself.

Her eyes are closed and her right hand covers her left eye, a double enclosure. Yet she is not trying to hide from us. Her sadness has taken her beyond shyness, and so her chin is raised slightly, as if she is coming out of a spasm of tears. As we look, we think that this woman will survive. She is not crumpled. She has poise.

We would find it painful to look at a real woman crying, especially if she was someone we knew, so art in most cultures has allowed us to look at such sadness in a surrogate way. In Christianity, paintings of the lamentation of Christ – for example Giotto's extraordinary fresco in the Scrovegni Chapel – depict those around the dead Jesus Christ in a wailing spiral, as if sadness is a vortex, a seen thing that spirals outwards.

In almost all of the lamentations, the bodies are shown full length, but many artists have felt that the discretion of Picasso and Mizoguchi in only showing the back, and the body language of the Mexican sculpture and the lamentations, were all too oblique. They wanted us to look directly,

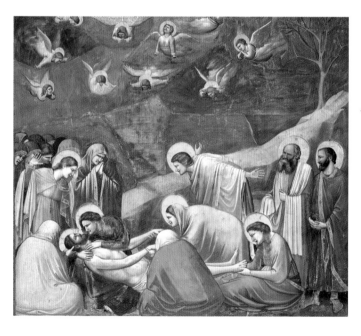

closely, at human faces to read the emotions in them. This silver-plated iron mask was found in Homs, Syria, and dates from the second millennium BCE:

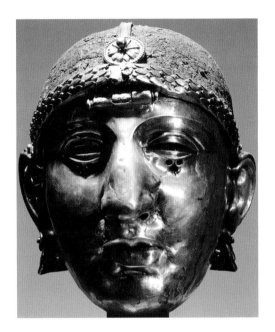

The mask might have been worn in combat, but it is the teardrops that catch our eye. The central one below the man's left eye is pulled downwards by gravity, into a globe, but on either side of it is another one – spherical, like a dew drop. Unlike the Mexican woman, this king's tears do not seem momentary. They are stylised, as if a lifetime of sadness is being suggested. The face is not wrenched. It is in repose, the mouth slightly open like the eyes are slightly open. Looking at this face, we seem to see not the onslaught of emotion, but its memory.

In the twentieth century, when the Danish film-maker Carl Theodor Dreyer came to show the religious trial of the fifteenth-century Frenchwoman Jeanne d'Arc, he did so by filming his actor – Falconetti – mostly in close-up. Here, as in the Syrian mask, tears fall from an unadorned face, seen almost square-on.

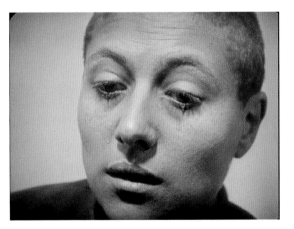

When we get to the late nineteenth century in our story, we will see that the close-up was one of cinema's most distinctive visual strategies, but at this stage let's imagine that this is not a still from a movie, but a moment seen by our developing child. She reads this face. The downcast eyes are not appealing directly to her for help. The muscles around the mouth and on the forehead are not contorted. The lower lip drops slightly. There is quietude in how the tears drop. The storm has passed, though another might be on its way.

It is important for us to learn to look at emotions for evolutionary reasons, of course. We need to be able to see if someone is going to help us or hurt us. But looking at emotion is not only self-interested. Take this painting, *Susanna and the Elders*, by Ottavio Mario Leoni.

The woman has been accused of adultery by the two men. She is condemned to death, but is eventually released when the men cannot agree on where the adultery took place. In the painting, though she is almost

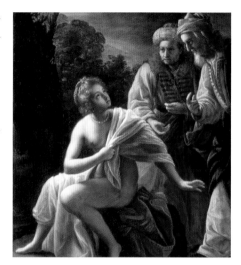

naked, Susanna is not perturbed. She looks up at the men, reaches out; she wears a pearl necklace, her hair is up and her make-up carefully applied. The scene is calm. She and the men seem to be discussing her fraught situation with relatively little emotion.

Then look at the same subject painted by Artemisia Gentileschi.

This Susanna turns away. Both her hands are up, gesturing to the men that they should leave her alone. Her brow is furrowed, the redness in her cheeks shows upset, shame maybe, and her hair is down. The first painter saw the subject as a theme, a discourse, a morality tale to consider. Gentileschi sees pain, perhaps

abuse. In the first picture, the moment could go on for some time; in the second, Susannah wants it to end as quickly as possible.

Gentileschi is looking in a precise way. She was only seventeen when she painted the picture, and the records suggest that she had been raped a year earlier. As most painters until this time – the early 1600s – had been men, many artworks had a tendency to downplay the suffering in such mythic stories, or to present them in such a way as to allow the men who looked at them to imagine themselves as the men in the scene. Gentileschi does not quite allow this. She directs our eyes past the discourse, below its bonnet, into the suffering. She is putting herself in the position of Susanna, asking what she would have felt, closing the psychological distance that the story otherwise affords.

In other words, she is empathising with her, she is connecting. At its best, looking allows such empathy. It makes us travel along the z-axis, out of our own experience, into someone else's. It requires an element of self-loss, a dialling down of our own mental noise and rooted subjectivity, in order to dial up the other's. Our eyes are disembodied. Looking at the pain of others is a key way in which we counterbalance the centripetal force of being us with the centrifugal ability to see how they see.

To understand this more, let's jump to the year 1543, and the deathbed of a sixty-nine-year-old Polish man. As he lies there, into his hands is placed a copy of his book, *The Revolution of the Heavenly Orbs*. He came to write it because he, like many before him, looked at the paths of the planets in the night sky and was puzzled by how complex the orbits are. Most of the patterns of nature are simple, yet the Sun, Moon and other heavenly bodies did not move in simple ways. Why? His explanation was a leap in understanding, a centrifugal thought, arrived at by himself and other thinkers before him. The orbits look complex because we observe them from where we happen to be, on planet Earth. If, instead, we stood on the surface of the Sun and looked from there, the paths would look much simpler because . . . the planets orbit it and not us.

The Polish man's name was Mikołaj Kopernik, better known as Nicolaus Copernicus. He is in the hall of fame of looking because his work introduced humility to seeing. Maybe, because he was from Poland at a time when the Mediterranean was thought of as the centre of the trading world, and Venice the centre of that centre, he was less inclined to buy the idea that we are at the heart of things and others are peripheral. He did not have a colonial imagination. *Maybe the centre's elsewhere*, he and others said (or nowhere). Copernicus taught us that *From where are you looking?* is one of the best questions we can ask. He dethroned the Christian Mediterranean.

Dethroning is part of empathy, and neuroscience helps us understand it more. Two Italian researchers, Giacomo Rizzolatti and Vittorio Gallese, monitored the

brains of monkeys when they did a task, and then the brains of monkeys who simply watched the task being done. They found that the same bits of brain lit up in each case. You use the same part of your brain when reaching for a peanut as you do when watching a peanut being reached for, though the latter is much smaller, about 10 to 20 per cent of the former. Doing and looking at doing are, in brain terms, similar in kind.

The implications of such mirror neuron activity are still being debated, but in principle the discoveries show that looking at another person's emotions can make us feel those emotions, though less strongly. This is common sense, but it explains why Gentileschi's painting is different from Leoni's, and establishes the role that looking can play in social cohesion and multicultural interaction. The bigger question becomes how looking-inspired empathy interacts with our other behaviours and instincts. We look at this image of someone begging on the streets of Dublin at the time of Ireland's economic crash.

Is it a woman? Do her clothes make us guess that she is Eastern European? Old? We see the snow and her gloves and the fact that she seems to be sitting on a rolled up cloth and we feel her coldness, her plight. The image is helping us understand the pain of others. But this is a cropped photograph. Reveal the full picture, and we are troubled in a different way.

The women on the left have nice warm clothes and handbags. They are not looking at the homeless person and seem to be keeping as far away from her as possible. We as onlookers can empathise in two ways here, especially if we identify with the women on the left who would hate to be the woman on the right, and who share her space, but who are psychologically very far away from her. This is a picture of empathy tension. The three metal structures which brace the bridge seem strange bracket metaphors. Our eyes cross the image as they do, connecting left to right.

The ambiguity of the above picture raises the issue of the opposite of empathy: aggression or looking for a fight. In this famous moment in the film *Taxi Driver*, Robert De Niro looks at himself in the mirror and asks 'You talkin' to me?'

But it is not really a moment about talking. Printed as an image in a book like this, we obviously do not hear the dialogue. We see the confrontation, the burning eyes, the held stare. Just as looking at Abramović brought tears, looking can bring fear. People in dangerous places learn not to make, or hold, eye contact with potential aggressors. Doing so can make the aggressors feel invaded and challenged. De Niro here is looking for a fight, rehearsing a fight. A line in Shakespeare's *Othello* – 'This look of thine will hurl my soul from heaven' – captures the violence of a look.

This is just a fragment of a nineteenth-century Congolese *nkondi*. Though its eyes are barely there, the open V of the eyebrows and the forward head give us a sense of the aggressive intent of the piece. Its stare was meant to scare: in this case to keep people away from a place where bodies were buried. The mouth is very similar to De Niro's, more open on one side, the beginning of a snarl. The *nkondi* and Travis Bickle, De Niro's character, say, *Go back or there will be trouble. Do not proceed!*

In this chapter the looking life of our developing child has proceeded. The way we see has acquired vectors, directions, bridges. We looked at the eyes of other living things; from place to place to see movement; to the natural world to see message and story in it; and to the feelings of our fellow human beings. We have become detectives in the visual world. The story of our looking grows. Now it is time to look at ourselves.

CHAPTER 3

LOOKING, SELF, HOME AND DESIGN:
THE THINGS NEARBY

LET'S imagine, now, that we are looking through the eyes of a four-year-old. As an infant she began by seeing blurs in black and white. She then saw distance, colour, other people, emotions and nature.

This chapter sees an expansion of her seeing. The things that are close by, within arm's reach, begin to mean more to her. They furnish her world. She sees objects and her home, and the people immediately around her. She looks at how those people interact with each other, and sees that some of them make more decisions and have more power than others. She starts to understand social context and function. When she looks she sees how things fit together. She stitches images together to make composites.

LOOKING AND ME

For the child, the things which are closest to her – other human beings – will begin to form a visual network. She will notice where they are in relation to each other, how their movements and patterns repeat. It is like the girl in the

middle of this painting by Sofonisba Anguissola. Anguissola was born in the 1530s, had five sisters, was admired by Michelangelo, and lived into her nineties.

Here she paints three of her sisters dressed in brocade and pearls, overlooked by a maid as they play chess, which at the time was thought of as a man's game. The youngest, Europa, enjoys how her sister on the right seems to call for the attention of the third sister, on the left, who looks at us. Our interest here is in those looks. Europa is in the middle of a network of them. We can imagine her head turning, her eyes darting between her sisters, taking in their expressions and noticing how they react to each other.

She is perhaps too young to follow the game, or understand much of what was happening in 1555 on the continent after which she was named, but she is drinking-in human interactions. She is getting a sense of where she is in the

world. We glimpse the wider world behind her, and her eyes will of course have run out along that z-axis too, and she will have a sense that the maid is part of the family but on a lower level and less well dressed, so will have begun to see social structures. Will she have noticed yet that the maid is less happy than the sisters, and more anxious because more charged with responsibility?

Imagine now that Europa is not a privileged sixteenth-century Italian girl, but an old Indian man, hunkered down at a busy crossroads in Kolkata. It is dawn. The city's flower sellers are laying out their huge baskets of yellow blooms and saffron. Young men on bicycles whizz by, bringing cloth to markets. The sun is still low and cows kick dust up into its beams, so that they become shafts of light. People are everywhere. Mechanics open up garages to begin their day's work. Someone welds with an oxyacetylene torch. The old man is going nowhere, so takes in the scene. He hears many things, of course, but he sees the face of a flower seller and for a moment imagines her home life. Then his eye is caught by one of the cyclists (who, as we have seen, does not seem to blur, despite moving fast) and he is reminded of his own son. Then the mechanic talks to the welder and the old man imagines what each is saying to the other. The flowers and sunlight give colour, the dawn adds *sfumato*, there is emotion on the flower seller's face – she is old and seems arthritic. What complex looking the man is doing. Mostly, he is people-watching, like Europa was people-watching, like we people-watch when we are at train stations. His network of glances give him pieces of a visual jigsaw puzzle, which he assembles to create not only a street scene, but a reading of that scene involving educated guesses about the status and inner lives of the people he sees.

Like the old man, Europa is building her visual world, its physical and human spaces. At the centre of it is herself. The earliest humans saw themselves reflected in water, and there have been mirrors since at least the Bronze Age. In ancient Egyptian hieroglyphics, the most visual of written languages, *ankh*, the sign for life, was also the word for mirror. A child's fascinated encounter with its own image in a mirror has been much discussed in psychoanalysis, and most people will look at themselves regularly throughout their lives, more so in the ages of photography and digital.

What do they see? In a mirror, our heads are exactly half the size they are in real life, but we do not notice the smallness because seeing ourselves outside ourselves, as an object in the world, is stranger than the mirror's optical illusion. The billions of selfies now taken happen because of the fun of seeing ourselves from outside our own visual cortex, in space and time, with our friends or in a famous place. Painters have been particularly good at looking at themselves. Their self-portraits reveal the obsessiveness, neurosis, ego and

pathos of being alive. Van Gogh and Rembrandt used their own faces to chart their anguish and ageing. This self-portrait by the French painter Gustave Courbet is sometimes called *The Desperate Man*, but perhaps more than desperation, it is possible to see in it the shock of catching sight of yourself.

He pulls his hair back and seems to say, *Is that really me?* He was about twenty-four when he stared at himself to paint it, and would live for more than three decades after this, but his picture registers his fascination with the Big Bang of himself.

In comparison, the German artist Albrecht Dürer, who was only a few years older than Courbet when he did this painting, is way beyond the shock of self.

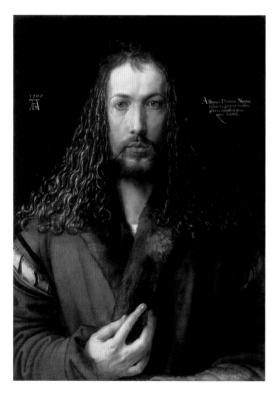

He did a remarkable pencil sketch of his right profile when he was thirteen, the first of many self-portraits (including a naked one), and he is perhaps the first artist ever to have his own logo – the famous 'AD', on the left of this painting. This is a man who is very comfortable with looking at himself and seems to see Jesus Christ in his geometric symmetry, handsome stillness and almost sculptural confidence. There is no flicker here, no rush to the canvas like Courbet's. As did many, Dürer thought that the Day of Judgement would come in 1500, so when it did not, he perhaps felt that he had to reimagine himself on a longer timeline. He is seeing himself as a god: the self-portrait as an act of love. The word mirror comes from *mirari* in Latin, which means 'to marvel at'.

Like Dürer, Egon Schiele painted himself often. He is usually naked in the sketches, and they have a dash about them. He drew rapidly, lifting the pencil from the paper as little as possible, then often coloured around the figure, making it look thinner still than its whippet proportions. The self he saw in the mirror was attenuated.

Often, as here, the darkest things in his watercolours are the eyes and genitals. They look at each other. The body is just the skeletal, angular, runway in between. The fingers, like Dürer's, are long and bony. Schiele was bad at everything in school apart from art and sport, the body and the line. His short active years as an artist (he died, aged twenty-eight, in 1918) coincided with the end of the Austro-Hungarian Empire, and the rise to prominence of his fellow Austrian Sigmund Freud. Sexuality was surfacing. Human beings were being figuratively unclothed, their social pretences stripped away. When Schiele looked at himself, he undressed. He removed the old varnish of empire as if to say *We have been hiding*, behind our hands, as here, like the child who thinks she disappears when she covers her eyes, but also behind our old-world, nineteenth-century, uniformed bourgeois rationalism. Schiele was not edified by what he saw, but was compelled to look.

The same is true of Mexican artist Frida Kahlo. In this picture from 1932, she stands on a plinth on the border between Mexico and the United States.

At first glance it seems that the smoke, factories and sky-scrapers on the right show the America she hated, and that the flowers and cacti, ancient sculpture, pyramid and electric spark between Sun and Moon on the left are symbols of the elemental Mexico that she preferred. She even holds the Mexican flag. But the painting is not nearly so binary. Kahlo was a modernist and leftist, so she was not averse to smoke stacks. It says FORD on them, and she had just had a miscarriage at the Henry Ford clinic, so the image starts to seem as much about personal loss as nation. The stoves on the

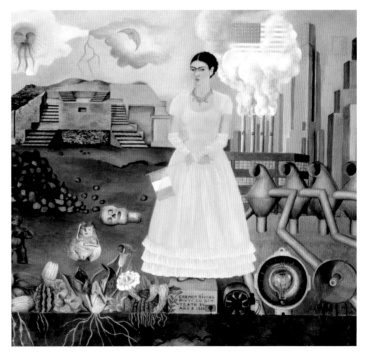

right almost look like cannons which could have fired the skull or stones piled on the left. They are lined up like the flowers, and the sun has its echo in the orange heater in the bottom right.

What is striking is how Kahlo – or Carmen Rivera, as she signs herself on the plinth, using her husband's name – plants herself so squarely into this nation-dream. Everything is within touching distance. It is an image of the proximate. Anguissola set Europa into a network of glances. Kahlo, here, is presenting the Mexico she has seen and the America she has seen, the two societies she is torn between, and has herself rise above them, once on the plinth, a second time by showing us the ground underneath it. Artists like Kahlo, Dürer and Schiele or, later, Joseph Beuys or David Bowie, show that to look at yourself, and so consider your place in the world, is to see something hidden, surreal (which we will come to later) and even mythic. For the looker, the self is the most available object in the world. It is inescapable, a thing that contains looking and interacts with other lookers.

LOOKING AT HOME

Homes are extensions of selves, exoskeletons that shelter and express. They are where we look from. So far in our story we have been mostly outdoors. Now we build a cocoon around ourselves and, suddenly, we make a new distinction between in and out, here and there, safe and unsafe.

The first image in this book looks out into the dawn from the shelter of a home. As we build our sense of the looked-at life, it is time to imagine our early lookers in

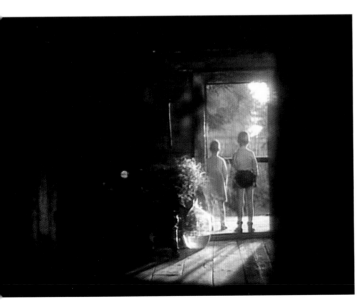

their homes. Caves at first, but then structures built of mud, wood, stone, brick, concrete, steel or glass. What kind of looking do homes allow us to do?

Consider this image, from the Soviet film-maker Andrei Tarkovsky's 1975 film *Mirror.*

The first thing we notice is that the home creates darkness, an opaque enclosure. Looking needs light, but homes exclude light. We are inside, already here, rooted. The hunter-gatherers have stopped, and have been here some time; the floorboards are well worn. Inside the home, the children we see will have looked at each

other, their family, the table on which food is served, and so forth. Most still life paintings in the history of art capture such looking – the half-peeled lemons in the pictures of Dutch artist Willem Kalf, the peel dangling over the edge of a table which is covered with a damask cloth. Édouard Manet's bunch of asparagus, quickly painted, is less showy than Kalf's lemons: it is not trying to be elegant or posh. The asparagus is just there, to capture the way it lies. In the Tarkovsky image (shot by Georgi Rerberg) a bunch of flowers, something to make the indoors more visual, sits on the table.

This second-century Roman mosaic, known as *Unswept Floor*, has removed everything thematic or visual that is not about the simple pleasure of indoor looking. We do not see the people or the food table, but what has fallen from it. It is as if someone yanked the tablecloth in a still life.

This is underneath, domestic looking. We see secrets here. A house is full of visual secrets. There is even a mouse nibbling on a nut. In his book *The Poetics of Space*, philosopher Gaston Bachelard says that our home is our corner of the world, seized upon by our imaginations. It is nested looking. A home is a nest which is contained within larger nests – villages, cities and nations.

In the Tarkovsky image, home is seized upon by his imagination. The camera is not under a table, but is inside. There is a security to the image. We are not

exposed, we are not outside trying to get in. We are looking at the children, who in turn look outside. Doors and windows as eyes of sorts. The kids are like Caspar David Friedrich's man on the mountain top, staring across the misty hills. Again there is a mythic dimension: in Tarkovsky's image the home is womb-like, a haven, the place where our living starts, our looking starts. It is a harbour image. The sea will be rougher beyond the harbour.

At first glance it seems to have little in common with this image of a home, from *Early Summer* by Yasujiro Ozu, whose image of red flowers against a green fence we considered earlier.

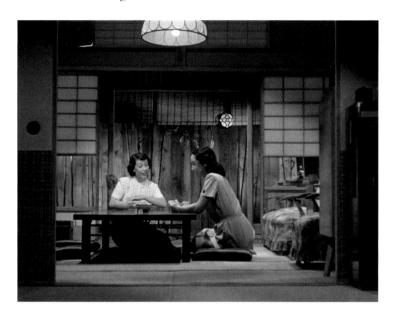

This home does not exclude light. We can see everything. And where Tarkovsky's image was high contrast, this one is mostly mid tones, shades of grey. Yet this home invites looking even more than the previous one. The image is rigorously composed of squares within squares. Including its outer edge, we can count five concentric frames. The camera is at kneeling height. A dozen verticals are balanced by a dozen horizontals. Tonality and composition give the scene great equilibrium. Add in the fact that Ozu and cinematographer Yûharu Atsuta have used a long lens to flatten the image and we have the sense that they are trying to deny the z-axis, that mythic departure that the Tarkovsky image evokes.

The fact that the image seems to hold the women within it, rather than encourage them to leave it, resonates in the film and for the theme of looking and home. The woman on the right is Noriko, a twenty-five-year-old whose family thinks she should be married by now, and so has found her a suitor. Their sense of how a woman's life must unfold in Japan means that she should not still be in the family home. She should be looking for a man and to the future and at her own home. Noriko, however, gently and with good humour, rejects their plan. She feels that her departure should not be so predetermined. And the image seems to back her up. It is unheroic, non-injunctive. It says that a home is not necessarily a departure terminal. It is a waiting area, a place in

which to consider, to people-watch, to experience time passing. We can imagine that the two adults in the Ozu image are the two kids in the Tarkovsky image, twenty years later, having done a *tour d'horizon* and then returned home.

In the twentieth century the Swiss architect Le Corbusier started to think about what a home within a home would look like. In his 1959 French priory La Tourette, he wondered what the simplest living space would be for friars meeting for collective experiences – eating, worshipping, teaching, etc. – during the day, within the broader building, but who would then want to retire to private space to study and sleep. After seeing Greek and Italian monasteries and the cabins on ocean liners, he came up with these minimalist, cellular rooms, each of which looked onto a view.

When we want to escape human interaction, he thought, we need a pure space made of simple materials and satisfying proportions. The physical space was small but the looking space was not. Perspective takes your eye to the balcony and beyond. The image is similar to Vincent Van Gogh's famous painting of his simple bedroom: the bed on the right, a chair and desk to the left, a green floor, a window at the far end, towards the vanishing point.

When we look at our homes and the homes of others we see machines for living. Our sense of the objects in the world grows.

DESIGN AND THE THINGS AROUND US

On the table in La Tourette we can see an Anglepoise lamp, one of the few things in the room that is not at a right angle. Its name alone – Anglepoise – tells us that it cares about geometry and balance. Le Corbusier will have chosen it for its good design.

Design is everywhere. In his book *Principles of Gestalt Psychology* (1935), German psychologist Kurt Koffka wrote that a handle 'wants to be grasped' and that a post box invites you to post a letter. 'Things tell us what to do with them,' he argued, and used the word *Aufforderungscharakter* – literally 'prompt character' – to describe how they prompt us to understand how they should be deployed. To ask if something is well designed is to ask if it is a solution, if it functions well in its surroundings, if it makes us think *Of course*, if it uses materials well, if its form is clear or imaginative, if it makes the thing desirable.

Looking is central to design. A child begins by grasping the things that are closest to it – its own feet and hands. The earliest people shaped tools, weapons and cooking utensils by considering what they had to do, but also what they looked like. We will get to architectural and fashion design later in this book, but for now let's consider seven objects from the worlds of domesticity, fashion, work, science and sport that early and then later lookers made, and how they were shaped by looking. Each is a design classic. To make it easier to see their forms, none of them have colour.

The first is an Iranian bowl from 3000 BCE, when Egypt was first unified, and when the potter's wheel was introduced in China.

Its nimble base supports a wide receptacle which might have held herbs, grapes, honey, figs or cucumbers, all of which were eaten at the time. A wider base would have made it sturdier, but the potter will have seen elegance in the contrast in the base and rim circumferences, an opening out, a flowering. Only the inside is decorated. The dark lines are hard edged and bold. They visually echo basket weaving, which was popular in this area of Iran – near both Afghanistan and the Gulf. The painter confidently gives the bowl four rims, and a set of circles which emphasise the volume, the belly.

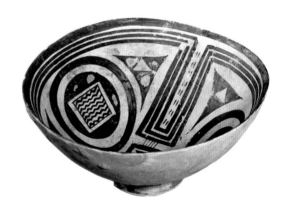

There is nothing figurative here, there are no animals or plants, but there is pleasure in shape, in swooping the eye into the bowl, then around its edge. It was defined twice: once by its maker, then by its decorator. This is a functional object and an optical one.

As is this Celtic St Ninian's brooch. It is from the early Middle Ages, around CE 800, when Zen Buddhism was dominant in Asia, while Christianity was in central and southern Europe. Vikings were attacking Scotland, where the brooch was found. Made of Pictish silver, it was used to fasten a cape, the centre of the needle being under the material.

In the Iranian bowl none of the bold stripes intersect, but here the silversmith has lines in the top pattern weave under themselves, then dart backwards and repeat the process to meet their own tails and create trefoils. Pictish design delights in moving our eyes in this way. And it loves horseshoe shapes, and playing with circles too. Visually we want to complete the brooch's main circle, but medallion discs on each arm bring our eyes to a halt with the right amount of visual weight, and five concentric circles in each. The pin boldly bisects all this soft metal curving. The brooch would work just as well with a much shorter pin, but the latter's length – twice the diameter of the horseshoe – is a confident geometric slash. Wear it at your left shoulder, and the pin points to your heart. Pictish art was often body art, which is why it is so popular in tattoo parlours.

The brooch would have been found only in fancy homes, but this Australian carrying tray would never be. It was made by Aboriginals, in the time before the first European migrants arrived in 1788, from the bark or outer edge of a tree trunk. Women carried fruit, fish or their child in it, holding it under their arms or on their heads.

Its open-ended, concave shape means that it was probably a digging implement too,

and also used for separating heavier from lighter granular materials. It is sculpted but also heat-bent. To stop it from cracking and to make it waterproof, it will have been oiled, probably with emu fat.

Our sense of the tool's beauty comes in part from the fact that it visually echoes nature – the curve of the tree – and also from the sensuality and patina of the oiling. More than that, the designer-artisan has found a shape which underlines, or is inherent within, the three jobs it does: carrying, digging and winnowing. As we look at it, we imagine it doing each, and it starts to seem like a distillation of rural women's work, a mathematical equation.

In the dark homes of early peoples, it was of course hard to see. In the late 1200s in Italy, monks illuminating manuscripts began to attach to their noses lenses on wire, wooden or shell frames, to enhance their vision, to bring detail into focus. Reading glasses were born and lives were transformed.

In this pair of glasses, from the twentieth century, the upper edge is darker than the lower, and more pointed at each end. The design echoes eyebrows,

creating an architrave. In some societies, ideal faces are heart shaped or triangular, with the apex downwards. These glasses' exaggeration of the brow width plays to that ideal. Earlier models pinched the nose ('pince-nez'), but these rest on it and, via extended sides, the ears too, thereby applying minimal pressure to the wearer's skin. The whole front section has not a single straight line, nor do our faces. There is an almost Pictish flow to the design. The jagged lines of the Iranian bowl would work better on a warrior helmet than on these glasses.

The most famous design movement of the twentieth century, the Bauhaus, produced this teapot in 1924.

Human beings by then had produced thousands of pot designs, but not one quite like this. Its main hemispherical chamber has similar proportions to the Iranian bowl – that narrow base/

wide brim ideal. But it sits on a cross, and the spout does something like the pin on the brooch: it daggers the curves. The lid is a circle within a circle, but set back to the rear of the pot, to counterbalance the spout-dagger. Beneath the lid is a leaf infusion chamber. The black ebony handle is a half-moon rudder, which makes a coracle of the pot. A century earlier, its surfaces might have been etched and decorated, with metal figures or even a landscape on its lid, but here the lid is an ultra-simple mirror, and we get to see the basic rivets which attach the handle to the body. The designer wants us to look at the pure geometric forms which underlie the object, and also how it is made.

Clearly there was revisionist visual and material thinking at the Bauhaus. The tea infuser's designer, Marianne Brandt, was a central figure there. The school emphasised the interaction of the arts and, appropriately, she was a painter, sculptor and photographer as well as designer. She and her colleagues were inspired by the medieval craft guild system which emphasised the integrity of materials and practices, as well as the role the craftsperson plays in the city. The Bauhaus embraced the industrial age and manufacturing techniques, but felt that that age's use of workers as cogs in a machine had resulted in a loss of soul, that designers were not understanding their object, its function and materials, holistically. They had to problem-solve. Design was research. Brandt's teapots were research. She made several of them as a student in 1924. One recently sold for $361,000.

It is hard to think of two less related objects in human history than a teapot and a space satellite, but look at Sputnik 1, the first manufactured object to orbit the Earth.

It is like two of Brandt's teapots welded together. Launched by the Soviet Union on 4 October 1957, it orbited the Earth every 96 minutes – 1,440 times, before it fell to Earth. The spindles are two sets of antennae. It contained three batteries, a fan for heat regulation and a radio transmitter, and was filled with dry nitrogen.

All this was achieved on a small scale by its design leader Mikhail Stepanovich Khomyakov. He made Sputnik 1 no bigger than a beach ball, and had its surface covered with 1mm aluminium–magnesium–titanium. Function was primary, of course – the

Reprinted courtesy of Össur

satellite had to be a heat-resistant, self-cooling radio station – and yet Khomyakov, like Brandt, used one of nature's most basic forms, the sphere, as his model. He had an orb circle an orb. It is possible to see the Pictish horseshoe and pin in the Sputnik, and, if we look at the shapes it reflects, the pattern on the Iranian bowl.

Coming into the twenty-first century, our last design object is this running blade.

Its shape shows that design sometimes requires a counter-intuitive thought detour. When an athlete loses his or her leg, the obvious thing would be to replace it with something that looks like a leg – vertical with some kind of ankle joint and a telescoping, compressing, shock-absorbing system. The aim, you would think, would be to make the prosthetic resemble a real leg.

But research by the Icelandic company Össur showed that it needed to have *horizontal* stress capability. Running is, after all, forward, so an unexpected line – a parabola which flattens at the top – became the shape. Material is again key: carbon fibre makes it light, flexible and strong. Though it extends to below the knee, the blade's shape looks like a foot and ankle, the toes pointing left, the heel raised. Nike designed the lower part of the prosthetic specifically for world-record-holding runner Sarah Reinertsen.

What would the makers of the Iranian bowl, or the Australian tray, have thought of the running blade? By looking at Reinertsen using it, they would have seen, and probably marvelled at, its function. A problem in the world had been solved. It had been solved in conjunction with an awareness of visual pleasure or geometry. It seems absurd to suggest that the Iranian, the Australian, the German, the Russian, the Icelander and the American had much in common, but designers look into the future. They see an object that is not yet there, but that will satisfy when it is. They look beneath the fuselage.

This chapter has been about things, and us as things. It has given our story a set, a set design. We have seen how looking describes self, how homes shape behaviour and how we see how things are used. Looking has been material in these pages, but in the next chapter it is back to immaterial things. We start with desire.

CHAPTER 4

GROWING UP LOOKING: *DESIRE, ABSTRACTION AND GOD*

LOOKING, BODIES AND DESIRE

Imagine, now, a child who is approaching puberty in Italy in the late 1400s. She is becoming aware of sexual desire and is developing the intellectual ability to think more abstractly.

In the 1460s, a four-metre block of marble lay in the grounds of Florence's cathedral. Almost fifty years later, the authorities commissioned a twenty-six-year-old Tuscan from a banking family to make a sculpture from it of a warrior king who may have lived around 1000 BCE. Whilst still a boy, the warrior had killed a giant on a battlefield by hurling five smooth rocks at him, and then cut off his head.

The sculptor worked on the commission for three years, drawing on the marble's surface rather than using a life model. Usually in art, the warrior in question was depicted after his triumph, and with the giant's severed head at his feet, but the sculptor decided to show him before the killing, once he had

decided to square up to the giant, but in advance of him setting off. His brow would be tense with resolve, his eyes staring, his neck muscles clenched: a portrait of anticipation and purpose. The boy would also be naked (and uncircumcised, which was the custom for Italian sculpture at the time, but significant given that the warrior had objected to the giant in part because the latter was uncircumcised). The boy was David, the giant was Goliath and the sculptor was Michelangelo.

On 8 September 1504, forty men begin to haul Michelangelo's *David* to the place in Florence where it is to stand, a place that had been decided by a committee that included Leonardo da Vinci and the painter Botticelli. On the way, crowds gather. Our pubescent teenager is amongst them. The sculpture is stoned. The teenager does not fully understand why. Presumably the protestors did not want to look at its nudity, and nor did they want others, especially children, to do so. They felt that looking at bodies was wrong, or looking at them in public was wrong, or allowing women or children to see them was wrong.

The story of how we look at other people's bodies builds on what we have seen so far. We have talked about distance in looking, meeting others' eyelines, social looking, the pleasure we take in looking at the sky

and nature, the visuality of objects, and a growing interest in our own self-image. So what happens when an evolving young person's gaze becomes desirous? This chapter is about such evolution – those moments in our lives and in human culture when seeing something physical leads to something less physical, as a road leads from here to there. Bodies, shapes and the sun are the starting points of this chapter, but desire, abstraction and God are its destination.

In the case of *David*, marble had led to desire, and the fear of desire. David was a teenager, and our teenage years are when we first have erotic responses to the world, so how does our Italian Renaissance teenager look, and how do other teenagers look? Consider this remarkable one.

The movie actor Lauren Bacall was nineteen when this image, a still from the Hollywood movie *To Have and Have Not*, was shot. She is in shallow focus, like the *Mona Lisa*. Her body is torquing, her chin drops, her hair is a frame, her eyes complete the twist. The key light is top left. It catches the top of her hair, her right cheek, her upper lip, the tip of her nose and her chin. Bacall in real life was interested in light, and talked of how Marlene Dietrich was lit with a top or 'north' light. Bacall's image here was called 'the look'. Bacall had 'the look'. The look meant sexy, confident and disdainful. She was saying, *Do you really expect me to believe that?*

The surprise, therefore, is that Bacall was shaking when images like this were filmed. She was so nervous, so new to cinema, so intimidated by her director Howard Hawks and her leading man Humphrey Bogart, that she shook. To stop the shaking she dropped her chin, which made the back of her neck stiffen and throat clench, thus stabilising her head. Her lack of confidence resulted in something that looks very confident.

There is an optimal time to see certain images. The impact of some photos is hidden. Guarded. Not here. The confidence in this image, its sexuality, its graphics, mean that it is clear and present. Her face is in your face. The best time to see this photograph is when you are young, like Bacall is young. It is so available, so full of attitude, so unforgettable, so ready for life and all it will throw at it. Lauren Bacall is dead, but here she still disdains, still attracts, still abstracts, still refrains. Bacall is a teenager here, and so is the image, and so are we. When we think about our own looking as a teenager, we realise that there was quaking in it, shaking in it. We felt both insecure and desirous, both of which make you tremble. We wanted to stand confidently and look like we knew what we were doing, but we were faking it in some ways. Teenage looking is formative looking because it is so alert and adrenalised. It is fight-or-flight looking.

There was fight or flight in those who threw stones at Michelangelo's *David*. Looking for them was a force field. When the Australian film-maker Baz Luhrmann was making *William Shakespeare's Romeo + Juliet*, he could not think of a way of filming the moment when the teenagers first glimpse each other. He racked his brains. One night he was in a restaurant, and went to the toilets. At the washbasins he looked up and saw a fish tank and, through it, the ladies' washrooms. As he looked through the tank, he realised that this was the visual solution to his problem. Here, in a very horizontal image, he has Juliet glimpse Romeo,

who is dressed as a knight and is reminiscent of medieval stories of courtly love – Abelard and Eloise, Dante and Beatrice, Lancelot and Guinevere or, in Iran, Layla and Majnun.

Luhrmann's image shows teenagers like our Renaissance one. It makes us ask what we are looking through when we look at the body of another. What does a teenager look through? What is the fish tank, what is the medium? In any love story, the question is *What is stopping them?* In *Romeo and Juliet*, it is family. Often it is the fact that home, that camera obscura, that place where we learn the seeing network, wants to keep the teenager childlike. It is scared of what the young adult might see. It realises that looking can be disruptive, especially when the looked-at is a body. Teenagers' erotic looking often scares those who want to arrest their childhood gaze.

This painting by Titian, which was finished in 1559, tells the mythological story of Actaeon who, whilst out hunting, happens upon the bathing spot of the goddess Diana and her nymphs.

He pulls back the red curtain, sees their naked bodies, and they recoil. Diana's response is to turn Actaeon into a stag, who is then hunted to death by her own hounds. Though he did not intend to transgress, he is punished for looking, for pulling back the red curtain, for entering the force field – as the Florentines did when they looked at *David*, as we do when we look at Bacall, as Juliet did when she looked at Romeo – and for not, then, averting his gaze. His looking led to something else – desire, reproach, transformation and then death. We cannot blame Actaeon, but in feminist terms we can say that the force field in which he looks is political. In *Ways of Seeing* John Berger says that a woman's presence 'defines what can and cannot be done to her'. If you get to look at another's naked body, it is often because you are more powerful than they are, because you are rich or male or white, or all three – especially in Western culture. Such privileged looking is the male gaze. As most artists have been men, as have their patrons, the dominant direction of looking in culture has been from a man to a woman. The road has led that way.

In France in 1863, Édouard Manet painted this scene which complicates or plays with the male gaze. In it, we the viewers are the only ones who look at the naked woman. The men in the picture do not look at her. They are dressed fashionably, the hipsters of their day. The obvious thing would have been to make her the visual centre of gravity, but Manet's network of glances is less expected. We are challenged by the desire in the scene. It does not work in conventional ways. The men lie back but the naked woman sits up, alert, looking at us, restless, unengaged by the hipsters, needing more from the force field.

Flip the picture so that the men are naked and the woman is not, and you will get an equal scramble of looking frequencies. The image has been restaged numerous times, including, in the 1980s, for the band Bow Wow Wow's LP *The Last of the Mohicans* and for the *Star Wars* generation, where the naked woman is Princess Leia, the man on the right is Darth Vader and the man in the brown jacket is Chewbacca.

Three years after Manet, Gustave Courbet, who we saw earlier scraping back his hair and

being shocked by his own face, painted the genitals of his lover, and called the result *The Origin of the World*. The woman's legs are spread. We see her vulva, belly and right breast.

An image from the world of pornography had migrated into the realm of art and, by doing so, challenged the low culture/high culture distinction. The latter enriched and the former debased, so the bourgeois assumptions claimed. But as the desire to look at sexually stimulating things was felt by most humans, how could it be inherently demoralising and enfeebling? The Florentines in 1504 would have been apoplectic, and even today, when we look at it, we might think *How are we getting to see this much?*, and *Is this allowed?*, and *What looking is there to do after this?* Our teenager in Renaissance Italy will feel such lust, amongst the most powerful sensations they will have experienced. The mixture of pleasure and yearning in sexualised looking is tempestuous. The erotics of looking sets the teenager on a stormy sea. Most looking has, within it, an element of attraction and, therefore, the potential to disrupt, but when attraction becomes compulsive, looking can feel like bullying. The teenager wants it but not to be lost in it, or wonders what it says about them if they do get lost. Lust's ability to exclude or distort other thoughts is like a looking fever.

The Origin of the World was not a destination; it was just another note on the scale of looking at bodies. The French artist Orlan showed this by copying the painting, but replacing the vulva with an erect penis and calling it *The Origin of War*. The British painter Francis Bacon zoomed out from genitals to portray his lovers as escapologists, wriggling out of their own bag of knees and knuckles.

Bacall's look, Romeo and Juliet's fish tank glimpse, Actaeon's tragic accident, Manet's wrong-footing lunch, Courbet's close-ups, Bacon's male wrestling: looking at bodies is an ongoing fascination. In the 1930s the film-maker and Nazi sympathiser Leni Riefenstahl pictured naked bodies with awe and classical grandeur, as if they were *David*; five decades later, despite years of denazification, and long after it was possible for her to hang on to any of the ideas of the Hitler times, she was in Africa, again photographing young people naked and heroic, with the same aesthetic as before, as if Auschwitz-Birkenau had not happened, as if her filming bodies was still just her filming bodies. Her fascination had become

stuck, unresponsive to changing times. Hers was a female gaze which led nowhere, or to bland, heroic idealism. If our theme in this chapter is the road that looking takes us on, hers was a dead end.

Elsewhere, the female gaze was far more of an adventure. We have already said that looking at bodies is a force field and a bumpy road, but this image from Claire Denis's film *Beau travail* (shot by Agnès Godard) makes us mix metaphors again and say that it is like a war zone.

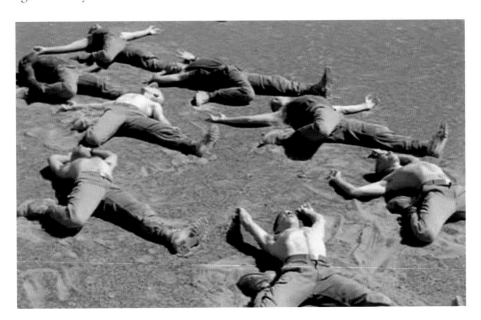

What would a teenager think of this? Eight soldiers are too well posed to be dead. In the film we have seen them circle each other and fight, now four are topless, their legs spread, as if struck by lightning, or supplicants to some wrathful god, or willing to submit to the political and erotic imagination of a film-maker who was brought up in West Africa and wants to turn the tables on men looking at women. But if Denis had been standing really close to one of these men, or filming in the 1920s or 1930s, or trying to show what it would feel like to be in love with him, she might have used the soft focus that we saw in Chapter 1, the focus of the look of love. Instead, she makes it look like they are doing snow angels in the sand. Their poses serve no rational purpose. Instead, the image is reaching towards abstraction.

ABSTRACT LOOKING

Maybe that is what desirous looking really is; maybe that is what Juliet saw in Romeo, or Michelangelo saw in his slab of marble or our Renaissance teenager sees as she grapples with the disruptive power of erotic looking – an abstraction, a journey from a body to an idea. Teenage minds come to terms with both. In the 1000s CE, the Chinese painter Sung Ti advised a fellow painter to throw a sheet of white silk over an old stone well. He should then gaze at the sheet day and night, as it billows in the breeze and as the clouds cast shadows on it, until he starts to see, in its creases, the formations of a landscape – mountains, ravines and rivers. 'Get all these things into you,' continued Sung, and his advisee would see in the sheet 'men, birds, plants and trees'. More than four hundred years later, in his *Treatise on Painting*, Leonardo da Vinci gave similar advice:

> Look at certain walls stained with damp, or at stones of uneven colour . . . you will be able to see in these the likeness of divine landscapes, adorned with mountains, ruins, rocks, woods . . . expressions of faces and clothes and an infinity of things.

Later in the same book Leonardo writes that looking at clouds can stimulate our imaginations.

Imagine, then, that as Yves Klein looked up at his blue sky, clouds came. A watercolour painting of them would look something like this.

A few moments after this painting was completed, the very same cloud-scape was photographed with the digital zoom of a phone camera, and the result was this.

Pixelated, grey becoming dark and purple, like a bruise – what could be called an automatic abstraction. The journey from real clouds to abstract shapes was unplanned. Minutes after the skyscape was painted, the photograph was taken. We perhaps like to think that as abstract art became famous in the twentieth century, human beings started looking abstractly then too, but Sung and Leonardo were talking about looking abstractly centuries ago, and the earliest sculptures show that stylised looking is very old indeed. Take this Iron Age sculpture from La Spezia, Italy.

No human or animal looks like this, but that does not mean that its lack of realism is a failure on the artist's part. The U nose is not trying to look exactly the same as a nose or beak that appears in nature. The sculptor has looked at real noses, then tried to make something that is visually distant from, but evocative of, a nose or beak. The same with the far-apart eyes and the oval head. The result is simplified, graphic, detached and other.

Early sculptures often purposely stylise in this way. They show that Klein, or a baby carried on her dad's back looking up

at the sky, had a tendency to tune out from the specifics of what they are seeing into something more generalised. The sculpture is semi-abstract the way the digital photograph of clouds is semi-abstract. In his book *Visual Thinking*, German theorist Rudolf Arnheim compared this Corot painting of mother and child . . .

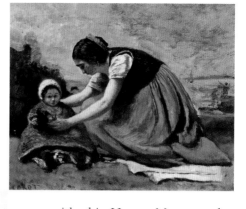

. . . with this Henry Moore sculpture of two objects, the larger one on the right leaning over the smaller one on the left.

The painting is specific about costume, hair and location. Nothing in the sculpture can be said to have a specifically human subject, yet the visual connection to the painting seems true. Like the designers in the previous chapter, Arnheim is pointing to an essence, an underlying form. Corot paints the fuselage, Moore sculpts the engine that lies beneath it.

The face with the U nose shows that people have always done such looking. Abstraction has not just been an occasional destination of looking, or an idea exclusively for learned lookers; it seems to be a product of looking. In the same era that the face with the U nose was made, and thirteen hundred years before Cleopatra, the Egyptian pharaoh Amenhotep IV changed his name to Akhenaten. He did so because he had undergone a religious conversion. He had rejected the old Egyptian theology which worshipped the Moon, stars and other heavenly bodies, and become entranced by the most visible body of all, the Sun – Aten – a disc god, which he saw as a godhead. This relief sculpture from 1375–54 BCE shows Akhenaten on the left and his wife Nefertiti on the right, radiated by the Sun.

They have eyes only for themselves and it. Its beams of light travel from it, out into the world, and into the eyes of the people, as in a child's drawing of the Sun.

The man and woman's three daughters wriggle for attention. Their son Tutankhaten, who later changed his name to Tutankhamun, and who we will come to later in our story, has yet to be born into this kingdom of the Sun.

To see a god in the Sun, to see in it a god's mythic journey and intent, Akhenaten had done abstract looking. He had seen something physical and turned it into something metaphysical, allowing what he had seen to explain the conundrum of consciousness and the agony of death, and to be the source of life and the patterns in nature. God was light. Akhenaten photosynthesised light. He turned it into awe. Visible light, the tiny bit of the electromagnetic spectrum that human beings need in order to see became, paradoxically, the great symbol of the unseen. By the time of the Middle Ages, this abstract light was seen as distinct from the everyday light actually perceived by human eyes. The former was *lumen*, the latter was *lux*. The road of looking led from *lux* to *lumen*. This idea, this visual pun, these two types of light, held sway for centuries.

In the sixteenth-century Italian paintings of Caravaggio in particular, light was both *lumen* and *lux*, divine and optical. He became famous for his realistic light which also, in its drama and clarity, transcended realism. Shards of light suddenly seem to fall upon street people in his large paintings, enacting sacred or profane stories. The light dimmed in his work as the painter aged, but it did not lose its duality. Jump forward to the twentieth century and you get artists still interested in using light to refer to something beyond the material world. There are numerous examples. American artist James Turrell has us look up to the sky in his works, through open discs in ceilings. He frames Klein's sky, like the roof of Rome's Pantheon does. In the annual Fête des Lumières in Lyons in France, new computerised light animations seem to make buildings buckle or bend at the knee.

On a hill close to Lyons there stands a building that is made of concrete and looks like a beehive or a *Star Wars* battleship, but which controls light exqui-

sitely. Seen from the outside of Le Corbusier's La Tourette priory, these blunt stumps of concrete give little indication of their function.

But here is what happens on the inside. The stumps are the tops of light tubes or barrels, into which sunlight enters then bounces down,

softening as it does so, *lux* becoming *lumen*. Through a circular aperture in its ceiling, they descend into a dark chamber, and here fall upon a concrete block, painted deep red.

In front of the block stand three pedestal altars on which monks could practise mass. The whole composition seems to combine Akhenaten's sacred light (we could be inside a pyramid here) with Arnheim's reduction of form. Also, perhaps, the image makes us think of the Tarkovsky image of the home with the children at the door – dark inside, the luminous beyond. Design, colour, light, shelter: a feast of looking. La Tourette focuses the theme of this chapter, how looking at something concrete, or of the real world, can lead to more abstract things. These altars in the convent are like *David* or Bacall.

But looking at light is not the only way in which human beings have seen the unseen. This Russian panel from the 1200s gives Jesus Christ an attenuated nose, tiny mouth and large almond eyes, framed with multiple curves. Two strands of hair add a hint of realism into this otherwise geometric portrayal, but what is relevant here is where Christ is looking.

At first it seems that he is staring directly out at us, but

judging by the asymmetry of the whites of his eyes, he is actually looking slightly past us, over our right shoulder, to a place adjacent to where we are but not the same. We look at him, and then with him, past ourselves, to something other. In the Christian tradition, this place is heaven. He is saying, *It is close. Paradise is not lost.* He is doing the abstract looking for us. It seems a jump to go from a Russian icon to a Japanese film, but Yasujiro Ozu makes his third appearance in our story here. His scene of red flowers and walking girls showed

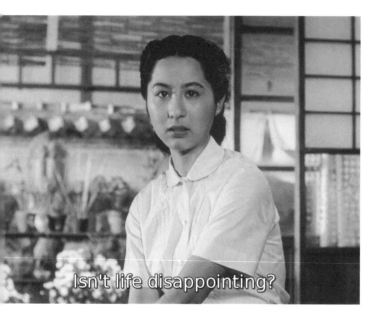

Isn't life disappointing?

how an image can take our eyes for a walk, and his balanced domestic interior showed how rooms can contain looking. In this shot, from his most famous film *Tokyo Story*, a woman looks in exactly the way that Christ looks in the icon: apparently at us, but then subtly not. Our eyes do not look with hers. Is she looking through us, beyond us, or again, slightly over our right shoulder?

Ozu was not overtly Buddhist, but he certainly wanted his film to gesture towards the metaphysical. His gravestone carries neither his name nor details of when he lived, just the symbol mu, 無, which means emptiness or the void. This detail from an Islamic manuscript of the 1400s uses the form of an eye, but as a symbol of the gateway to the soul and as a meditative symbol of the eternal. Twin-track abstract looking.

A converse abstraction related to looking is evil, or the devil. In ancient Greece, the Arab world, Iran, India and North Africa, iniquity is represented by, and then repelled by, directly staring eyes. In ancient Egypt, this image of the Eye of Ra represents the destructive and malign aspects of the sun god.

Across the Middle East, *nazars* are talismans which reflect the satanic look back onto itself.

Reflection is a key point: mirrors are sometimes the harbingers of wickedness. The vanity they fuel is, it seems, damnable. The Russian icon painting could almost be Christ looking at his own image, but look too long into a mirror and you see the beast. The godless queen in Jacob and Wilhelm Grimm's 'Little Snow-White', who became the Evil Queen in the film *Snow White and the Seven Dwarfs*, stared into her mirror and saw a green, demonic version of herself.

And the idea that malevolence lies within a looking glass continues. In *Candyman*, based on Clive Barker's short story 'The Forbidden', the eponymous angry and vengeful presence can be summoned by looking into a mirror and saying his name five times. Three subsequent films dramatised the story which, in turn, became an urban legend.

God, emptiness, abstraction, the void, the devil, the metaphysical: human beings have always convinced themselves that they could see such things, and have had ways of seeing them: in ancient Egyptian hieroglyphs, brutalist architecture, Orthodox icons, Japanese film frames, Middle Eastern talismans and horror fiction. In India, the Hindu god Shiva is pictured dancing the world into existence, surrounded by a ring of flames, his hair flung outwards into the universe. The image somehow manages to tell a story of creation, of destruction, of the circularity of the cosmos, of the centrality of god, and of the power of dance – a journey around the world.

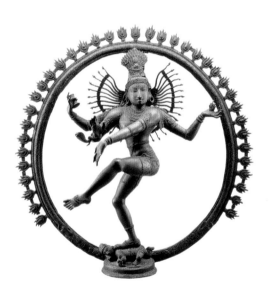

Hinduism is strikingly figurative. The gods take many human and animal forms, as if the looking journey is not from the material here to the abstract there, but in the other direction: from the divine and the invisible to the tangible. In another one of the world's great religions, Islam, there is a different kind of visual exchange between the human world and the god world. The centre of worship in Islam is as abstract as Le Corbusier's red block. The Ka'bah in Mecca was a place of pilgrimage for pagan polytheists before the Prophet Muhammad had his first revelations in CE 610 and made his migration – hejira – in CE 622. Soon he declared it the holiest shrine in Islam – a visual sun, as it were, made of black stone, to which all should look when they pray, and around which faithful pilgrims should process. The image on the next page from a 1500s Persian poetry manuscript shows the black square in a blue horseshoe, surrounded by the rectangular walls of the al-Haram mosque, which are surmounted by forty-seven domes resembling the flames in Shiva's dance.

Again, it is the geometry that strikes, the abstraction. It is like using maths to prove god. The Ka'bah is an object-building of such formal beauty and rigour

that it allows those who look at it to contemplate timeless things, and everywhere. The golden circle of Akhenaten's sun and the black square of the Ka'bah are visual opposites that do the same thing.

And long after the construction of the Ka'bah, black squares have reappeared in culture as symbols of the infinite, or refractors of our looks. In 1913, a thirty-five-year-old Russian Pole, the oldest of fourteen children, designed the curtain for the Futurist opera *Victory over the Sun* as a black square. It was as if the Ka'bah blocked out Aten. Two years later the designer – Kazimir Malevich – reworked the design as a single black square on a white canvas. The resulting painting became one of the most famous images in twentieth-century art. When Malevich died, mourners carried black square banners, and he was buried under a black square headstone.

In Arthur C. Clarke's Space Odyssey novels, flat black, rectangular monoliths appear throughout the universe and across time. Their inorganic, unweathered forms are clearly built rather than growing. In Stanley Kubrick's film *2001: A Space Odyssey*, these stelae are first seen at the dawn of man.

Prehumans cannot stop looking at them. Their unbending immobility, their refusal of referent or function, fascinates. Their dimensions are 1:4:9, the first three whole numbers squared. The rest of the visible world is pitted or detailed;

the fact that the stelae are not makes them seem extra-physical, or metaphysical. Even in science fiction, the seen leads to the unseen.

But here is the epilogue to the story of metaphysical looking: people want their gods to be unlike them, but also like them – to be far away but very close. As the Russian icon panel suggested, as well as wanting our gods to be elsewhere, we want that elsewhere to be just over our shoulders and recognisably ours. In this nineteenth-century picture of Jesus Christ, for example, he has his back to the world. He is sorrowful and downcast.

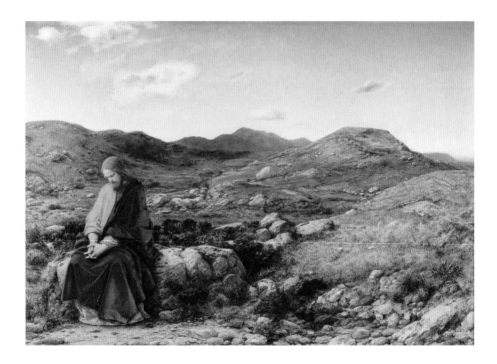

The setting is not the Middle East where Christ lived. The painting is by a Scot, William Dyce, who has chosen to have his subject sit in a very Scottish landscape. The contours and strewn rocks are what we see in the once glaciated Highlands, the colours are those of a Scottish autumn. Dyce's picture, like many religious images, reassures its audience by saying, *He is one of us. He walked where we walk.* The road turns back on itself. This is an image of desire too.

How to sum up what we have learnt about abstract thinking? Perhaps with this woman. She is a North Carolinian Hupa, photographed in the 1920s. Her people migrated to where they now live in around CE 1000. Her relevance to our story is that she is a shaman, so all her adult life she has been looking at the spirit world. Abstract looking is her job.

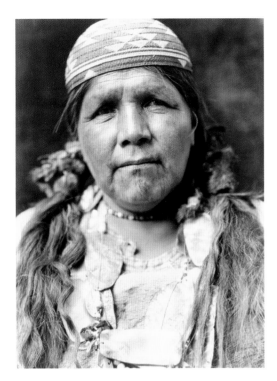

Her looking might have been trance-like; she will have claimed to have had visions of other dimensions where benevolent or malevolent beings are, and will have used those visions to guide her fellow Hupa, perhaps to help retrieve their souls. What is striking is how canny her gaze is. There is no attempt to look awestruck in her face, no reverie. We search in vain, in this photograph, for any sign of exaltation. She stares over our right shoulder, as she will have done to many others. She will have done a lot of abstract looking.

Can we see confrontation in her face? The converse of the divine, in many cultures, is the evil eye. In the Bible (Proverbs 23: 6) it says, 'Eat thou not the bread of him that hath an evil eye, neither desire thou his dainty meats.' In times of minimal medical understanding, it was thought that sickness could enter our eyes from the malign look of another. Such is the power of eye contact that, throughout human history, we have felt that looking can be accursed. The eyes of a goat, for example, can seem demonic. A burning or scathing look can seem to send to its recipient, like a poisoned dart, ill will or fortune. Once looking opens up to the supernatural, it must accept that that realm can be malign as well as benign.

The Hupa shaman could be a distant relative of the baby we thought of at the beginning of this book, now towards the end of her life. In her teenage years, she started to look at other bodies. She became aware of desire and its corollaries, abstraction and god. Her looking had grown up.

Where would it go next, and what would next happen in human development?

It is time to consider the sort of looking that takes place as people live more closely together, in larger groups and more elaborate built environments in which they share, barter, serve and socialise. Their looking becomes more polyvalent in these built places. It is time to focus on urban looking. It is time to enter the built world, to see it rise and fall.

CHAPTER 5

LOOKING AND CITIES: *VICINITY AND VISTA*

CONSTRUCTION

Chapter 3 was about what a young person saw in their immediate vicinity – their own bodies, objects and their home. As we noted, a house is a cocoon which sits within larger cocoons: neighbourhoods, towns, cities and nations. In this chapter let's imagine that the young people whose developing looking we have followed are adults now. They are leaving their parents' homes or the villages of their extended families and heading towards the built world of work, service, romance, discovery, exploration and, often, struggle. They are mobile in the world. Maybe they will have the urge to build? Maybe they are in Asia walking through a Hindu temple? Maybe they are living in a great, historic city? We will explore the broader built environment by first considering individual structures, and then how they combine into the urban mazes that we call cities.

There are 4,416 cities in the world that have a population of at least 150,000 people. For most of human history we lived in villages or tribes a tiny fraction of that size, but industrialisation and capitalism's hunger for cheap labour forced millions into (often unwanted and unhappy) lives in those 4,416 cities. Los Angeles, Mexico City, Mumbai, Moscow, Dakar and Manila: modern cities are places of servitude for the many, an iniquity well beyond the scope of this book. But massively increasing cohabitation changed the speed and direction of human looking, and also its nature. Cities became visual thinking. A tree is not an idea, but a Gothic cathedral is.

So what is the story of looking at buildings and cities? How has building facilitated our looking? How has it excited it, controlled it or excluded it? To answer these questions we need to look at the structures of individual buildings – how they raised roofs, made windows and told stories visually – and then consider how they cluster into cities. We have already looked at the simplest, primal buildings – homes. Now we build out from them, to social buildings and beyond.

We can begin by thinking about rhubarb. It was used in China from at least 1000 BCE, was imported along the silk route to Europe, arriving in the 1300s, and made its way to America in the 1820s. In those years and places, its bigger leaves – and gunnera, which is often called 'giant rhubarb' – will certainly have been used as umbrellas. A look at their underside reveals why. Their sturdy stalks divide into five branches, which then subdivide several times. Unlike trees, whose branches each sprout numerous small leaves, the rhubarb's tributaries all support a single canopy. Upthrust is dispersed across an often large surface area – up to a square metre.

Looking at natural examples like this, geometric rock formations and even sea arches, early builders will have started to imagine how a pile of rocks on the ground,

or the branches of a tree, could be assembled vertically, in defiance of gravity, to create shelter and internal spaces. The desire to do so seems strong in human beings, for utilitarian reasons and more. In Los Angeles in 1921, a forty-two-year-old Italian American tile mason, Simon Rodia, began building a series of towers that had no purpose as home, meeting place or church. For thirty-three years, working alone, he inserted bottles, broken shells and porcelain into seventeen growing structures of steel rods and wire mesh, the tallest reaching thirty metres. When he had finished, aged seventy-five, Rodia left the site, moved to another part of California, and never returned to what became known as the Watts Towers.

The gunnera and rhubarb leaves and Simon Rodia begin to explain the creativity of building and the kind of looking that ensues. When the Egyptians or the Greeks wanted to raise a roof, it was straight and usually horizontal, and held up by verticals – columns. The results, such as the Parthenon or the temples at Paestum, were often exquisite mathematical structures, but then came the Romans. They noticed that lintels and roofs fell down, and realised that they did so because the central point, between two columns, took most of the load. So the Romans started to use semicircles of stone, rather than straight lintels, on top

of their columns; the load was equally dispersed and the arch was born. Most of the Roman viaducts and aqueducts in Europe are built with arches.

Islamic architects were so enamoured of arches that, for example, the Mezquita in Cordoba is a forest of them. The curves were even painted with keystone wedge stripes, as if to say, *Look how this works*. The painted stripes made the engineering seeable.

The Mezquita is beautiful, but needed a lot of columns and is therefore cluttered. As people came together in covered structures to barter, worship or wash, they needed the internal space to be more open. Builders and engineers devised flying buttresses, braces on the outside of buildings which would take some of the weight, thereby requiring fewer columns inside. Notre Dame in Paris is like Cordoba attenuated, and made of lace. Its flying buttresses on the outside have allowed height and detail to become part of the

religious interior. Our eyes are forced upwards, but also stopped more often by tracery and ribbing. Semicircular arches have become semi-ovals, and the thin columns resemble the undersides of rhubarb leaves. The god looking we saw in the previous chapter was incubated in cathedrals like this one.

From flat-roofed Greek temples, to Roman arches, to Gothic filigree: engineering and design was making looking more elaborate. Looking in this building is not a matter of mere function – finding where the exit is, seeing where the priest will conduct mass, etc. – it is like looking at the sky, or clouds. Notre Dame is built to make our eyes soar, make us feel small and see grace or God or abstraction in the patterning, the fall of light, the overall visual activity, which overwhelms.

The fact that the walls were not bearing all of the weight also meant that they could be pierced and glazed, to let in daylight. The windows in Notre Dame are of filigreed detail, but simple fenestration can be seen in wall paintings of buildings as far back as ancient Egypt and Assyria. Such wall piercings allowed residents to glimpse oncomers, and harsh weather outside. Soon they were affording other types of looking too. Our story began with a glimpse through a bedroom window, out to a tree against the dawn sky, and we have noted that a room with a view sells or rents for more than one without, but windows in buildings have not always been placed to maximise the pleasures of the z-axis. Many older cottages on the Celtic fringe of Europe, like the Scottish

one below, seem indifferent to the view, or to turn aside from it out of displeasure or familiarity. If you were outside working the land all day, you had had your eyeful, so did not need your windows to give onto the vista.

As steel became a more frequently used building material, as what was required to hold up a roof became visually smaller, and as the idea of enclosed living declined amongst architectural modernists and urban elites, so windows started to win the battle with walls. Instead of being something that was beautiful, structural and fortifying, a wall was something that was in the way, that blocked the view. Glass spread across the façades of commercial, retail and residential buildings, resulting in a structure such as Philip Johnson's Glass House, built in Connecticut in 1949.

It was like a Bedouin tent with all the flaps rolled up. Every direction was a looking direction. In it, living was looking. Seeing was a regal thing. The richer you were, the more that you could see. In the Scottish cottages at night, you could look at the flickering flames in the fire; in Johnson's house you saw the wind in the trees. At

dawn, everywhere he looked, he saw a sight like that with which this book begins. One unintended consequence was that, at night, with the lights on inside and darkness outside, as he moved around all Johnson could see was himself reflected in the windows, so he installed under lighting in the trees to make the outside more visible.

Raising roofs and inserting windows created new types of looking, but so did walking through a building. In China from the 1100s BCE, isolated walls called *yingbi* were built either in front of or behind the main entrances to palaces and the homes of the well-off. This one is in Beijing's Forbidden City.

There is a doorway behind it, but its specific purpose is to stop us looking. As people lived together in greater numbers, things were built to occlude looking. As light travels linearly, *yingbi* killed off eyelines, but not only that. Their purpose was also to prevent bad spirits, which also travel in straight lines, from entering the building. They were the brick equivalents of the talismans that repel the evil eye.

Yingbi also acted as visual deferrals. As buildings blocked formerly clear views, architects began to manipulate the new route to seeing that their structures afforded. Where Notre Dame was, mostly, a single, long cavernous central space, in Asia especially, such one-off sight lines were less prized. Instead, looking in some Asian buildings became a series of reveals, each taking us closer to the centre of the structure. This Kailasa temple in Ellora, India, is dedicated to Shiva,

whom we saw earlier, dancing the world into existence. Completed around CE 765, it took seven thousand stonemasons 150 years to build.

Worshippers enter on the far left of this image, through a low *gopuram*, a decorated tower. As they move into the building, left to right, they cross a bridge and then into the second, larger, chamber, which is higher than the first and surmounted by four lions, symbol of the four noble truths. The feeling is of having a visual story unfold, an ascension, walking from confined to more open, in and out of darkness. Heading onwards they climb more steps and come to the tallest structure, on the right here, built on a base of stone elephants, with its rising tower, *shikara*.

This is what it looks like inside:

Massive square columns shoulder the vast weight of the overhead structure and frame the final, holiest of holy, chambers, the *vimana*. Our walk through the building has been a series of suspenseful looks. Everything here directs our eye to the vanishing point of the image – the low, wide, dark column in the background. It is the *lingam*, the phallus of Shiva, the symbol of his creativity, which sits on a circular base with a groove at the front, the *yoni*, the symbol of the female goddess, the divine mother. The eyes of Hindus and non-Hindus alike widen when they see this remarkable object, the potent destination of an architectural procession, all the more striking when you hear that the building was not constructed – it was chiselled out of the solid mountain rock, in the way Michelangelo sculpted David.

The room containing the *lingam* and *yoni* is a destination room, a fetishised room. It is the sort of place that construction seemed to be aiming for: spiritual, anticipated, imagined, revealed. From flat roofs to windows to the Chinese screen which made us want to see what was behind it, the building created the desire to see. The Kailasa temple multiplies and layers this process and, in its single structure, tells us something about how old cities work visually. But what about cities in general? How did the individual structures we have looked at combine to make them? Highly planned urban spaces often have avenues or a grid system which afford long sight lines, but many of the cities that we are about to look at either evolved in less planned ways and so have less geometric structures or, from the start, were intended to deflect or inhibit our gaze, to make us keenly anticipate our glimpse of a royal palace or sacred cathedral.

LOOKING AT EIGHT CITIES

A building creates looks; clusters of buildings rather more so. Hunting is glancing, so is being out on the street. Our eyes move perhaps thirty times when we cross a road, hundreds when we go to a bus station to buy a ticket and find out where to board. Cities increased the density of looking. So what is a city? They are the most complex planned systems we have made, within which unplanned systems operate. They are millennia-old inorganic and organic patterns (like Davros in *Doctor Who*) which vary greatly according to latitude, geography and political system. What, however, are their essentials and constraints? To find out, let's consider eight remarkable cities: Babylon, Rome, Baghdad, Esfahan, Yokohama, Metropolis, Astana and Pripyat. Each is from a different period in history. Together they reveal aspects of the monumental, clustered, disorientating, collective, voyeuristic, anonymous, dazzling, religious, imagined, futurist and destroyed looking that urban life affords.

Imagine, first, that it is the year 570 BCE. We are at the north end of the vast alluvial plane of the Tigris-Euphrates Delta, fifty-nine miles southwest of present-day Iraq. We have been travelling south all day, in scorching heat. We begin to climb a 200-metre-long limestone-paved road, the beginning of the Processional Way of perhaps the greatest city on earth, a city state that would be imagined long after its fall. The sun is in our eyes but we can see, ahead of us, backlit, a monumental, fortifying structure that seems to block our path. To our right, stretching to the ancient Euphrates River, are hanging gardens, stacked like a theatrical ziggurat, and lined with bitumen and lead to prevent the moisture and roots of the massive fruit trees that adorn them from breaking down into the layer below. They are one of the wonders of the world.

We pass a line of 120 ceramic lions, then step into the shade of the fortification and see this.

The Gate of Ishtar, the goddess of love and war, built five years earlier (this is it rebuilt, half size, using many of its original tiles, in the Pergamon Museum in Berlin). The gate is covered with lapis lazuli moulded brick tiles and edged with gold trims, the colour combination that we looked at in Chapter 1. As we walk towards it we have to crane our necks to see its top and then, looking downwards again, come eye to eye with one of the lions.

Its face sits proud from the monumental wall. We enter and discover a tumult, imagined here by the movie director D.W. Griffith in his film *Intolerance*.

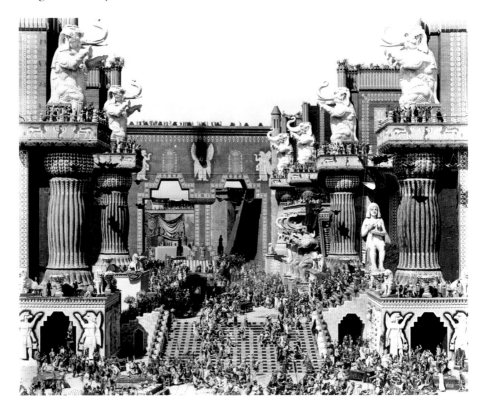

We are in Babylon. The city state dwarfs us. We do not know where to look. Griffith wanted us to be overwhelmed by this film set of Babylon, as we have been by the real city. This is epic looking. Gateways and figures are magnified. Merchants, citizens, slaves and pilgrims jostle. They have places to go in this vast city, which contains thousands of routes and journeys. Ladies in red dresses walk under parasols carried by servant girls. Shadows are coloured from the reflections of the tiles, like those in Hitchcock's *Vertigo*. We walk for almost a kilometre, then turn right into the temple of Marduk, the protector god of Babylon. According to the king who oversaw its construction, he 'covered its wall with sparkling gold, I caused it to shine like the sun'. We see this burnish, but as we walk into the evening, and as the air cools, we also see a designed city, a secular city, social hierarchies like those glimpsed by the Indian man people-watching at the Kolkata crossroads, libraries of learning, canals along which sailing boats laden with spices cast shadows within flickering reflections, and structures that speak of political power. In Christian mythology, Babylon was a symbol of

prostitution and decadence, and its famous Tower of Babel came to mean verbal confusion. There should be an equivalent word for visual confusion – 'vabel', perhaps? Babylon was a Mecca of vabel.

Such an experience, such cluster living, was addictive. That is the first element of city looking: it is cluster looking, vabel looking. In the ancient world, the logical result of settled living was a distillation of such living. More and more people moved in together, if 'in' means behind the protective walls of citadels.

ROME

Instead of our day on the Processional Way in Babylon in 570 BCE, if we found ourselves climbing the steps of the Flavian Amphitheatre in Rome exactly 650 years later, we would be about to see this.

The Colosseum. There are no photographs of its original spectacle, of course, but Ridley Scott's film *Gladiator*, designed by Arthur Max, researched it carefully and imagined it well, picturing it as another epic space, lit by shards of light. On taking our seats in it, it would be no surprise if we felt vertigo. The largest amphitheatre ever built, on misty days the far side of its vast ellipse is invisible from its near side. Weather happens within it. It held 50,000 people, a town in a building. And it was paid for, in part, by selling the treasures of the Jewish temple in Jerusalem that the Romans had looted a decade earlier.

What this image makes clear is that the Colosseum was a seeing space. It was curved, and had no internal walls or columns such as those in the Mezquita, so that everyone could see. Such places are sometimes called auditoria, but the

Colosseum's primary purpose was looking rather than listening. It was a video-drome, a place for voyeurs. Fifty thousand pairs of eyes all looked inwards. People flocked there, the rich at the bottom, the poorer further up the structure, to indulge in collective looking, and to do something transgressive and even repulsive: to see animals killed, nine thousand of them in the Colosseum's inaugural games. There was groupthink in this, and a kind of visual hysteria, a blood lust which introduces into our story unedifying looking. It is often said that Christians were fed to lions in this building. There is not conclusive proof that this happened a lot, but what did happen here is enough to note that looking, like other aspects of human life, can be a weakness as well as a strength. That is the second aspect of city looking – its oppressiveness. The cluster judges.

BAGHDAD

When to choose not to look, and what if we do not make that choice? The desire to look, as we will see later, can damage the person who experiences it.

Six hundred and eighty years after the opening of the Colosseum, a city was founded that would outdo Babylon or Rome. Northeast of the former and on the Tigris River, its basic plan was remarkably like that of the Colosseum – a perfect circle, a radically innovative city design.

And, like the Colosseum, Baghdad too was a videodrome. Under the CE 786–809 aegis of its greatest patron, Caliph Harun al-Rashid, it became the place in the world that most aimed to dazzle the eye. Funded by vast tax revenues from the Abbasid Empire and trade from its key position on the Silk Road, it had banking and legal systems, but also pageantry and ostentation. Henna and rose-water were sold in its bazaars. The lavish mansions of its wealthy citizens housed Chinese porcelain. Thousands of gondoliers ferried the well-off along the great

Tigris River and the city's canals: Venetian journeys of flickering and double-bounced light. 'My story is of such a marvel,' claims one character in *One Thousand and One Nights*, the great story cycle set here, 'that if it were written with a needle on the corner of an eye, it would yet serve as a lesson to those who seek wisdom.' The same could be said of Baghdad.

In the era of Harun, Baghdad was a city that not only looked inwards at itself, but outwards to the world. Scholars gathered there, and amongst the greatest was the polyglot medic and scientist Hunayn ibn Ishaq, who wrote thirty-six books and translated 116 more. Born in CE 809, Hunayn travelled abroad, learnt Greek and rendered classical texts by Plato, Aristotle and many others into Arabic, thus protecting their insights from the neglect, or worse, of the European Dark Ages. In such a visual city it comes as no surprise that one of Hunayn's best original texts was *The Book of the Ten Treatises of the Eye*, a celebration of looking – he argues that sight is the greatest of the senses – and a meditation on how eyes work. In this image from the book, the eye is in section; the outside world is below, the inner world of the brain is above.

In Hunayn's conception, *pneuma* – a kind of circulatory air – travels forward from the brain, along the red curving lines in the image, enters the eye from the back, causes the pupil to dilate, then travels out, into the air, encounters the object that is seen, which reshapes the *pneuma*, the new shape travelling back to the eye and allowing the object to be seen. This sounds fanciful today, yet neuroscience's discovery that more back-to-front brain activity happens when we look, than front-to-back, means that Hunayn was metaphorically, in part, right.

In its golden age, Baghdad, the largest city in the world, housed an estimated 1,200,000 people. By the beginning of the twentieth century its population had dropped to 145,000. This grew rapidly when the city became the capital of Iraq. Oil income

boosted construction in the 1970s, but war in the 1980s, political authoritarianism and corruption, and then invasion and more war in the new millennium, brought the city to its knees. The lenses of the world's reporters were trained anew on the suffering of the videodrome.

The storytelling of Kailasa, the Processional Way of Babylon, the circle citadels of Rome's Colosseum and of Baghdad: the kinds of looking that these afforded – suspenseful, clustered, oppressive, learned – give us a developing sense of looking in cities. In more recent centuries, our visual sense has continued to be shaped by architects and urbanists.

ESFAHAN

'Esfahan is half the world,' say the Iranians. On the four-hour drive from Tehran, your eyes get accustomed to desert landscapes, dusky-yellow and red earth, glaring sunlight and wide vistas. The city's outskirts are industrial, noisy and polluted. The unclean air removes whites and blacks, making the street scene shades of grey. At its centre, the city opens out into one of the largest squares in the world,

and at its southern edge there is a grand portal to the Emami mosque, completed in the early 1600s. It leads to dark, enclosed, echoing chambers which turn you and your eyelines right and left, and then there is this reveal.

On the left, a sublime *iwan*, or framed pointed-arch entrance, is covered with glistening *haft rangi* – seven colour – tiles, including Iranian and Turkish blue, black, white and gold. The blue sky echoes the deeper of the blues. The *iwan*'s form is reminiscent of the flat, but highly decorated, façade of Notre Dame in Paris. It stands proud of two stacked colonnades of similar shaped niches, and when your eyes follow those you notice that the pattern is repeated on all four sides, as if four Notre Dames stand facing each other. But walk to the centre of this inner courtyard and the reflecting pool makes the four look like eight, and the gold-blue glisten shimmers in the water. The overall effect of these 18 million bricks and 475,000 tiles is to create an illusion: this space looks aquatic. There are Koranic

verses and descriptions of the five pillars of Islam (prayer, giving to the poor, profession of faith, fasting and pilgrimage), but as well as traditional, the aesthetic is modernist. This mosque is a colour field, redolent of a Jackson Pollock drip painting or one of Yves Klein's meditations on blue. A place like this reminds us that Islam has its mystical strain, practised by Sufis.

The designers of the Emami mosque drew on Islamic design and architectural traditions, refining them and simplifying them in some ways, to create a visual experience of great equilibrium. The aim was contemplation rather than sensation. The geometry and restrained colour, the lack of figurative decoration, gave a sense that the city beyond, with its everyday living, had been erased or muted.

To the other types of looking we have seen in buildings and cities, we can therefore add sanctuary looking, the feeling of the cloister, the uninterrupted, contemplative place. Cities that were built within a small time frame, such as Brazil's capital Brasilia, are also able to plan a spatial regime from scratch, so that little interferes with the overall visual scheme. But in most urban spaces, randomness, unpredictability and the specifics of everyday life scatter any original visual purity that there was, and successive ideas about buildings and society jostle for attention. This was a product of the cluster of ancient cities, but it is also visible in more recent examples.

YOKOHAMA

Some city looking is timeless. Take this image, for example, from a Japanese film, *Pale Flower*.

How unlike a blue sky or the savannah, or even the Emami mosque this is. Three trees poke up into an otherwise built world – the city of Yokohama.

There is no empty space here. Everything fights with everything else for our attention. Foreground and background have similar weight. Do we look at the arch at the far end of the bridge, or the people walking towards us, or the cars on the left, or the shaded window on the right, or the electric cables running through the image? There is so much to take in.

Types of concrete had been used in building construction since the 6000s BCE; the Romans added horse hair and volcanic ash to it, and used it in structures like the roof of the Pantheon in Rome. Concrete was sculptural; it allowed buildings to be shaped in new ways. Asian cities have higher average population densities than Western cities, so things are more visually crammed and layered; you could say that they are the most city-like of cities. After taking in the clutter in this built environment – the directions, actions, attractions – our eyes might land on one of the thirty people, and we might imagine where they are going. As well as the quantity of things to look at, we can see ideas here. An arch is the sign of a threshold; it tells the residents that they are moving into a new neighbourhood. The buildings look onto the river and the three trees, giving views of them. Nature is something to be arrived at, to be directed towards. And this intersection shows that the city is designed to be moved through in different directions and at different speeds: the strolling walker, the car driver and the riverboat user, bringing goods into or through the city, all coexist. Their speeds are not separated into different zones. Our Japanese city (the film's opening scenes suggest that the setting is Tokyo, but it was actually shot in Yokohama because the latter has narrower lanes and looks more like a maze) extends our sense of how we look in cities. To suspense, cluster, oppression and learning, add randomness and simultaneity.

Director Masahiro Shinoda says that *Pale Flower* was influenced by the French writer Charles Baudelaire, whose reaction to cities we will encounter in the nineteenth century. And we will look at tall buildings when we get to the twentieth century. Cities have always been imagined before they were built. Babylon did not need a gateway as extravagant as its one dedicated to Ishtar. Baghdad did not need to be circular. In each case a form and scale were envisaged, then the city was built to fit that vision.

METROPOLIS

Cities, then, have always started as future things. In 1927, this was the future.

It is a moment from Fritz Lang's film *Metropolis*. An aeroplane flies between buildings, walkways connect the top of structures. It is still busy and multi-directional, like the Japanese city, but now life has become airborne. Living and travelling takes place in the sky. City life has some of the lightness of air. Yet Lang's film was a hierarchical city and a critique of cities. Its story tells of worker exploitation and revolt. One character imagines another as the whore of Babylon, and a club is called Yoshiwara, after Tokyo's sex district. Metropolis folded into itself ancient cities, Japanese cities and modernism.

ASTANA

And here is another city of vistas and fantasy visuals, dreamt up by moviemakers.

Except it wasn't. It is Astana in Kazakhstan, built from scratch in the last twenty years, as audacious as Baghdad or Babylon's gates, and as much a product of commerce – here, oil revenues. One of Astana's functions is to be seen, to make our eyes boggle. It has a White House with a turquoise cupola and a golden spire. Behind it is a bird's nest stadium and a vast tilted bowl building. On either side of this image, huge golden cones reflect everything, in case we have not seen enough. Tiny cars in the foreground, which look like toys, give us the scale. There is ancient looking here, and curved materials

only possible in the twenty-first century, and the joys of symmetry and a touch of Las Vegas. Astana wants us to want to see it. And don't we? Our composite city has the future in it too.

PRIPYAT

But the future eventually becomes past. What will Astana look like when it falls into ruin, like Babylon did? Something like this place, perhaps, Pripyat in Ukraine. Like Pompeii, it was abandoned, because of the explosion of Unit 4 of the nearby nuclear power plant, Chernobyl.

Above, at the time of the city's construction, we see clean, new public buildings, organised in blocks. Neatly planted roses bloom. Order, power and beauty. In the bottom image, thirty years after the city was abandoned because of

radiation, trees and bushes have seeded themselves in the concrete plazas. They look young and beautiful, and cast shadows in the evening light. Where once thousands of people went about their daily business, now almost no one does. The city is quiet, and returning to what it was before people, the Soviet Union, nuclear scientists, town planners, utopians, cold warriors and young families all imposed their will upon it. It has become an un-city.

For centuries we have been fascinated by abandoned and destroyed places, their abandonment telling us what we have lost. There are many books and websites on the subject. What do we see in them? The way we were, perhaps, a threnody or human hubris, or the fact that the present order is the disorder of the future? Pripyat is an image of mortality, of change, of the parade moving on, and – in its specific case, of course – jeopardy.

DESTRUCTION

Pripyat was not destroyed, but many of the greatest built things have been. Our human response to this is not simply to lament the destruction. If Notre Dame fell, our media would be saturated by images of the fall. Large buildings contain in them vast amounts of potential energy – all that lifting of stone high up, into the air – and we can, in our minds' eyes, picture the release of that energy into something more kinetic.

It seems always to have been so. In the Chauvet caves in the Ardèche in France there are russet, erupting, spray-like wall paintings, from around 36,000 years ago, which are probably depictions of a volcano hurling lava into the sky twenty-two miles northwest of there. We can imagine its eyewitnesses being terrified but dazzled by these ancient fireworks, by their scale, energy and ferocity. Thirty-six millennia later, on 18 July CE 64, the Emperor Nero is said to have watched from a distant hill, with aesthetic pleasure, the burning of Rome, during which an estimated two million citizens lost their homes.

Just fifteen years later and less than two hundred miles further south, on 24 August CE 79, Mount Vesuvius erupted, creating imagery like the paintings in Chauvet's caves. The smoke and ash cloud was twenty miles high. Pliny the Younger said that it was like a vast pine tree. It buried local towns under three metres of pumice. Visually, the event has recurred in Western culture. There are hundreds of paintings of it, and it was restaged in early silent films and again, in recent years, with the advent of computer-generated 3D imaging.

The destruction of cities, the urban apocalypse, had grotesque appeal to the imagination of conquerors. In this twelfth-century illustration from a Spanish manuscript, an angel flies over burning Babylon.

As Babylon symbolised sin to Christians, the manuscript illuminator, who was adapting an eighth-century image by St Beatus of Liébana, sees the burning as a cauterisation or punishment, yet the licking tongue flames seem not to damage the glorious city. Its minarets, domes, tiling, gardens, vases and horseshoe arches are intact. The artist cannot bring himself to destroy the city so, instead, represents it stacked, geometric and haloed with fire.

Jump forward to 13 February 1258 and we find the videodrome's circle citadel in flames. The Mongols raped and looted in the once great city's concentric streets, smashing or stealing what Chinese porcelain remained. They seized thousands of scholarly books by Hunayn and others, which had been collected over half a millennium, and threw them into the Tigris. The ink turned the river black, a striking image of mourning for lost learning. The destruction of this symbol of Arabism was relished by the city's enemies, but it, too, haunted the mind's eye.

We could go on. The earthquake and tsunami that destroyed much of Lisbon on 1 November 1755 led the French thinker Jean-Jacques Rousseau to argue for a return to rural life and peasant values; maybe all those people living at close quarters in cities were only asking for trouble? One hundred and twenty-eight years later, one of the most startling natural visual events in history occurred. A volcano west of Java erupted, creating a smoke cloud twice the height of Mount Vesuvius's. The ash that entered the atmosphere reduced global temperatures in the coming year and made sunlight refract or scatter in more extreme ways, thus intensifying sunsets and creating new visual patterns in the sky. Thousands of miles away, in Oslo, the painter Edvard Munch saw these and painted them in the background of his disturbing, highly chromatic *The Scream*. And at 11.58 a.m. on 1 September 1923, a massive earthquake in Japan devastated Yokohama and lit fires in Tokyo's wooden buildings, which spread like a forest fire. Over 100,000 people died, and most of Japan's great silent films, its moving image memories, were lost in the blaze.

Compared to these tragedies, the loss of life in Manhattan when the World Trade Center was attacked on 11 September 2001 was small, but New York is psychologically closer to white Westerners than most cities in the developing world and is the new Babylon, and so the atrocity was all over our perma-news, and there is no need to reproduce an image of that day here. 9/11 was the millennial Krakatoa, its imagery seared. It had its meaning – the awful deaths of 2,996 people – and it had its seeing. Later in our story we will come to unseen dying.

Our chapter on building and cities comes full circle. We started with a rhubarb leaf, considered how the visible worked in eight urban places, and ended with 9/11. Everything built must fall, but in the period before it does, a building and the city to which it contributes affords engineered, contemplative, clustered, oppressive, educative, random and future looking. The present order is the disorder of the future.

PART 2

EXPANDING

CHAPTER 6

EXPANDING HORIZONS FROM THE MIDDLE AGES
ONWARDS: *TRADE, CRUSADE, EMPIRE AND CONQUEST*

IN our story so far we have progressed through ranks of looking. We saw colour, space, other people, emotions, movement, design, abstraction, light, buildings and cities. Around us, as our consciousness and inner eyes developed, human living became more complex. People used tools, began to farm, lived together in more constructed settings, worshipped a wider range of gods and developed larger and more hierarchical societies. When we imagined walking through the Ishtar Gate in 570 BCE we found ourselves in a kind of biosphere, an entanglement, an ancient-world looking system. We have established how we looked out into our immediate environment and the people, objects and buildings within that environment. Next in our story we should look further outwards, beyond our bailiwick, to a larger cocoon. We should extend our sense of who we are beyond our individual experiences. Nations looked. Traders looked. Empires, sailors, warriors and kingdoms looked. From the Middle Ages onwards, and from the 1400s in particular, Europeans attempted to navigate the world and see it in new ways. This chapter is rooted in those eras and explores the centrifugal looking they involved.

The age of exploration has a prehistory, of course. On 23 August 55 BCE, Julius Caesar invaded the northwest of his world, Britain. He sailed after midnight, in boats from Gaul. When the sun came up behind him, the white cliffs of Dover were a glowing curtain, so close to the water that the awaiting Britons could throw spears down onto his boats. A man of the Mediterranean, he found the English Channel grey and tempestuous. The swell and the defence were too much for him. The water's surface was scattered with floating parts of the boats that had been wrecked; his men fished them out of the sea to repair the remaining ships, and returned to Gaul. Caesar had barely set eyes on this *terra incognita*, this unknown land. His gaze was privileged, presumptuous and acquisitive – a forerunner of the male gaze. He was looking at something entirely new, and will have seen it through the myths he carried to the place, his visual expectations. As well as this, his eyes encountered flora, fauna and geology that he had never seen before. It was exciting to see such new things, and troubling too, if you wanted the whole world to be like your world, or if you felt superior to new.

On his second attempt at an invasion the following year, Caesar noticed, as we have already seen, that Britons dyed their bodies with woad. He wrote that this gave them a 'terrible appearance in war'. As they, in his words, 'wear their hair long, and have every part of their body shaved except their head and upper lip', we have a sense of him being visually disturbed by the natives. But he, too, had a surprise up his sleeve. Confronted with lines of sharpened sticks, embedded in the ground and in rivers, he sent in an elephant in fighting armour, on which rode archers, to trample the defences. Thus began Rome's annexation of much of Britain. The Roman Empire's edges were adaptive, and so the conquerors

absorbed some of the new land's visual language into the iconography of the imperium. New, hybrid image systems – buildings, clothes, utensils, jewellery and so forth – were the result. This was one of the relatively benign driving forces behind conquest: the desire for visual novelty and renewal.

Caesar headed for Britain to extend the Roman Empire, of course, but in many cultures the land beyond what can be seen haunts or taunts. In J.M. Synge's Irish play *In the Shadow of the Glen*, the image of 'the back hill with the sheep upon it' blocks the view of the characters. They hardly know what is beyond it and, living in the valley, are mentally and visually imprisoned. They cannot see more, and are frustrated. Similarly, imprisoned people cherish the chink of sky or landscape that they can glimpse through the window of their cell. It is a lifeline. In the Hungarian film-maker Béla Tarr's film *The Turin Horse*, the characters are equally visually confined. The hills around them make the horizon unseeable, and the outside world unknowable. At one point people do climb the hill, and disappear for a time, but return to report that there is nothing there.

Such visual captivity applied to countries too. If you lived in China in ancient times, the world to your northwest was screened off by a vast mountain range that arced from Eastern Mongolia to Afghanistan. To see beyond it, or trade with the lands on its other side, you had to skirt the Gobi Desert, trekking between oases. But one break in the vast natural barrier afforded vistas to Central Asia and the west: the Dzungarian Gate. In this photograph, it is the hundred-kilometre corridor that runs from the lake at the bottom, between two snow-topped ridges, to the smaller lake in the top left.

The Chinese could not see it from the air, of course, but our photograph shows what they imagined. As the country's window on the Western world, the Dzungarian Gate became a key part of their visual imagination. They sent silk westwards along it, ensuring income and prestige for a millennium. The country whose *yingbi* walls blocked visual access to palaces and grand homes enjoyed having a visual corridor to see outside itself. Emperor Wu sent his diplomat Zhang Qian through the Dzungarian in the first century BCE – a pair of proxy eyes, to see what lay beyond. Thus it opened China to other civilisations – Persia, Arabia, the Horn of Africa and Europe – and vice versa. Ideas and religions, as well as goods, travelled through the gate. And in case we think that the Dzungarian is an old-world story, the computer company Hewlett-Packard recently relocated from western China to the mouth of the gate, to make the thirty-five million computers and printers that it manufactures annually easier to send west.

Such expansions were driven by commerce and, as we have seen, the desire to expand the country's visual world. Merchants were the primary beneficiaries of the new routes, and they were the first to see the new countries. The people back home eventually heard about the new lands and trading partners, and their imaginations expanded as a result. But it was not only merchants who did the travelling. Things did too. The material that gave the Silk Road its name was not aromatic like spice, it was not an intoxicant, and it was not timeless, like gold. Silk's appeal was its look. On this semi-formal emperor's tunic, silk threads embroidered on more silk depict a band of boiling seas in green and grey; rainbow abstractions seem to fall from the sea, whilst a buttercup-gold sunrise and twisting, soaring dragons are above.

Silk was great at such detail. It held dyes brilliantly, and caught the light of the sun or candles. It was spun by worms then again by people, then sewn into stories, garments or decorative furnishings – statements of power and taste. There is nothing it could do that other things could not, except dazzle the eye. In its raw form it was used as currency. Its thinness was daring, erotic even. The

Roman writer Pliny the Elder, uncle of the Pliny who wrote about the eruption of Mount Vesuvius, said that silk allowed women to 'shimmer'. Others noted its visual ambiguity: it covers and does not, conceals and reveals. The emperor's tunic is an elaborate predecessor of a holiday picture postcard or a Facebook post of Times Square in New York. It says, *Look what this place looks like. Look how different it is to us. Look how glamorous it is, how visually striking. Don't you want to come here?*

If the mountains to the north and west stopped the Chinese seeing beyond, the sea to the east and south hypnotised them. As we saw earlier, the sea is the sublime z-axis: it takes our eyes effortlessly to infinity. It is a window, but a forbidding one, which gives unto that which we do not know. China had long sailed the seas, but in 1405, nearly a hundred years before the Portuguese rounded the south of Africa to head for the Indian Ocean, a Muslim eunuch set out on the first of seven voyages into that ocean.

Zheng He was a diplomat and admiral, born in around 1371. A skilled courtier, he caught the eye of the emperor, who set him on his journeys. On his first voyage alone he had about 28,000 men and 62 ships. Two years later he returned, having seen Vietnam, Thailand, Java and Ceylon. Thereafter he got as far as Mecca, Egypt and Kenya. What is strange about his trips is their apparent purposelessness. They did not establish major trading posts, and nor were they land grabs. Instead, Zheng went to see and report back. His were envoy eyes. His trips strip travel of its apparent purpose in these days – to make money – and reveals, instead, one of its subsidiary purposes: visual and cultural curiosity. Horizons expanded for material gain, but also other reasons. Zheng He's trips were driven, in part, by looking for looking's sake.

Conquest and exploration spread across Asia in waves, each affording vistas – looking that was curious, fascinated or rapacious. Zoom in on Agra, India, in the late 1500s, for example, and you find another dimension to the story of Asian looking.

We are standing on the ramparts of the vast Agra Fort, staring southeast. In the distance, in this modern photograph, we can see the Taj Mahal. It was built by the grandson

of the man whose looking we are here to see. The grandfather, Akbar, was the third emperor of the Indian Mughal dynasty. Born in 1542, he acceded to power aged thirteen, and became interested in architecture, hunting – he trained thousands of cheetahs to hunt with him – interfaith understanding and military tactics.

Akbar was a fascinating looker. He devised speech deprivation experiments with children – not to punish them, but to try to stimulate their senses. He was dyslexic, so was more adept at visual than written things; the Catalan Jesuit Antoni de Montserrat wrote, 'his eyes so bright and flashing that they seem like a sea shimmering in the sunlight'. There are lots of paintings of Akbar receiving Jesuits for interfaith discussion, hunting with cheetahs, sitting in elegant Mughal palaces, hearing of the birth of his son, and so on – he clearly loved to see himself visualised – but the vista on the previous page tells us more about him. The Mughals were northerners, descended from Genghis Khan and Mongol-Turks from beyond the hills. Akbar consolidated their empire and extended it downwards from the great rivers of northern India – the Indo-Gangetic plane – onto the vast, triangular, southern Deccan Plateau. The Deccan was a goal for Akbar, the place beyond, a new world where he wanted the Mughals to have military, political, cultural and economic dominance. We can imagine him standing on the ramparts above, looking southeast and east, the new master of what he surveyed. His story tells us something else about colonisers. They are surveyors. They are fascinated by the place beyond. The less rapacious of them, are well as wanting to steal from it, want to know it, to bring it into their visual imagination. And Akbar tells us something else about this impulse. Not only did he want to see the new world, he wanted to see it from great structures, balconies, domed rooms, latticed and horseshoed windows. This patron of the arts framed his vision of empire. Part of the new seeing that conquest brings is framing.

Empires and nations have looked north (Julius Caesar), west (China) and south (the Mughals) but, of course, east too. Europe had started to become Christian in the first century CE, the Roman Empire converted in CE 380, and during the early Middle Ages most of the rest of Europe heard the Christian story and took it to its heart.

It was a story of embodiment. A young man's body was tortured. Things he touched became holy: the cross he died on; the nails used to pin him to it; the cloths used to wipe and wrap him; the thorns that crowned him; and then, the belongings of those who became sacred because of their devotion to him. The story of Christ was a story of a chain of such objects, such pearls. Christians venerated them, but there was a problem. The objects, and the places where

the story took place, were hundreds or thousands of miles away from Europe, to the southeast, in a city called Jerusalem in a place called Palestine. Their remoteness made them hard to see, these places and things, but what made them more so was that, after a bloody siege, Jerusalem had in CE 637 surrendered to Islam's Caliph Umar. The things and places were behind a veil. They were in enemy hands.

For more than four centuries this situation remained unaltered, but in 1095 and during the following 391 years, a series of European military campaigns sanctioned by popes and royals set off for the Holy Land to reclaim the place, the story and the objects, and to guarantee access to them for Christian pilgrims.

This painting by Tom Lovell dates from many centuries later, but shows how the Crusades were seen by Europeans. Barefoot monks walk in head-bowed procession, the cross of Christ held proud in the golden sunlight. Behind them, Crusaders humbly fall in line, their pennants echoing the cross. To their left, Jerusalem is a city on a shining hill, which its walls surmount. The whole painting glows in warm tones – no blue here – and from it we can imagine the Crusaders' pious, principled entry to the centre of the Holy Land. On the left of the painting, a single catapult stands ready. According to this depiction, the crusading gaze was noble, humble, inevitable, epic, golden and panoramic.

And what of the objects behind the walls? Again, painters have shown us how they were envisaged. In this 1740 painting by Tiepolo, the cross on which Christ was crucified is discovered by Helena, the mother of Constantine, the Roman emperor who converted to Christianity.

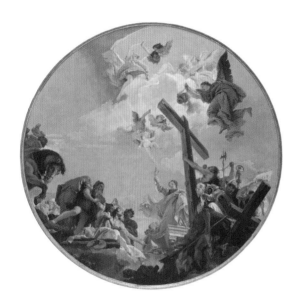

The cross is intact. We are underneath it, as if in the ground where it was buried, looking upwards at a vortex of swirling orange and blue garments, angels and clouds. This is an ascension image, an elevation which expresses what will happen when Jerusalem is liberated by the Crusaders, and when the objects in the Christian story are unearthed. Tiepolo gives us a dramatic and exciting vision of the Crusades' purpose. The expanding Christian horizon was like archaeology – discovering something long buried and restoring it to the glorious light of day.

And once they were unearthed, what would happen to these long-envisaged and then finally seen things? They would need to be housed somewhere remarkably visual, somewhere like this, in the same city as, and even more lattice-like, than Notre Dame.

Sainte-Chapelle, in the heart of Paris, is a crown to crown a crown. It was built by King Louis IX, himself a Crusader, to house the crown of thorns that was forced on the head of Christ to mock his claim that he was a king. The crown, together with some nappies worn by the baby Jesus and some of his mother's breast milk, were brought to Paris in August 1239. Their installation here completed a virtuous visual circle. The potency of the supposedly authentic objects created visually extravagant things – in this case a vast church – around them. Seeing begat seeing.

Except, of course, there are other images of the Crusades, and other stories to tell about them. In this small French painting on animal skin, three Crusaders on the right, masked like Darth Vader in *Star Wars*, ride their horses, which are draped in salmon and blue, into an abstract gateway of similar colours. Left of centre, in a red tunic, one of their number is finishing off a fleeing Muslim, whose head spurts blood. Six decapitated heads of bearded Muslims are stacked at his feet.

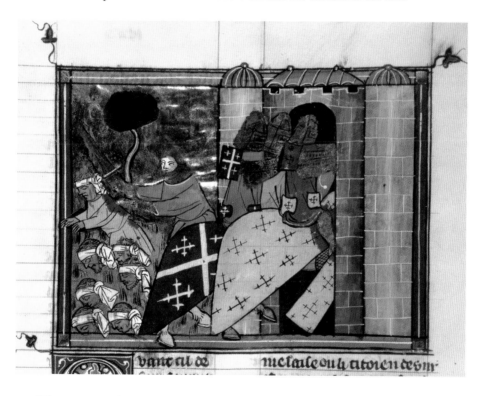

The image acknowledges that the Crusades were horrifically violent; the number of casualties is disputed, but it was likely to have been in the hundreds of thousands. But the illustration is not trying to say, *Look how violent we were*. Instead, it tells a story of a job done, of enemies dispatched and the next stage

commencing. We read it from left to right, from chaos to order, from death to liberation. Looking in such Crusader imagery is self-deceiving and self-congratulatory. Which of the two Crusader images is closer to the truth – the golden arrival at Jerusalem, led by monks, or the bloody dispatch of infidels before the knights triumphantly enter the city? Each image is so aligned to the Crusaders' own sense of their mission that neither can be relied upon to tell the broader story, but the bloody image is more useful today. It was not intended as an indictment, but can now be used as one.

Were things different when Europeans looked westwards? The silk route east got trickier to negotiate when Constantinople fell to the Turks in 1453, so Western kingdoms and nations started to imagine accessing Asia's spices and silks by sailing westwards, around the globe. Enter this man, an Italian son of a wool weaver and cheese seller, who was not a great thinker, but whose ambitions led him to learn Portuguese and Castilian, the languages of Europe's most seafaring countries. He looks warily out of this picture, his hands as prominent as his eyes, which seem cloudy; he had a type of conjunctivitis later in life.

In his twenties, he sailed to England, Ireland and Iceland, as if to prepare for four grander voyages between 1492 and 1503, which would change the world and move its centre of gravity westwards. His name was Cristoforo Colombo.

In his accounts, we see the trips through Columbus's eyes. On 5 December 1502, for example, after being caught in a thunderstorm on his fourth voyage, he wrote: 'Never did the sky look more terrible; for one whole day and night it blazed like a furnace.' But Columbus was an unreliable eyewitness, caught between competing claims, ideas and desires. In this colour

lithograph of his first trip in 1492, when he met the Taíno Indians, we can begin to imagine how Columbus saw, and mis-saw.

To gain their sponsorship, Columbus had promised the royals of Spain great booty from his trips. He described to them the riches he would find, but when he landed on islands in the Caribbean he was puzzled. What he saw did not fit with what he had imagined. He thought he was in India, yet was less than halfway there. He said that he found cinnamon and aloe, but did not. He wrote to King Ferdinand and Queen Isabella that he had seen gold mines and 'a thousand other things of value', but this modest picture shows that far from being epic or festooned with riches, his encounters were happenchance and took place on simple beaches. The locals wore no clothes. They had no palaces. They seem entranced by the bell tinkled above Columbus's right shoulder and the mirror held to his lower left. They are depicted like children.

Having a sense of the visual, Columbus sent parrots to Ferdinand and Isabella, and eunuchs, but it is he who should have looked in the mirror. If he had done so he would have seen a man who believed the Bible's doctrines, and who would fail to deliver on his promises. He promised India, and did not get there. He was a moralist who tortured the natives he encountered. He wanted them to be fabulous, otherworldly and dripping with gold, and they did not live up to such mythic, almost erotic, expectations. The desire to see the other was strong in him. Over months of seafaring, his visual expectations grew. His trips were about God and money, but visual curiosity too.

Columbus had been disappointed by the locals he met. He failed to see himself in them. Empathy deserted him, so he was able to treat them in ways that were disrespectful, or worse. His men punished the natives. One man who stole corn had his nose and ears cut off. The Spanish monk Bartolomé de las Casas wrote that he saw cruelty in the new colonies 'on a scale no living being has ever seen, or expects to see'. Columbus himself ordered bodies to be dismembered and carried through the streets. He was blind to their suffering. Before Columbus's

arrival it is estimated that there were about 500,000 Taíno. Within a few decades just 2,000 remained.

A teenager of noble Spanish stock, Hernando Cortés, heard the stories of Columbus's voyages, visualised their adventure and plenitude, and so himself set out for the New World. Cortés's first trip was in 1504, the year after Columbus's last, but it was his conquest of Mexico from 1518 to 1520 that left its mark. Mexico under the Aztecs had the palaces and gold that Columbus had envisaged. Cortés was gratified to find them, received lavish gifts of gold jewellery, shields and helmets from their leader, Moctezuma, and then plundered. Moctezuma died, and the great city of Tenochtitlan was destroyed. In this angry narrative mural, painted centuries later, Frida Kahlo's husband Diego Rivera crams nearly a hundred people and animals into a visual indictment of Cortés's murderous greed. The conquistador is in the centre at the bottom, in a wine-coloured tunic, receiving a tribute payment.

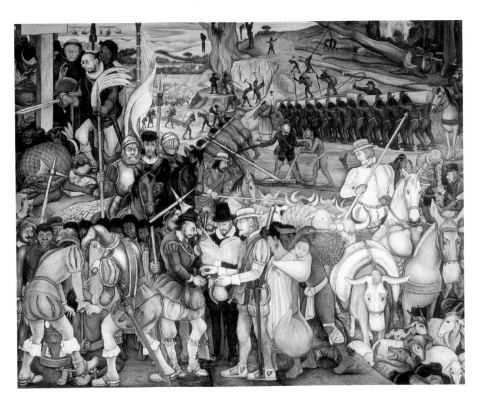

In both cases, Cortés is pale-faced and hunchbacked, the suggestion being that his physical deformities were because he was syphilitic. In the background, native Mexicans hang from trees, and others are driven to quarrying and

enslaved construction work. Rivera was painting in 1951, so borrowed imagery from the African American liberation movement. In the bottom left, an Aztec is shackled and branded. In the lower centre, La Malinche, a native woman who translated for Cortés, carries their child on her back. The boy, Martin, stares out at us, his piercing blue eyes a sign that he is mixed race. His look is intense, lost, bewildered. His eyes hold ours. In the bottom right, a dog's snarl gives the painting its signature and tone. This vast panorama is a space-time snarl. If Europeans projected images, fantasies, desires and voracity onto the New World, image-makers like Rivera batted them back. His mural is a counter-visual. He was speaking to anyone who visited the Palacio Nacional in Mexico City, but especially to his own people. He wanted them to carry image outrage in their heads.

Back in Europe in the time of Cortés, as scores of ships arrived carrying the treasures of the Aztecs, people swooned. Albrecht Dürer wrote on 27 August 1520:

> I saw the things which have been brought back to the King from the new land of gold: a sun all of gold a full fathom broad . . . All the days of my life I have seen nothing that rejoiced my heart so much as these things . . . and I marvelled at the subtle *ingenia* of men in foreign lands.

Conquest was continuing to create visual shocks. There are no images of the exact treasures that Dürer saw, because they were all either melted down or discarded, but this gold pendant from the time does exist, and can be seen as a symbol of the European intervention in Meso-America. He is Mictlantecuhtli, god of the dead.

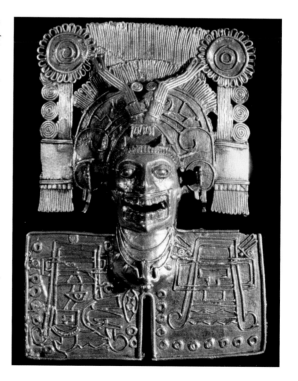

His face is a skull, but with eyes. He seems to scream, and his teeth part so that he can swallow the stars when daylight comes. Human bones hang from his ears and his necklace is often strung with eyes. His headdress is of owl feathers, and his breastplate could have been drawn in the twentieth century by Eduardo Paolozzi. Before the arrival of Cortés, Meso-American

art had often depicted agony and death. The European lusters after gold brought both in spades. A new agony came to the natives' shores, but their metalworkers and artists were up to the task of capturing it. The gold pendant is like Edvard Munch's *Scream*. Perhaps the agony in the face of this pendant is another indictment, showing the anguish that Cortés and his cohorts should have felt.

After these multiple examples, how can we sum up the look of a coloniser? On the surface, the Crusaders and conquistadors seemed to be outwardly directed, to have a centrifugal imagination. But when they got to Jerusalem or the beaches of Central America, their eyes failed them. They saw less humanity than was there. What was in front of their eyes, and behind them? In this image from Terrence Malick's film *The New World*, Colin Farrell plays Captain John Smith, yet another migrant, another mendicant who has left his own world to search for something more. He is in Virginia, and the year is 1607, but the neutrality of Farrell's expression allows the moment to stand for something more timeless than that. The migrant has paused. We see the natives behind him, but out of focus. A few stare at him as if to see why he has stopped. His facial muscles are loose, he gazes into space.

What sort of thinking is John Smith doing? What kind of looking is he doing? Is this what Caesar looked like when he glimpsed the white cliffs of Dover? Did Akbar pause when he first saw the Deccan, or did Marco Polo when he met Kublai Khan in 1266? The Crusaders had many moments of solitude on their way to the Holy Land, but once they got there was the land grab too frenzied, and was their search for relics too intense, for contemplation? Every conqueror is looking for something, an object or place or people to own. They search for a holy grail, something like the Indian Koh-i-Noor diamond, found in the 1200s or earlier, flaunted by dynasties and sultanates, used by Shah Jahan to view the reflection of the Taj Mahal, looted by the Shah of Persia, claimed by the British, recut over

thirty-eight days and greatly reduced in size by Queen Victoria's husband, Prince Albert, and now part of the British crown jewels. We can read in the face of a character like the one Farrell plays a longing for such a diamond, or some other relic that will travel through history and end up on the altar of Sainte-Chapelle or as a necklace on the breast of some queen or movie star. People will flock to see what he finds, drawn by the sense of sublime, or its longevity, or the thought of all those who have touched it, or what it has seen, and he will be remembered for ever and become rich. The diamond or relic will become the symbol of him, or his temerity, forever seen. The conquistador sees gold, land and immortality.

In doing so, he distorts the world. To see how, flick your eyes between these two maps, and notice how Africa and South America change size. The upper map is a refinement of the Mercator projection, devised by the Dutch carto-grapher Gerardus Mercator in 1569.

In flattening the spherical Earth into a 2D map, he increased the size of Europe and North America, then the most known parts of the Earth, and made the equatorial world smaller. He was not consciously belittling Africa, but the effect of his mapping was precisely that. His projection inadvertently captured the self-aggrandising psychology of Europe in the sixteenth century.

LOOKING AND WAR

War is usually the means or the end of expanding national horizons. It is the fallback of the conquistador, his go-to. Like expansion and conquest, war has its own fascinating image systems and ways of looking.

Thermopylae, the Arab-Byzantine wars, Agincourt, the Hundred Years War, the South American wars of independence, the first Sino-Japanese war, the Vietnam War: each of these, and hundreds of others, had many stories – of ideology, tactics, class, massacre, technology, trauma, famine, migration and memorialising. Some of these themes will appear later in our story, but let's complete our section on conquest by adding to it six images of war, zoomed-in flashbacks to moments of battle that reveal some of the looking that war affords or inflicts. Six glances at the horrors, stories, bodies and manipulations of war.

The first is set in feudal Japan. A war has just ended. A samurai, Washizu, has his future foretold by a ghost. Years pass, a new war approaches, and the ghost reappears to tell Washizu that he will win the war unless the trees of Spider's Web Forest attack him. Akira Kurosawa's film adaptation of William Shakespeare's *Macbeth* creates a world of doomed stillness and dubiety, but then we see the trees of Spider's Web. They grow out of the mist, and are advancing toward Washizu's castle, just as the prophecy foretold.

There is no fighting in this image, and no bloodshed, but it is a haunting visualisation of the superstition of war. Fighting is often a product of the unconscious, a thing of fetishes, mascots, folklore and myth. Shakespeare's Macbeth is driven less by strategy and calculation than fear, dreaming and shibboleth. His fighting is a product of the murky depths of his mind, culture and times. The trees in the forest do actually move (Washizu's attackers are carrying them as camouflage, and to spook him) but this is a nightmare image.

And what about depicting the combat itself? Spanish painter Francisco Goya's *The Disasters of War* etchings and aquatints famously show dehumanisation and dismemberment. The caption on one of them is 'One Can't Look'. He was a court painter, so it was risky for him to portray nakedly horrifying scenes that were unsanctioned by patrons. So challenging was his visual protest that the prints were not published until thirty-five years after his death. Decades later, but in a similar vein, the early war photographer Roger Fenton was told by the British government not to shoot images of the dead or maimed bodies he encountered in the Crimean War. The visual realities of war were deemed too graphic to show. Mughal miniature painters are great at what looks at first like a mosaic, but then is revealed to be a tangle of bodies, blades, blood, elephants, limbs and horses. Tangle is right, because in the era of hand-to-hand combat, bearings and footing were lost and it was hard to know which way was up. This image is from the Battle of Shrewsbury, fought on 21 July 1403, as depicted in Orson Welles's film *Chimes at Midnight*. There is no horizon here, and there are no heads.

Three men have fallen and two more seem to be on their way down. Before fighting started, their knitted tunics, metal armour and leather boots will all have had different textures, but now everything's the same, covered in mud as if some ash cloud from a volcano has cast a pall upon them, a reminder of Leonardo da Vinci's advice to artists painting war: 'Make the dead partly or entirely covered with dust.' The men were said to have fallen 'like leaves in autumn'. Nobleman Henry Percy was shot in the face with an arrow when his visor was opened. At the end of the day, many did not even know which side had won. How could they? If mud and blood had covered everything, if all markings were erased, if the horizon was gone and people were a tangle of bodies, then the battlefield was a brown-red snarl of dying. German Lieutenant F.L. Cassel wrote of his time at the Battle of the Somme, and what he saw when he went out of his trench: 'On the steps there was something white and bloody. In the trench was a headless body . . .' A British shell had 'torn off his head. It was his brain that was lying on the dugout steps.' The brain's whiteness shone against the mud, the blackness. If our first image of war was a nightmare, our second is a tangle on the battlefield.

Our third film gives us another snarl of dying, this time with children and in the twentieth century, but it could apply to any war. We are in Belorussia in 1943. A teenage girl, Glasha, and a teenage boy, Florya, have just met but are running away together, to escape the Nazis who are advancing with murderous ferocity. As they run, Glasha looks back to Florya's village, and she sees this:

Florya's kinfolk, slaughtered and lying in a heap. Glasha is shocked, runs on, and does not tell Florya. The glimpse of the atrocity has made her an adult, a protector of someone her own age. Then comes the central image of the film.

Florya and Glasha arrive at a mud bog and must cross it. They are up to their necks, cursing through sludge. The mud sucks on their bodies.

Will they drown in it? The image, by director Elem Klimov and cinematographer Aleksei Rodionov, is a metaphor for the immersive nature of war, and its weight or pull. The war tide ebbs sometimes, but then it is back and you are close to drowning again. War years are *anni di piombo*, years of lead. This is what they did to fourteen-year-old Florya: they turned his hair white, and made his face old, like a grandfather's. His eyes stare, the distant look of the war stare. The film is called *Come and See*, which could be the title of this book.

Nightmare war, tangled war, ageing war. The first image in this chapter was filmed from the air, and so is the last. To most of the lookers we have considered in this book, the following would make little sense. It is a blurry abstract, the sort of thing a baby first sees.

Abstract is the word here, because this is an image about the way recent warriors have abstracted themselves from the battlefield. Technology has made it possible to kill without getting down and dirty, without getting covered in mud as in the Battle of Shrewsbury. War does not have to be about being there any more. This final war image has a gun sight in it, but you have to be from the digital age, and to have watched television news at the time of the Gulf War or since to recognise it. A US aircraft's undercarriage camera films as, directly below it, a bomb explodes on impact, somewhere in the Persian Gulf in 1990 or 1991. We do not know if anyone was killed or, if so, what were their names. The shot is not filmed by a journalist or eyewitness, but by the weapon itself – the aircraft. It is a weapon's-eye view. Such images appeared in the media every day. They were present tense, evidence that things were being targeted – dramatic, televisual and heroic to many. Other implications of such an image will be dealt with later, but here it can be noted that the looker and the killer have become aligned.

The Silk Route, Akbar, the Crusades, Columbus, Cortés and the world's warriors: when traders, evangelists, conquistadors and nations have sought to expand, they have usually done great harm. Their main desires have been for money, power and control; in each case these desires have been pre-visualised, then seen as they happened, then rendered into paintings, photographs and films. Expansionism is a fertile field of looking. Our next chapter is equally fertile, and expansion of another kind. In it we see looking in a more edifying light.

CHAPTER 7

LOOKING AND SCIENCE: *NOT IMPOSING A STORY*

'I admit nothing but on the faith of the eyes.'

– **Francis Bacon**

'THE faith of the eyes' is a good phrase. In the last chapter, religious faith led to bloodshed, but here English philosopher Francis Bacon introduces a far less aggressive form of looking, the opposite of the crusading mentality. He is talking about looking as evidence, and the way that, if we are open to what we see, we can update our understanding of how the world works. Where colonisers impose their story on the world, at their best scientists look at the world and let it impose its story on them.

That is the theme of this chapter, which is centred on, and starts with, a stroll in Venice in Italy in 1609. It is night-time, the sky is clear and the Moon is bright. We look at it and see a simple, luminous crescent. Our eyes are then caught by a small, red-haired, middle-aged man standing on top of Venice's famous Campanile. He looks as if he could fall. He is staring into what looks like a tube, towards the horizon, twenty miles away. He has just made the tube, which was inspired by a similar one by a Dutch optician, Hans Lippershey. The tube is a telescope. The red-haired man is Galileo Galilei. The telescope magnifies what he can see, so that the sails of oncoming boats, which perhaps have hostile intent, can be glimpsed a full two hours before they arrive, thus allowing Venice to prepare for invasion. War looking again, but Galileo was not a warrior.

Instead, as we will see, he will point his telescope at that Moon which seems simply luminous to our naked eyes, but which will become more detailed with his new instrument for shortening distances and magnifying detail. Tonight, on the Campanile, a key step is taken in the science of looking, a sphere of visual experience which dismantles in order to understand. Galileo will become one of the great tour guides of the visible world. He will suffer for what he sees and discovers tonight, breathing in the humid Venetian air. His sufferings were the birth pains of modernity. Before we hear about them, let us leave him for a moment, standing on that skyline at the centre of the trading world, and flashback to the story of looking and science that preceded him.

Not everyone looked to understand. In the early 400s CE, St Augustine said that investigation and curiosity were diseased. But as early as 5000 BCE, in Afghanistan and in Persia, people noticed that when they heated green malachite stone, copper flowed from it. The metal was clearly in the stone, somehow, and the flames released it, broke the stone into its constituent pieces. As a result, those of an enquiring mind wanted to know what else was inside what else. Like children who want to break stuff open, they heated many things, one of which was cinnabar, a red rock which, when inflamed, produced silvery mercury, like a soft-boiled egg leaks orange yolk. As scientific looking evolved, the story of matter unfolded.

But heating and observing what happened could not answer all the questions of what lies inside things. In 250 BCE, the king of Sicily wanted to know if his crown was pure gold or if it contained a lesser metal like silver. He asked a thirty-seven-year-old Syracusan brainbox, Archimedes, to solve the problem. Archimedes was stumped, as he could not melt the crown to see its constituent metals, but then, as he got into a bath one day, so the story goes, he looked at the level of the bath water and realised that it rose by exactly the volume of his body. A visual event led to a cognitive one: he could measure the exact volume of the crown by immersing it in water, divide that volume by its weight and, therefore, discover the precise average density of its metal. As the density of gold was already known, this would clarify whether or not the king's crown was the real deal. Thrilled by his visual realisation, it is said that he ran down the street naked, shouting 'Eureka!' ('I have found it!').

The chances are that he actually used a more sophisticated method of analysing the crown (which did indeed contain silver) but his bath time experience shows that observation is the root of science. Greek natural philosophers made many breakthroughs, but despite the visuality of Greek culture they often did so through disputation, reasoning or dialogue. Thus Greek science did not start with the look. In many cultures, however, looking played a key role in science. The root of the word evidence is *videre*, to see. Long before Columbus came to do his fantasy conquistador looking in Central America, the Mayans used only the naked eye to

develop what was probably the most accurate astronomy in the world. This Caracol observatory, from around CE 906, raised Mayan star watchers above the tree canopy on the Yucatan plateau, where there were no J.M. Synge mountains to block their views of the sky at night. Observation is the starting point of physical science, the sort of science that looks in order to understand, the sort of science the Greeks did not really do; this building is a temple of looking and a landmark place in our story.

IBN AL-HAYTHAM

Around eighty years earlier, in CE 828 in our circle citadel, Baghdad, another observatory was founded. Our scholar of looking, Hunayn, certainly studied there. If he had looked up at the Moon one night, as Galileo was to do nearly 800 years later, and the night was really clear, he might have seen some of the craters in the Moon. He would have been surprised to hear that, more than a thousand years later, one of them would be named after a countryman of his, working in astronomy and optics in the same era as him. We might expect that Moon craters are named for astronauts of recent times, or Enlightenment scientists of the 1700s, but one of them is called Alhazen, after Ibn al-Haytham, to give him his real name, who lived one thousand years before man walked on the Moon. Born in 965 in Basra in present day Iraq, he was one of the first people on earth to say that the world *comes* to us. Rays enter our eyes, al-Haytham argued, a subtly different argument from Hunayn's. Looking is a kind of invasion, the opposite of colonialism. It is a submission to the world. We spend our lives managing that invasion, and enjoying it. Al-Haytham was fascinated by this assault, this managing and enjoying, and so wrote books on the subject. They were in Arabic, were translated into Latin and greatly influenced European thought on his subject – optics – for centuries to come.

Ibn al-Haytham was rewarded with a crater on the Moon, but also with this:

His face on the Iraqi 10,000 dinar note. There he is on the right, turbaned, bearded and staring balefully to the centre, past a sketch of dots and lines to represent his looking.

SHEN KUO

Ibn al-Haytham was the first to experiment with pinhole camera obscuras, but looking in science was becoming a global phenomenon. In China just a few decades later, this man did the same.

He noticed that the image created in a black box with a tiny hole in it is inverted, and compared the hole to the bracket on the side of a rowing boat. The oar sits in the bracket; when you pull the oar's handle towards you, its paddle end moves away from you. The direction is inverted by acting through the bracket. Light is like an oar, he reasoned. Its action gets inverted by going through the hole: an ingenious visual metaphor, and a sign that he thought about what he saw with great imagination. Again, to reverse the theme of our previous chapter, it can be said that he allowed life to colonise him.

Born in 1031, Shen Kuo was educated by his mother. Some of his thinking makes him sound like an anti-looker. As a Daoist, he felt that observation alone would never reveal the mystery of life, that looking provided only 'crude traces'. But what traces. He was sickly as a child, but his physical restrictions seem to have sharpened his eyes. His father's work took the family to many provinces. During these travels, incapacitated son Kuo observed the passing landscapes. He would later pioneer relief (3D) maps and study geomorphology. By looking at rainbows, he worked out that the colours came from the sun's light being split as it shone through water droplets.

Canals, drainage, silt, dry docks, fossils, geology, geomorphology, fortifications: his was a striking visual world, but he did not have a passive response to it. He had reformer's eyes, innovator's eyes. He saw how things were and deduced how they could be improved. He could not stop looking. He saw fossilised bamboo trees in the north of China, which was, by his day, too dry to sustain bamboo growth and, as a result, developed a theory of what we now call climate

change. And he distinguished between magnetic north (to which a compass points) and true north.

In later life Shen was held responsible for a military disaster that was not his fault, and so was sacked from his government job. In the subsequent years of diminished reputation he wrote the 507 chapters of his book *Dream Pool Essays*, named after the Dream Brook estate where he lived. They do not cohere into a single theory of the physical world, but tell the story of a remarkable looking life, an *optique*.

Looking feels like such an outward thing that it is perhaps no surprise that the science of astronomy developed earlier than that of medicine. We were happy to discover what was inside cinnabar before we wanted, scientifically, to explore our own organs. Human viscera were studied in ancient times, but for divination and prophecy, not to understand how they work. The Aztecs, who looked at the heavens with such acuity, seemed uninterested in internal bodily function. In 1308 a group of Italian nuns cut open the body of the recently deceased Sister Clare of Montefalco. As they were followers of St Augustine, who, as we heard at the start of this chapter, had his mind set against visual enquiry, it comes as no surprise to hear that they did the post-mortem not in the spirit of anatomical discovery, but to look for any signs of divinity within. They were in luck. She had three gallstones, they reported, a sign of the Holy Trinity, and her heart had a crucifix on it. This organ is still on display in the church in honour of her.

Not everyone went in search of what they wanted to see, or thought that stars were more visually interesting than the inside of a human body. The Roman scholar Galen had made anatomical studies, and as the Middle Ages ended an increasing number of images were made of muscles and organs, but then came Leonardo da Vinci. This time in our story, he is a great dissector-detector.

He started drawing the inside of bodies to get their outside right. He learnt dissection by watching others, then did his own, more than thirty, many by candlelight, in a church vault. This is one of his most famous anatomical drawings:

He cuts away a third of the womb to show us the foetus, its ankles crossed. Below and smaller, there are comparable drawings of seeds in pods, which look like horse chestnuts. We can see Leonardo's visual thinking here. The seed is a metaphor for the baby.

He finds a universe within, and in searching for equivalents without he not only thinks of seeds, but animals. His drawing of a placenta is from a cow. Most of all, he is looking. He wrote, 'This umbilical vein is the origin of all the veins of the creature that is produced in the matrix, and it does not take its origin in any vein of the pregnant woman.' The fact that the mother and baby have separate blood circulation systems would not be conclusively discovered for a further hundred years.

It was not only Leonardo who was doing such cutting, of course. In 320 BCE, the Indian emperor Bindusara was born using a technique that became known as Caesarean section. In around CE 1000, the fabled Persian princess Rudaba's pregnancy was so extended that, to save her and the baby's lives, her abdomen and uterus were cut into. Both survived and the child went on to become Rostam, the national hero. In many of the ancient cases, a life was at stake and the mother died, but newer medicines have meant that today a quarter of babies in the UK are born this way, a third in the USA, a higher proportion in Italy, and nearly half of Chinese babies.

Most depictions of births, like this one, are seen from a bystander's perspective: two men attend to the baby, another two have a good gossip, and the painter imagines that he is standing further back, near the mother's feet. She is wearing a posh frock and a necklace, as you would, and has a nice tight golden belt, which will have aided the birth immensely. For maximum comfort, she lies on a wooden bench in what looks like a dungeon. Her eyes are open yet no one, not even the child, looks at her. What would the scene look like from her point of view, or that of the millions of women who give birth this way each year? In a vaginal birth the mother's abdomen partially

obscures her sight of her baby's first seconds, but this is somewhat less so with Caesareans. Often, of course, the operation is screened off from the mother, and some will have had general anaesthetic, so will be entirely unaware of what is happening, but mothers are, in theory, able to watch the moment. In the remarkable 1972 documentary *Chung Kuo:Cina*, we see a Chinese woman in hospital have very long acupuncture needles inserted into her legs and right into her abdomen. They are then used to conduct electric pulses, and her Caesarean begins. This is her at the moment when the doctors cut through her abdomen:

She smiles, is fully alert, answers a question from the film-makers – hence her eyeline towards us but above the camera – and even eats some food. A screen at her chest prevents her from seeing the operation, but if it had not been there, she would have seen the small fountain of the viscous amniotic fluid as her uterus is incised, and then a series of vertical cuts to increase the incision to remove the baby. The doctors twist it as it comes out, and we see the amphibian creature using its lungs and making it onto dry land, doing in seconds what took millions of evolutionary years. The child begins to see – black and white blurs, then his mother's face, then colours and distance, and soon, landscapes and the sky. The film beautifully presents her birth as a theatre of looking, something that Leonardo would have loved.

His drawings remained unpublished until long after his death, but he would help pioneer a new looking space, and a way of looking there. In the centuries that followed, dissection and anatomical study became a new frontier. Look at this striking photograph on the opposite page of an anatomy lecture theatre at the University of Padua. Built in 1594, it is the Colosseum shrunk as if in a nightmare. The ranks of concentric viewing platforms stack upon each other, all tightly clustered around the single seat and the table in front of it, where the cadavers would lie. There is immense theatricality in this show and tell in the round, in that it creates a space for the audience to see a spectacle.

The shadows are like those in the paintings of the Italian Surrealist de Chirico. There are not many chambers in the world that so entirely direct looking. This image could be on the cover of a book about looking, and again it hints at how anti-colonial the best of science is. Where the Crusaders and conquistadors were acting egotistically and driven by national hubris, great scientific looking is more humble and patient than that. It takes its time, and tries to invalidate what it believes. If it cannot do so, then what it believes might be true.

As we will see, bodies would be looked into in future centuries, using other parts of the electromagnetic spectrum than light, but at this stage let's consider one more point about looking, science and bodies. Medics do not need to open a body up to

understand its function, or diagnose its problems. In the past, a doctor was someone who read from large tomes on medical knowledge and looked little at the patient. But it came to be understood that diagnosis is observation, not only for physical health, but mental too. Particularly in countries where there is less medical equipment, the doctor must observe in great detail the patient's physical symptoms – diagnostic looking is another type of detective work.

GALILEO GALILEI

Our flashback to ancient science and anatomy ends and we are back in Venice in 1609, a city with great colonising and mercantile ambitions but which, in our story, is now the site of looking of a different type. Galileo's experience on the Campanile has shown the possibilities of magnified looking, so within months he builds a new telescope which can make things thirty (or more) times bigger than

they are. He trains it on the night sky and changes what we know about it. This, from his book *The Starry Messenger*:

> That which will excite the greatest astonishment so far, and which indeed especially moved me to call the attention of all astronomers and philosophers, is this, namely that I have discovered four planets, neither known nor observed by any of the astronomers before my time.

The four planets were moons of Jupiter. Looking had become something that is not only done with the naked eye. The desire to see had made us build things to advance seeing into other realms and other scales. The new optics made things come closer, or visible in more detail. Galileo had cast the visual net wider and hauled more things in with it, things that we could choose to understand, to slot into our existing world view. Casting the net sounds like colonising, like hauling in the richness of the outside world for our own gain, and yes, human beings did indeed gain from scientific looking. The difference is that, in its ideal form, scientific looking is not about appropriation. It is not possessive. Its aim is enrichment in ways that are other than material. Science is often itself hijacked by commercial interests bent on financial benefit, and a lot of scientific looking starts that way too, but it is important to disentangle here, in these centuries in our story, the principle from the application.

If the new visual evidence of how things are did not fit, then a rethink was in order. Looking could have great disruptive force, as Galileo soon discovered. His observations helped prove some of what Copernicus and others had worked out, that the Earth is not the centre of the universe. The moons of Jupiter clearly circled it, not us. The world is not geocentric, another blow to the colonial European imagination. This did not in itself disprove Christian theology, but it greatly weakened it. Like some modern surveillance state, in 1611, not long after he had stood on the Campanile, the Catholic Church's central administration, the Vatican, opened a file on Galileo. The file is sloppily written and the inquisition is disorganised, but at one point it states, 'Propositions to be forbidden: that the earth is not at the centre of the heaven.' So Galileo kept shtum – until, that is, a new, more thoughtful pope, Urban VIII, came along. Under him, it was hoped, scientific investigation would be more tolerated. He had even written a poem about Galileo, so the latter went to see him. They walked in the Vatican gardens, and Galileo presented the case for believing what can be seen.

Would Urban back what was seen or what was believed? Or, to put it more in the terms of its time, would the new astronomical debate undermine the ultimate authority of scripture? The answers are well known. Some natural philosophers of Galileo's acquaintance refused to look through his telescope. As

Galileo said, they 'shut their eyes to the light of truth'. In a famous letter, which Arthur Koestler called 'a kind of theological atom bomb, whose radioactive fall-out is still being felt', Galileo wrote 'nothing physical which sense-experience sets before our eyes . . . ought to be called into question upon the testimony of biblical passages'. Francis Bacon, again. In 1616, Galileo was ordered to 'abstain completely from teaching or defending this doctrine or from discussing it . . . to abandon completely . . . the opinion that the sun stands still at the centre of the world.' In the 1630s he was brought to trial. The case was legalistic. He was accused more of ignoring a previous warning than trying to undermine the Church; and Galileo's personality – he was self-righteous and ungenerous to fellow scientists like Johannes Kepler – fired the animosity towards him. But the trial is central to how the European imagination shook off the Dark Ages. In this anonymous seventeenth-century painting of it, Galileo, dressed in black, looks like he is about to be dissected in the Padua demonstration theatre. He sits before seven cardinals and is surrounded by six horseshoed ranks of seats: a theatre as well as a dissection. Behind him a priest reads from the Bible. Galileo's back is to the cross.

In the foreground, the debate spills out over the edge of the amphitheatre. An old man in white leans out and glimpses a discussion between a noble and a Jewish man, who wears a magenta tunic. The painter is either telling us that the debate reached beyond Christianity, or is perhaps making an anti-Semitic

point. Galileo was not well in these years, and the pressure hit hard: 'For two nights continuous . . . cried and moaned in sciatic pain; and his advancing age and sorrow.'

On 22 June 1633, Galileo knelt in the inquisition hall to hear his sentence. His books were to be burnt, he was to live under house arrest for the remainder of his life, and – though this was not said on the day – he would not be allowed to publish again in Italy. He moved to a farmhouse, went blind and died in 1642, aged seventy-seven. In the twenty-first century, NASA photographed Io, the furthermost of Galileo's Jupiter moons, and what a beauty it is.

OLE CHRISTENSEN RØMER

Just thirty years after Galileo's death, the Danish astronomer Ole Christensen Rømer observed Io more than 140 times, leading to a remarkable discovery. On Hven island near Copenhagen, he noted exactly the time that its eclipses began and ended; in Paris, a colleague noted the times they happened there. Using the differences in these timings and the distance between the two observations – 1,000km – they could calculate the difference in longitude, a considerable breakthrough.

But something more striking was to come from looking at Galileo's moons in these years. Rømer and the same Paris colleague noticed that the timings of the

eclipses of Io shortened when, in its orbit around the Sun, the Earth was moving towards Jupiter and lengthened when it was moving away. If light travelled at infinite speed, as previously thought, there should be no difference in the timings. Light from the eclipse was, therefore, taking time to reach Earth. Light had a speed. A major element of looking had been discovered. The implications of the speed of light would not be fully understood until the early twentieth century.

Telescopes not only linked looking to reflecting on our place in the world, they had connected looking and calculation. On 3 June 1769, the British explorer Captain Cook and others extended the experiments of Rømer. This time the planet Venus would transit across the Sun. Timing its progress in Tahiti and Europe allowed the observers to calculate the distance between the Earth and the Sun to more than 99 per cent accuracy.

In a speech in 1992, 359 years after Galileo Galilei's sentence, Pope John Paul II acknowledged, in careful terms, that the Church had been wrong to interpret scripture so literally. The Church was finally, reluctantly, admitting its aggression, its evangelical, colonising attempts to impose a story on the world rather than look at the world and discover the story it had to tell.

The relationship between looking and believing will recur when we consider the Reformation, but let's continue the story of looking in science with a man born eleven months after Galileo died. The latter's insights showed how dangerous looking could be to the evangelists, the story-imposers, but in the mid-1600s the cosmos was far from understood. It had long been assumed that objects – raindrops, thrown balls, pine cones – fall to earth because the Earth is the centre of the world. Since that was no longer the case, why did they fall? There were other, very different explanations for why the planets orbit as they do. There had been tentative suggestions that the forces that move the planets and a pine cone are the same, but to say so was to fill the universe with 'magic fingers' pulling everything towards everything else, an almost supernatural thought redolent of the Holy Spirit, and we did not want to go back to that again.

ISAAC NEWTON

Enter Isaac Newton, who was born premature, bullied at school, and whose influence on science was, according to Koestler, 'like an explosion in reverse'. He took fragments of scientific insight, as if they had been expelled from some disruption to understanding, and fitted them together. One of his key insights came as a result of the most famous visual moments in science since Archimedes took his bath. It is often dismissed as a myth, but Newton told the story to at least five people. One of them was the French philosopher Voltaire, who wrote, 'Sir

Isaac Newton walking in his gardens, had the first thought of his system of gravitation, upon seeing an apple falling from a tree.'

This is the tree. It is at Woolsthorpe Manor in Lincolnshire, England, where Newton was born and brought up.

The area was farming land, but Newton hated farming, preferring to think, and enjoyed solitude. Of the apple incident, his friend William Stukeley wrote:

> we went into the garden, & drank tea under the shade of some appletrees; only he, & my self. amidst other discourse, he told me, he was just in the same situation, as when formerly, the notion of gravitation came into his mind. 'why should that apple always descend perpendicularly to the ground,' thought he to himself; occasion'd by the fall of an apple, as he sat in a contemplative mood. 'why should it not go sideways, or upwards? but constantly to the earths center? assuredly, the reason is, that the earth draws it. there must be a drawing power in matter. & the sum of the drawing power in the matter of the earth must be in the earths center, not in any side of the earth. therefore dos this apple fall perpendicularly, or toward the center. if matter thus draws matter; it must be in proportion of its quantity. therefore the apple draws the earth, as well as the earth draws the apple.

Seeing leads to thinking. The law of gravity, that masses attract, the force reducing at the rate of the square of their distance, dawns on Newton. A falling apple had helped fill the universe with the magic fingers of gravity.

Newton's looking and thinking led to many other insights, not least his work on light and its colours, into which Goethe would later bump. Before him, it was argued that when light travelled through a glass prism, it was changed by the glass into something else – colours. Looking seemed to confirm this. But what was the nature of this 'change'? Newton devised a visual experiment to find out. He used two prisms, and had the light that emanated from the first shine through the second. The light that emerged from the second had no additional colours in it, thus proving that the prism was not transforming the light into something new – colour – it was simply revealing what was in the white light, a range of bent coloured lights. The story of light was imposing itself on those with an eye to see. Newton was further able to show that the coloured beams bent to different degrees. If light had a patron saint, Isaac Newton would be in the running for it. He was an eccentric character, had wild hypotheses in other fields, never married and, after he died, mercury was found in strands of his hair. His experiments might have contributed to his death. 'Newton with his prism,' wrote William Wordsworth, 'and his silent face.' His most famous sentence is also about looking: 'If I have seen further it is by standing on the shoulders of giants.'

ALFRED RUSSEL WALLACE AND CHARLES DARWIN

Our scientists have looked at planets, human bodies, an apple and light. What would they see, these acute lookers, if they now trained their eyes on the natural world, animals and insects? In 1802 the great German explorer Alexander von Humboldt climbed Chimborazo, Ecuador's highest volcano, and claimed that 'in a single glance' he saw the whole of nature. Until beady-eyed explorers like the Welshman Alfred Russel Wallace, born in 1823, and the English naturalist Charles Darwin, fourteen years his junior and an ardent fan of von Humboldt, it

was largely assumed that species were immutable. Fish were fish and birds were birds. But Wallace and Darwin looked carefully at detail and, crucially, at difference: the differences within a species over time, and between species. They were fascinated by visible change.

For example, this peppered moth's markings make it visually similar to the tree trunk on which it sits. As it is not easy to spot, its predators are less likely to find it.

In looking at the image, we are spotting small difference. During the time of the

Industrial Revolution, when the barks of the trees on which peppered moths landed were, because of smoke in the air, darker, the moths' bodies and wings were dark. Since the mid-twentieth century, as air has become cleaner and tree trunks lighter in colour, the moths have become lighter too, not because they are also less dirty, but because the lighter ones have survived more.

This is a simple, rapid example of the change over time that Wallace and Darwin saw on their travels. Wallace's is the lesser-known story. Unlike Darwin, he did not come from a wealthy family, and was instinctively radical, supporting women's suffrage and the reform of the UK's free trade agreements. He spent four years collecting and studying on the Rio Negro, one of the Amazon's tributaries. Here, and in the Malay Archipelago, where he collected an astonishing 126,500 specimens, he became very interested in the differences in similar fauna that have been separated for a long time by a natural boundary – a major river, for example. The animals on one side will not have bred with those from the other, and so, reasoned Wallace, their current differences derive from the fact that, over the years, they changed in different ways. In other words, they evolved. Fish are not just fish, and birds are not just birds.

Darwin was a bit like Pablo Picasso to Wallace's Georges Braque. In 1859, on 24 November, 1,250 copies of Darwin's *On the Origin of Species* were printed. They all sold on the first day. His book was a masterclass on looking and visual variation, an inadvertent celebration of the ocular. He said that collecting specimens on his travels was 'like giving to a blind man, eyes'. Author Andrea Wulf has said that his methods were both 'telescopic and microscopic'.

Twenty-two years earlier, Darwin had drawn this sketch in his notebook:

In essence it is a timeline. A single species is alive at the start, the bottom left, but millennia pass, naturally occurring differences within the species branch off and then begin to evolve separately, either because they are on opposite sides of a natural boundary, like a river, or because the habitat is changing – an ice age, or the end of the Industrial Revolution.

The branches of Darwin's sketch are hybridity branches. Wallace and Darwin scanned the world for living and fossilised hybridity and mutation. They were looking for in-betweenness, miscegenation, flux and impurity. When you decide to look for something specific – even something simple, like the colour yellow – you begin to see it everywhere. It pops out at you. The world becomes a visual host for yellow. Wallace and Darwin were like yellow-seekers. The evidence for natural selection and the evolution of species was right under our noses, but previously we had not been looking for it, and did not know how to see it. We needed to pay more attention. To use a sound analogy, we needed to stop speaking and start listening. Science looking was like listening.

One of the proofs and pleasures of the science of natural selection is that it is predictive. For many years we had fossils of vertebrate life in the sea and vertebrate life on the land. Evolutionary science predicted that there was a midway gap between these things, that there were in-between organisms. A space on the zoological shelf was left for fossils of such creatures and eventually, in the Scottish Borders, such fossils were found.

DMITRI MENDELEEV

The gap helped scientists guess what they might find, and look for what they might find, which, in a way, is exactly what happened in another story of scientific

looking. The looker was this man. What keen, beautiful eyes he had, all the better to spot the gaps in what we know of the world of natural elements.

Dmitri Mendeleev came from a family with little money, was born in 1834 into the silvery light of Siberia, and was the youngest of at least fourteen. Looking was a leitmotif for the family. His father went blind and his mother made glass.

He is most famous for a grid that he says came to him whilst asleep: 'I saw in a dream a table where all elements fell into place as required. Awakening, I immediately wrote it down on a piece of paper. Only in one place did a correction later seem necessary.' Given the insight of the table in question, this is astonishing. It started with Mendeleev listing the known solid, liquid and gas elements according to their basic properties, their main standard atomic mass. Before him it had been suggested that elements like lead, oxygen and iron related to each other in some categorical way, but no one had been clear exactly what that way was.

Mendeleev tried to see the way by writing the name of each element on cards, then ordering and reordering them, looking for patterns. This led him to begin his grid. He wrote . . .

Lithium (relative atomic mass 7)
Beryllium (9)
Boron (11)
Carbon (12)
Nitrogen (14)
Oxygen (16)
Fluorine (19)

. . . a layout from which we perhaps do not learn very much, as lithium (an unstable metal that you can cut like cheese, and which exists almost nowhere on its own) seems to have nothing much in common with carbon, nitrogen and oxygen, the stuff of our lives, which are kind of everywhere.

But then Mendeleev started a second column . . .

Lithium (7) Sodium (23)
Beryllium (9) Magnesium (24)
Boron (11) Aluminium (27)
Carbon (12) Silicon (28)
Nitrogen (14) Phosphorous (31)
Oxygen (16) Sulphur (32)
Fluorine (19) Chlorine (35)

. . . and, visually, something started to happen. Read across the way and you notice the family similarity between lithium and sodium (another cuttable, fizzy metal), or carbon and silicon, or fluorine and chlorine . . .

It was in Mendeleev's third column that his decision to visualise his thoughts into a table really reaped rewards. Potassium fitted nicely into the front row of

cheesy metals, and robust titanium followed horizontally from equally stable carbon and silicon, but that left a gap after aluminium:

Lithium (7)	Sodium (23)	Potassium (39)
Beryllium (9)	Magnesium (24)	Calcium (40)
Boron (11)	Aluminium (27)	?
Carbon (12)	Silicon (28)	Titanium (48)
Nitrogen (14)	Phosphorous (31)	
Oxygen (16)	Sulphur (32)	
Fluorine (19)	Chlorine (35)	

Mendeleev had a missing link, just as Wallace and Darwin had. What to do? It must have been tempting to conclude that there was something wrong with his grid, but instead he believed that there was something wrong with scientific knowledge. Visually, his chart suggested a missing element, and the chart was right. In 1879, in the same decade that he made his chart, scandium (45) was discovered. Only ten tonnes of it are produced each year, and its greatest use is – as Mendeleev again might have predicted – as an alloy with aluminium. Visualising the relationship between elements allowed him to suggest what had not yet been discovered in nature, a virtuous circle in which seeing led to envisaging and, as a result, more seeing. Like Ibn al-Haytham centuries earlier, Mendeleev has had a crater on the Moon named after him and an element, mendelevium (258), which was discovered in 1955 and fitted his grid.

Moons, wombs, trees, moths, apples, elements: the advances we have considered would not have happened without looking. Seeing was their fuel, their trampoline. They looked before they knew, and in order to know. The great Islamic scholar Ibn Sina – who is called Avicenna in the West, and who lived around the end of the first millennium CE – wrote of the 'empirical familiarity with objects in this world from which one abstracts universal concepts'. Our scientists were empiricists. Their advances were not advances out into the world, to impose Christianity or trade, they were advances out into the world to pay attention to the story of the universe. Such patient, receptive looking improved our lives. Francis Bacon's 'I admit nothing but on the faith of the eyes' was a sturdy endorsement of the looking life. Such an endorsement was necessary in the century in which he was born and at which our story has arrived, because looking was about to be more contested than ever. A man called Martin Luther was about to put looking in the dock and find it wanting and, not to put too fine a word on it, evil. Looking scared many people in the 1500s, and so they attacked it. People were about to fight and die over the visual.

CHAPTER 8

IMAGE WAR AND THE POWER OF LOOKING IN THE 1500s AND 1600s: *PROTESTANTISM, THE BAROQUE, THE OTTOMANS AND VERSAILLES*

GALILEO'S work took us into an era of lenses, of magnification. The European Renaissance rediscovered the classical past. Cities like Esfahan and the buildings completed under Akbar in India were sentinels and signs of visual contemplation. Columbus set sail. The 1500s and 1600s were panopticons.

If there was an overarching story in the 1500s and 1600s in Europe, it was the war over looking. For centuries, like a future Hollywood, the Catholic Church had been image-maker in chief. In faith-based societies with low literacy, its altarpieces, frescoes, stations of the cross, stained-glass windows, mystery plays and the visibility of its cathedrals had made Catholicism visual storytelling. The Scrovegni Chapel in Padua's interior walls are frescoed with successive rectangular images of the life of Christ, reminiscent of 35mm film frames and the cells of comic books. In the climax of the Catholic mass, the priest held the host up in front of the faithful and, quoting Jesus, said 'This is my body.' That body was soon to be a war zone.

By the early 1500s it was being portrayed in remarkable ways. Here is German painter Matthias Grünewald's take on it, in the *Isenheim Altarpiece* in France.

Atrophied, he is so pock-marked from beating that he looks as if he has been plucked. Thorns stick out of his yellowing flesh. He looks like he will snap at the waist. Agony and texture. This image wants to break your heart and invites your touch. Michelangelo's *David* was sculpted less than a decade previously. Two great artists had trained their eyes on male bodies with profound admiration and pity.

Did such images make people feel closer to God, or distract them from God? The art historian and painter Giorgio Vasari reports that priests complained that women worshippers felt corrupted by

'lascivious imitations' of saints. Had artists become too good at their jobs? Had Christianity become too visual? In 1511, just two or three years before Grünewald's painting, a round-faced monk visited Rome and was shocked by the visuality of the Vatican, as well as how it monetised devotion. On 31 October 1517, he is said to have attached a list of ninety-five objections to Catholic practice and doctrine to the door of a church in Wittenburg. Whether or not this actually happened, the seed of the Protestant Reformation was sown. The person who planted it was Martin Luther.

Luther's sense that the optical and the spiritual were separate was not new. It was a wind that blew through looking. Moses, of course, railed against idolatry. St Augustine's suspicion of the pleasures or outcomes of looking came early in Christianity. Two hundred years after him, the prophet Muhammad said that imagery intended for worship misdirected the faithful. As we saw in the mosque in Esfahan, for example, Islamic architects and tile makers could be masters of visual mood, light control and spatial reveal, but a story about one of the prophet's wives reveals the visual ambiguity at the heart of Islam. He is said to have returned home to find that one of his wives, Aisha, had hung a curtain across the door. As it was embroidered with images of animals and plants, he objected to it, not purely because it was pictorial, but because its images were so dominant in the room. He pulled it down, but Aisha had it made into a cushion cover, which was acceptable to the prophet. A compromise had been found, but this was not always the case.

In Japan in the twelfth and thirteenth centuries there was a similar division between an elite who thought temples and icons were the way to the divine, and purists who felt that to de-visualise was to enhance. This thirteenth-century sculpture of the wandering, impoverished priest Kuya, who lived in the 900s, is a double rejection of looking. Artist Kosho shows Kuya worshipping by inton-ing, and closing his eyes to block out the distraction of the optical. Words and their sounds cut through visual interference.

Martin Luther was in the same anti-visual stream as Moses, the prophet and Kosho. He was not averse to sitting for portraits, as Lucas Cranach the Elder's spare paintings of him – bedecked in black, his face and hands hinting at purpose – show, but a century before Galileo the Church trained its guns on him. On 10 December 1520, Luther burnt *Exsurge Domine*, the document with which the pope condemned him. His cause caught fire. This was the era of Gutenberg's press, so literacy was on the rise. An estimated ten million theological printed texts were in circulation, spreading the word of God. In the beginning was the word. In France and Geneva from 1536, Jehan Cauvin (John Calvin) took up the baton and proselytised reform in new ways. Images of God result in idolatry, he wrote, and said that blindness amplified religious conviction. These beliefs were born of previous controversies in Christianity. Supporters of the use of imagery in the Church said that it merely symbolised God, Jesus and the saints; opponents said that worshippers treated the images as holy things in themselves, relics to be venerated. Such veneration might make people feel holy, but was misdirected and interrupted what should be a more direct line to God.

The battle lines were drawn. The opponents, led by Calvin, Luther and other lieutenants, had to decide what to do with all those images of bodies, all those shrines and stories. Their answer was to deface them. Dissolve the monasteries; make a bonfire of the vanities. In Holland they called it statue storm. In this altarpiece in St Martin's Cathedral, Utrecht, nine heads, including those of the virgin on her throne and Jesus on her lap, were chipped off with some precision in 1566.

The building was then converted to Protestantism and the damaged altarpiece was bricked up. (In 1919, during the cathedral's restoration it was rediscovered, thus presenting a new visual problem: what to do with a Catholic image in a Protestant church. It could have been removed, but was left *in situ*, veiled by a curtain during Protestant services, but unveiled for all to see at other times.)

In the swash and backwash of religious regimes, looking and un-looking layered. One side prevailed and damaged religious iconography; its successor reinstated or attacked different types of imagery. This fourteenth-century fresco, in the monastery of Vlatades in Thessaloniki, has also been chipped at – flayed, in a different way to Grünewald's flayed Christ – not by Protestants this time, but by incoming Muslims.

In such attacks, which happened all over Europe and the Middle East, the faces and eyes were the most targeted. The look seemed to be the focus of the iniquity. The stare of the religious object, the thing that drew in the faithful, was considered most toxic by those suspicious of that faith.

When it arrived in Thessaloniki in the 1400s, Islam recycled religious buildings, or forgot them and built new ones. When its regime – the Ottoman Empire – in turn fell, its wall paintings, which were less figurative but equally decorative, were destroyed or plastered over. *Plus ça change.* Some of the plaster has, in recent years, been removed, to allow us to look back in time, at imagery long lost.

Iconoclasm remained a potent force in the centuries to come – the Jacobins in the French Revolution tried to remake the imagery of public life and, most recently, Daesh destroyed parts of Palmyra – but in the period covered in this chapter, the tide turned and the Catholic empire fought back. The battle over the body of Christ switched direction.

THE BAROQUE

The Counter Reformation was a conceptual thing, a reaction to Protestantism, con-quest and science, but its rhetoricians were image-makers. Its visual rearmament, its counter-attack, was a vast rallying cry and charge. It became known as the Baroque. One man who played a key role in this re-visualisation was Ignatius of Loyola, a Basque nobleman born in 1491 and brought up by a blacksmith's wife because his own mother had died young. As a youth he enjoyed the décor and fashion of the aristocratic life, but he then underwent a series of convulsions about looking. He tried asceticism by living in a cave, was injured and, in hospital, saw visions:

> a form in the air near him . . . was exceedingly beautiful . . . it somehow seemed to have the shape of a serpent and had many things that shone like eyes . . . He received much delight and consolation from gazing upon this object.
>
> (quoted in Jean Lacouture's *Jesuits: A Multibiography*)

'We know that to these mistrustings of the image,' wrote Roland Barthes, 'Ignatius responded with a radical imperialism of the image.' And some. Protestants were advised to shield their eyes; Ignatius, who founded the Jesuits and the Counter Reformation, said *Let them feast*. The eye was no longer shamed, it was acclaimed. Here, for example, is a ceiling fresco by Andrea Pozzo, completed in 1694. Top and

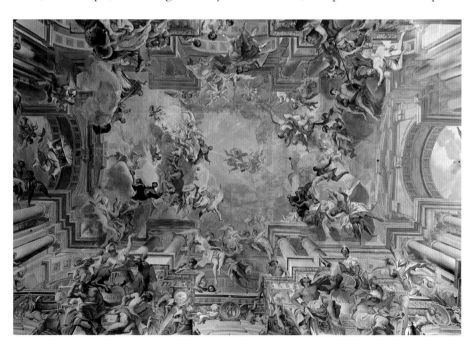

bottom are real windows, but Pozzo extends them in paint, illusionistically upwards. Marble becomes clouds. Scores of weightless figures ascend, as does our look.

Where the Protestant churches of the Reformation had plain walls and unadorned wooden crosses, Catholic Baroque art build a ladder from us to the divine, showing us how to get there. It burst spectacular illusionistic holes through walls and cupolas to create theatrical spaces where the Church and its elites interceded between us and God. Its depicted materials were gold and rippling silk. It wanted looking to bring us to our knees. It was visual hysteria or melodrama. The subject of this particular ceiling fresco? *The Entry of St Ignatius into Paradise.* A Baroque painting about a hero of the Baroque.

But if Baroque looking had only been visually extravagant invitations to soar to paradise, it would be dismissible as ideology or kitsch. At its best, it re-energised point of view and re-embodied our eyes. Take two of the key images of their time, Bernini's sculpture *The Ecstasy of St Teresa of Avila* (1647–52) and Caravaggio's painting *The Entombment of Christ* (1603–04).

On the surface, these are very different worlds. Bernini's is palatial and aristocratic, sculpted in marble, backlit in golden shards, dressed in voluminous robes, whereas Caravaggio's people are like peasants, bare-footed, plainly attired in unembroidered clothes, in some nowhere place, as if lit by moonlight rather than divine sunshine. If they had soundtracks, Bernini's would be the 'Hallelujah Chorus', Caravaggio's would be the shuffle of feet.

Yet horizontally flip Caravaggio's image and we begin to see how similar their visual strategies are.

In both, we are at ground level, at the feet of the participants. Each image gestures upwards to a source of light, which seems divine in Bernini but human in Caravaggio, *lumen* and *lux*. Two divine people – St Teresa who, like Ignatius, was Spanish, and had ecstatic visions during sickness, and Jesus – sag with the weight of their own bodies. Their hands dangle, their toes protrude, their mouths open in expiration or revelation. Jesus's shroud trails like Teresa's, like their hands, into our world, so that you reach out and touch. In modern terms, these images could be seen with 3D glasses. The aim is identification. St Teresa believed that spiritual revelation was trance-like and sweetly painful, a sensory overload or collapse. By contrast, Caravaggio has Nicodemus, who was a rich man and anointed the dead Jesus with myrrh and aloe, express nothing as he lays the body into the tomb (though some have argued that Christ is not being buried here, but laid out on the protruding slab). The difference between these two artworks shows that Baroque looking was not only about quickening the pulse and heightening emotion. Instead, it allowed the looker to see directly into the stories of, and sacred spaces of, the Church. It unified our realm with theirs. It was a transubstantiation. Such images were the heavy artillery in the war of religious imagery in these centuries. They lobbed explosive shells at Protestantism and said, *Beat this for conviction and vitality. Your attempts to rally your troops with churches of plain walls and the simple study of the Bible cannot compete with our visual storytelling and world-building.*

Often in Baroque art, a pulled-back curtain emphasises the looking. A veil has been drawn back and we have the chance, pleasure and privilege of seeing what lies beyond it. Even in non-Catholic Europe in this era, the drawn-back curtain was a way of drawing attention to looking. Let's imagine we are a thousand miles north of Rome, where Caravaggio's *Deposition* hangs, and that we've turned to a subplot: Delft in the Netherlands, a country undergoing a golden age of seafaring, commerce, science and art. Windmills provide cheap power. Calvinist Protestantism is on the rise. The Dutch East India Company is importing spices from Asia and making vast profits. A rather different world from Vatican-centred Rome. We see a painting which gives us the impression that, with our left hand, we have pulled back a blue and gold curtain, to reveal this. A stage-like room in which art is happening.

The painter's turned back perhaps reminds us of the hidden emotion in the Picasso painting and in Mizoguchi's film. There are three sets of eyes – the painter's, the model's and those of the plaster mask on the desk – but none meet ours. This is a contained peep show, a world where clothes matter, like they did in Bernini's sculpture – the young woman is draped in crisp blue silk, and holds herself theatrically. The artist's father worked in silk; his son, Johannes Vermeer, insisted on using extremely expensive ultramarine blue in his work, as

Leonardo had done. The candelabrum is elegant, but has no candles in it. The curtain has weight and texture. The room is probably north facing. On the back wall is a contemporary map of the Netherlands, a country that opened its floodgates to repel enemies.

There is nation in this room, and wealth, and a belief in art and mystery, all unified in a modest space and modelled by a cool, soft light. In recent years it has been argued that Vermeer – unlike the Italians in the same period – used lenses or mirrors to help him achieve the intimate reality of space, object and light in his famous paintings of interiors. There are few underdrawings in his work, and the detail in the textures of upholstery and costume suggest, to some, that he was not working with unaided eyes and that his audience was not always looking at the completed pictures without spectacles. This is 1666, more than fifty years after Galileo used lenses in his telescope.

THE OTTOMANS

3D theatrical looking and lens-assisted looking: the 1500s and 1600s were a time of visual revolution, and not only in the Christian world of image war. Outwith that war, the main storyline of looking in these times, there are other subplots. Fifteen hundred miles southeast of where Vermeer was working, an empire was at the height of its powers. The Ottomans captured Constantinople in 1453, then

bled outwards to Hungary, Arabia and North Africa, eventually grabbing all of the east and south Mediterranean, and occupying the whole of the centre of the old world. Most of the ancient cities were part of it. The Ottoman Empire was a spaghetti junction of sea and land routes linking seas, civilisations, religions – it was noticeably multi-faith – and land masses.

On 21 September 1520, a twenty-five-year-old goldsmith and poet became the empire's new sultan and set about reorganising its legal and financial systems, extending its educational opportunities (boys were given free education before Europe offered the same) and rejuvenating its arts. The result was another golden age of planning and architecture, comparable to Akbar's in India.

Suleiman the Magnificent gave form to his times principally by appointing a Balkan-born military engineer several years his senior to an almost unprecedented position in the empire. In his half century as de facto urban planner of the empire, Mimar Sinan directly designed, or oversaw the construction of, about two hundred mosques and *madrasahs*, dozens of palaces, forty-eight bath complexes, a score of mausoleums, as well as bridges and aqueducts. In Italy at the same time Michelangelo had great architectural and aesthetic influence, but nothing on the scale of Sinan.

This image shows how he composed the city of Istanbul – so different from the classicism of Rome – and moved our eyes around it.

In the foreground is the Rüstem Pasha mosque. Behind it, higher up one of the city's hills, is the Süleymaniye mosque. The former, which is smaller, defers visually to the larger, higher structure. Sinan's construction unit was the dome. There are more than two dozen in this image alone. Unlike in the Persian architecture that we saw in Esfahan, Sinan's domes are wide and flat. Compositionally, his mosques were like vast bubble structures floating on water. A grand central dome daringly spanning a wide area – gone are the multiple pillars of Cordoba's Mezquita – would be buttressed by numerous semi-domes arranged in squares, just as small floating bubbles surround and support larger ones. This gave a satisfying visual sense of weight dispersal, but also created smaller spaces at the periphery of a mosque complex and increasingly larger ones as the visitor approached the structure's centre. The looking that we saw in the Kailasa Hindu temple was a visual contraction, leading to an inner sanctum; moving inwards, Sinan's mosques are a visual expansion – as you move towards the centre, the spaces get bigger.

Though not his largest structure, Rüstem Pasha is one of his most visually interesting. It is built on a vaulted platform high enough to house shops, thus integrating the mosque into the social fabric of the city. We climb up to it, out of the retail bustle, to one of the most decorative porches in the Islamic world. Its Iznik tiles are not only blue, there is cherry red in them, and there are tulips, and mixed borders and patterns. Sections like this, which have been repaired piecemeal over the years, add to the visual syncopation.

Sinan certainly intended something more unified, but he understood the intricacy and detection of looking and the deferral of reveal. He created the Ottoman panopticon, the empire's visual excitement, its seeing in all directions.

VERSAILLES

Our plot and subplots interact in France in the 1600s, where one of the world's longest-reigning monarchs combined the Catholic dazzle of the Baroque and Suleiman the Magnificent's desire to remake the visual world. He treated France like a theatrical stage. He was its director. Louis XIV's mother had been married for twenty-three years and had four still births before she had him. His arrival was seen as a gift from God, an attitude that influenced his adoption of the creed of the divine right of kings. Louis's sense of his own divinity led him to remake a hunting lodge into a building-citadel to rival the Vatican. Where Suleiman had Sinan, Louis's architect in chief was Jules Hardouin-Mansart. Here is the Gallery of Mirrors that Hardouin-Mansart built for the king.

It is as enraptured as *The Entry of St Ignatius into Paradise*. What kind of looking did this tunnel afford? Narcissistic, certainly. As Louis proceeded down it, he would see himself in each mirror, framed in gilt and stucco, and lit by candelabra – the ones here are not the originals, but candle lighting was extravagant in Versailles. It became a looking machine. Spectacles become more commonplace in these years. To control the nobles, Louis made them come and live in the palace. Each day they would observe him and serve him. Rituals became elaborate, councils of influence were tiered, more even than in most previous regal worlds. Power was a spectacle. You could tell how important someone was by looking at the semaphore of how they moved and dressed, and where they were situated in relationship to the king. *L'état, c'est moi* ('I am the state'), Louis is said to have announced, but he said it just as well through Versailles itself, which was his exoskeleton. Hardouin-Mansart's Gallery of Mirrors and the other grand chambers gave Louis the power to, for example, persecute France's Protestants, or to indulge in empire and conquest, or establish new diplomatic relationships with the Ottomans; just by looking at such rooms, you could tell that he was some new pope or pharaoh, this Sun King, this Akhenaten.

The idea in this room was to create a visual infinity. The reflective surfaces of mirrors, chandeliers and gold multiply each other. Carved metal, painted classical columns, stacked friezes and the painted, barrel-vaulted ceiling are further reflected and provide too much to look at. We are visually flooded in a way that is intended to create awe rather than thought.

And if we walk out of the Gallery of Mirrors into the gardens of Versailles, we find another remarkable visible regime in this era of European power and assumed glory. Designer André Le Nôtre studied in the Louvre and used the French military to move the vast amounts of soil and stones in the grounds of the palace to compose vistas into what has been called a second nature. The scientific revolution had found mathematical order and systems in nature; if you had the purse and eye of the king, you could sculpt the land to reveal that under-lying order. Hence the formality and geometry of the great French gardens of this time. Versailles' are symmetrical. On visiting them, Madame de Maintenon quipped that you could 'die from symmetry'. On either side of a boulevard which looks like a landing strip, its two halves are mirror images of each other. Its vistas are composed like classical paintings. Trees and plants are used like walls and arches. At night, more than 20,000 candles lit axes which radiated out from the palace and its windows as if they were in a force field, which perhaps they were: the force field of the controlling eye, the eye that wants the world to look like science says it is.

There were geometry and symmetry in the buildings of Versailles too, but they were making something new, from scratch, a citadel to overwhelm. The gardens were taming something old. The aim was to calm the eye more than overwhelm it, to reassure those privileged enough to stroll in the gardens that their world view was both true and safe, that their thoughts were the greatest and most evolved that there had ever been. As we will see in the next chapter, the thought that nature should be tamed would soon be gone with the wind. Other visual pleasures were on their way, or on their way back. The small matter of the French Revolution would unsettle the settled looking of the seventeenth-century panopticons.

Sinan's Ottoman cityscapes and the opulence of Versailles show that the war on imagery was not won. Protestant visual minimalism hardly lacked converts, but when shackled to power, imagery was very happy to sing a song of glory. It was good at inequality, at propping up privilege, at soliciting piety. The splendid imagery of the 1500s and 1600s kept people on their knees. When they were down there, what could they do? Two options were to laugh and cry. A great new form of visual comedy was born in these centuries, and one of the greatest monuments to grief was built.

CHAPTER 9

WHAT LIES BENEATH: *LAUGHING AND TEARS*

VISUAL comedy and looking at death could enter our story at any point, as this chapter will show. We are considering them here because of the birth of the *commedia dell'arte* and the Comédie-Française and the construction of the Taj Mahal – good places to root the story of each.

After a chapter full of the vainglory of the 1500s and 1600s, it is a relief to come to laughter and tears, because they are profane and have the ability to undercut. Both show a collapse of self, of ego. Each had its own social codes, and so were frequently woven into the courtly extravagances of the Vatican, Versailles and the Ottomans. But at their most astringent, visual comedy and the visualis-ation of grief squeezed a lemon on the spun sugar of the Baroque, on the world of stucco and hyper-decoration.

Laughter first. The Greeks had their comic plays, other ancient texts have comic interludes, Shakespeare had human folly galore, gender confusion and the ribaldry of Falstaff. In general in literature, the comic genre had happy endings, thus establishing escapism, or respite, as the traditional service comedy delivered. There had been mockery in painting since ancient times too.

In the 1500s, in Italy, Bartolomeo Passerotti found humour in the grotesque. Here is his *Happy Company* of 1577:

It is not a bundle of laughs, if truth be told, but the expression on the dog's face as it copies the drunken roar of the guy trying to be Bacchus is funny, and the picture has a healthy cynicism about decorum. It is easy to see only the grotesque in it, but the food and wine on the table tell us that, whilst this night might not be the most elegant moment in the lives of each of these people, they are having a good time. They will groan when they see it on Facebook in the morning. When Aristotle wrote, way back in 335 BCE, that comedy shows laughable people screwing up (not an exact translation) he might have had them in mind. These people will know of the grandeur of Rome and the hierarchies of the Vatican, but they have no chance of reaching these heights, so will have a laugh instead.

Theatre in these years was more closely associated with entertainment than painting, so it is no surprise that in the birth of the Italian *commedia dell'arte* and the French Comédie-Française visual comedy advanced. They, too, saw the world from the bottom up, as if on their knees. The first documented *commedia dell'arte* show was in 1551, in Rome. Soon types of comic business were standardised: the faint, which would morph into the less gainly pratfall in coming centuries; the double take – a quick glance followed by a long stare of disbelief (a technique mastered centuries later, in cinema, by Cary Grant); the comedy run; the salacious knee rub; and the fight, or kick up the arse, which again remained a staple of visual comedy up to, and after, Laurel and Hardy. Anarchy was mixed with eschatology – probably a reaction to the seriousness and Puritanism of the Protestant revolution.

And the characters of *commedia dell'arte* became standardised too. Pantalone was a penny-pinching Venetian merchant – skewering Venice's mercantile ego – whose chin was always out and who walked on his toes. Il Dottore had his belly out. Here is the Neapolitan Pulcinella, in white with a black mask, which is often beakish, hence his name, meaning 'little chick'. Better known in the UK as Punch, he was belligerent, battering those who came near him with his wooden spoon, which, in one variant, was a stick for slapping, hence 'slapstick' comedy. His look, character and pugnacity lent itself well to puppetry.

The Harlequin wore his famous diamond-patterned outfit, and Zanni led with his nose. The social content was lost on no one. The *commedia dell'arte* world mirrored contemporary hierarchies: at the top were the masters – always masked – and at the bottom were the servants, who were masked too. In the middle were the lovers, who were not masked. This tradition continues in pantomime today. The shows were performed outdoors, with recognisable props but little or no scenery, on makeshift stages. Posh people loved the shows, though they often mocked them, and the influence of the *commedia* was lasting. In France the playwright Molière, for example, used its uncanny masking and exaggerated body language in plays such as *Tartuffe* to satirise and ridicule. Mr Punch was in the UK from around 1662. The English philosopher Thomas Hobbes called comedy a 'sudden glory', and it is not hard to understand, in these hierarchical, codified, constructed, courtly societies, in which the lower classes in particular could see little release from their daily grind, the sudden and glorious appeal of letting rip and destroying stuff.

That appeal was felt in the country of Versailles as much as in that of the Vatican. In this detail from a painting in the grand Comédie-Française building in Paris, French and Italian actors perform together. The Harlequin is on the right, looking startled. In black with a white neck ruffle is a character straight out of Molière. Around them, five other actors strike poses, peer, look bewildered, or dash with untold urgency, oblivious to how daft they appear.

As in Italy, the elite in France adopted such stage mockery. The Comédie-Française became the national theatre of France by decree of the king. Its repertoire was much broader than visual comedy – *comédien* means actor in French – but it had the brilliant savagery of Molière's satirical writing at its core. Molière's art is verbal, but he also thought visually. Here, for example, is a modern staging of his *Tartuffe* (1664).

On the right is the title character, a hypocrite who claims to be pious, modest and to have a direct line to God. The play is a verbal masterpiece, but the costuming here shows how it derives from the *commedia dell'arte*. Tartuffe is in black and white, like Pulcinella. He has a long nose like Zanni and his clothes are an absurd display of excess and narcissism: silver striped boxer shorts, silver shoes with bows, shirt with see-through arms and exaggerated lace cuffs, and ringlets in his hair.

The play's mockery of the excesses of French elite life discomfited part of that elite. Though Louis XIV was amused by it, the archbishop of Paris threatened to excommunicate anyone who saw *Tartuffe*. Molière's response to the Catholic Church's censure explains how visual comedy was seen in these times. 'The comic,' he wrote,

is the external and visible form that the bounty of nature has bestowed on everything unreasonable, so that we can see, and avoid, it . . . [A]ll lying,

disguise, deception, dissimulation, all outward displays that differ from the real world, all the contradictions between actions that come from a single source, all this is in essence comic.

Reality and facts are inward, he implies. Lying and the unusual are forced outwards, where they are manifested as the absurd. Martin Luther might have agreed with this statement, but it certainly helps us understand visual comedy in the 1500s and 1600s because it marries it to Tartuffe's hypocrisy. The liar hides his mendacity; comedy reveals it. More visual than Molière were the plays of Pierre de Marivaux. His *La Surprise de l'amour* (first performed in 1722) is about trying but failing to renounce love. In this modern staging of it, the man's diamond costume shows that he is derived from the *commedia dell'arte*'s Harlequin. The colouring and myriad details of the costumes and backdrop seem giddy, effervescent almost. This lightness is a kind of visual wit.

The sight gag and visual comedy in Italy, France and elsewhere have continued to be, at their best, disruptive and performed. And the form has remained strikingly popular. Some of the most famous film images of the twentieth century are visually comic. This moment from Jacques Tati's film *Playtime* could also be a comment on a seventeenth-century maze like

Versailles, and certainly was intended to jape modern white-collar life in Tati's own time.

In the middle, Monsieur Hulot wanders through a maze. He has tried to keep up with social change and the modernising of France, and kids himself that he has, but he is an alien in the world of telephones and cellular office work. Contemporary life bewilders him. It brings him to his knees. All those accelerations in the 1500s and 1600s, the remaking of Rome, Istanbul and Versailles, similarly created mazes in which people could be contained. Versailles was certainly a maze in which one response was helplessness. People schooled in looking on a human scale and within the natural order might, in Baroque Rome or the Istanbul of Sinan, feel that they had forgotten how to look. Like Tati in *Playtime*, they might feel that the locks have been changed, that their keys do not work any more.

What was Monsieur Hulot's reaction to the world he did not understand? This. He kicked it up the arse, in a classic *commedia dell'arte* gesture. Everything irritates Hulot, and despite his image of himself as a sophisticate, he has no idea that he is a child.

Which raises another aspect of visual comedy – attack. You had to be brave to skewer the popes, royals and emperors of the 1500s and 1600s, so few outré sight gags explicitly did. Types were mocked, masked buffoons represented the greed of Venice or the aggression of Naples. The targets were not named.

A political film-maker in the twentieth century left audiences in no doubt whom he was skewering. Here Charlie Chaplin imagines the genocidal expansionism of Adolf Hitler as a hare-brained daydream. Earth is a balloon, and the dictator

lounges as if popping bon-bons on a chaise longue, bouncing the balloon into the air – an image of great elegance, but also satiric power. It captures the vacuity of the dictator, his onanism. He stares at the balloon world like a child stares at a toy. The sight gag reduces him.

Another version of a sight gag deriving from the *commedia dell'arte* – this time the comedy run – is Wile E. Coyote, created by animator Chuck Jones in America in 1948. He is driven to destruction by his own hunger, his own desire to catch the Road Runner. Like some deranged Galileo, spun out of orbit, he devises ever more elaborate contraptions, each intending to kill the Road Runner, but, as in this image, his passion outstrips reality as he runs over the precipice and gravity is paused for long enough to allow us to see him realise, again, that he is not very wily at all. He looks into the eyes of the Road Runner, unable to comprehend why it has happened again and why he has been outwitted by

something so daft that it can only say 'beep beep'. Wile E. Coyote has brains and passion, but not an ounce of common sense. He is a fool.

What would the world look like if its laws did not work? That seems to be the question of visual comedy. What do we see when the ages of the knight and the king are over, when romance and duty are dead? Hitler looks at a balloon, Wile looks at the Road Runner, and here, in the film *Duck Soup*, Groucho Marx looks at himself. Or thinks he does. Again the joke is incomprehension.

Groucho has somehow become the inept ruler of a land called Freedonia, a surrealist Versailles or Vatican, perhaps. Rampant nationalism and war ensue; law and power are farcical. In this moment, the president and his adversary Pinky, played by Marx's brother Harpo, encounter each other at what was once a mirror. Each tries to fool the other by mirroring his actions, simply at first, but then by doing bunny hops and jazz hand dances. The president and the dissident entrance each other, like toddlers, or kids playing

stare. His majesty the baby. At least Hulot was only a deluded, ordinary guy who had no idea how things work. Here, the person who is supposed to make things work has not a clue how they work. If the courtiers of Versailles in the Gallery of Mirrors could have seen this, would they have been shocked? Would they have laughed?

Our final mode of visual comedy which has been echoed in twentieth-century cinema is the impersonation or masquerade. Exaggerated clothes and make-up were commonplace in seventeenth-century comedy, when wigs and powdered faces were all the rage; they externalised absurdity, as Molière wrote. Dressing up or drag works as a sight gag because you can see − often the joker wants you to see − both layers. Unlike Chaplin's Hitler, this is not a point about mockery. In the following image from the American film *Some Like It Hot*, for example, actor Jack Lemmon has dressed as a woman to hide from gangsters. The man on the left has fallen for his feminine guise and, at first, Lemmon is not amused, which is amusing. The joke in this scene is that, as a

man, Lemmon can see through and anticipate the other man's attempts to romance him.

But over time Lemmon's character seems to forget his masculinity. This is charming in itself, as so many men are desperate to assert it and anxious not to be seen as unmasculine. That masculinity can slip your mind is a bold idea. But the shedding does not simply leave an absence. Lemmon's self morphs. In his own eyes, at least, he starts to see his life from his new, female, point of view. This image is funny because Lemmon is taking no nonsense from his suitor, but also because he is helplessly turning into someone else, just as the coyote is helpless.

MEMORIALS

Maybe that is the deeper theme of this chapter – helplessness. Laughter and death are helpless, or the results of helplessness. In Europe in the 1500s and 1600s, the rich became richer, their eyries more palatial. They looked down into the social abyss where the underclass lived, who, in turn, looked up – jealously, uncomprehendingly, accepting of their place in the world, or in anger. It was anger that would bring the French Revolution, but that was years away, and tears away.

The king, the sultan, the pope, the merchant, the soldier and the pauper all had to face death, of course, and – in some ways worse than death – loss. No Versailles Gallery of Mirrors nor even the Rüstem Pasha mosque or Christ on the Isenheim Altarpiece could prevent it, so instead there was the culture of consolation. When you were helpless and grieving, families rallied, rituals were enacted, music was played and prayers were intoned, but in our story it is the building of visual things that matters.

It will end in tears, parents say to kids when they are play-fighting. Like visual comedy, our lachrymose second subject in this chapter could be

written about in other places in this book, but just as the *commedia dell'arte* and the Comédie-Française gave us pegs for sight gags, so the numerous mausoleums of the 1500s and 1600s allow us to get to the root of looking at memorial buildings here. Right at the start of our period, in 1501, Tamaudun in Okinawa, Japan, was built, and now houses the bodies of fifteen royal families. More than a hundred shrines and mausoleums were constructed in Nikko, also in Japan, in the 1600s, starting in 1619. More famous than these, however, is a building that was completed in 1653.

The Taj Mahal is one of the most looked-at things in the world, which is a good reason for it being in this book, but also a bad reason. The more something is seen or photographed, the staler the looking becomes. The redness in this photograph pictures it in a somewhat new light, as if seen through the blood of eyelids on a scorchingly bright day. Some have argued that it is not only a memorial, that it is also a demonstration of the 'perfection' that Mughal civilisation had achieved. This is true, but does not lessen its primary intent, to remember someone. The grandson of Akbar, he who surveyed the Deccan, built it after his wife, Mumtaz Mahal, died in childbirth aged thirty-eight. The bubble-like central dome and surrounding semi-dome structure were borrowed from the Ottoman buildings of Mimar Sinan, as were the pencil minarets. The domes are less flat than Sinan's and more redolent of Persian architecture.

Before looking at its meaning, and as memorials are from all ages, let's draw some others, from later centuries, into the net. In Treptower Park, Berlin, for example, a sculpture of a female figure, the Motherland, lowers her head and weeps.

She is falling to her knees, the key image of this chapter, and her eyes are lowered, but had they not been, they would see a grand processional way interrupted visually by two vast semi-abstract sculptures of lowered flags, genuflecting as the mother does, each clad in red marble, reputedly taken from Nazi buildings.

The flags frame the sky and earth, along which the processional path continues to the joint burial grounds of 5,000 of the 80,000 Soviet soldiers who died in the battle to liberate Berlin from the Nazis. Beyond these burial plots, steps rise to a monumental sculpture of a Soviet soldier – just visible in the distance – standing on a swastika and carrying a baby. He looks back down the axis, to the weeping mother and to the horizon. This Soviet war memorial is contentious for those who subsequently suffered under Soviet power, but it is as big as the Roman hippodrome, a monument to the dead built around a look so reverent, and also defiant, that flags of marble bow before it.

In Washington, DC in 1982, a memorial to the US veterans of the war in Vietnam was completed. Where Treptower is a vast visual event, a looking epic, this memorial is different. It certainly has scale. Two basalt-like polished gabbro walls meet at an angle of 125 degrees, from where they taper away from each other, reducing in height. They are backed up by earth, giving the impression, as twenty-one-year-old designer Maya Lin intended, of an abstract black scar. On them, the names of 58,318 war casualties are etched. They are listed chronologically from 1959 onwards, a day-by-day registry of those who died or went missing. To visit it is a visually intimate experience. From a distance no detail is big enough to be seen; only on approach can names be discerned, and, as the stone is polished, it is reflective so, as you look, you see yourself with the names of the dead written across your own face. Relatives seek out and stand before the name of their own loved one, often oblivious to other visitors around them; this adds to the propinquity.

At the end of the 1980s the Latin American Memorial, designed by Brazilian architect Oscar Niemeyer, was opened in São Paolo. At its centre an open, concrete hand sticks out of the ground, like the ending of a horror movie, as if its owner is buried but still alive, desperate to be rescued. On the hand is painted a map of Latin America; red and attenuated, it looks like blood dribbling from the palm, across the wrist and into the earth. The open-handed image is a reminder of those who died in Latin America in its internal conflicts but, more so, at the hands of, or through the diseases brought by, the European conquistadors.

On 4 December 1971 a bomb in a busy pub in Belfast, Northern Ireland, exploded. Fifteen people were killed, including the wife and daughter of the pub's owner, Paddy McGurk, who was himself injured. The same night, on local television, McGurk asked that there be no retaliation for the attack. The pub was destroyed, but thirty years after the bombing locals recreated its façade by painting its walls and windows on a nearby concrete flyover. In the painting, Paddy leans in a doorway, his sleeves rolled up, looking outwards

onto the street scene. There is no particular expression on his face, no anxiety or delight. He is doing nothing. Time passes. Stand close to the wall and it is clearly flat, but look at it from ninety degrees and the illusion is that he and his establishment are still there.

In the Tuol Sleng Genocide Museum, Phnom Penh, Cambodia, photographs (along with written biographies) of 5,000 people are on display. A former school, the building imprisoned 17,000–20,000 people during the Khmer Rouge's time in power (1975–79), most of whom were murdered. In total, at least two million Cambodians died. As they do at the Vietnam memorial, visitors stand close to the walls of images, look at the photographs and try to take in the horror. Like the McGurk's bar murals, the memorial is site-specific. The exhibits do not just say 'These people died,' they say 'These people died *here*.'

We will look in more detail at photography in a subsequent chapter, but here it is worth saying that a photograph is perhaps the simplest memorial of all. When the mothers of those who 'disappeared' during Augusto Pinochet's murderous Junta regime in Chile (1973–90) protest, they often hold photographs of the missing person in front of them, with two hands, at belly level. The women frame the images, they process with them.

Like comedy, which tries to invert the world and bring high personages low, grief is a leveller, an abatement. Lie on your back and look at the Taj upside down and you get a better sense of what it, and all these memorials, mean.

We do not know who its architects were but we know that it was intended as an earthly replica of a building in paradise, the house of the departed. The reflecting pools double the image, giving us marble and aqueous vistas, a physical and metaphysical pair. The Taj Mahal is substantially an expression of personal grief – 'O! how can Love's eye be true, That is so vexed with watching and with tears', wrote Shakespeare – albeit expressed with the visual ideas of empire and nation. The Mughals had come to think of themselves as Indian, and white was the colour of the Brahmins, hence the white marble. White is also the colour of mourning in Hinduism.

How did it express grief? Or, to ask a better question, what function did its elaborate construction (all those tales of a thousand worker elephants and vast

scaffolding, etc.) serve? It and Treptower, the Vietnam wall, the São Paolo hand, the Belfast wall paintings and the thousands of other memorials around the world, all allowed individuals, families or states to point at them and say, *Look. They did not die in vain, or even if they did they are not forgotten.* They existed, and the proof is that we can see this thing. This pointing, this looking, can be in sadness or anger or both. In the case of the Taj, what is also being said is that Mumtaz Mahal's consciousness was magnificent. This makes us realise that memorials are the ultimate looking. Obviously there has been great writing about loss, and great music too, but looking is central to remembering because visual memorials make visible something that is no longer so. They are proxy consciousnesses. They are a place built where people once were. Versailles would be so much better if it existed to remind us of something gone. The Taj is instead of Mumtaz Mahal. It reminds us that looking is desirous of thought.

It was important to the families of the dead of McGurk's bar to have something physical to memorialise their loss because of the natural grieving process, but also because the British government was refusing to acknowledge the true identity of the bombers and their links to the state. Often memorials serve this function. They say that memories of the lost are fading because of the natural attrition of memory over time, but it is also because those with a vested interest want them to be forgotten. If they died violently, or avoidably, the memorial serves not just to remember them, but to visualise the injustice and as a sentinel for change. In the same year that Niemeyer's bleeding hand commemorated the dead of Latin America, hundreds or even thousands of protestors in Beijing's Tiananmen Square were killed by their own government. The 'square of heavenly peace' ran with unheavenly blood, but no monument stands to the dead. The lack of anything to look at, to point to, which imperfectly, solidly stands for the void left by these lost lives aggrieves many Chinese people. Looking would provide some kind of consolation. It is not that Chinese culture does not require such looking. Right at the centre of Tiananmen Square the body of a man who died in 1976 lies embalmed, uncovered and available to be seen. Thousands queue to do so each day. His name is Mao Zedong.

In Italy in 1653, the *commedia dell'arte* was codifying and popularising visual comedy, a style that would influence the imagery of entertainment for centuries to come. In that same year, a mausoleum was completed in India that would arguably become the world's most famous symbol of grieving. Each was part of the elite discourse of its time, and so can be understood in terms of power and society, but both were more than that. They were pictures of people on their knees. They were, as Molière claimed of comedy, externalisations of what is hidden – frailty, inequality or powerlessness in the face of grief. In our next chapter, such inequality causes a rupture. Turn the page of the century and you find much that cannot be seen, for example liberty, equality and fraternity.

CHAPTER 10

LOOKING AND THE 1700s: *GRAND TOURS,*
ENLIGHTENMENT, INDUSTRY, REVOLUTION AND FLIGHT

THE 1700s were years of reading and listening. London's first newspaper, the *Daily Courant*, and America's first weekly, the *Boston News Weekly*, were launched. National libraries sprung up all over the place. The first pianoforte was made. Johann Sebastian Bach's *Brandenburg Concertos* could be heard in posh places, as could Handel's *Water Music*, and then came Mozart and, at the end of the 1700s, Beethoven. Opera was the elite art form *du jour*. There were treaties, but also more wars: Sweden and Russia fought, as did the Ottomans (who were still riding high) and Persia (and Russia); the UK and France; the UK and its American colonies; France and half of Europe; and there were wars of succession in Austria and India. The Mughal Empire fell apart. The Jesuits steered off course to map India.

All this makes it sound as if the 1700s might better fit into books about the other senses, and so we could skip forward to the juicier 1800s, to the births of photography and the movies and the coming of painterly Impressionism, but not so. The kind of looking established in previous cities continued. Germans, Scots and Irish migrating to America in this century saw anew, as Europeans from previous centuries had. New cities – Cincinnati, Washington, DC – were founded in America, and so new visual networks came to pass; and the painter Canaletto visualised an old city, Venice, with hyper-reality. The English image-maker and satirist William Hogarth enhanced visual comedy, and of course science continued to advance.

Beyond these continuations, new movements, people and ideas led to new visualisations. Nine in particular will form this chapter's stepping stones through the century: travel and the grand tour; David Hume; Denis Diderot and the Enlightenment; Catherine the Great of Russia; the Industrial Revolution; the French Revolution; visual propaganda; slavery; and flight. Far from being years in which looking was on the wane, the 1700s were a picture gallery. A picture gallery that would be destroyed.

GRAND TOURS

If you were an Algonquin in these years or an Australian Aboriginal, life was changing. The former had hunted in Quebec, travelling in canoes or toboggans, but after contact with the French from 1603, many became fur traders and were converted to a hybrid Christianity. For Australian native people, semi-nomadic, living outdoors, their sight lines were almost infinite but their exposure to other places or other people was limited. Then came the British, and the bell jar was broken.

As the 1600s ended, the imaginations of middle-class and aristocratic northern Europeans became centrifugal. Young men (mostly men) from the

UK, Scandinavia and Germany set out for Venice, Rome and Pompeii – not on a religious pilgrimage, like the Crusaders, but, not unlike the Japanese tourists mentioned in the introduction of this book, to see Europe, in their case the ruins of the Roman life whose ancestry they claimed. In Aboriginal culture the walkabout is a rite-of-passage adventure in which a young person's psyche is assailed so that a galvanised and adjusted adult self can emerge. The grand tourists wanted to improve themselves rather than unravel, and to mingle and be seen.

It is easy to think of them as the jet set of their day, but books like Daniel Defoe's *A Tour Thro' the Whole Island of Great Britain*, first published in 1724, did help establish anew the idea of travel broadening the mind. Venture from England, through the Alps, into Italy, and you will see landscapes, climates, geology, flora, culture and people change. If you have an alert eye, you will notice the differences and learn from them. Your mind will become a picture gallery. Goethe wrote of his first journey, undertaken in 1786, 'My passionate desire to see these objects with my own eyes had grown to such a point that, if I had not taken the decision I am now acting upon, I should have gone completely to pieces.' By objects he meant rocks and classical statuary, but *passionate desire to see* is the key phrase for us. The Italian Renaissance had created a new image bank for the continent of Europe; reproductions and engravings made those images widely seen, but mostly in black and white. Imagine seeing Rome for real. Imagine walking through it. Imagine it towering above you.

This painting by Giovanni Panini captures the picture gallery quality of the grand tour idea. The tiny, well-dressed, eighteenth-century citizens at the bottom of the picture are in the belly of the whale, dwarfed by their own unconscious and by everything they have seen or want to see. On the right is the famous sculpture *Laocoön*; there is also the Pantheon, the Colosseum and the Forum. There was something of a child's sticker book in this. You began with

empty pages, then filled them one by one with stickers of your favourite footballers or sports cars or, in this century, cities, vistas, ruins and sculptures. This distillate of the inner eyes of elite travellers in the 1700s would prefigure the most famous books of these years.

Which brings us to a corpulent Scot who did most of his original thinking in his twenties, pissed off a lot of people, and liked to drink beer and play backgammon. Some readers will perhaps find this book too much about externals and will argue that to understand people we have to start with an idea of self, or society or god. David Hume radically rejected this. Born in 1711, he became an intellectual star, a doubting Thomas who, in his own words, 'was not enclin'd to submit to any Authority'. What he did submit to was the visual.

Hume was an empiricist. He said that nothing was innate. We were not born with souls, or a sense of justice. These were retrofits. All our ideas, beliefs and yardsticks came from observation. Yves Klein's looking at the sky, Galileo's looking at the moons of Jupiter: these were what Hume called impressions. Impressions were, to use his word, *lively*, present tense and vivid. Nothing precedes them. There were no cameras in those days, but the first function of a seeing person was like that of a camera.

He also had elaborate theories of what happens once we have seen, once the impressions go into the black box of ourselves. They combine to form mental ideas. He was fascinated by how they combine. Imagine there is a pharmacy on the corner of your street. Hume would say that each time you see it, your memory connects it with previous times you have seen it. It will resemble other pharmacies you have seen, at different times in your life, in different places, so your idea of what a pharmacy is involves time, place, resemblance, memory and quantity. Your imagination will also work on the impressions that are forming into ideas, and you will make qualitative judgements too (some pharmacies are better than others), and you will contrast your growing sense of what a pharmacy is with other things (coffee shops, perhaps, or beauty salons, or hospitals or gyms). The iterations and instances of seeing pharmacies will allow you to build, in your

mind, a sense of what makes them what they are and not something else, and what they mean in your life. Is not this Cézanne's *optique*? Doesn't the neuroscience we heard about in Chapter 2 – that looking is 20 per cent input and 80 per cent output – back up Hume's theories to a degree? He was describing how the inner eye comes to be.

ENCYCLOPEDIAS

Hume's writing on impressions did not have a huge impact at the time, but it was timely because he was living in the era of the *Encyclopédie*. In China a century earlier, a scientist and government administrator, Song Yingxing (1587–1666) had produced *The Exploitation of the Works of Nature* (1637), a book containing a huge amount of illustrations about how things work. Flick through it and you saw the physical world, broken down into its mechanics. Song's tome transmitted knowledge, preserved trades and was a great visual learning resource. From 1675 onwards, German botanical artist Maria Sibylla Merian published images of flowers, frogs, caterpillars, butterflies, snakes, beetles and spiders, which enabled Europeans to see aspects of the natural world for the first time. 'Her greatest legacy,' says historian Huw Lewis-Jones, 'was to remind us to keep our eyes open.'

More influential was a wayward, impecunious French writer who was at various points in his life disowned by his father and imprisoned. Denis Diderot (1713–84) was taught by the Jesuits. His book *Letter on the Blind* (1749) debated the same perception versus reason divide that had animated Hume. For more than twenty years he was the main editor of an encyclopedia of thousands of images that tried to show everything. The *Encyclopédie* was, in part, a remarkable picture book – Leonardo's notebooks meets Google. Here is an image from its chapter on optics. Above, we discover how to measure the height of a building without scaling it. Below it, a camera obscura illustrates how an image becomes inverted.

Optique

The butcher, the baker and the candlestick maker were in Diderot's vast work. Everything from a needle to an anchor was here. It was another picture gallery; said Diderot, 'a glance at an object says more than a page of text'. This moment, this new visualisation of life, was controversial. The looking sceptics, those who thought that imagery was redolent of surface, aligned with other vested interests who did not want knowledge to spread too widely, or those who wanted to control the type of knowledge dispersed (the Jesuits). The central message of the *Encyclopédie* was *You can understand this, and, what is more, you should*. Freedom of thought was at its core, and so it was suppressed for a time. The *Encyclopédie* was the opposite of Versailles: it was outward not inward. It changed the world, but did not make Diderot or his colleagues rich. When his daughter came to marry he sold his library of books to fund her dowry.

Take Isaac Newton's will to look and think, add Hume's impressions and Diderot's Google *avant la lettre*, remove metaphysically inclined thought habits and deference to Church and Crown, and you have the conditions for a new type of thinking in Europe: the Enlightenment. Its title alone – in France, *le siècle des Lumières* – implies a previous unseeing, a new light illuminating those unseen things. This was optimistic; it was *Yes, we can*. As we will see when we get to the French Revolution and meet another great thinker of the time, the *we* was crucial.

CATHERINE THE GREAT

A prominent person who bought Denis Diderot's books was Sophie Friederike Auguste von Anhalt-Zerbst-Dornburg, better known as Catherine the Great. She was born in one country (Stettin, in Prussia, now Poland) but ruled in another (Russia). Like Louis XIV, she had a palace complex. Like Suleiman the Magnificent, she partially revisualised a city (St Petersburg). Diderot said that she had the soul of Caesar and the charm of Cleopatra. She called Diderot, who became an intellectual guru for her, 'an extraordinary man', and, because he would bash her on the thigh as they spoke, 'I emerge from interviews with him with my thighs bruised and quite black. I have been obliged to put a table between us to protect myself and my members.'

Why is she in this book? Because she was a great visual thinker; she used images and symbols of state to enhance Russia's standing in the world and to increase its territory, but also because she was passionate about art and the visual world. She dragged the unconscious of the grand tour up into the consciousness of Russian society.

Catherine came to power in 1762. There are scores of contemporary paintings of her in palatial settings, but this twentieth-century reimagining

of her by the film-maker Josef von Sternberg, the actor Marlene Dietrich and cine-matographer Bert Glennon, has the correct aesthetic intensity. In the first image Dietrich looks in a mirror and holds a painted Russian icon to her face.

Catherine converted to Russian Orthodoxy and learnt to speak the language, a process of fitting into a country of whose blood she was not, and a power structure to which she had no legal claim. The hand-held icon is a reminder of the iconostasis seen in Russian churches: screens of images dividing the body of the church from its holiest parts which control what the faithful see and how they see it. In other churches, and in theatres, this function might be performed by a velvet curtain, but in the Orthodox religion, seeing was prevented by seeing.

Picturing Catherine looking at herself in a mirror refers to her visual interest in herself, and the many depictions of her reveal that she had that, but it is better understood as a metaphor of nation. In this next image she is like a sculpture come alive, stepping out from the stone, distinguished by the texture of her fur, the intricacy of her hair and the directness of her gaze, which stares out of the exact centre of the frame.

The stone figures around her carry torches; they are enlighteners, and it looks like they are carrying her too. When Catherine acceded to power, the elite buildings in St Petersburg were Baroque and Rococo, the latter a playful, decorative and flowing French style which sidelined order and symmetry. Inspired by the rationalism of the Enlightenment, she rejected Rococo for a return to the grandeur of classicism. She enlarged the home of the tsars, the Winter Palace, adding three grand new structures which became known as the Hermitage. Though they themselves were anything but modest, their title gestures towards a simpler way of living, an ambition reputedly acquired from Jean-Jacques Rousseau, whom we will encounter soon. Catherine lived in the Hermitage and entertained with less ostentation in it.

And she filled it with art. She was the greatest picture gallery maker of her day. Her desire to own imagery made her a bigger collector than the Louvre in Paris. Rembrandts, van Dycks, Rubenses, Titians, Giorgiones and Raphaels are amongst the museum's three million items. Whereas Giovanni Panini's painting *imagined* the art gallery as a kind of belly of the whale, Catherine actually built it. The Hermitage was Versailles filled with art.

It is a place to go and see, to have too much to see, to get tired of seeing. There are so many paintings that they feel like plunder. Catherine was the image hostess with the mostest. The epic quality of the Hermitage was captured by the 2002 film *Russian Ark*. As its title suggests, the film hints that the museum is a massive boat that has rescued visual DNA to save it from a flood, which could represent consumerism or popular culture. The film is unique. Set at the end of the nineteenth century, it shows tsarist aristocrats, who have been partying all night, flow down the steps from the building, towards the river. The whole film is a single shot that has travelled more than a kilometre, through 33 galleries, filming 867 actors: museum officials, spies, balls and portents of the horrors to come. Catherine's art collection was conceived in canny joy, a massive marketing exercise which said, *Look how European we are*, but was also a sincere expression of the visuality of its time. The film is temperamentally the opposite. It says, *Look what is in danger, look what we could lose*. It says that the picture gallery was a great thing, but that its founding ideas were destroyed by revolution.

THE FRENCH REVOLUTION

There have been many uprisings in human history, but the French Revolution was to be amongst the most influential. A financial crisis in France and defeat by the British and Prussians in the Seven Years War (1754–63) meant that the country was broke and degraded. Deference to authority decreased, Versailles started

to look like a fetish object of the *ancien régime*, and the ideas of Diderot and Hume did the spade work for revolt.

Enter, amongst others, Jean-Jacques Rousseau. Born in Geneva in 1712, his mother died when he was an infant and he married a laundresse, Thérèse Le Vasseur, with whom he had five children. He was friendly with Denis Diderot and argued with David Hume; in fact, he argued with everyone. He was *contra mundum*. He walked a lot, abandoned his children, celebrated wildness and was a lone wolf, which makes the seated statue of him in Geneva, in which he is dressed in classical robes, tame. Rousseau was a writer, not an image-maker, but because his ideas so influenced the society of his time, especially what was understood as virtuous, his writing helped change the visual world.

In his *Discourses* and in *The Social Contract* (1762), Rousseau kicked against both the privilege of aristocratic life and the Enlightenment belief in science and the arts. None of these things steered people in the direction of the good life well lived. Artists wanted applause, just like the courtiers of the Sun King. Rousseau's third way was a rejection of bourgeois urban manners altogether. He believed that the innate goodness in human beings could be found in living closer to nature. He was, then, an iconoclast who wanted to remove the cataracts of fancy living.

Rousseau's revolutionary thinking about the nature of virtue and the collective rights of the people fed into the French Revolution itself. People should stop looking at the king, Rousseau said, and start looking at values. Do not look at Versailles. Make judgements. Diderot's advice, 'to make virtue attractive, vice odious' was Rousseauean. But how did the French Revolution, which believed in progress, women's rights, egalitarianism and the abolition of privilege, picture these new values?

Through fashion, colour and propaganda. Women's hooped skirts were no longer the in thing. Elite men stopped powdering their hair. The silk of court was replaced with plainer materials, in darker and more muted colours. The knee-length breeches worn by aristocratic men became passé; the ordinary trousers of workers and peasants became the symbols of their time, hence the term *sans-culottes*. A symbolic young woman, 'Marianne', similar to the USA's later Statue of Liberty, began appearing in posters and paintings.

Colour became crucial. Before the Revolution, the symbol of France was the fleur-de-lis – a stylised lily, an image of royalty. In the new thinking it was

replaced by rosettes (another type of flower, but less figurative) in blue, white and red. Blue and red were the colours of Paris, but the 'purity' of these hues (no secondary purples or oranges, for example) spoke of the ideological reset that the Revolution envisaged.

In 1789 it was rumoured that some of these cockades, as the rosettes were called, had been trampled upon by drunken soldiers of the king. The masses were outraged, and so marched to Versailles to confront the seat of royalism. Soon the three colours became associated with three values of one of the Revolution's mottos: liberty, equality, fraternity. Regal looking, Baroque looking, looking at gold, stucco and the gardens of Versailles, had been replaced by something far more spare and aesthetically abstract. The elite picture gallery was being destroyed. Blue does not mean anything, though its sky-ness or sea-ness might remind us of infinite space and, therefore, liberty. Red does not mean anything, though its blood-ness reminds us of brotherhood, fraternity.

There was a new classicism to this. The French flag was three minimal columns. It said that the Revolution was ordered, not ecstatic.

It has often been countered that the terror of the Revolution *was* ecstatic, blood-thirsty and uncontrolled. On 21 January 1793, Louis Capet, also known as Louis XVI, king of France, great-great-grandson of Louis XIV, lay face down, his neck braced within a wooden frame. In three-quarters of a second, an angled blade weighted with forty kilos of lead fell on his neck and decapitated him. It is likely that he remained conscious for about three seconds, and, in that time, could still look. From May 1793 to June 1794, 1,225 people were killed in Paris in this way, about three a day.

Previously, public executions were carried out using swords, but the guillo-tine was considered efficient, clean and humane. People gathered to see the momentary deaths of the nobles, and the severed heads were often held aloft, but some women in the audience knitted during the murders, and the number of

attendees dropped as the spectacle became commonplace and the Revolution became tainted. The guillotine became a symbol of terror, but also resolve and efficiency. Some of the *sans-culottes* wore red ribbons around their necks to refer to the beheadings, and women wore guillotine earrings.

This is troubling to imagine, of course. Beheading is barbaric. And yet, since the nobles being killed had committed vast moral crimes (living grandly at the expense of others, propagating the suffering of millions for generations) it is possible to imagine a more frenzied, vengeful killing spree along the lines of the bloodbaths of the Crusades. Even the iniquities of the Revolution had a neo-classical aspect.

On 17 July 1793, a twenty-four-year-old woman, Charlotte Corday, was killed for murdering the radical journalist Jean-Paul Marat. Here is fiery artist Jacques-Louis David's painting of the assassination.

How unfiery it is. A Renaissance, Baroque or Rococo artist would have filled that back wall with vistas, buildings, landscapes or people sweeping in to witness the death of one of the most ardent revolutionaries. David's wall, which covers more than half the painting's surface, is like mud. David had organised a number of theatrical funerals to celebrate the martyrs of the revolution, so he could do visual splendour, but here his friend Marat lies in an austere cave or cell. The grandeur of the old picture gallery was replaced with a new, disturbing, simplicity.

Why? For Rousseauean reasons. David wanted to create an image of mythic severity. He had studied Caravaggio in Rome, and Marat's dangling arm resembles that of Jesus in the Deposition, as does the simple white cloth. The blanket over the bath is green because eyewitnesses said that the real bath had a green cover. The pose is a *pietà*, as if Marat is lying on the knees of the mother of Jesus but she has been airbrushed out.

A lot has been airbrushed out. Marat was in his bath when he was killed because he had a chronic skin complaint, and so bathed in water and oatmeal, but his skin is like marble here, like Michelangelo's David, slain. Corday herself is not in the image, but the knife is. In reality she left it stuck in his body. Here it has

197

fallen; the quill is more active than the dagger. The space in the image is small, but the light streaming in from the left evokes outdoors, history on the march, the sounds of the crowds on the barricades. The image became one of the most famous of its times, and has been frequently used in advertising, politics (there is a version of the painting with Marat being tear-gassed by a policeman), television comedy (*The Simpsons*) and cinema. In this moment in *About Schmidt*, for example, Jack Nicholson's character falls asleep in the bath whilst writing a letter. The composition and dangling arm are unmistakable visual echoes. The French Revolution had rejected royalty and privilege and replaced them with another set of images.

PROPAGANDA

To talk about replacing old image galleries with new ones is to raise the idea of propaganda, which has existed throughout human history but which is best dealt with here. Few historical events so consciously tried to tell its political story through imagery. David's image of his friend's death was doubtless painted in sadness, but also in ideological anger. The painter idealised Marat in order to convince the revolutionaries that their cause was just, that they were on the right track. The four words *in order to convince* are amongst the most discussed in image-making. The statue of Cleopatra was built in order to convince her subjects of her status; the Ishtar Gate in Babylon aimed to convince those who approached it of the power and beauty of the city; the images of the Crusades told people how noble was the cause; Diego Rivera's murals told Mexicans how ignoble were the conquests; the Catholic Baroque aimed to convince on a supernatural scale; the aerial bombing footage in our war section was released to the media in order to convince. In his 1928 book *Propaganda*, Edward Bernays used the

phrase 'engineering consent' to describe how our minds are moulded, our tastes formed, our ideas suggested by invisible economic and ideological vested interests, and by their accomplices in advertising and PR. Vance Packard's *The Hidden Persuaders* again indicts the invisibility of the methods used (appeals to the unconscious and sexuality, plays on self-worth, etc.) to tell us what to buy and think.

It is right to be suspicious of such manipulation. Imagery is so apparent, and provides such an instant hit, that looking is very open to manipulation. So what is to be done? For many – Martin Luther, the Frankfurt School critics of popular culture, Daesh, etc. – the potency of imagery is so open to misuse that they reject it in principle (though Daesh, for example, have substantially told their regressive story using online videos). This is misplaced blame. It is not imagery's fault that it is exploited. It is not looking's fault that it is so potent. The response to the power of looking should not be to reject it. The alternative to rejection is evaluation. The issue becomes more focused when we ask a simple question of any image: is this a lie?

Was David's picture of Marat a lie? No. Marat was beautified, like people in magazines are airbrushed today, but there was no major misrepresentation in the image. He was killed in his bath, which is what we see. Beyond that, people at the time, and since, must judge him on his writing.

In his book *Seeing is Believing: The Politics of the Visual*, Rod Stoneman tells the story of another image, which illustrates the point. In late January 1991, the world's media carried a photograph of a cormorant drenched in oil from a slick caused by Iraq when it invaded Kuwait. As a result, the British government accused Saddam Hussein of 'environmental terrorism'. A few days later the American government issued a low-key statement that the Iraqi spill could not have stranded the bird. Almost a month later it was finally revealed that the first oil slicks to strike land were caused by American attacks, and that a third of the rest of the oil pollution was caused by the allies. The bird pictured, they claimed, had been eighty kilometres away from where the initial photograph alleged that the damage had been done. Further reports suggested that cormorants would not be in that part of the Gulf at that time of year, and that the image was from a much earlier oil spill in France.

Did the original photograph lie? No. As far as we are aware, no one deliberately covered a bird with oil, and it was not Photoshopped. Was it used in a deceitful way? Yes. It was deliberately repositioned and presented as evidence of the iniquity of the enemy to convince more people (especially environmentalists) to back the first Gulf War. The bird image was propaganda.

And what about this image, from Leni Riefenstahl's *Triumph of the Will*, a documentary account of the 1934 Nazi Party rally and congress in Nuremberg?

Does it lie? On the surface, no. There are no model shots here. Seven hundred thousand people attended the rally, so everyone in this vast space is real. But this does not mean that Riefenstahl was a passive observer. She was involved in the planning and staging of the event so that its vistas could be impressively captured from her camera positions. This image understands vanishing point and awe. It says to the audience, *Look at the scale of this, and the discipline.*

In other ways, *Triumph of the Will* does lie. Its message is that Germany was a directionless, formless mass, waiting for a messiah. In the prologue to the film, the messiah – Hitler – arrives, out of the clouds and out of history. The film hardly mentions or shows the army, or the racial politics and anti-Semitism which had fuelled Hitler's thinking and plans. The film uses classical form, striking perspectives and musical structure to create a dream-scape in which the process, implications and casualties have been elided. In this way it is a vast lie.

Just a few years after Riefenstahl's film, this equally monumental, heroic sculpture was sited at the 1937 World's Fair in Paris.

The handsome worker carries a hammer; the woman, a collective farmer, carries a sickle, the symbol of her profession. They strike forward and hold their tools aloft, a symbol of the noble worker, progress, gender equality, power, optimism and the Soviet Union. The sculptor, Latvian Vera Mukhina, looked to classical sculpture as a model, and it is hard not to see echoes of the Statue of Liberty in its scale and pose, as well as Marianne from the French Revolution. Unlike Riefenstahl, who showed no interest in modern art, Mukhina experimented with Cubism, but here her style was a thrusting art deco realism. The sculpture was so admired that it was removed to Moscow, where it still stands, and became the logo on Soviet films from the late 1940s.

Is it a lie? In part, yes. By the time this sculpture was completed, it was clear that the collectivisation of farming in the USSR had been a disaster. Peasants were forced to work in the new way, and were not allowed to travel. At least four million and possibly as many as twelve million people died from the ensuing famine. The ending of serfdom, the celebration of labour and gender equality were noble and necessary aims, but the heroic stance of the collective farmer in this sculpture is a sham.

Mukhina's fellow Rigan, film-maker Sergei Eisenstein, thought deeply about 'in order to convince'. In his first film *Strike* (1925), made when he was just twenty-seven, he wanted to show that workers in a 1903 strike were treated with great brutality. Towards the end of the film, we see them fleeing. Eisenstein intercuts their flight with shots of the military wielding guns. Then we see

cows, an abattoir, and cattle being killed – the image on the left, below. These have no role to play in the plot. We to and fro between the fleeing and the cows, and then we see, in the image on the right, the workers lying dead. Eisenstein does not show them actually being shot. Instead of that, he gives us another type of slaughter, from another realm.

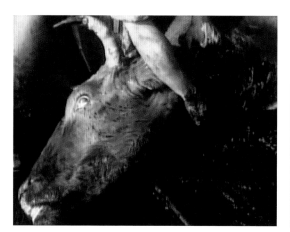

Why? To take us by surprise. To capture our imagination. To create a visual shock. And, as a result, to make us do thought work. In David Hume terms, he presents us with a strong impression, dying cows, about which we will already have thoughts and associations, what Hume calls an idea. Then he presents us with impressions of workers en masse (not individuals), about whom – especially if we are living in the Soviet Union after the Revolution – we will have more ideas. Putting the two images together not only connects those ideas, each of which is already complex, it makes a spark fly between their polarities, to make a new, more complex third idea: the slaughter of the workers by the military; $1 + 1 = 3$.

This is using our emotion, empathy and shockability 'in order to convince'. It is propaganda, but is it a lie? No. Though the Revolution became compromised and murderous, striking workers in the early part of the twentieth century had been treated appallingly. Eisenstein was right to marshal his new, somewhat mechanical, ideas about thought and cinema to show this.

One more example, one more contention. The 2006 film *300* is a fantasy retelling of Thermopylae, a three-day battle between Spartans and other Greeks and a much larger army of Persians. The film's morality is black and white. The western Spartans are good, the eastern Persians are not only bad, they are monstrous, decadent, deformed and effeminate. In this image, the Persian King Xerxes I, portrayed by Brazilian actor Rodrigo Santoro, is dressed like a

courtesan, naked but draped in chains, with neck rings, facial piercings and plucked and pencilled eyebrows. He is enraged, a kind of burlesque.

Iranians were outraged. In one of the country's greatest treasures, Persepolis, he is a noble gatekeeper and is seen in sombre procession. Iran's Academy of Arts wrote to UNESCO to decry the portrayal.

300 was called 'psychological warfare'. Perhaps that is taking it too seriously, but this was the era of President George W. Bush, who, in 2002, had included Iran in his 'Axis of Evil' speech. The film's portrayal of Iran reflects the suspicion, ignorance and bellicosity of its time. It was an eruption of unconscious material. It seemed to be the product of a racist and nationalistic imagination. It did not lie about America's fears, but it lied about Iran.

Each of these examples illustrates what was at stake at the time of the French Revolution. Each shows how regimes need picture galleries.

THE INDUSTRIAL REVOLUTION

At the same time as the encyclopedias, Catherine the Great and the French Revolution, another revolution was taking place. It started in England, required people to live more closely together than ever, led to unprecedented forms of exploitation and sounded, smelled and looked new.

Its timeline was remarkable: at the beginning of the 1700s, coke rather than wood was used to smelt iron ore; in 1712 the first commercial steam engines started to become a major new power source and were used to pump water out of coal mines; in 1758 came threshing machines; in 1761 barges on canals

began carrying coal to Manchester; in 1764 James Hargreaves's new spinning jenny, in which up to eight (and eventually more than a hundred) spindles could be worked simultaneously, massively increasing the speed at which cloth could be produced; after 1769 the first factory was built near Derby; in the 1770s canal construction grew rapidly; in 1775 James Watt created a new, more efficient steam engine; four years later mills were powered by steam, turning skilled workers into factory labourers; by 1850 there were a quarter of a million power looms in the UK; in 1780 the circular saw was invented; three years later, rollers started making steel plate; in 1791 came the gas turbine; a year later the first home was lit by coal gas; in 1794 Philip Vaughan invented ball bearings.

Threshing, burning, smoking, pumping, drilling, spinning, steaming, whirring. It was the era of the present participle. New types of looking took place. Many of those who worked the machines were young women in big mills in northern England. They were barefoot, probably, and the clatter of the spindles was so loud that they may have learnt to lip read. What will they have seen? Machines doing things with much less input from human hands than ever before. Outside, they would see rivers spanned by metal bridges. The air got dirtier. Larch and willow trees, which could not stand sulphur dioxide, declined in numbers. Lichens, too, decreased: only six types grew in London at its most polluted. (Now, according to naturalist Tristan Gooley, there are seventy-two.) And as the prevailing winds in Europe blew towards the north-east, the east ends of cities were sootier than the west ends.

This painting, by J.M.W. Turner, is of Dudley in Worcester, in the Black Country, named after the smoke that came from factories and homes.

At the top is Dudley Castle, near which the first steam engine was operated. There is a hint of a church spire in the misty background. In the foreground on the left, artificial lights tell us that it is dusk and night is coming. On the far right, hot red and white smelting lights bring a kind of sunset to the urban scene. A barge in the foreground heads for the factories in the middle, their chimneys the spires of their day, their

smoke creating a Leonardo-esque *sfumato*. The Moon is perhaps rising. The three types of illumination make the haze glow.

Many commentators decried the world-shift of the Industrial Revolution, and rightly denounced its working conditions. Factories became visual clusters, like palaces and churches before them. Come the assembly line, workers became a cog in a machine, fixed in their place as the car or consumer item passed before their eyes. This Fordist system did not allow you to see the whole picture, just your bit. Turner's painting was later seen as dystopian, but it is probably less judgemental than that. He uses watercolour to create aqueous steel grey, brown and crimson zones which glow and merge – a new type of visual experience, a radically new picture gallery.

Imagery was adjusting to changing realities. When last we looked at imperialism, Captain John Smith was standing in a forest in Virginia in 1607. Since then the British Empire had spread like ivy. Fuelled by a sense of destiny, by the belief that it improved the people it colonised, by the belief in divine right, it taught and exploited. In the main room of the East India Company's headquarters in London, there was a relief carving called *Britannia Receiving the Riches of the East*. The empire discovered that the shipping of tobacco back to Europe would be lucrative, and tried to strong-arm its way into the spice trade. Then tea became the new currency, the agency of empire. The myth of El Dorado, the golden place of great riches that was yet to be discovered, had not quite died.

In this illustration, the coloniser's New World home crowns the mountain. Birds do a fly past and the trees seem to bow down before it. At the bottom, a tobacco ship begins the long journey from the wharf, across the Atlantic, to the pipe smokers of Britain.

But who lives in the small homes on the slopes?

SLAVERY

A good way to look at slavery is through cotton. Known as white gold, it was the oil of its day. In 1750, West Indian cotton plantations comprised 5 per cent of the British economy. There is evidence of human enslavement as early as the agricultural revolution, nine millennia BCE. In ancient Rome, the life expectancy of a slave was seventeen. When the Domesday Book was compiled, a tenth of English people were slaves. In some Islamic African states in the middle of the second millennium, that figure was a third. The first African slaves arrived in the New World in 1501. From that date to the 1800s, about twelve million West Africans were shipped to the Americas. Brazil was their main destination.

What kind of looking did a young African do on his or her way to Brazil or North America? Coerced, traumatised, dissociated, surviving. Here are engravings of a slave ship, *Brookes*, built in Liverpool in 1781. They are factual and diagrammatic, images of a battery farm, which allow us to imagine the loss of home, pain of enchainment, claustrophobia and disbelief.

These are things that will have been experienced by the abductees' whole nervous systems. Looking on the *Brookes* would have been a weary, reluctant confirmation of what your body was telling you and what, in your despair, you envisaged. How long before you stopped denying that something this monstrous was happening? Eventually you would have to stop fighting the impressions (to use Hume's term), the fact that you had been abducted and were living in a way that defied the word living, and installed in a boat in circumstances that showed

that it had not occurred to your captors that you were the same species as them, and sentient. Wouldn't you stop looking, because what you saw confirmed the worst? Wouldn't you try to invent an inner living that tried to exclude your physical circumstances? Wouldn't you hate everything you glimpsed?

And then you would get off the boat and scan the scene. Fight or flight? You would search in vain, in the eyes of your new owners, for empathy, accord or a starting point. You would see deadness, toil, purgatory and no ending. You would be made to apply coconut oil to your skin to make you shinier, like an ornament is polished so that it catches the eye. One day you would realise that dissociation is death, and so you would begin, month after month, to become a detective, looking for clues as to how to escape, or alleviate the agony, boredom and loss. From having dulled eyes, you would develop razor-sharp ones which treated your surroundings like a crime field, a minefield.

Did imagery emerge from this purgatory? The *Brookes* lithograph was just a diagram, but it let others see some of how the captured Africans lived. The boat travelled between Africa and Jamaica throughout the 1780s. In 1788, British abolitionists circulated printed cards of the plan of it, along with eight others, to show that 292 slaves were held on its lower decks alone. As much as verbal descriptions of the iniq-uities, it was looking at the cards that shocked people and helped build the case against slavery. Later, in the era of photography, this image of a man called Gordon, enslaved in Louisiana, was a visual batter-ing ram that helped break down the denials of, or justifications for, slavery.

His scars are so raised, so criss-crossed, that they look like welds or solders.

Quakers in Pennsylvania had been protesting against human enslavement since the 1680s; in 1772 the Somerset's case suggested that slavery should be made illegal in

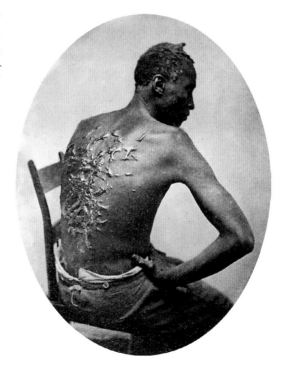

England. France abolished slavery in 1794. It was not until 1807 that Britain did the same.

In the 1650s Europeans began new plantations in the West Indies, to cultivate sugar. Again, their rapacity was combined with their ability to exploit on an industrial scale. Millions of Africans toiled from 4 a.m. each day to feed Europe's sweet tooth. In the UK, Oxbridge colleges and chunks of cities like Glasgow, Bristol and Liverpool were the beneficiaries. The Tate galleries carry the name of one of the biggest sugar companies, which adds to the resonance of Kara Walker's monumental sugar sculpture, *A Subtlety*, housed in the factory of another sugar company, Domino, in Brooklyn.

Sugar is brown, but is refined to become white, the by-product being dark molasses which darkens the walls and metalwork in this image. Walker's artwork points to this separation as a symbol of segregation, and draws attention to the value judgement in the word 'refine'. The sugar industry, as well as being built on slavery, was also a visual metaphor for racism. Walker's figure is a sphinx, a mythic creature which defended cities and, in Egypt, sits amongst ruins. Walker saw the factory as a modern-day city ruin. She gave the sculpture exaggerated sexual characteristics to emphasise how enslaved people were often sexualised, but her sphinx also has a bold pose, as if she is ready to pounce. Her face and headscarf are similar to logos used to sell molasses in the 1800s. Confident and cowered, mocking and defiant, Walker's artwork looks like it has come back, centuries later, to haunt the industry that made it, like an occupation, a manifestation of anger and guilt.

And in these years the image systems, the galleries of pictures, kept on coming. As the *Brookes* imprisoned people, two French brothers tried to do the opposite – to free bodily experience in a new way. Human beings had, of course, seen from great heights by climbing mountains, trees or pyramids, but never had they created a vehicle with an uplift greater than gravity's down-pull. Until, that is, 21 November 1783. Some time previously, Joseph-Michel Montgolfier, an other-worldly twelfth child of a paper manufacturer, noticed how laundry tried to take flight as it dried over a fire. Like Newton's apple, this glimpse gave him an idea. He assumed, wrongly, that the smoke from the fire was lifting the clothes into the air, which led him and his brother Jacques-Étienne to invent a hot air balloon. They did early tests, and then, in Versailles with a balloon decorated in taffeta, they sent a duck, a sheep and a cockerel up into the air (King Louis XIV had wanted to use criminals). The experiment worked and the animals survived, so it was time for a great moment. Human beings would fly, untethered. The task fell to Pilâtre de Rozier (who would die aged thirty-one in a later balloon flight) and the Marquis d'Arlandes. The balloon this time was festooned with regal colours and the face of the king, who would soon be decapitated.

They went high – nearly a kilometre into the air, over Paris. Its Eiffel Tower had yet to be built, so the city, and the world, had never been seen in this way before: miniature, drifting past, the height of buildings diminished to almost nothing, arterial streets becoming defining shapes. This downwardness was enthralling, immaterial, inhuman. In medieval manuscripts, God the divine geometer would be shown standing above the Earth, his dividers spanning its circumference. In this painting on parchment from the 1220s, God does just that. His alert eyes look down upon the thing he has created. His lofty vision allows him to measure the planet and to see into its core, its essence.

This was the eye of the planner, the designer, the all-seer. This overview was not that of the everyday, the field or valley or street, not of humankind, but of the creator of that kind.

What, then, happened when we began not to look up to the heavens, but down from them? The myth of Icarus warned of such hubris, of flying too close to the sun, of getting above your station, of trying to look in the way god looked. The Italian film *8½* captured the world-shift that the Montgolfier flights ushered in. On the ground, in the z-axis, distant people might look small, but they were clearly on and of the same base. Here, a man dreams that he is above a beach. He looks down at his own foot and, beyond it, to human figures who are not only smaller than his toes but who are grounded in a way that he no longer is.

They are pitiful, trapped within gravity, without escape velocity. There is a grandeur to the floating view, and perhaps an exposure too. A rope tethers the man's ankle to the ground. What if it were to be cut? Would he float off into the clouds, to some higher state still? And if so, would that state be exalted, a higher living, or by floating away from the earth, does the human perspective decline? Is elevated looking inhuman? By affording perspective, by seeing, from above, how Paris really works and how its arteries shape the cities, have we sacrificed our earthbound looking? Are our eyes spoiled for ever?

The looking from above that happened in subsequent centuries, in later parts of our story, gave mixed messages. In 1897 a Ferris wheel in Vienna allowed people to look in wave motion, in rise and fall. The elegance of the x-axis. Then two American brothers, Orville and Wilbur Wright, took the Montgolfier ideas further. Observing the swivel of birds' wings as the French brothers had observed smoke, they devised a powered, wide, flexible-winged aeroplane and, on 17 December 1903, did several flights over a few hundred metres. Their plane, the *Wright Flyer*,

flew just three metres above ground, so the metaphysics of high looking were not an issue that day, but of course the jet age grew out of their experiments, and then came budget airlines. For most of human history, to fly was the stuff of myth; nowadays, eight million people fly each day and there are more than three billion flights per year. The image below is taken from a plane flying over the ancient city of Thessaloniki. St Paul preached here. As we have already seen, Greeks, Christians and Muslims remade the city according to their own beliefs. Only with flight could it be seen like this, as a whole, un-immersive, as cities usually are. Its scale confuses. No greater change in the history of looking has taken place.

Of course in seat 34E on a night flight from Florida you see little, and claustrophobia rules out lofty thoughts about looking aesthetics, but the familiarity and discomfort of modern flight do not always block its visual shock. The first time you see the slight curvature of the Earth from a high flight, it is tempting to raise a glass to the Greeks and Ferdinand Magellan who postulated and then proved it. To be earthbound is to think that your world is everything. The higher up you get, the smaller your bailiwick seems. This sounds crushing, but, as we will see in the next chapter, the feeling of smallness has excited people's imaginations. Flyers often report heightened emotions on aeroplanes when they fly over the Alps or great cities, or away from or into their home towns. Flying is more mythic than ground travel, closer to religion or final departure.

Two hundred years after the Montgolfiers and more than sixty after the Wrights, another threshold in height and distance looking was crossed. In December 1968, for the first time, human beings escaped the gravitational pull

of the Earth and entered that of another body, the Moon. Three astronauts were on board Apollo 8. Their craft went around the back of the Moon and then, on the other side, they saw this:

A far-distant blue and white hemisphere, apparently weightless and luminous. Everything human that had ever been done, seen or thought had happened on that swirling disc. If looking is 80 per cent projection, what projection those three astronauts had to do in that moment! They had to tell themselves that nothing that is human is not there. The effect was like looking at a brain and trying to encompass the fact that everything about its owner's consciousness had been contained within it. Looking at Paris from above, you could see its complexity. Looking at the Earth from afar, you could see its simplicity. And unity. Talk of

the global family and single species now have a devotional image and icon. And the other thing about this 1968 photograph is that it has a foreground, a here. It looks like it has been taken from a grey, ashen place, the Moon. The Earth is not here, it is there. This radicalised Copernicus's decentred thinking. The astronauts were not inside humanity, they were outside it. From here, the Earth looked not only small, but fragile. This photograph contributed to newer, environmental ways of seeing. Forty-seven years later a spacecraft three billion miles from Earth beamed back images of Pluto and one of its moons, Charon. They showed that the planet had icy mountains, like the Alps. It was as if we had flung an eye across the solar system.

Our eyes had been variously untethered, and eventually, as in flight, the novelty would lessen. In the twenty-first century, drone cameras would routinely take digital cameras into the sky to show archaeological ruins, road races, or citizens' demonstrations in city squares. TV news and documentaries became full of such images, and often the question had to be asked: why are we above? What does it add to see this event from the sky – does it give perspective or scale – and, also, what does it subtract? Drone shots quickly lost their thrill. To be airborne is to detach, to lose human contact, to see process rather than people.

This implies a loss of meaning or affect, but that is not always the case. Take this image. At first it looks like a geometric, abstract painting; the blue circle in the bottom left, which is intersected by yellow triangles, seems drawn by dividers, but it is actually a shot from Alfred Hitchcock's film *North by Northwest*.

The film tells a 'wrong man' spy story, through which it weaves a troubled romance and a series of set-piece suspense sequences. At this moment, however, the camera takes its leave of its characters and goes unnaturally high. At first we might think that we are looking from the roof of the skyscraper on the right (and we will come to tall buildings later), but the perspective does not allow for that. Instead we are in the air, beside the building, looking down to a circular pool, a curve of yellow taxis and a lawn bisected by a sharp diagonal. The only possible story justification for this angle is to stop us, the audience, from seeing what is happening at ground level, but that in no way explains the height or geometry of this. Director Hitchcock was famed for his understanding of cinematic point of view; he knew whose looking should be represented at any moment. But here, no eyes are represented. Instead, he wanted to escape point of view, to add a moment of detachment, an inhuman, 'objective' glance. He once compared such a high shot, which he used rarely, to a high-pitched note played on a violin, so there is a synaesthetic quality here, in which a look is representing a sound.

Citizens in the early 1700s who knew something of history could be forgiven if they had asked, *What more is there to see?* The world was explored; gods had come and gone; science was looking with a new emphasis on evidence and insight; Christian faiths had fought a theological war, which was also a looking war. Cities could not get more complex. Buildings could not get more beautiful than the mosques of Esfahan. But looking was far from done. On the contrary, Versailles would turn looking into a courtly kaleidoscope; Catherine the Great used it as state branding; picture books were published that said *Look, you can understand this*; slavery produced its own, vile image system; and then the visual began to be airborne. Far from being a consolidation of looking, the 1700s introduced new ways of seeing and new things to see. The 1800s could not be as momentous, could they? Looking could not keep riding the rapids, could it?

The answers are yes and yes. At the end of the 1700s, the *siècle des Lumières*, darkness became fashionable once more. But looking did not hide in the shadows; if anything it became the theme of the 1800s. When you least expect it, the best stories find a new gear.

OVERLOADING

CHAPTER 11

LOOKING AND THE EARLY 1800s: *ROMANTICISM,*
AMERICA, RAILROADS AND PHOTOGRAPHY

LOOKING has always been a kind of searching, but in the first seventy years of the 1800s it was especially so. Politically, these years were warlike, were sung to the same old horror song: powerful countries annexed and then stole from less powerful ones to enrich themselves and establish more markets for their goods. France invaded Algeria, Britain grabbed the Transvaal, and Belgium's imperial foray was, if anything, even more violent and degrading than many carried out by its European neighbours. The Enlightenment had broadened the known world; the Ottomans dominated life around the Black Sea; Britain fought China, which then, in the Taiping Rebellion, saw loss of life on a vast scale; and Napoleon Bonaparte threw his weight about, eventually losing half a million men in the French retreat from Moscow of 1812. In retrospect, Charles Darwin's *On the Origin of Species*, published in 1859, seems like the melody of the horror song: those who felt they were the fittest thought that only they should survive.

This painting is a visualisation of the horror song. It is a painting about surviving and seeking a rescue.

It is set at sea. The saved and the damned are clinging to a raft. Food has run out, so the wretched have to resort to cannibalism. The fittest, or most ruthless, will perhaps survive. Barely visible on the horizon is a rescue vessel. The bodies surge forward and up in a great pyramid, desperate to attract its attention.

Completed in 1819, *The Raft of the Medusa* tells the story of the *Titanic* of its day. A French passenger ship, the *Medusa*, was heading to Senegal on colonial business – to install a new French governor of the country. But it got blown off course and ran aground on a sand bank sixty miles short of the African coast. The journey had to be completed on the vessel's lifeboats, but they could only hold 250 of the 400 passengers, so a raft was built to carry the rest, 146 men and one woman. They only had biscuits to eat, and these were consumed on the first day. Their water was lost overboard during a fight. Desperation led to depravity. Thirst and hunger created panic and blame. Some threw themselves overboard rather than endure the onboard hell. The French press tried to paint the horror scene in words, but then came Théodore Géricault, who was just twenty-five when the tragedy happened, and who had painted in Versailles – not in the grand rooms but in the stables, sketching horses as they reared and, sometimes, died.

Just as people were obsessed by the *Titanic* in the twentieth century, Géricault was obsessed by the imagined agonies of the raft. He needed to visualise it, to see it, to satisfy his inner eye's dread and fascination, and so he interviewed survivors, researched documents, did preparatory paintings at Paris morgues – of which, more soon – and had the person who built the original raft make him a replica. He could have tried to summarise the thirteen days between being cast off and glimpsing a rescue ship, but instead chose to present a climactic looking moment. The already dead stretch out from the picture's foreground, but those with life in them rise up like one of the waves that toss the raft, searching for their rescue. The one African crew member, Jean Charles, stands tall, waving a flag like an unofficial surrogate Marianne, symbol of the French Revolution after the terror, as the hope is dying. The image is admonishing, like a Last Judgement fresco in some Renaissance cathedral. *Here is hell*, it says, *blanched and writhing.*

There is no doubt that Géricault realised that showing such a recent event in such an epic, lurid manner would get him talked about, but he was equally driven by the will to see, what would in Hollywood in the 1970s be called 'want see'. This might lead us to imagine him working in a frenzy, but he painted *The Raft of the Medusa* in total silence, reportedly being disturbed by the sound of a mouse, and shaved his head for the duration. The fact that at the apex of his painting is a black man shows that *The Raft of the Medusa* was anti-slavery; it was a story ripped from the headlines, an epic news report in the last years before photography.

ROMANTICISM

It was also a signature work in a new movement that would come to be called Romanticism. It seems strange to call starvation and cannibalism romantic, but in these years the term was tenebrous. If the eighteenth century was the *siècle des Lumières*, the visual pendulum swung, in the early nineteenth century, towards the penumbral, the shadowy. It was as if there had been an eclipse of the Sun. As if to signal this, Géricault painted his picture in part with bitumen. The actual moment of the glimpse of the rescue ship took place in calm seas, on a sunny day, but Géricault envisages it in a tempest, the sky blackened, a giant wave on the left roaring upwards into a great curl, like the curl of the sail. This was the weather of Romanticism, and its lighting design.

In these looking years, there were flickers of imagery everywhere. More people lived in cities than ever before. Napoleon had himself crowned in Notre Dame in Paris in a ceremony so grand that it was intended to remind those who saw it, and the paintings of it, of the coronation of Charlemagne a thousand years earlier. But we have seen how cities work visually, and we have been to the courts of Louis XIV and Catherine the Great. Romanticism was something else. It dug down into the subsoil of looking.

Where did it start? Maybe with a child alone on a deserted beach in Donegal or Goa, or slung on her dad's back, looking up at the sky. Solitude has a bitter romance. Throughout human history, people have felt that bitterness. It is like a possession, a flooding of melancholia or that pathetic fallacy when we feel that the world around us is us, or is reflecting us. Romanticism was the search for outward signs of what was happening within. J.M.W. Turner's painting of Dudley during the Industrial Revolution was romantic in that it noticed the beauty in smoke, and was emotional rather than sociological. Mizoguchi's misty *Ugetsu Monogatari* film was romantic in that its main character is possessed by love.

But by the early 1800s Romanticism with a capital R was the mood of Europe.

As if in rejection of all that brightness and clarity in the 1700s, the Romantics were moved by that which was beyond their apprehension, the hidden, the half glimpsed, the shrouded. Numerous thinkers and artists contributed to the idea. In 1757 the Conservative Irish writer and politician Edmund Burke grandly argued in *A Philosophical Enquiry into the Origin of Our Ideas of the Sublime and Beautiful* that we are moved by the unseen, and that fear is part of that emotion. In the photograph opposite, the fact that the mountains on either side of this central one are hidden by the flat winter light and fog means that we can imagine their enormity and become confused by their scale.

Like Burke, Jean-Jacques Rousseau had a thing for such images and for the Alps. Denis Diderot said that Rousseau was a madman, and he certainly seemed to enjoy letting go of the handrail of reason. He argued that cities, and the edifice of civilisation, brought unhappiness, alienation and despair. His flight from the Enlightenment led him 'back to nature'. He felt that people lived in a 'world of chimeras', and he overturned rocks to see what was under them. This passage from his book *Confessions* shows the tenor of his thought:

> My passions, when roused, are intense, and, so long as I am activated by them, nothing equals my impetuosity. I no longer know moderation, respect, fear, propriety; I am cynical, brazen, violent, fearless; no sense of shame deters me, no danger alarms me. Except for the object of my passion, the whole world is as nothing to me; but this only lasts for a moment, and the next I am plunged into utter dejection.

'No sense of shame deters me' – the truth of the searcher. Solitude and nature were the springboards of Rousseau's Romantic reveries. Would he have been surprised how far back his impulses went, and in which cultures they could be found?

In this ink-on-paper work by Hasegawa Tohaku, for example, the pine trees dissolve into a burnished mist, brilliantly backlit by sunshine. Romanticism is seen as a movement that peaked in the 1800s, but this work is from 1580.

Its fog is a key element of Romanticism. The trees in the pen-and-ink work are partially unseen, as were the Alps, when they were shrouded in mist and glimpsed by the grand tourists of the 1700s. Jean-Jacques Rousseau would surely have loved Hasegawa's image.

Romanticism, then, was the realm of the caprice, of feeling rather than thought, of the individual rather than the group, of the village rather than the city, of folk art rather than high art. This picture by the German Carl Gustav Carus shows us more about the role looking played in it. No other type of painting is more about looking, and this work sums up much about Romantic looking.

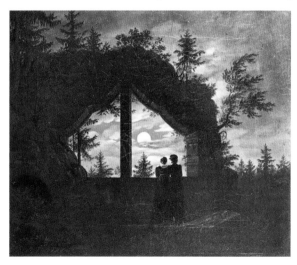

In Romantic art, human figures are usually small, dwarfed by a landscape or a ruin, and often seen from the back, looking out into space. Romanticism was the movement of the z-axis. Its ruins express a longing for the past, or decay. Trees have seeded themselves in this old church like they have in Pripyat in Chapter 5. Any order is the disorder of the future. Nothing that people build will ever outlast the glacially paced procession and grandeur of the natural world. Romantic looking is

sunrise or sunset looking, when the day is dying or being born. Like the two figures in Carus's picture, Romantic lookers are often framed and usually backlit, so that they are not wholly distinct. We have to use our imagination to see who they are, what they are looking at and what moves them. Mountains, ravines, forests and waterfalls are the distant objects in Romantic looking. In this picture the sky is almost surreally clear, like a painting by the twentieth-century Belgian René Magritte.

Travel – searching – was central to Romanticism, but not quite in the sense of the grand tour. Travellers in the 1700s were attracted to ruins too, but they were in search of European civilisation. The Romantic traveller is in search of him or herself. In *Childe Harold's Pilgrimage* Lord Byron tells of the wanderings of a young man who is full of ennui. The world is opaque to him. In his travels to other lands he hopes to shake off his complacent habits of thought and glimpse more profound ways of living. In the writings of Walter Scott, the Highlands of Scotland are a place of psychic release or expansion of self. Lady Hester Stanhope went to the Middle East and never came back. She was shipwrecked, dressed in men's clothes and settled in Lebanon. In 1856 Richard Burton and John Hanning Speke set out to find the source of the Nile. In 1865 Edward Whymper led a team up the Alps' most visual mountain, the Matterhorn. In 1869 the Dutch explorer Alexandrine Tinne tried to meet the Tuareg nomads of Africa. She was knifed to death, and her body was not found. In William Wordsworth's most famous poem he wandered lonely as a cloud, and then he saw daffodils, and then he describes how many he saw, and then they flash upon his inner eye. 'Daffodils' (published in 1807) is about two types of searching – outward and inward. And Wordsworth's long poem *The Prelude* is full of Romantic looking. In one scene, after he has been skating on ice, he stops but the world seems to spin onwards, the optical effect of dizziness.

> . . . then at once
> Have I, reclining back upon my heels,
> Stopped short; yet still the solitary cliffs
> Wheeled by me – even as if the earth had rolled
> With visible motion her diurnal round!

Wordsworth was a great walker, having covered an estimated 180,000 miles on foot by the time he reached his sixties. All of these travellers were Romantics. Each was on a quest for the ecstatic.

Their ideas had scientific, educational and political implications. Mary Shelley's *Frankenstein: or, The Modern Prometheus* (1818) was science in Romantic mode. Where an Enlightenment scientist patiently observes, Shelley's Dr Frankenstein is

a man of passion, driven to make something sublime, a new composite human being. The Swiss Romantic educationalist Johann Heinrich Pestalozzi argued that learning was not something that came from books as much as individual observation. In the manner of David Hume, a child used its senses to see how the world worked. Pestalozzi said that each child was different – a very Romantic idea – and that their sensibility was the way they absorbed learning. His approach was so influential that illiteracy had almost disappeared in Switzerland by 1830. Albert Einstein was taught using Pestalozzi's method, resulting – as we will see later – in the scientist's famous extrapolations from what he saw.

And in politics, the drama and anti-elitism of the French Revolution meant that it was an obvious cause for the Romantics. Their interest in the common man and rejection of city life made them fall in with grassroots social justice movements. They were liberals, though their attraction to blood and soil made them bedfellows of the nationalists who would emerge in these years, personalities who were as likely to haunt the right of the political spectrum as the left.

And then there is Romantic music. In a book on looking, is there room for this sonic cultural form? Yes. Itself invisible, music conjures images in our heads and, sometimes, like literature, is directly inspired by seen things. Romanticism is the cult of the unattainable and, in a way, all music-making is Romantic.

Consider a trip that a well-to-do twenty-year-old German intellectual, Felix Mendelssohn, made on 8 August 1829 to see this remarkable Scottish island, Staffa.

The seas were stormy and Mendelssohn was sick, but still he could not believe his eyes. His travelling companion Karl Klingemann wrote, 'Its many pillars [make it] look like the inside of an immense organ, black and resounding, and absolutely without purpose, and quite alone, the wide grey sea within and without.' The cave does look like a vast petrified church organ, anchored at sea. We can imagine Mendelssohn and Klingemann on the small boat in this illustration, approaching and then gazing up at the basalt columns, which look like the ribs of a cathedral or whale, or like the Mezquita at Cordoba. The pillars appear sculpted, engineered and as remote as the buttes of Monument Valley in America.

By this stage in his life the prolific Mendelssohn had notched up scores of musical compositions and impressed Goethe, but the visual encounter with Fingal's Cave that stormy day inspired in him a new musical sketch which, over the succeeding two years, would become his eleven-minute *Die Hebriden* concert overture, one of his most famous works. To his sister, Fanny, he wrote, 'In order to make you understand how extraordinarily the Hebrides affected me, I send you the following, which came into my head there.'

The musical sketch developed into a theme for cellos, oboes and bassoons. Mendelssohn transliterated: he took a leap from the visual to the aural, making the latter an analogue of the former. What can I do in my world, he must have asked himself, that is an equivalent to what I have just seen? It is a question which, over the years, many musicians in a wide range of musical genres have posed: on 21 April 1915 the Finnish composer Jean Sibelius saw sixteen flying swans, which inspired the horn finale in his Symphony no. 5 in E flat major; in the 1930s Abel Meeropol saw a Lawrence Beitler photograph of the lynching of Thomas Shipp and Abram Smith in Marion, Indiana, and wrote a protest song, 'Strange Fruit', that became a despairing, angry anthem sung by Billie Holiday; in 1962 Bob Dylan wrote 'Let Me Die in My Footsteps', having remembered watching, for an hour, two years earlier, men building a bomb shelter, the image having stayed in his head; in 1964 the French singer Barbara released a song, 'Nantes', in which she beautifully describes what the city looked like one bleak morning when she visited it as her father was dying; in 1966 Leonard Cohen watched Suzanne Verdal as she danced in a jazz club in Montreal, and wrote his song 'Suzanne'; in Berlin in 1977, seeing his producer Tony Visconti kiss his girlfriend by the city's dividing wall, David Bowie wrote his song 'Heroes'; in 1982 the Holland Festival premiered a play-concert-dance by Philip Glass, which was inspired by the photographs of English American Eadweard Muybridge.

These sound artists were all, metaphorically, on that boat with Mendelssohn as he entered Fingal's Cave. Nature, slavery, work, cities, love, youth, division,

photography. The history of music is full of such encounters with the visible world. There is a leitmotif running through it which could be called 'The First Time Ever I Saw Your Face', after the yearning song made famous by Roberta Flack.

ZOOS AND MORGUES

Part of what attracted Mendelssohn to visit Fingal's Cave was the element of danger. Modern life in Europe was becoming too safe, so the Romantics journeyed outwards, to other landscapes and to the animal world. As we have seen, eye contact with other species would have been an arresting experience for the earliest humans, a step on the road to the development of consciousness and the beginning of the culture of animal husbandry. The development of the great cities led to a loosening of inter-species attachment. Non-domestic animals started to be captured and displayed, usually as lifestyle adornments of kings and emperors. The more palatial your life, and the more layers between it and the agrarian world beyond your citadel, the more animals lost their function as beasts of toil or sources of food. Many cultures saw some animals – birds, beetles, calves, etc. – as symbols of the divine, and most practised ritual sacrifice, but beyond food or god, wild animals eventually, in being removed from their natural environment and displayed in new ways, became things to be looked at for the purposes of entertainment or spectacle. Aristotle collected animals with aims which could be called educational. In the Roman Colosseum, of course, combat with lions and other beasts gratified the audience's bloodthirsty desire to see. Albrecht Dürer's desire to see the rhinoceros sent from India to Portugal in 1515 was so great that he famously made an etching of it without seeing it. The result was a reality-fantasy construct, an animal with the bulk of a real rhino, but covered in what looked like plates of medieval armour.

But in the early 1800s zoos became far more popular. The Enlightenment and Romanticism compulsions to study and escape, a double imagination, produced them. In the wake of the French Revolution the menagerie at Versailles became more accessible to the public. That palace's rational, geometric garden design was, in the Romantic imagination and zoological garden design, replaced with something more like Carus's painting: in the new, ascendant idea of the zoo, the animals would be glimpsed in settings similar to paintings – amongst wild planting and natural rock formations. Visitors had multiple things to see. One of the first modern zoos, established in London's Regent Park in 1826, was far from monofocal. It was a promenade, a social outing, a safari, a series of glances. It was not a place where the elite showed off, more a post-Industrial Revolution entertainment where the masses could enjoy locking eyes with creatures from distant

lands, a pleasure which had archetypal properties. In later decades it would increasingly be seen as a mistake to design zoos around the visual desires of the lookers rather than the welfare of the looked at, but in the 1800s the layout was structured around the human gaze at the animals.

And in this era of searching there were human zoos: people looking at people engaged, or presented as an object. The looker had the right to look; the lookee had no right to deny the look. The Connecticut-born businessman P.T. Barnum saw that money could be made out of looking, and so exhibited the conjoined Thailand-born twins Chang and Eng Bunker as a curiosity. In 1876 the German Carl Hagenbeck sent colleagues to Sudan to abduct Nubians to exhibit in Europe's capitals. In a sense this was just another iteration of the slave trade, but this rare photograph shows the theatre-zoo that resulted.

On the right, the polished leather shoes indicate the social class of the lookers, their faces blurred because of the long exposure of the photograph, their heads presumably turning to each other as they react to and discuss what they are seeing. Across the low diagonal wall lies that thing: a painted diorama of village dwellings and trees and, in front of it, on display, a simulacrum of village life. Here are human beings whose dignity is so forgotten, or unconsidered, that they are required to sit there, semi-naked, and pretend to be themselves.

Did they make eye contact, even for a moment? And if so, what did each side think? Did the polished shoe people feel ashamed? Probably not, because the ideas of the time led them to believe that others should be available for their inspection. This was Romanticism debased. 'Back to nature' said that we could learn from those who lived outside the industrial, Enlightenment world, but what learning was taking place in this looking? The people on the left could hardly be closer physically to the people on the right, yet, psychologically, the distance is vast. Even the women in Dublin passing the homeless lady sitting on the bridge are closer to her than these onlookers in the human zoo are to the Africans at which they stare. At the World's Fair in 1889, an estimated four hundred indigenous people were looked at by its twenty-eight million visitors.

In 1810, twenty-one-year-old Sarah Baartman was abducted from South Africa to become a servant in England and be exhibited in zoos. She had stea-topygia, genetically conditioned large buttocks, a body shape often seen in ancient figurines of female goddesses and fertility symbols. She was dressed skimpily and displayed in a cage in London's Piccadilly. In Paris she was caged next to a rhinoceros, and encouraged to stand in similar ways to it. When she died, aged twenty-six, her bones, brain and sexual organs were exhibited in the Museum of Mankind in Paris. They were only removed in 1974. Nelson Mandela asked for them to be repatriated. It took France eight years to complete their release, as it did not want her return to set a precedent.

PARIS MORGUE

How similar the human zoo is to this image.

Again we are in Paris in the 1800s. Again we are looking side-on. Again the world of the image is split by a diagonal threshold. Again well-dressed people on the right look on in fascination at those on the left who are undressed. The clothes of the unclothed hang above them, the better to emphasise their recent exclusion from the land of the right. They have been stripped, and are propped

up, for display. Boards cover their genitals, as to reveal them might offend propriety or the idea that the looking happening here is educational.

Open from dawn to dusk, seven days a week, and centrally located behind Notre Dame, the Paris Morgue was a highly visible free theatre array of dead bodies, a vitrine experience, a forerunner of the bourgeois arcades and window shopping. Up to 40,000 people a day passed through its rooms, in groups of fifty. For its first decades the morgue was unrefrigerated, so cold water dripped onto the bodies, making them bloated and shiny, like marble. After three days, decomposition would lead to the removal of a body and its replacement with another.

In the early 1800s, if you survived into adulthood you were likely to bury your parents before you hit forty. You might well have buried a child too, and these deaths would probably have taken place at home. Also, public executions still happened, so death was visible. But still people sought it out. Aspects of the Paris Morgue phenomenon were of their time. It was collective and social.

In some cultures today – including Ireland's wakes and Hindu cremation ceremonies, for example – dead bodies are still viewed in social groups, but in the Western world real corpses have become less visible, hence the dilemma about the mobile phone photograph in the introduction to this book. Most of the dead in the Paris Morgue were unidentified – they were found on the street, or floating in the River Seine, or prostitutes or people made homeless by Paris's medieval streets being turned into grand boulevards – so there was a mystery to them. You could look at their faces, their wounds, their clothes hanging above, their brooches or how worn their shoe leather was, and play Sherlock Holmes. More generally, however, like looking at a ruined building, looking at the ruined body gave and gives a psychic jolt. It is a memento mori, a safe frisson, a dare you play with yourself, a threat to your own feeling of being timeless and for ever. There is the sense of transgression in looking at a dead body. It can be improving, it can be a step to overcoming fear of death, it can be *There but for the grace of God*, it can be compassionate, it can be erotic, but it is always looking across the limelights into a realm where your vanities no longer prevail. It is looking into the void.

AMERICA

Romanticism was so attracted to the void that it saw it even when it was not there. The story of the United States of America in the nineteenth century, which is rooted in the early part of the century, is centred on such a non-void void, the western frontier. The main branch of the Mississippi River divides America between an eastern third and a western two-thirds. For European settlers arriving

from the old world, this was a divide between an eastern here and a western there. The frontier-river was like the diagonals in the images of the human zoo and the Paris Morgue – it was a looking line. Even time itself was different on the other side of it. The west was imagined by the east, it was in the latter's mind's eye, on its canvases and, eventually, in its Western movies.

The facts themselves conjure images. In 1803 France needed more money to fund its wars, so it sold a vast area west of the Mississippi – Louisiana – to America for $15 million. The latter doubled in size. Beaver trappers headed west to harvest furs to feed the fashion for beaver hats in Europe. They became familiar with the plains of the new west and, eventually, its western wall, the Rocky Mountains. The German-born American Romantic painter Albert Bierstadt followed in their footsteps and visualised their journeys. This oil on paper picture, *Western Trail, Rockies*, fascinated those who saw it. Settlers struggle to get their covered wagon across a pass. They are so high up that they are leaving the tree line behind them. They are heading west – pictured right – because that was the direction of travel for the new Europeans. They carry their worldly goods in their wagon. No other human beings appear in the picture. Their odyssey is epic and solitary. No one has told them where to go, or how to get there. They can settle when they wish, or not settle at all. The German sublime is here. The Rockies are like the Alps.

Within fifty years a new entertainment technology based in a vast state that lay ahead of the trappers and traders would replicate such imagery obsessively. At least a thousand films have been set in the world of the American frontier, one of the largest image systems of the last century. This frame grab from one of them, *Red River*, which was named after a tributary of the Mississippi, again pictures small covered wagons against a soaring mountain backdrop. Once more, the sublime is at play, the scale is vast, the freedom is exhilarating and the smallness of human life is strangely releasing.

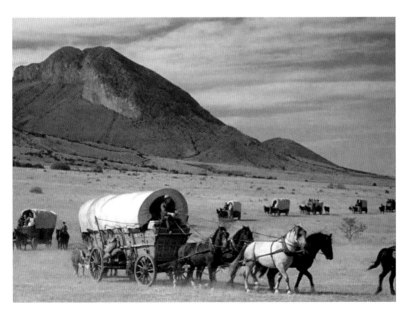

The film captures the fascination of frontier looking, and Hollywood's compulsion to render it. It is focused on a classic cowboy, Dunson, who dreams of establishing a ranch in the south. His woman is murdered, which fires his wrath, and he adopts a boy, who will grow up to be a knight to his king, New Testament to his Old. Dunson claims land is his, is challenged by representatives of its Spanish owners, kills them, and fights and then makes peace with the younger man. Manifest destiny, entitlement, freedom and masculinity are the themes. Dunson's desire for land and for a place without rules is mythic, Mosaic. He wants to make rules, not play by others'.

The United States Congress shared his reverie. It passed the Homestead Act, which allocated 160 acres of western land for free to any citizen (including women and freed slaves) who applied and committed to farming it for five years. Half a million did so, of whom one-third were successful. As in this image from John Ford's Western *The Searchers* (which could be the title of this chapter), homesteads framed the new, empty paradise. They were often places where women were, domesticated shelters whose windows and doorways provided vistas and became new places to distinguish here from there, us from them, in from out. The homestead was a fiefdom, a place of complete personal control. No government could interfere in it, and it would be defended to the death.

Bierstadt and the film-makers were visualising human desires for space, nature and control that date from the Pleistocene era. Then there was the desire for

gold. It was found in Georgia, and then, on 19 August 1848, a New York newspaper reported that gold had been discovered in California. America's visual imagination shifted westwards. The void became a treasure store.

Except, of course, that it was not a void. It needed to be voided. In 1830 Congress passed the Indian Removal Act, which made possible the negotiated or forced removal of Native Americans to the west of Mississippi. Eight years later, after that discovery of gold in Georgia, 16,543 members of the Cherokee Nation were forced off their southeastern homelands by 7,000 US troops. Up to a third of them died in a displacement that became known as the Trail of Tears. None of the thousand movie Westerns adequately portrayed the Trail of Tears.

The dominant imaginative direction was westwards, but the occupants of the West looked in another direction. In this double image, photographed in Sacramento, California, a Native American looks down a canyon, onto the low sun and the coming railroad.

Congress had given the railroad companies 100 million acres of land, and subsidised them to the tune of $16,000 to $48,000 per mile. The man in the photograph looks at the thing that will sequester his history, culture, family, livelihood and spiritual beliefs. He is the Picasso woman with her back turned, another nineteenth-century searcher wondering how another of the century's lines in the sand will change his life. The small figure in the landscape was such a trope of nineteenth-century seeing that, although the content of this stereoscopic image is a challenge to dominant looking, its form, scale and framing are of its time.

What kind of looking would, then, be a truer antidote to Hollywood's Western genre? Perhaps something like this image of a mother and child from Nome, Alaska. Whereas the settler trappers shipped furs back to Europe for women to wear on the new Paris boulevards, this woman and her child need them to keep warm.

The image perhaps reminds us of the Mexican sculpture of a child strapped to her father's back in Chapter 2. Two human beings coupled, moving in the same way, seeing in the same direction. The mother here looks dejected, her child's sleep suggesting the tiredness the adult seems to feel. The child's arm dangles like its mother's plaits, like Christ's arm in Caravaggio's *Deposition*, like St Teresa's arm in Bernini's ecstatic sculpture. But there is nothing ecstatic here. The dangle is a loss of consciousness, not an excess of it. The photograph has the beauty and texture of a great Dürer portrait. In the story of looking it is more valuable even than Dürer because it shows a moment, a relationship, a fatigue too often over-looked (or underlooked) in the mythic American West of the 1800s.

Increasingly in this chapter a latent aspect of looking has been surfacing. In the human zoo image, the unequal power relationship between looker and looked at was most obvious, but in much of what we have seen so far, questions of the right, privilege, advantage or misconduct of searching have been in play. The nineteenth century's heady mix of Romanticism, colonising and – as we will see – decolonising and technology means that here, too, the relationship between looking and advantage should come to the fore. To our eyes, the image of the Sacramento Indian gazing at the railroad upends the John Wayne myth of the West, but it was taken by Alfred Hart, who was employed by the Central Pacific Railroad, so maybe we are reading into the image a liberalism that was not intended. The photograph of the Alaskan mother and child was taken by another white man, H.G. Kaiser. In neither case does the race of the photographer sub-stantially undermine the value of the image, but this nineteenth-century sketch

sheds additional light on this us/them issue in looking.

The artist, Henry Ossawa Tanner, achieved that elusive feat for an artist, acclaim in his own time. He was written about internationally, exhibited in the Paris Salon and was the first African American full member of the National Academy of Design. In our story so far we have looked at many images of non-white people by non-white people (Mexican sculptures, Japanese films, etc.) but this charcoal sketch is a more deliberate wresting of power from white supremacy. Tanner's mother had been born a slave, and he was conscious that some of his images were acts of resistance. In his autobiography he discusses racism

and the fear it sparked in him. In his drawing, the man is neither a possession nor a victim, neither labouring nor suffering. He is not part of the slavery paradigm. He is not in a landscape or associated with tools or symbols of a profession. He is not doing anything. In one way the drawing could be compared to the quiescent female nude in Western art, but this man is invulnerable. Yes, he is naked, and yes, he has no social context – the drawing was probably done in a studio – but images of black men had been so burdened that Tanner scrubs his clean, leaving something unmetaphorical and undiscursive: just a man who seems to be happy unclothed, looking downwards, aware that he is the subject of art rather than something far worse. *Study of a Negro Man* feels part of a new beginning in how one African can depict another.

NATIONALISM AND RESISTANCE

Tanner's drawing was a reclaim. It said, *This is not yours, it is ours*. In Belgrave Square in London, a similar claim is staked. At its southern corner a bronze sculpture of Christopher Columbus sits, his legs crossed at the ankles, his right arm outstretched towards the west, holding a rolled-up map. Erected in 1992, it

was a gift from Spain to the people of the Americas. Two years later, a standing and much more stern statue was unveiled, in the same square, to someone who was Columbus's historical opposite. José de San Martín (1778–1850) was, along with Simón Bolívar, the liberator of South America. He helped throw off the European imperial yoke that Columbus's first contact initiated centuries earlier. It would be great if the two sculptures eyeballed each other. They do not, but San Martín's most famous moment was highly visual.

In January 1817 San Martín led his army of more than 4,000 men – Argentine soldiers and Chilean exiles – across the Andes from Argentina, westwards and down into Chile. The aim was to free the latter from Spanish rule. He raised funds for the trip through donations, leaked misinformation about his plans so that the royalists would be wrong-footed, and then gathered together a vast caravanserai of cooks, food wagons, cartographers, builders and horses.

Augusto Ballerini's painting of the crossing draws on the sublime again. Distant peaks are buttery in the sun; the trail of horsemen is tiny against the landscape. In their trek west they struggle to climb a curtain of mountains, as the covered wagon did in the Bierstadt painting, and as cowboys do in so many Westerns.

The painting deploys the mythic language of its day, but San Martín's manifest destiny was stronger than that of the North American gold rushers. After

twenty-one days of ascent and descent, his army fought the Spanish forces at Chacabuco. The crossing of the Andes afforded San Martín and his men vistas like Akbar's of the Deccan. The ensuing victories were key steps in the liberation of South America. Two centuries later the armies of Chile and Argentina restaged the crossing to mark the bicentenary of the revolution.

San Martín's success and the other South American wars of independence remind us that the 1800s were the era of the nation state. Napoleon Bonaparte's attempt to create a supranational Europe met with national resistance. Along with such anti-Bonapartism, countries rejected Austrian and Ottoman power, and Italy and Germany were unified. These new national consciousnesses were hungry for symbols, just as the French Revolution was. Anthems were part of that, as were flags. In 1818 the US Congress passed the Flag Act, establishing one of the most recognisable images in the world, the Stars and Stripes. The act stated that the country's flag should have thirteen horizontal stripes – one for each of the former British colonies that originally declared independence – and twenty stars on a blue background, one for each of the states. The number of stars has increased, but the design of this metonym has otherwise remained the same. Nearly three-quarters of its surface commemorates about 4 per cent of the country's land area.

We will consider looking and protest when we get to the twentieth century, but a few of the many other acts of resistance in the 1800s had visual components. In France in 1827 the government passed a law restricting forestry use, so farmers and land workers dressed as women, wearing long skirts and scarves, attacked land owners and forest guards incognito.

How to say something about the most calamitous rebellion of the 1800s, one of the most violent wars in history, which took place at the same time as the

American Civil War and involved more soldiers than the Napoleonic wars, but is much less well known than either in the West. Maybe with this picture?

The Taiping Rebellion was the subject of a whopping forty-six-part TV series in mainland China and a forty-five parter in Hong Kong. Between twenty and thirty million people died between 1850 and 1864. This photo could be of Taiping prisoners, but it could be later, around 1875. Its brutality fits, and the fact that it is women is right, but their feet look bound, which is wrong: the Taiping rebels were for women's equality.

Maybe there is no good image of the war. It started in the south of China. The Qing dynasty had been defeated by Britain in the Opium Wars, but was still preaching and enforcing Confucian conformism, deference and female subjection, plus the Qing elites were Manchu northerners. Southern, working Han Chinese did not like this, and so, encouraged by the bizarre but convincing Hong Xiuquan, who thought he was the brother of Jesus Christ, they rose against their oppressors in search of justice. Their wish list was a mix of land reform, an end to Buddhism, a rejection of folk supernaturalism, the establishment of Christianity and the banning of foot binding, and their grievances marshalled a massive army. For fourteen years each side destroyed the farms of the other and massacred its city dwellers. Famine and disease spread. Hong died in 1864 and his ashes were blasted into the sky, from a cannon, so there would be no place to worship him, Christian-style, on Earth. His followers were treated with great brutality. In Nanking 100,000 of them were murdered in one three-day period alone. In the absence of verifiable images of the

atrocities, let's accept the one of the three women, as women were one of the bones of bloody contention. How could they have walked with that board around their necks? They could only have shuffled, as underlings were meant to, as women were used to. Each holds her own hand, a tiny self-comfort. Their aprons are dirty from work or worse. There is an echo of the guillotine in the image, as if three were beheaded at once, for extra efficiency. Moving from left to right we see cool defiance, anger and dejection. That will do as some kind of depiction of the horrors of Taiping.

RAILROADS

At exactly the same moment that the Taiping Rebellion was quelled, China's first railroad was built. The world's first steam locomotive passenger service had begun in the north of England. Continental Europe's first passenger railway was in Belgium. Soon lines were laid in France, Germany, Italy and Canada. In the USA the subsidised Central Pacific and Union Pacific lines met in Utah in May 1869. Twenty years later the first through train ran from Paris to Constantinople. Railways were product supply lines, and so fuelled capitalism. They were arteries and infrastructure projects. In India they allowed the British to connect the heart of the country to its periphery.

They were a looking revolution. Despite the great ability of the human eye to stabilise visual movement, rail travel introduced new optical vectors and valencies. In this image taken from a moving train in Chernobyl, Ukraine, for example, the dust on the window is in focus, and a black, leaning strut – part of a bridge – sweeps by, out of focus, too fast to be sharp. In the distance the sunset reflected in a lake calls on our visual attention, which is torn between it and the other layers.

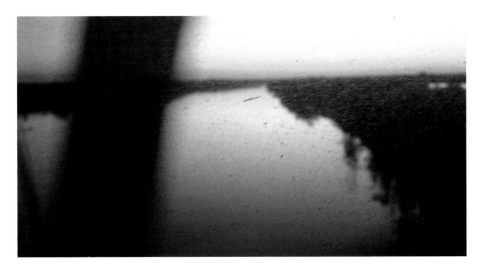

The image shows that this new thing, railway travel, was a movable feast. Trains clattered and glided. As they sped up, passengers were presented with a whizzing foreground and a flowing background. Looking from a train was like having a surveying eye. It was like map-reading, or sailing along a coast on a good day. Whereas tourism involved pilgrimages to famous places like Rome, a train journey gave equal visual access and emphasis to in-between places. Watching such places go by encouraged rapid eye movement which, it is now understood, stimulates bilateral brain activity and – as eye movement desensitising and reprocessing (EMDR) studies suggest – cognitive activity. To look from a train is to become entranced, akin to hypnosis, akin to a tracking shot in a film.

And so the way we looked at landscape changed. As we have already seen, land was something to be worked, then it was to be looked at, and became landscape. On horseback and in stagecoaches we moved through it, but trains made that movement more smooth, regular and dreamlike. The aesthetic was less destination, more process. The getting there became as important as the arrival. Weekends changed. You could now really get elsewhere and come back in one.

All of which is assuming that you were on the train. The Sacramento Native American was not; it was something that arrived from the east, from cities, bringing with it the future, modernity and perhaps threat. This sense of threat and invasion is captured in the following image from Sergio Leone's film *Once Upon a Time in the West*. The train seems to arrive inches away from the character's face. The long lens brings it close, and flattens, or elides, all the distance and history between them. He is staring at it, searching for answers to how it will change lives.

Railways come from cities, but they facilitated commuting into them too. Their modernity bolstered urban modernity. Underground from 1863, they became subways, increasingly bold mined infrastructure projects of visual confinement. As there was usually nothing to look at outside the window of an underground carriage, they became dramas of eye contact within. Modernity was presenting new ways of looking at strangers.

PHOTOGRAPHY

Though we are only now arriving at its invention, photography has already in our story shown us striking images such as the face of the Hupa shaman, the slave's scarred back, the human zoo, the Earth seen from the Moon, the Alaskan woman and child, and the Sacramento Native American looking out to the railroad.

Every new technology needs pathfinders – people who search for its potential and essence. For one such searcher, Julia Margaret Cameron, the new technology was painting by radically other means. Cameron's 1865 image, *The Return after Three Days*, opens a window onto the early world of photography. It was taken using a wet process, so the preparation of the negative, shoot and

development took place in a frenzied fifteen minutes. The girl on the left is out of focus, and so gives a hint of speed and the ongoing moment, but Cameron's imagination was stirred by stillness and out-of-timeness: the stare of the boy on the right; the overall softness, which was a deliberate attempt at *sfumato*; the shallow space like that in a Rembrandt painting.

The title refers to a story in the Bible involving the twelve-year-old Christ and his family. Christ is played by four-year-old Freddy Gould and his mother is Cameron's maid, Mary Hillier. Cameron was a Christian, so her visual softness is gesturing (as we saw it do in Chapter 1) to another world, which is what religious painting did.

But the image also shows that photography was unpainterly. As artist David Hockney has pointed out, 'in a photograph it is the same time on every part of the surface'. There is inadvertent reportage in Cameron's image in the slight pout of the boy and the touch of boredom we detect in the faces – Cameron required her models to sit often for her camera, to the point that they got fed up. Roland Barthes called these unintended effects the punctums that prick you when your eye lands on them. He wrote that some images 'provoked tiny jubilations, as if they referred to a stilled centre, an erotic or lacerating value buried in myself'.

So there is visual tradition in Cameron's image, but also time, technology, spirituality, homage and the unexpected. And in particular there is authorship. Far from being a 'pencil of nature', to use William Henry Fox Talbot's phrase, her photography was contorting the world around her – household staff, her and others' children, flowers in her garden, and so forth – into a composition, a frame, an image history. *The Return after Three Days* was a new equation using some old elements. Painting + the moment + bodies + technology + religion + family = Julia Margaret Cameron's work.

This next image adds to our sense of what photography was becoming. Self-taught Seneca Ray Stoddard's *The Way it Looks from the Stern Seat* emphasises its subjectivity by having the photographer's feet poke into the frame. In a painting this might have been considered a bad composition because it leads the eye out of the picture. Stoddard's image certainly has graphic rigour: the horizontal lake edge harmonises with the nearly 180 degree oars; it is almost symmetrical; the rower's head turns at right angles to the camera; the feet seem to touch, but the lightness and informality of the scene are new. They express the photographer's

pleasure at being out on the lake with just one other person and no buildings in sight. The sun is shining. The guy is not wearing a big coat, so it cannot be cold. The pipe suggests quietude. This could even be a lover's image.

The Way it Looks could be the first four words in the title of any photograph. The paintings in this book which purport to show historical events, such as the one of the Crusaders processing outside the walls of Jerusalem, or Galileo's trial, aim to say, to varying degrees, *This is what it was like*. Stoddard's image says *I was here* or even *I am here*. First person singular and present tense. What a wow factor this was. Photography could capture what it felt like to be alive without doing very much at all. This effortlessness angered and threatened traditionalists and led them to draw moral conclusions: if it is this easy, it cannot be any good. Looking was no sweat now. You did not even have to go to see. Looking came to you. The photographer did the searching, so you did not have to. *The Way it Looks from the Stern Seat* is a celebration of looking, of the z-axis, of me–we.

From the unexpected moments in Cameron and the hereness and point of view of Stoddard, let's go to this photo of a boy called Harold Whittles by Jack Bradley. It is a charming frontal pose of a boy, his body twisted slightly, as in a Renaissance portrait. His wide eyes, like those of Courbet's self-portrait on page 62, suggest a glimpse of something startling. But add the following sentence, and watch what happens: the boy is deaf, but in this moment is hearing for the first time, thanks to the hearing aid in his left ear. Now the image fascinates. We focus not in front of the boy's eyes, but behind them. Our eyes flick between his ears and eyes, imagining a sudden opening of the sound world. We see the boy's stunned silence, then guess at what he might say, or ask.

Like Cameron's photograph, Bradley's shows how well this new technology works in tandem with something else – here a sentence of information about the

subject's previous deafness. The photograph's relationship with the words is desirous. Each does something the other cannot. An image wants to be words, and words – as we will see in the next chapter – are often desperate to be images. Miscegenated, they are the looking dream team. They make Harold Whittles's face unforgettable.

They do so, in part, because of time. Russian Futurist Natalia Goncharova's painting *The Cyclist* (page 46) tried to show movement through time by repeating the image of a bicycle's wheels and the cyclist's body as if they were visual echoes. In this chronophotograph by Étienne-Jules Marey, eight photographs prove Goncharova's hunch, so to speak. Her painting gave an impression of a movement that was too fast for the shutterless human eye to isolate into a series of still images. Marey, Eadweard Muybridge and other pioneers used a series of photographs taken in quick succession to capture individual stages of a kinetic event. The poetics of dance, the physiology of a cantering horse, the kinesiology (study of muscle movement) of a tennis player: the process of all of these could now be seen. Chronophotography was like infrared imaging. It allowed us to see beyond what is visible with the naked eye.

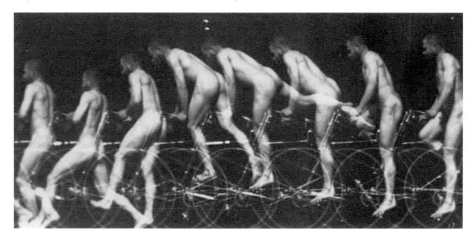

The unexpected, hereness, the relationship with words, time and movement – our sense of photography is growing in complexity. Most photographs contain each of these elements. Marey's man mounting a bike, for example, shows that the movement is like a waveform. As he swings his right leg back, in stage five, so his torso leans forward to keep his centre of gravity above his left foot, which is on the pedal. But Marey's image is not just analytic, an Enlightenment observation of the visible world. It is also ghostly and translucent. Its obvious silence, the fact that we can see through the legs of the man, and his nudity make it dreamlike. He is a wish fulfilment, our dead or free or aroused self. Marey's photograph was searching for the nature of movement.

A final picture, by Damir Sagolj, emphasises this immaterial aspect of photography. We are in the capital of North Korea in October 2011. Buildings in shades of pistachio, purple, blue and ochre are all unlit and shadowless, as if at dusk on a flat, grey day.

A single photograph of Kim Il-sung is the single point of light, like the North Star. This remarkable shot is reminiscent of the Surrealist paintings by René Magritte in which the sky is blue but the street lamps are still on: there is something wrong about the light source. It is too bright, or the sole survivor in a world that has died. In an image like this, a frame from Roy Andersson's Swedish movie *Songs from the Second Floor*, we see similar colours and light, but it is a fiction – the scene was shot in a studio, the plunging perspective painted.

Sagolj did not construct the blocks of flats in his photograph or invent its world. It is knowing this which makes it astonishing. We think we know what cities look like – visually chaotic, polycentric, multiple. But what Sagolj shows us is so unified and formal that it seems to come from the unconscious.

It would take a thousand images to get to the heart of photography, but in a book of this scope, our five must suffice. When it arrived in the 1830s the new technology seemed like magic, as wireless internet first did. For millennia painting had stalked the visual world, then a new, *arriviste* technology sprinted past it. With its speed and precocious mimesis, this Usain Bolt seemed to outstrip the human eye. In *The Cinematic Apparatus*, Jean-Louis Comolli wrote that 'the mechanical eye of the photographic machine now sees *in its place*, and in certain aspects with more sureness. The photograph stands as at once the triumph and the grave of the eye.'

Such life-and-death talk was understandable. Photography could do everything – pastorale, portraiture, propaganda and pornography. It was, it seemed, bye-bye Vermeer. Why spend months meticulously painting, perhaps with the use of lenses, a Delft interior, when – in the daguerreotype – you could fix one on a copper plate covered with silver in about fifteen minutes? As we know, photography did not replace painting, but it was the most significant innovation in our century of visual searching. Ralph Waldo Emerson thought there was a link between the camera and death. Susan Sontag talked about photographs as lights from a distant star; the star may have died, but the light is still travelling. In *Camera Lucida* Barthes writes: 'In front of the photograph of my mother as a child, I tell myself: she is going to die: I shudder, like Winnicott's psychotic patient, over a catastrophe which has already occurred.' In that sense all photographs of people are catastrophes that will occur – the people will die. That is a final, 'Lazarus' excitement of photography. And it, again using Barthes's words, 'fills the sight with force'. More than a trillion of them are now taken every year.

We have looked at photography and war and propaganda, and will explore celebrity and digital imagery in a later chapter, but what did the photochemical reproduction of life do to individuals? How did Mary Hillier's sense of herself change when she saw herself in Julia Margaret Cameron's photographs? And were people changed once they were able to reach for a photo album and flick back through their lives to see their magic moments?

It sounds as if Mary Hillier took little pleasure from being immortalised by Cameron, but surely Harold Whittles valued being able, in later life, to see the moment when he could first hear? More generally we feel strong emotions when we look at old photos of happy times, holidays in childhood or Christmas mornings. Part of those feelings is mourning for those who are now dead, or perhaps for our youth or beauty. At its best, photography was consolation for the dying of the light, or for the slippage, beyond memory, of our pasts. Photographs helped people narrate their own pasts. They were strewn crumbs by which individuals could retrace their steps. In the introduction to this book we imagined what Cleopatra would have seen: the Roman civil war, Mark Antony naked, her twins by him born, and the dying of the light as she committed suicide on 12 August 30 BCE. Imagine if we had photographs of these things. Human history would be less mythical, less like a fable.

It was coming to its end, this first half of the nineteenth century, but it did so with a visual bang, not a whimper. In 1851 a new structure four times the size of St Peter's in Rome was opened in London. Crystal Palace was like a glass Versailles. It was as if Diderot's *Encyclopédie* had come alive. It held 13,000

exhibits, including a model of Niagara Falls, the crafts of the world, the products of the industrial age, the Koh-i-Noor diamond, national pavilions, a forerunner of the fax machine, things that were being made then and speculations as to what would be in the future. The Great Exhibition was a visual portrait of what was known, with the UK at its apex. It was intended as the greatest Come and See ever staged, but did people go? Yes, in their millions. On 7 October alone, 109,915 showed up. The *Art Journal* wrote that 'On entering the building for the first time, the eye is completely dazzled by the rich variety of hues which burst upon it on every side.' The total number of visitors was 6.2 million, a third of the UK's population. Karl Marx saw the whole thing as a capitalist come-on, a shop window, a vulgar incitement to consume, but the great and the good showed up. Of her visit, Charlotte Brontë wrote:

> It is a wonderful place – vast, strange, new and impossible to describe . . . Whatever human industry has created you find there, from the great compartments filled with railway engines and boilers, with mill machinery in full work, with splendid carriages of all kinds, with harness of every description, to the glass-covered and velvet-spread stands loaded with the most gorgeous work of the goldsmith and silversmith . . . It may be called a bazaar or a fair, but it is such a bazaar or fair as Eastern genii might have created . . . Amongst the thirty thousand souls that peopled it the day I was there not one loud noise was to be heard . . . the living tide rolls on quietly, with a deep hum like the sea heard from the distance.

Let's imagine that we are one of the people in that living tide, jostled by the crowd, or carried along by it, brushing past the hoop skirts in yellow and lime, our eyes darting between telescopes, the lamps of lighthouses, Persian carpets and the hats of men. We would see the plunder of the world. The things of modern life encaged and staged. Untouchable and mostly silent, they were there to impress our visual sense. By looking at them we would see the eighteenth century, its capabilities, desires and sense of beauty. There would have been satisfaction in such seeing and, according to Brontë's account, calm. But then came the frenzy of the visible.

CHAPTER 12

THE TRANSPARENT EYEBALL; LOOKING AND THE LATE 1800s: *LITERATURE, LIGHT BULBS, IMPRESSIONISM, CINEMA AND SPORT*

'The second half of the nineteenth century lives in a sort of frenzy of the visible.'

– *Jean-Louis Comolli*, **The Cinematic Apparatus**

'The eye is not a miner, not a diver, not a seeker after buried treasure. It floats us smoothly down a stream; resting, pausing, the brain sleeps perhaps as it looks.'

– *Virginia Woolf,* **Street Haunting**

THE brain sleeps perhaps as it looks. Neuroscience tells us that that is not true, but Virginia Woolf is referring to that switched-off, absorbent, preconscious aspect of looking. The sort of looking that involves self-loss. To what extent can we switch ourselves off as we look? To what extent can we become 'transparent eyeballs'? This was one of the big themes in looking in the late 1800s, and will be the theme of this chapter.

The subjects in what follows are very diverse. We start with new types of naturalist looking in literature, then consider a great exhibition in Paris, electric lighting, Impressionist painting, then cinema, sport and X-rays. It is tempting to separate them into different chapters, but to capture their simultaneity, what Jean-Louis Comolli called the 'frenzy of the visible' in the late 1800s, it is better to think of them as a block. They coexisted in the cultural and technological currents of these years. Informed, educated Europeans had to encounter and understand these innovations together, so we should try to also.

LITERATURE

Human beings had, for centuries, been hung up on unprovable, unseeable things – gods and superstitions. Now that they were building more, travelling more, riding trains, visiting great exhibitions, displaying and buying consumer products, and looking at and taking photos, the optical was on the up. The years of the late 1800s might be best known for painting and the birth of cinema, but the innovative authors of the time are a useful way into its visual world. They drew from literature in previous centuries and prefigured what was to come, so we will flashback – and jump forward – from the 1800s to look at examples of visual writing from other periods.

Reading is non-looking; it is dropping your eyes from the visual world into a book whose text almost wholly replaces direct seeing with abstract markings – words – which in no way resemble what they describe. So why write about literature in the story of looking, and why in the 1800s? Here is why, the ending of Émile Zola's novel *Nana*, about a 'blonde Venus' prostitute and actress who, in this scene, is dying of smallpox:

> Nana was left alone with upturned face in the light cast by the candle. She was fruit of the charnel house, a heap of matter and blood, a shovelful of corrupted flesh thrown down on the pillow. The pustules had invaded the whole of the face, so that each touched its neighbor. Fading and sunken, they had assumed the grayish hue of mud; and on that formless pulp, where the features had ceased to be traceable, they already resembled some decaying damp from the grave. One eye, the left eye, had completely foundered

among bubbling purulence, and the other, which remained half open, looked like a deep, black, ruinous hole. The nose was still suppurating. Quite a reddish crush was peeling from one of the cheeks and invading the mouth, which it distorted into a horrible grin. And over this loathsome and grotesque mask of death the hair, the beautiful hair, still blazed like sunlight and flowed downward in rippling gold. Venus was rotting.

Look at this paragraph and we see a block of words, yet it is surely one of the most visual things in this book. The paragraph is like a retina. The author is trying to ignore what he was expecting to see and force himself to look, to report. He is trying to become a transparent eyeball. His style of writing, naturalism, was born out of journalism, photography, socialism, and the democratisation of culture. Zola was a political journalist, a great photographer, a friend of Paul Cézanne, whose story we are about to hear. In his book *Les Romanciers naturalistes* he theorised naturalism in literature; later distinguished from realism, which was seen as an attempt at presenting less visible, more structural social truths, naturalism's method was apparently dispassionate looking at the physical world. It was evidential and documented looking. It was looking with our preconceptions switched off. Zola's description of the dying Nana is like a crime scene photograph.

Naturalism was *à la mode* in the second half of the 1800s, but it was not new in literature. A detailed account of it – or of the overall role of looking in novels, poetry and plays – is well beyond the scope of this book, so our technique will be to zoom in on moments.

Though our subject is literature in the 1800s, let's rewind for a moment as its backstory is revealing. In China in the late 1500s, *Jin Ping Mei/The Golden Lotus* charted the wrangles in the household of the main character, twenty-something Ximen Qing, with many passages of sexual candour that feel like close-ups of physical details. Still in China, a century before Zola, Cao Xueqin wrote a 2,500-page novel about the decline and fall of four aristocratic families. *Dream of the Red Chamber*'s vast world is more socially grand than *Nana*'s, but, like Zola, Cao has an eye for detail and bears witness to the social, financial, legal and educational dilemmas of his feudal times. As Leonardo da Vinci observed the motions of water in a waterfall, Cao at times seems to freeze-frame the social churn of his country and period, as the living conditions of peasants, overlords and businessmen constantly shift. 'Outwardly, they may look as grand as ever,' he writes, 'but their purses are nearly empty.' Looking past the social façade into the purses of the characters gave naturalism a microscope.

At exactly the time that the anonymously written *The Golden Lotus* was first being read, the author of another early novel was in prison. As a tax collector,

Miguel de Cervantes travelled widely and saw many things which would later make an appearance in *Don Quixote* (1605–15). Picaresque and mordant, the novel skewers the ostentation of literary romance with an eye for earthy details. Its title character sees life through the artifice of such romances, the naturalist elements acting like an astringent squeeze of lemon on the Don's chivalry. Cervantes's edifice of a novel seems to say *Open your eyes* and *Look how little he can see*. Not being able to look was, in Cervantes's book, illusional and delusional. Cervantes was trying to look beyond the conventions of his era's writing.

Back in France, in the 1800s, the idea that a writer should look at life with a 'transparent eyeball' was growing. Amantine-Lucile-Aurore Dupin – better known as George Sand – also was interested in the concrete. A socialist who launched her own newspaper and campaigned for women's rights, she zoomed into details of the lives of those outside the charmed circle of society, and often wrote about the look in science and painting. In a letter to Sand, one of the great literary lookers of the age, Gustave Flaubert, said 'The artist should not appear any more in his work than God in nature.' Though his own descriptions of his methods suggest otherwise, he was driven to write about what was in people's purses and how the world looked. Vladimir Nabokov rightly said that Flaubert disliked 'pretty pretty prose'. In his *L'Éducation sentimentale* his main character, Frédéric, is not a heroic romantic whose passions the author endorses; rather, his life is described externally and objectively. When he sees a woman, Flaubert writes:

> Never had he beheld such a magnificent brown skin, so entrancing a figure, such dainty, transparent fingers. He stood gazing in wonder at her work-basket as if it was something extraordinary . . . He wanted to know what furniture she had in her bedroom, the dresses she wore.

'Magnificent brown skin' and dainty fingers are perhaps to be expected, but gazing at her work-basket is more originally optical – the author is allowing his eyes to do their work without being overly guided – and the furniture and dresses suggest an almost Humean world view. The writer is collecting visual fragments and presenting them like the tesserae in a mosaic.

Eight years after Flaubert's novel, the English poet and Jesuit priest Gerard Manley Hopkins penned an opening verse to his poem 'Pied Beauty' which is amongst the most visual forty-five words in English literature:

> Glory be to God for dappled things –
> For skies of couple-colour as a brinded cow;
> For rose-moles all in stipple upon trout that swim;

> Fresh-firecoal chestnut-falls; finches' wings;
> Landscape plotted and pieced – fold, fallow, and plough;
> And all trades, their gear and tackle and trim.

Dappled things; a couple-coloured sky; brinded, meaning streaked; stippled, pink-moled trout: it comes as no surprise that Hopkins could paint. His writing is as optical as Zola's about Nana.

Jump to America in these decades and we find writers whose eyes are as trained on nature as Hopkins's. In *Walden*, Henry David Thoreau wrote what could be a manifesto of nineteenth-century Romanticism:

> I went to the woods because I wished to live deliberately, to front only the essential facts of life, and see if I could not learn what it had to teach, and not, when I came to die, discover that I had not lived . . . I wanted to live deep and suck out all the marrow of life, to live so sturdily and Spartan-like as to put to rout all that was not life . . . and, if it proved to be mean, why then to get the whole and genuine meanness of it, and publish its meanness to the world; or if it were sublime, to know it by experience.

Like Rousseau's and those of the image-makers of the American West, these were transcendental aims, but their means were naturalistic. In his essay 'Natural History of Massachusetts', Thoreau wrote: 'Nature will bear the closest inspection; she invites us to lay our eye level with the smallest leaf, and take an insect view of its plain.' This is the impulse of the documentarist, the gatherer of visual information. In a diary entry on 3 January 1853 he takes this further: 'I love Nature partly because she is not man . . . None of his institutions control or pervade her. There a different kind of right prevails . . . He is constraint, she is freedom to me. He makes me wish for another world. She makes me content with this.' The naturalistic detail in his writing, then, orientates him and is ballast against alienation. Thoreau called Walden Pond, where he lived, the 'earth's eye'.

Ralph Waldo Emerson has the central idea that helps explains much of this. He writes

> nothing can befall me in life, – no disgrace, no calamity, (leaving me my eyes,) which nature cannot repair. Standing on the bare ground . . . all mean egotism vanishes. I become a transparent eyeball; I am nothing; I see all; the currents of the Universal Being circulate through me; I am part or particle of God.

Evacuate yourself, he seems to be saying. Be nothing, look as if it is all you are, or the start of what you are. Look as if looking is worshipping. In order to deliver its substantive rewards, looking should be selfless. The transparent eyeball sees looking as a release, an opening onto the fields and to the sky.

In July 1855 Emerson wrote to a young journalist about a manuscript the journalist had sent him: 'I rubbed my eyes a little, to see if this sunbeam were no illusion.' The manuscript was the core of the book of poems *Leaves of Grass*; the young man was Walt Whitman. *Leaves of Grass* was a thousand coloured pen pictures to the eye, a hymn to America, men, bodies, nature and passion. A section such as 'Cavalry Crossing a Ford' is eyewitness writing (Whitman had seen first-hand the American Civil War), photographic (the writer was attracted to the new technology) and naturalistic in the new nineteenth-century manner:

> A line in long array, where they wind betwixt green islands;
> They take a serpentine course – their arms flash in the sun – Hark to the
> musical clank;
> Behold the silvery river – in it the splashing horses, loitering, stop to drink;
> Behold the brown-faced men – each group, each person, a picture, the
> negligent rest on the saddles;

The repetition of 'behold' invites the reader to see in the present tense. In the silvery river and each person a picture, you can almost see the silver halide.

Another American contemporary of Whitman seemed to think that looking was central to writing. Here is Emily Dickinson's 'A Bird came down the Walk':

> A Bird came down the Walk –
> He did not know I saw –
> He bit an Angleworm in halves
> And ate the fellow, raw,
>
> And then he drank a Dew
> From a convenient Grass –
> And then hopped sidewise to the Wall
> To let a Beetle pass –
>
> He glanced with rapid eyes
> That hurried all around –

They looked like frightened Beads, I thought –
He stirred his Velvet Head
Like one in danger, Cautious,
I offered him a Crumb
And he unrolled his feathers
And rowed him softer home –

Than Oars divide the Ocean,
Too silver for a seam –
Or Butterflies, off Banks of Noon
Leap, plashless as they swim.

A tiny percussive poem of apparently childlike simplicity (until the last stanza), it has room in it for two lookings. Narrative more than painterly, it nonetheless is clearly optical, a report of an event. And this miniature by Dickinson has the eye as an ailing hunter:

I've seen a Dying Eye
Run round and round a Room –
In search of Something – as it seemed –
Then Cloudier become –
And then – obscure with Fog –
And then – be soldered down
Without disclosing what it be
'Twere blessed to have seen –

And in Scandinavia at the same time, writers were looking with real intensity and new attempts at transparency too. In his later plays Norwegian Henrik Ibsen, 'the father of realism', used the stage as a demonstration chamber to make people look at contemporary life, morality and pretence. In *The Pillars of Society* respected businessman Karsten Bernick's social standing is performative. He makes money from shipbuilding and new investments in railways, and orders a ship to sail, though he knows it is not seaworthy. Ibsen says, *Look at the values that we admire. Look at his ego and hypocrisy.*

But authors looking and describing naturalistically are just one way in which literature can be visual. We again find precedents for what was happening in the 1800s in previous times. In Greek myths, looking is something that gods do more than writers do, often balefully. It is less a way of revealing hitherto unseen social truths, more a metaphor or exhortation. The hunter Narcissus comes across his

reflection in a pool and is so taken by his own beauty that he spends the rest of his days looking at it. In this silk and wool tapestry from around 1500, the pool is a font, he is princely clothed, a paradise of exotic birds, animals and flowers surrounds him, but he has eyes only for himself, so much so that the paradise is in blackness, like the night sky.

The Narcissus myth in Western culture is a warning about excessive look-ing; it is anti-empathic and pre-Copernican. Another caution against looking comes in the Orpheus and Eurydice story. Orpheus can lead his beloved Eurydice out of the underworld provided that he walks ahead of her and does not look back until both have returned to Earth. But concern and curiosity make him turn his head to her before she has left the domain of death, and so she returns to it. The desire to see, suggests the myth, should not always be satisfied. In Greek mythology Argus Panoptes was a multiple-eyed giant. When some of his eyes slept, others were awake, and so he became a symbol of vigi-lance. In the poem *Aegimius* it is said of him that 'with four eyes [he] looks every way . . . And sleep never fell upon his eyes; but he kept sure watch

always.' One of his mythic roles was to keep watch over the white cow Io, but the messenger Hermes lulled each of Panoptes's multiple eyes to sleep, and then killed him. His obsessive, vigilant looking was over. In the tapestry Narcissus is in a kind of heaven. When the Florentine medieval poet Dante came to write *Paradiso*, the last section of his *Divine Comedy*, he envisaged his own progression from seeing in an inferior way, through a glass darkly, to a superior way, as a result of the light of God. His guide, Beatrice, explains looking, to him, as well as the patterns on the surface of the moon and even an optical experiment using three mirrors. In naturalistic literature of the 1800s the authors tried to become transparent eyeballs and register what they saw. In these examples of looking in ancient literature, looking is judged; it becomes the subject of the story and its ethical dilemma.

Back in our current period, the 1800s, looking in literature was not only naturalistic. As in the case of Narcissus, Argus Panoptes and the *Divine Comedy*, it sometimes was an end as well as means, an element of plot or story, and therefore part of the image system of the novel in particular. The transparent looking of the author gave way to the story looking of characters. In Herman Melville's *Moby-Dick* the narrator Ishmael so wants to remember the size and details of a whale skeleton that he has them tattooed on his arm:

> The skeleton dimensions I shall now proceed to set down are copied verbatim from my right arm, where I had them tattooed . . . But as I was crowded for space, and wished the other parts of my body to remain a blank page for a poem I was then composing – at least, what untattooed parts might remain – I did not trouble myself with the odd inches; nor, indeed, should inches at all enter into a congenial admeasurement of the whale.

He looks at the visual aide-memoire and enjoins the reader to do likewise:

> But as the colossal skull embraces so very large a proportion of the entire extent of the skeleton; as it is by far the most complicated part; and as nothing is to be repeated concerning it in this chapter, you must not fail to carry it in your mind, or under your arm, as we proceed, otherwise you will not gain a complete notion of the general structure we are about to view.

We are about to view: conjoined, present-tense looking.

'There is no writer who is so much a painter and a black and white artist as Dickens,' wrote Vincent Van Gogh in 1883. Many have argued that the panoply

of visuals in Victorian England shaped the stories and looking in his novels. *Bleak House* opens with a brilliant foggy sequence that is like a Turner painting, and then there is the boy Pip's visit to the Gothic house in *Great Expectations*. He goes inside, and Dickens's writing is about light, objects, colour, materials, seeing, discerning:

> No glimpse of daylight was to be seen in it. It was a dressing-room, as I supposed from the furniture, though much of it was of forms and uses then quite unknown to me. But prominent in it was a draped table with a gilded looking-glass, and that I made out at first sight to be a fine lady's dressing-table.
>
> Whether I should have made out this object so soon, if there had been no fine lady sitting at it, I cannot say. In an arm-chair, with an elbow resting on the table and her head leaning on that hand, sat the strangest lady I have ever seen, or shall ever see.
>
> She was dressed in rich materials – satins, and lace, and silks – all of white. Her shoes were white. And she had a long white veil dependent from her hair, and she had bridal flowers in her hair, but her hair was white. Some bright jewels sparkled on her neck and on her hands, and some other jewels lay sparkling on the table. Dresses, less splendid than the dress she wore, and half-packed trunks, were scattered about. She had not quite finished dress-ing, for she had but one shoe on – the other was on the table near her hand – her veil was but half arranged, her watch and chain were not put on, and some lace for her bosom lay with those trinkets, and with her hand-kerchief, and gloves, and some flowers, and a prayer-book, all confusedly heaped about the looking-glass.
>
> It was not in the first few moments that I saw all these things, though I saw more of them in the first moments than might be supposed.

Thirty-five references to seeing, and the objects seen, in a few short paragraphs. The point here is not that this number of visual references is unusual in literature, rather that there are more of them than we perhaps notice. Authors often tell us what their characters think, but frequently what they see too. Much of literature is described seeing.

A similarly intense visual encounter occurs in Henry James's *Portrait of a Lady*, published twenty-one years later, in 1881. Seeing the scheming Madame Merle during a convent visit, Isabel Archer has the final proof that her recent life and marriage have been part of a strategy to access her inheritance. The scene is so involved, and so much about what is being seen, that it needs to be quoted at length:

Isabel got up, expecting to see one of the ladies of the sisterhood, but to her extreme surprise found herself confronted with Madame Merle. The effect was strange, for Madame Merle was already so present to her vision that her appearance in the flesh was like suddenly, and rather awfully, seeing a painted picture move. Isabel had been thinking all day of her falsity, her audacity, her ability, her probable suffering; and these dark things seemed to flash with a sudden light as she entered the room. Her being there at all had the character of ugly evidence, of handwritings, of profaned relics, of grim things produced in court. It made Isabel feel faint . . .

Madame Merle had guessed in the space of an instant that everything was at an end between them, and in the space of another instant she had guessed the reason why. The person who stood there was not the same one she had seen hitherto, but was a very different person – a person who knew her secret. This discovery was tremendous, and from the moment she made it the most accomplished of women faltered and lost her courage . . . She had been touched with a point that made her quiver, and she needed all the alertness of her will to repress her agitation.

Isabel saw it all as distinctly as if it had been reflected in a large clear glass. It might have been a great moment for her, for it might have been a moment of triumph. That Madame Merle had lost her pluck and saw before her the phantom of exposure – this in itself was a revenge, this in itself was almost the promise of a brighter day. And for a moment during which she stood apparently looking out of the window, with her back half-turned, Isabel enjoyed that knowledge. On the other side of the window lay the garden of the convent; but this is not what she saw; she saw nothing of the budding plants and the glowing afternoon. She saw, in the crude light of that revelation which had already become a part of experience and to which the very frailty of the vessel in which it had been offered her only gave an intrinsic price, the dry staring fact that she had been an applied handled hung-up tool, as senseless and convenient as mere shaped wood and iron . . . But she closed her eyes, and then the hideous vision dropped. What remained was the cleverest woman in the world standing there within a few feet of her and knowing as little what to think as the meanest . . . Then Isabel turned slow eyes, looking down at her. Madame Merle was very pale; her own eyes covered Isabel's face. She might see what she would, but her danger was over.

So many glances, so many eye movements. Seeing gives Isabel a story shock; being seen disgraces Madame Merle. Isabel looks away as if to cleanse her eyes,

then closes them, then turns slow eyes – a *J'accuse* – and then the culprit's eyes cover the victim's face.

One more example of looking's narrative role in literature, this time a flash forward to the twentieth century. In *A Clockwork Orange*'s futuristic, totalitarian state, fifteen-year-old Alex is imprisoned after a brutal crime spree. After some years, as a correction therapy, he is forced to watch extremely violent films. He describes the moment in the book's distinctive language:

> One veshch I did not like, though, was when they put like clips on the skin of my forehead, so that my top glazz-lids were pulled up and up and up and I could not shut my glazzies no matter how I tried. I tried to smeck and said: 'This must be a real horrorshow film if you're so keen on my viddying it.' And one of the white-coat vecks said, smecking:
> > 'Horrorshow is right, friend. A real show of horrors.'

Glazz-lids are eyelids, of course, and viddy is watch or see. Stanley Kubrick's film of the novel depicts the moment with relish, as if Alex's eyes are to be operated on or extracted.

Author Anthony Burgess uses looking as punishment rather than, as in the case of Orpheus, crime. Other types of literary looking would take place in the twentieth century, when the central metaphor could be said to be the sliced, rather than transparent, eyeball.

Horrible sores on the face of a dying woman; the patterns on the back of a trout; cavalry crossing a ford; Narcissus looking at himself; the tattoo of a whale; Miss Havisham; scheming Madame Merle; dystopian punishments: literature in its many modes has been a vast gallery of looking.

France had been the heart of visual writing in these years, and Paris the heart of that heart. What was it like to be in Paris in the late 1800s, and walk its streets or sit in its terrace cafés, where the seats would soon be laid out in rows pointing outwards onto the boulevards, all the better to people-watch? The writer Charles Baudelaire helps us see. He was not only a great looker, he was a great new looker. In Paris in these years he asked himself *What am I seeing? And why does this feel new?* He realised that looking in cities was kaleidoscopic, a series of fragments that we then edit together. 'It is residence in the teeming cities,' he wrote to Arsène Houssaye, 'it is the crossroads of numberless relations that gives birth to this obsessional ideal.' His use of the word 'ideal' is surprising because artists and thinkers had usually seen beauty in nature or power or the female nude, but Baudelaire saw the 'Ant-swarming city, city abounding in dreams / Where ghosts in broad daylight accost the passerby' ('*Les Sept vieillards*') as the new beauty. He celebrated looking at movement, which we saw in Natalia Goncharova's painting *The Cyclist* and Étienne-Jules Marey's photographs of the man mounting his bike, and at the visual flooding a city affords, what in painting would soon be called Impressionism.

In the 1930s Baudelaire helped inspire the German critic Walter Benjamin to produce a vast, materialist, unfinished montage book about the visual and psychological experience of walking in crowds and cities. His exhausting *Das Passagen-Werk* was a snowstorm of quotations and observations about the sort of world we see in this 1877 painting *Paris Street: Rainy Day*.

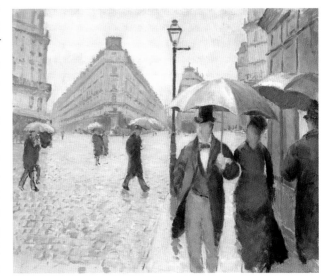

The well-dressed man and woman are out walking. She takes his arm. Their eyes are caught by something to their right. It could be a piece of advertising, someone wearing the latest fashion, or an event at a café across the street. Behind them the boulevard splits into three canyons. Our couple will have walked down one of them, perhaps

through an arcade, and looked into shop windows. Their eyes will have fallen on objects for sale, the detritus of the new consumerism. Life for them has been strewn with things under glass: vitrines of dolls or something more surreal, false teeth, horn-rimmed eye glasses. Their looking has become like dreaming or consuming, or both. They are out to be seen, and will have been seen, but also to swim in the city phantasmagoria. If someone falls and breaks a leg they will stare like the people in the Colosseum stared, like the early lookers stared at the goat. Their faces are smudged. They have no eyes. They have become transparent eyeballs, lost in the visual world of the boulevard.

Or so it seemed. Many writers challenged the idea of disinterested seeing and said that we cannot escape the ideas and ideologies of our times. If Walter Benjamin wanted us to be critical of seeing by thinking of it as a kind of commerce, three decades later, in the 1960s, again in Paris, Guy Debord cattle-prodded it even more. He said that we are living in a society of spectacle, that people like the umbrella couple overleaf only *think* that they are free to wander around and that, in fact, city seeing is an illusion, that we are hypnotised by capitalism, controlled by its apparent pleasures – visual and otherwise. He wrote of 'the decline of being into having, and having into merely appearing'. Debord counselled resistance, a city unseeing. He would have found the idea of the transparent eyeball very naive.

Urban developments in Paris in the coming century showed that his scepticism about looking was justified. The oil crisis of the 1970s, the construction of low-cost block housing on the edge of French cities, increased unemployment and poor transport links created, towards the end of the twentieth century, a new type of urban unseen. The *banlieues* (suburbs) of Paris and other cities were not necessarily built for disenfranchised and disadvantaged citizens, such as those who arrived from former colonies like Algeria, but they became dominated by them. Living conditions were very different from those of monumental, touristy Paris, with its pavement cafés and boulevard sight lines. Buildings were poorly maintained, and tourists seldom went there; there was nothing to see, or what was seeable was shameful. To live in some of the *banlieues* was to look, every day, at your disadvantage. Take the RER train from where you lived to rich central Paris and you saw an increase in building maintenance, affluence and spectacle.

Guy Debord and his fellow Situationists played with those kinds of journeys. He suggested, for example, that we should walk around one city with the street map of another in order deliberately to misread the signs a city has for directing us to its centre, its places to buy and desire.

Misreading was not on the mind of Napoleon III, the nephew of the first Napoleon, when he announced that in 1867 the looking city, the city of

light – Paris – would host a Universal Exposition. As if to augment the visual craze of his time, his exhibition would be four times the size of London's in 1851. At first it seemed jinxed. Heavy rain delayed the completion of the half-a-kilometre-long exhibition spaces, which were shaped like concentric Roman fora. The grand opening was clodded with mud. But the lure of the more than 50,000 exhibitors was greater than the drawbacks, and eventually seven million people flocked to see things from the future: tyres, dynamite, typewriters, a phonograph. The London *Times* said that it contained 'all that may be more or less worth seeing'. In echoes of the colonial accruals of previous centuries, the world's valuables had come to Paris. Another exhibition in the city in 1889 led to the construction of what was then seen as a folly, an epic structure which had no purpose but which was great to look at and from, the Eiffel Tower.

Elsewhere in these years, looking was expanding in other imaginative ways. For example, a canal across the south of Sweden had been mooted as long ago as 1516, but eventually, in 1832, after twenty-two years in the making, the 120-mile Gota Canal allowed people to sail, via a series of lakes, from the Baltic to the North Sea. In 1869 the shorter Suez Canal (120 miles, ten years in construction) linked the Red to the Med and created a surreal sea artery in the desert. Both led dead ends to be reimagined as thoroughfares. Neither can be seen as an example of the transparent eyeball. Both were interested, driven, engineered looking.

The same could be said about the new types of illumination that emerged. City thoroughfares in the 1800s began to look like this one, Washington Street, Indianapolis.

Theodor Groll's painting is not so much about the buildings as the light. As the sun sets, gas street lighting supports ecosystems – the horse-drawn trolley, the drugstore on the right, the street market tent in the foreground. Where daylight was high and wide, gaslight created rock pools; it was warm, lustrous and gloaming. Before gas lamps, the Sun, fires and fireflies were amongst the very few things in the world that produced light. Almost everything else, like the

Moon, were photoreceptors and reflectors, so nearly everything we had seen was the result of ambient light that bounced off something rather than being produced by it. Gas lamps were different. They started to be more widely used in London from around 1812. The Unter den Linden in Berlin, down which Napoleon had marched, was gaslit from 1826.

Then, of course, came incandescent electric light bulbs. In his factory in New Jersey, after developments by many others, the manic inventor Thomas Edison (who hung up a sign that said 'There is no expedient to which a man will not resort to avoid the real labor of thinking') made carbonised threads of cotton and, eventually, bamboo glow for up to a thousand hours. This image of Russian peasants installing their first light bulb captures the curiosity of those whose lives had been previously under-illuminated. Their purpose was to let us look at other things, but at first we looked at them.

The brightening of domestic interiors shifted sleeping and working patterns – you could stay up longer after dark – and gave people whose eyesight was fading a new lease on looking. In 1910 neon lighting appeared in Paris, and then, in the advertising centre of the world, the USA, it was extensively used for luminous signage selling places and things. Neon was never really intended to brighten the space around it; rather, its often hot colours sang out from night-time cityscapes or motels on open roads, suggestive of welcome, insomnia or eroticism, evocative like the notes of a distant clarinet. The new gas, electric and neon lights in cities were handmaidens for new types of work and leisure. Sometimes they created visual mood. At other times they allowed the kind of switched-off, objective, journalistic looking that Zola attempted in his description of Nana's horrific death. They extended the visual world of the 1800s in rich countries.

IMPRESSIONISM

Brightening was happening in painting, too, but in a very different way. A traditional technique used by older painters was to underpaint the canvas with '*le sauce*', a mix of oil and tar which gave a rich, deep tone and prevented brighter colours dominating. This began to change in the 1800s as the paints used by innovative artists got lighter. Just as street lighting extended life into the night, so new artists started to investigate the effects of daylight more directly than previously.

Their eyeballs, it could be said, became more transparent. They wanted to remove history and convention from their seeing. They started to do this in their depiction of movement. It is often claimed that the flying gallop of horses in traditional painting, in which all four legs are extended, was 'corrected' by painters when they saw photos of actual galloping horses, but *The Horse Fair* by Rosa Bonheur, the most famous female painter of the nineteenth century, was painted in 1852–55, before horse photographs were available, and accurately represents leg positioning. Like Leonardo, Bonheur dissected animals to understand their muscles and movement. She wanted to unlearn how galloping had been previously depicted and use the evidence of her own eyes like a journalist or detective or writer like Zola.

Art was a fashionable entertainment in Paris in these decades. A hundred new galleries opened in Paris in the 1860s. Up to a million people, out of a city population of 1.7 million, would visit the annual salon of painting. In a demure

era, when women were not even allowed on the top deck of public transport lest their ankles could be glimpsed, in the salons you could see nudes. Manet's *Le Déjeuner sur l'herbe* (1862) was rejected by the 1863 salon, but showed in the Salon des Refusés, its scandalous upstart, to which people also flocked. The times they were a-changing in painting. The lives and new ways of seeing of radical painters like Manet and Courbet were generating column inches. Émilien de Nieuwerkerke called them 'men who do not change their underwear'. In 1867 Zola visited Manet's studio, loved what he saw and acclaimed it in print. Manet wrote back: 'I am delighted by your remarkable article . . . I have not been considered worthy of the benefits enjoyed by other artists.'

One of many influences on the emerging ways of seeing in painting was Japan. The 1854 treaty of Kanagawa had opened the country up to the West. Japanese art was exhibited for the first time in Paris's Universal Exposition; Vincent Van Gogh saw it there, started collecting it and, as a result, painted the remarkable *Courtesan or Oiran (after Keisai Eisen)* (Paris, 1887), below left.

It looks like a screen, and has no shadows; the courtesan's dress is a series of two-dimensional patterns, her face is clearly Japanese and her hair decorations are

not like anything used by French women. To see how closely Van Gogh was influenced by the Japanese artist in the painting's title, on the right is Keisai's original, produced sixty-five years previously. He was dead by then,

but the composition, form, colours, fashion and pose are all remarkably similar. The influence of Keisai on Van Gogh shows that the latter was not, at this stage, trying to be Emerson's ideal, the transparent eyeball. He was not attempting to do away with visual templates. Instead, he was looking to Asia for unfamiliar ones. He took a detour to the other side of the world in order to defamiliarise his looking. Soon he would return to his immediate environs and become one of the most localised painters ever.

Other painters of the day tried to refresh their seeing and painting in other ways. To the visual changes brought about by the removal of *le sauce* and the influences of photography and Japan, we can add the loosening of the pictorial surface. The fastidious details in the paintings of Vermeer and the most prized French artist of the 1860s, Jean-Louis-Ernest Meissonier, started to seem fussy and academic. History painting, which was once the most prestigious of the genres, tumbled from its pinnacle. Art was less in service of the state; the unceremonious, quotidian and spontaneous caught painters' eyes. Zola's impulse was theirs too.

The origins of the visual changes, the breakdown, can be seen in the canvases of several artists. French painter Eugène Delacroix's horses had reeled and trembled. His skies had no time for academic niceties and the 'licked finish'. The wildness of Romanticism made his brush leap. He wanted looking to be stormy and convulsive. His fellow Frenchman Gustave Courbet mocked norms with his lusting over a woman's vulva, and the surface of his pictures of trees

in winter looked like they were boiling. Turner seemed incapable of crispness, presenting worlds of pathological fog haunted by sunsets or furnaces, an ardent aurora. On the other side of the world loose brushwork was commonplace. This, by Chinese artist Xu Gu (1824–96), is perhaps tree branches dangling in a river, but the page shows through bits of the branches, the lines are done with the side of a dryish brush, and the water could hardly be suggested in a more fleeting or smattered manner.

The drive to newness and the unforeseen use of paints in the service of fresher seeing continued. Oil painting was becoming more like watercolour. Artists started using oils *en plein air*. In 1872, in his home town of Le Havre – an unfancy, unceremonious place – Claude Monet did a seascape with as much dash as Xu's, and borrowed Turner's gauzy sunset.

He had been using new chemical paints – cobalt violet and chromium oxide green – and had the courage not to make his painting like a mirror image of the scene, in the traditional, academic way. He took a step back, cared little about the z-axis, risked being told that a child could do this, did something trippy, and saw that colour is not just a means to an end. Looking is smear here, and spatter and patch and daub. In *Ways of Seeing* John Berger pointed out that talking about the way a picture is painted often ignores its social meaning. Monet's painting makes no comment on the fact that its beauty comes from pollution, which would in time lead to global warming. Monet was not a visual moralist, and the art market sold his paintings on aesthetics rather than as documents of contamination. He called the above painting *Impression: Sunrise*. It gave its name, in 1874, to a new term, Impressionism, a label which stuck to a group of painters rejected by the salon in that year. The word implies immediate, unrehearsed, improvised and perhaps transparent looking.

It is easy to be impressionistic about Impressionism, so let's stand in front of one single canvas, this one, in the Courtauld Institute in London. It is by Paul Cézanne, whose *l'optique se développant chez nous* inspired this book. Cézanne 'completely shattered the block', said the Swiss sculptor Alberto Giacometti. In his sixty-seven years he produced about a thousand images. Though he did most of them in provincial Aix-en-Provence, he was no backwater looker. He wanted, he said, to astonish Paris with an apple.

Route Tournante is so beautiful that we could just look at it and say nothing, but beauty is provocative – it makes us want to understand our arousal – and so let's try to. If you are teaching art you want to get the students to learn to look, for example at a landscape with a tree on the left, a church in the middle and a

winding path in the foreground. If they have seen many paintings, which they will have, and which Cézanne had, they will see something like this Claude Lorrain image.

It is a landscape with a tree on the left, a distant building and a foreground. If the art students are painting the landscape they are looking at, they will project onto it the previous landscape paintings they have seen, many of which will look

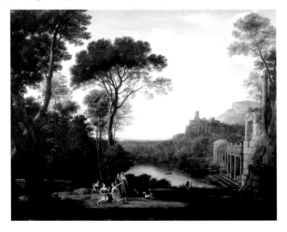

like this Claude one. As their teacher, your job is to help them see beyond the formulae, to overcome what E.H. Gombrich calls 'an inability to see'. Perhaps you will encourage them to be more like Emerson, Zola or Rosa Bonheur. The English painter John Constable wrote that 'the art of seeing nature is a thing almost as much to be acquired

as the art of reading the Egyptian hieroglyphs'. This is overstating it, but forcefully makes the art teacher's point that seeing is not natural or easy. Way back in the first millennium CE, Ibn al-Haytham had said 'nothing visible is understood by the sense of sight alone, save light and colours'.

They all could have been talking about Cézanne's painting *Route Tournante*, not an Impressionist painting, but one which inherited the radicalism of Impressionism. Flick our eyes between it and Claude's landscape and we see how much Cézanne was rereading the hieroglyph of nature. *Le sauce* is gone. Where the Claude image is honeyed, Cézanne's is bluer. Claude's painting is varnished, as if it is behind a pane of glass. Cézanne's is raw. Claude's warm greens merge into cooler ones. His colours are mixed to give gradation of tone. In Cézanne's picture, a sage green sits next to an almost violet blue without trying to find a halfway house. In the 1700s a painter's aid was invented to stop colours 'jumping' in this way. The 'Claude glass' was a warm-toned, slightly convex mirror, in which the artist looked at a landscape's reflection. It unified the colour scheme, reduced contrast somewhat, and gave a dusky glow to the scene. Cézanne had no time for such one-stop optical tricks.

The Claude picture works the z-axis by making the two figures by the lake about half the size of those in the foreground, and tapering the buildings on the right as they move away from the picture surface. Cézanne rejects such perspective and the idea of vanishing point to the extent that the brushstrokes of the trees on the left seem on the same plane – a close one – as those of the bushes behind the church, hundreds of metres away. The paint is not creating the illusion, it is denying it. Call this the Japanese surface. Giacometti understood this flattening process in Cézanne's looking, especially in regard to portraiture:

> As he painted the left ear, he established a greater rapport between the ear and the background than between the left ear and the right ear, a greater rapport between the colour of the hair and the colour of the sweater than between the ear and the structure of the skull.

As we have seen, when we look we deploy information we have already gathered about the world – say, the structure of a skull – in order to give form to momentary optical data. Cézanne, says Giacometti, was trying to decommission such information.

Look a little longer and more differences between Cézanne's and Claude's paintings emerge. Claude's is called *Landscape with the Nymph Egeria*, a B-list Roman goddess associated with good counsel. Cézanne's is a nymph-less, everyday scene. It is not valuable because it refers to great meaning, but because looking at the

everyday is valuable. Claude's brushstrokes are invisible – to see them would be to get in the way of the illusion. In art classes people were taught that if you do leave your brush or pencil strokes visible, ensure that they follow the contours of the object or the scene, so that they assist in the space-building within the image, and move the eye around the objects. Cézanne seems to have no time for this. Most of his brushstrokes are vertical and of roughly equal length as if, again, they are briefing against the message of the picture, or as if it is raining heavily and we are looking through the rain, or through frosted glass. In 1904 Émile Bernard expanded on such patches, as he called them: 'To read nature is to see it beneath the veil of interpretation as coloured patches succeeding one another according to a law of harmony. These major hues are thus analysed through modulations.'

It might seem that spontaneity is the aim of these modulations, but soon we realise that Cézanne's blocky paint marks and measured alignments between foreground and background create not a sense of dash, but rather contemplation. He wrote that he wanted to create 'something solid', which *Route Tournante* is, but then added 'like the art in the museums', which perhaps comes as a surprise after noting the ways in which he differs from Claude. Yet Cézanne is classical like Claude. Classicism is equilibrium, visual and thematic balance, a rejection of excessive emotion or expressivity. Thus we arrive at the apparent contradiction that, in

the late 1800s, French painters wanted not to see like Claude, to be freer than him, but some of them ended up giving ballast to their visual sensations by returning to his solidity.

Look at the solidity in this painting of Cézanne's wife, Marie-Hortense. He had been married to her for three years by the time he did this picture in 1888–90, so we might have expected intimacy, but she is as stiff as a board. There is so little z-axis that she hardly seems bent at the waist, as if she is standing rather than sitting.

When he looked at his wife in order to paint her, he saw an object like the curtain

and mirror that poke into the picture as objects. 'I paint a head like a door,' he said. The painting has so many apparent mistakes. She leans to her left, the dado rail behind her does not quite link up, the mirror and curtain are strangely visually heavy. As a piece of pictorial psychology, the image seems misdirected; inhuman things are emphasised.

Madame Cézanne's famous right eye seems to register this. Eyebrow arched and impatient, it looks like she has stuff to do and, having sat for her husband before, she perhaps knows that the curtain is catching his eye as much as she is.

She was right, and a letter from Cézanne to Émile Bernard explains why. 'The eye educates itself,' he wrote,

> by contact with nature. It becomes concentric by looking and working. What I mean is that, in an image, an apple, a ball, a head, there is a culminating point; and this point is always – despite the tremendous effect: light and shadow, sensations colorants – the closest to our eye.

In other words, Cézanne is saying do not be distracted by 'the tremendous' optical effects of shadows, etc. Remove z and shading, contour and what you know about an object, or person or landscape, and then render. This is Emerson's transparent eyeball rethought to remove any sense of the moment or indecision.

Cézanne's master, Camille Pissarro, summed this up well:

> When I start a painting, the first thing I strive to do is catch its harmonic form. Between this sky and this ground and this water, there is necessarily a link. It can only be a set of harmonies, and this is the ultimate test of painting.

He could have been writing about *Route Tournante*. The approaches of Cézanne and Pissarro involved two types of looking – past the canvas, into the world, and then at the canvas, using only those aspects of the just-seen that are relevant to the canvas-world. Looking and de-looking. The melody and the harmony. Cézanne's was a 'harmonic form' of looking.

Once you have misgivings about the illusionistic optical information you receive by standing in one place, during one condition of sunlight, then you allow other information to enter into the experience of looking. The Spanish painter and sculptor Juan Gris, who was born just a year before Cézanne painted the above picture of his wife, reworked a Madame Cézanne painting as follows:

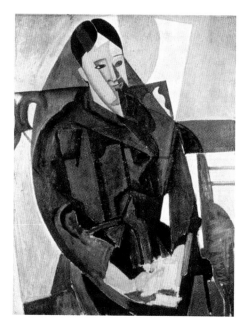

We recognise the stiffness, the raised eyebrow and the hands which would rather be doing something more useful. In copying the original, Gris has brought out its latent geometry. Straight lines have become straighter, curves more regular, contrasts more extreme. *Route Tournante* was not only a winding road in a landscape in Aix-en-Provence. In the story of looking, such images by Cézanne helped change the direction in which artists saw. Though they were out in the world, *sur le motif*, there was a degree of unlooking in their method. But then, to complicate things further, came a new technology of *plein air* looking which seemed like the most literal realisation of the transparent eyeball imaginable. Using a machine – a film camera – to record reality was, surely, the greatest mechanical method of creating objective looking ever invented. Surely it was the best way of showing what Nana's awful death would have looked like? Surely it was, then, Zola's dream of naturalism come true? In a way, yes, but almost at once the new technology became less about the machine and more about the ghost in it.

CINEMA

Films were first projected on a big screen for a public audience in 1895. Much has been written about the shock those first audiences felt, but it was the shock of recognition. Human imagination had long been phantasmagoric. To the question *Is this all there is?*, people had responded with monumental sculptures, mythic stories, theories of the heavens, rituals, the wildness of Dionysus, altered states and a fascination with desire. All these were projections. Consciousness was so immersive and illusionistic, so imbued with memory and longing, that it could not be kept hidden under a bushel. It needed to be seen and rendered, and god and myth were stabs at that.

The new stab was cinema. To capture the mystery of thought and feeling, it needed to be mysterious and hard to pin down, and so it was. It needed to feel absolutely real and of the moment, and so it did. Its way of doing so was remarkable. It threw up a succession of still images with such rapidity that they seemed to move. Futurist painters attempted something like this, and Étienne-Jules

Marey's chronophotograph of a man climbing onto a bike attempted to show movement. Further back, in the early 1600s in Japan, an image like this by Hon'ami Kōetsu and Tawaraya Sōtatsu could be seen either as a flock of cranes or one crane taking off, its movement not blurred but stepped, a sequence of frozen instants, glimpsed then gone.

By the 1800s the desire to see an image move had led to various magic lantern superimposition illusions and spinning devices like the zoetrope that gave the juddering effect of locomotion. In the new technology of film the pictures were not moving, of course. Each is replaced with a successive image so quickly that we do not see the replacement. Instead, we see a flow. The image seems to move.

All sorts of illusionistic movement were suddenly, newly, possible. One of the simplest was also amongst the most resonant: in England, a photographer – George Albert Smith – was one of the first to put a camera on the front of a train, creating a ghostly forward movement, the 'phantom ride'.

Decades later, in his documentary about the Holocaust, film-maker Claude Lanzmann filmed shots on the same train lines that took the Jews to the homicidal gas chambers. His phantom rides looked very like George Smith's, but were ghostly in a much more solemn way in that they paid homage to the millions of people who were now dead and whose last journey the train ride was. Moving forward, smoothly, along the z-axis continued to fascinate film-makers. Director Stanley Kubrick used the same technique near the end of his epic sci-fi film *2001: A Space Odyssey*. We move through space and light and advance towards something, into another realm – perhaps deep space.

Audiences had a sense of moving beyond the realm of the story and seeing into the outer edges of consciousness.

Such mobility gave us the word 'movies', but cinema brought other types of new looking. Though it is often watched on YouTube on small screens – even phones these days – for decades a defining feature of cinema was that it was bigger than life. It involved a massive magnification. In the past, monumental sculptures like the Sphinx in Giza presented things many times larger than life size (its face is about fifty times larger than a real one), but this was relatively rare in human culture.

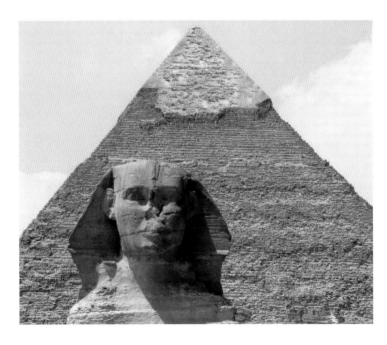

But then cinema magnified everything. Alfred Hitchcock's film *Marnie* starts with a close-up of this yellow handbag. In the 1960s, when the film was released, movie screens were so large that the handbag will have been at least six hundred times bigger than a real handbag.

Such scale reified the object. In the scenes that follow in *Marnie* we see the dark-haired woman who is carrying the bag dye her hair its colour, blond, and then it is revealed that she is a thief, so the bag's prominence heralds her swag bag and visual change. As the film is also about sexuality, it is easy to see something sexual in the bag's shape. No words are used, but colour, design and magnitude imply the world of the story or, you could say, its dreamscape.

More often, of course, it was not objects that were inflated in a film's image system, but faces. A close-up of a movie star on a big cinema screen was often larger than the Sphinx or the monumental sculptures of ancient Greece and Rome. Seldom before was human physiognomy so available for inspection. Faces were like clouds in the sky – vast, mobile things in which you could see other things. A tear felt like a waterfall. Seeing human emotions on a vast scale was cathartic. It afforded a surrogate emotional life. Proxy grief and joy were available for the price of a movie ticket. People had found those in Greek plays and the *Mahabharata*, to name just a few of cinema's predecessors, but never in such numbers. Cinema was the people's visual art.

This was particularly so in India, where it became that polyglot country's lingua franca, and the world's biggest movie industry. Hindi films were long, polygeneric tapestries of life, loss and love, with musical interludes, epic time-lines, and frequent flashbacks. Mainstream Hindi films – now slightly condescendingly called Bollywood – sought to offend no one, so were chaste and merely suggestive of sexuality. This relative censorship of the unclothed body sent the camera upwards to the face, which had to carry much of the film's meaning and intent. This meant that glances in Hindi cinema did more than in any other national cinema, and so the actors' eyes seemed to direct the film and stand for much more than eyes. In this famous moment in *Devi/The Goddess*

(a Bengali film), the teenage Sharmila Tagore slowly lifts her eyes up into frame and looks into the lens.

A top light creates shadows in her eye sockets, but a second light just below the camera gives a point light in her pupils and highlights the tip of her nose. The celebrated emphasis in Indian cinema on eye make-up widens her young eyes, and the emphasised eyebrows frame them. In the story she has, against her will, been declared a goddess who can heal the sick, so this is the face of a young woman saying *Do not do this to me. I do not understand your look.* Satyajit Ray's film reprehends the naive worshippers of this new goddess, but the kohl and ivory luminosity of the image – shot by one of cinema's great cinematographers, Subrata Mitra – avails itself of that worship.

Eyes have fascinated moviemakers. Filming an eye with a camera confronts two looking things, one organic and one inorganic. Each seems in love with the other. Each can do things the other cannot. Working in Paris in the mid-1920s, Brazilian Alberto Cavalcanti produced this image, a beehive of eyes, which he intended to represent the multiple, sometimes oppressive, looking that takes place in cities.

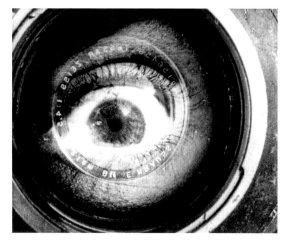

Three years later, in four Soviet cities in 1929, Dziga Vertov filmed *Man with a Movie Camera*, from which this famous superimposition comes.

Eyes and camera lenses have such affinities for each other that it was inevitable that someone would combine them into one shot. In doing so Vertov the technophile seems to be saying how versatile and alert cameras are. He used the term 'cine-eye', and wrote 'I am eye. I am a mechanical eye. I, a machine, show you the world as only I can see it.' Others would emphasise that because a camera is not linked to a feeling brain, it is dispassionate and amoral. Back to the transparent eyeball.

What is certainly true is that cinema has been good at heroic and even godlike looking. Indian cinema has produced the most extensive – and dynastic – movie star system on earth, perhaps influenced by Hinduism's vast and vividly visual system of gods. Other national cinemas were not averse to mythology either. This moment in a mainstream American film of the 1970s was Hindu-heroic.

On the right is an ascetically dressed knight of the Jedi, a monastic, scholastic order of reluctant warriors who value service, solitude and restraint. In the middle is his younger, impatient trainee. The older guides the younger on how to channel the force of life. Like a transcendent samurai, the young man – Luke Skywalker – looks to a sword which, as part of his rite of passage, he must learn to use with his unconscious mind. Both look – Luke – at the light. The future of the world is at stake, as war is gathering. It falls to this young man to 'assume the port of Mars', to turn into a hero.

Star Wars – one of the most seen cultural artefacts ever – was, then, a visual thing about what cannot be seen – its fictive 'force'. Its design was bright, dynamic and comic book, and such things came to be seen as 'cinematic' in mainstream culture; yet, at a deeper looking level, cinema was about other things too. In particular, movie directors discovered that the new technology was the art of point of view. Take, for example, this shot from one of the greatest films, Larisa Shepitko's *The Ascent*.

Unlike most of the images in this book so far which feature human beings, it does not seem to be framed with the human being in mind. Almost like Cézanne's wife, the man seems to be just one element in the shot, the other being the space above his head. Most film-makers' instincts are to frame the actors, to be anthropocentric. The greatest directors often do this too, but they also realise that although cinema is a machine, it has an implied subjectivity. It feels like a person looking. Film-making is the art of implying that the equipment has a heart, a brain, an ethical system.

So, of course, Shepitko and her cinematographer have not misframed the man's face. Rather they show us a soldier, Sotnikov, in the Second World War in Belarus. He gets shot in the leg and is being transported through a biting winter landscape, on a sledge. He is lying on his back. His friend is opposite him, and so, initially, this image shows the angle at which his friend looks. The foreshortening makes story sense. But then, perhaps with the pain of his injury, Sotnikov seems to begin to lose sense of where he is. His eyes look upwards and the camera tilts up. The image is no longer what his friend sees, but what Sotnikov seems to see – a gliding landscape. His head, poking into the bottom of the frame, remains almost static, but the background is a glissade. Shadows move across his face as if to conjure the clouds above him. The shot demonstrates the complexity of looking in cinema in that, without a cut, an image can change from showing what the subject sees to what the object sees. And all the time, of course, we are coupled to the seeing. Theirs is ours.

But even closer to the heart of cinema than bigness, closeness, heroism and point of view are shots and cuts. Before cinema there was nothing in the world like the combination of a shot and a cut – a chunk of life-time, then its sudden disappearance. (Though is a cut a disappearance, an event, or just something no longer being there? Does a shot have a wake?) Maybe cinema feels so alive because it is its opposite by other means – close to death. Like still photography, to use that phrase from Roland Barthes again, it is 'a catastrophe that has already occurred'. To see what is meant by that, look at this image from Ousmane Sembène's film *The Black Girl*.

Mbissine Thérèse Diop plays a young Senegalese woman who at first is happy to become a housemaid for a white French family. The film is full of blazing sun, but in her servitude and solitude Diop's character loses the will to live. Her face becomes expressionless, like a mask – a carved mask is the movie's main symbol – and she eventually commits suicide.

Cinema is full of death, of consciousness coming to an end, and some of its power comes from the fact that its basic form is like a death. A vibrant thing – a shot – suddenly ceases to exist when it is cut and replaced by another shot. It is often said that films are great at showing long-dead actors as they were when they were vibrantly alive, but an equally profound property is the opposite of this. The great Hollywood images of love and dancing are rightly celebrated in the films of Gene Kelly and Stanley Donen, such as *Singin' in the Rain*, but there is sorrow in the later films they made together and separately. Cinema's not just *l'esprit de l'escalier* (belated insight) but the spirit of the barricade.

In Jonathan Glazer's film *Birth*, a middle-aged woman played by Nicole Kidman is visited by a boy who says he is her husband, who died ten years earlier. She is unsettled and dismisses the boy, then goes to the opera. The camera starts wide, but cranes in on her face. We watch as emotions wash across it as she thinks back to the boy and his impossible claim. Her grief is so strong that she is attracted to the absurdity. Once the camera has arrived at her it remains watching, without cutting, for nearly two minutes.

In life we know that we are going over the top and that we will be gunned down by time, so to be alive is like a shot, and to die is like a cut. Glazer's image

has its eye on the clock ticking away, on time running out. It is about death, and staving it off. 'At least,' it says, 'we have this. These minutes. The cut will come, but not yet. Please, not yet . . .' When film came along in 1895 it at first seemed like a new, objective instrument of looking. But deployed by the greatest film-makers – people like G.A. Smith, Claude Lanzmann, Stanley Kubrick, Alfred Hitchcock, Alberto Cavalcanti, George Lucas, Satyajit Ray, Larisa Shepitko, Dziga Vertov, Ousmane Sembène and Jonathan Glazer – it revealed itself to be a sex, myth, magic and death machine. Far from making looking at the end of the 1800s more mechanical, cinema had a propensity to dream. It gave us the desire to see the world, fuelled escapism and increased our sense of the heroic.

SPORT

In 1896, just as cinema was flickering into life, a major event which made sport more visual than ever before was reborn. The formalised, modern Olympic Games had visual elements of the Colosseum in ancient Rome and the world's fairs and universal exhibitions. The games arena-ised sport and enhanced its spectator qualities. They were thus very much of their times.

Physical play was famously athletic and combative in the ancient, religious games in Olympia in Greece, which ran for about 1,200 years, until the fourth century CE. The Olympic Games were revived in nascent forms in Greece from 1859 and at London's Crystal Palace in 1866, fifteen years after the Great Exhibition. The 1896 games looked like this:

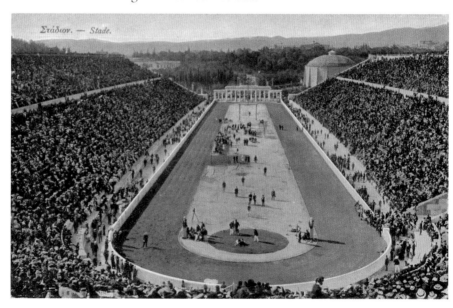

In a videodrome – a stadium for seeing – thousands of immobile people watch scores of very mobile people. Watching sport would become the modern spectator activity. In the era of television, major sporting events would attract up to 90 per cent of all those with their TV switched on. Zoom in on those few mobile people, and a world of looking opens up. In some of the track and field events, such as sprinting and the marathon, looking was not paramount (the finish line does not move), but in fencing and a projectile play sport like tennis, what the competitors' eyes did was crucial to their success. Studies show what trainers know, that the player does not keep her eye on the ball for its entire flight. Take these images of gold-medal-winning high jumper Charles Dumas.

How many times will he have performed such a jump? Tens of thousands? More? As a novice, the run-up, take-off, elevation, arc, descent and landing will have involved a rapid succession of distance estimates. Studies suggest that he will at first have experienced these as separate stages. In time and with practice, the stages will have been aggregated into fewer, larger and more automated processes to free parts of his brain to make more accurate visual calculations.

In tennis, this aggregation process is more necessary, largely because the ball comes at the player faster than the bar is approached in high jumping. In the *Journal of Motor Behavior* in 1988, K. Davids published the results of a study about hand to eye coordination and peripheral vision. He asked participants to catch a ball thrown at them and, at the same time, detect a signal at the edge of their visual field. The signal was variously timed at the beginning, middle and end of the flight of the ball, in order to see which moment would most disrupt the participant's ability to catch. As expected, in most cases the later the signal, the more the ball was not caught. Younger and less practised catchers were particularly vulnerable.

Davids's experiment was one of several which aimed to test how watchful an athlete is in projectile sports and how complex his visual attention can be. It is believed that the athlete focuses on the projectile with his foveal vision – the most acute part of the retina, directly behind the centre of the eye's lens. This spot can register just 1–2 degrees around the tennis or cricket ball. Everything

seen outwith this narrow cone is, to an increasing degree, peripheral. Of course it is not only sports people who use these different parts of the retina. Every time we cross a road or watch a landscape pass by from a bus or train, there is an interaction between the fovea and the rest. In projectile sport – and in fencing and boxing, where the position and angle of incidence of objects on approach must also be assessed rapidly, to allow the receiver to dodge them – such interactions, called saccadic movements, are accelerated.

Sports psychologists have also drawn on research in another aspect of how people look. Studies of the reaching and grabbing of humans and monkeys with brain damage have shown that there seem to be two different streams within the brain's rear visual cortex. The first, the ventral stream, which is in the base of the brain, assesses objects. It is the 'what' function, and tells you that this is a tennis ball barrelling at you. It is centred on the fovea. The second, the dorsal stream, which is higher up, assesses the position and movement of the ball, the 'where' function. It is speedier than the ventral, but more forgetful (it ditches its information sooner) and less connected to consciousness. As Andy Murray must assess the position of the tennis ball several times during its hundred-miles-per-hour, half-second flight, it is no surprise that his dorsal system does not hold on to the information in processes at each stage. It is useful to distinguish between the dorsal and ventral, but it is believed that they interact to a great degree.

A single tennis player and a ball tell us quite a bit about how eyes work under speed and with multiple stimulants, but what about team sports? Take this photograph of a goalkeeper in the foreground jumping to catch and save the ball, to stop a forward heading it into the net.

The goalkeeper's dorsal system will have repeatedly reassessed the ball's trajectory so that he could drive his body and hands forward and up to intercept it. We can see that he is looking straight at it. The ball is being seen by his fovea. Compare this to the forward. A split second before this photo was taken he was still driving his head towards the ball, not only to connect with it, but to change its course and redirect it towards the back of the net. He is still in flight, but his eyes are closed. Either his brain has completed its visual calculations and so he is about

to try to head it, unaware that the goalkeeper has already grabbed it, or he has already realised that he has failed and so is abandoning the plan.

What would happen if a graph was made which traced every ball position and how the players move around it? At first guess we might expect the result to be a chaotic scribble. But maybe something more recognisable would emerge. Dynamic systems, in which many things are moving at once, often have an attractor, a centre of movement, or a kind of pole. The ball in a football match is such an attractor. Trace the players' movements in relation to it and, visually, you get something like a flock of starlings or a school of fish which seem complexly to chase or orbit an invisible leader.

Romanticism, America, railroads, photography, visual literature, light bulbs, Impressionism, cinema and sport: so much happened in the looking in the 1800s that its story hardly drew breath. One compelling idea from the time helps sum it up its sense of discovery. The American frontier was an imaginary, receding border between what white Europeans knew and what they did not know. It was iniquitous and presumptuous, but was a reminder of how people define who they are and what they want to escape into. Photography, Impressionism and cinema were all frontiers in looking – conjectures born out of wayfaring and, at times, greed. This image of a German woman, Anna Bertha Ludwig, seems of its time. The pose is not dissimilar to that of Paul Cézanne's wife But this image of the same woman crosses a new frontier in looking. It is an X-ray, of course.

We see her wedding ring and bony thumb, so can read a little bit of her life into the image, but mostly the X-ray seems like a fascinating removal of her psychology and emotions in favour of a dispassionate structural analysis, perhaps the ultimate transparent eyeball. Her skin has become transparent. 'I have seen my death,' Bertha said, when she saw her bones. Her skeleton was visible without her having decomposed, or her skin having been removed.

We can only imagine what Leonardo da Vinci, the greatest looker-inside, would have made of such technology. His drawing of the bones and veins of a right hand is reminiscent of this X-ray, but this was something new. On 8 November 1895, six weeks before the first flickering movies were projected commercially, Bertha's husband, physics professor Wilhelm Conrad Röntgen, had accidentally discovered that electromagnetic waves with about

a thousand times the frequency of visible light were powerful enough to pass through skin. We can see through glass but not wood. If our eyes were sensitive enough to register X-rays, we would see through wood, people's clothes and into their skeletons. The world would become translucent. Röntgen surely was moved by this glimpse of his wife's engineering. In some ways it reminds us of Paul Cézanne's idea that his wife was just material, like an apple or chair. As Bertha's reaction tells us, the X-ray was also a memento mori.

The almost immediate use of X-rays in hospitals was a matter of life rather than death. And in a neat bookend of the 1800s, in their very first year another German scientist had discovered another ray that was invisible to the eye and which would become another seeing frontier. In 1800 William Herschel used a prism to split light into its constituent colours and measured the temperature of each. He found that each successive colour – violet, indigo, blue, green, yellow, orange and red – was warmer than the previous one, and that the space beside the violet that was dark was cooler than any of the colours. On a hunch, he then moved his thermometer to the opposite dark space beyond the red light, and found to his surprise that it was even warmer than the red. He called his discovery 'calorific' rays, but we now call them infrared. Again, they were a new frontier in seeing because they allowed special equipment to see, in the dark, things that produced heat. X-rays and infrared, on opposite sides of visible light, revealed invisible worlds.

Transparency and the extent to which looking can be detached from preconception has been the thread through this diverse chapter. It reaches beyond it, into much of what we have seen. X-rays, cinema, electric lighting and Impressionism: they could all be seen as add-ons to the kind of seeing that had come before. They were abnormal, or extensions. It is appropriate to end the troubled, tumultuous 1800s on bookends of abnormal seeing because early in the coming century another, much younger German scientist would, as a result of looking, come up with a radical theory which challenged looking and how we think of the world around us. The late 1800s saw new, parallel innovations in looking, but the early 1900s matched them. The story of looking continued to accelerate. It was as if the transparent eyeball had been sliced open.

CHAPTER 13

THE SLICED EYEBALL OF THE EARLY TWENTIETH CENTURY, PART 1: *MICROCOSMS, TIME AND TUTANKHAMUN*

'On or about December 1910, human character changed.'

– *Virginia Woolf*

IN this scene from the 1929 film *Un Chien Andalou*, thirty-year-old Simone Mareuil had her eye stretched and then, apparently, sliced in two by the razor we see on the right.

The film's Spanish co-director, Luis Buñuel, had dreamt the image. He and the film's other Spanish director, painter Salvador Dalí, had intercut Mareuil's eye with the eye of a dead calf really being sliced. As this happens, the liquid from its front and rear chambers spills out. Many famous figures from the worlds of art, music, architecture and fashion – including Picasso, Corbusier and composer Georges Auric – were at the film's premiere. The image became one of the most notorious of the century. *Un Chien Andalou* was a great success; its non-rational imagery and editing can be said to have influenced music videos decades later. Sadly both Mareuil and the actor who sliced her eye later committed suicide, the former by burning herself alive in a public square in Périgueux, where she was born.

The moment is a good way to begin the story of looking in the twentieth century, and can be taken as a metaphor for the violent increase in looking and imaging of these years. In the nineteenth century there were new types of looking, in the twentieth there were new amounts of looking. Affordable, lightweight cameras such as the Kodak Brownie, which became available in 1900, meant that by 1930 as many as a billion photographs were taken a year. By the century's end the amount had multiplied to hundreds of billions, and they were captured and shared not in any photochemical way, but by mathematical aggregates, computed in a process we now call digital. An image dam had burst, like the fluid from Mareuil's eye burst. At first the twentieth century's tsunami of images was an invasion of the eye rather more than an outpouring from it, but the tide turned and ordinary people who, for most of human history, had been visual consumers, became visual producers.

As in the previous decades, so in the early years of the new century many different things were happening in the story of looking. As one of them related to time itself, it is appropriate that there are flashbacks and flashforwards in this chapter. We will consider new types of looking, and also the pleasures they afford.

ATOMIC LOOKING

A good place to set off from on the long and winding road from the end of the nineteenth century to Skype is Bern in Switzerland. Here is an image of it from the period:

Women on the left, in the fashions of the late 1800s and early 1900s, stroll past street vendors, their eyes flicking and floating. In the foreground are gas lamps like the ones we have already seen, which would create pools of light in Bern's cool evenings. In the background is the Zytglogge (time bell) tower, first built in 1220. In the middle, a horse-drawn vehicle affords higher up and somewhat faster looking than that of walking.

But it is the tramlines on the right – an unintended detail in this image – that should catch our eye here, in the way that Roland Barthes described (page 242). Installed in 1890, in the early years of the twentieth century a twenty-something German employee of Bern's patent office sometimes rode the trams on his way from or to work.

On these journeys he would look at the clock tower as it disappeared into the distance and ask himself questions that he had toyed with for some time: What if I was travelling really fast? What if this tram speeded up to such an extent that it approached the speed of light? What time would I see if it actually arrived at the speed of light?

The traveller was Albert Einstein, and his answer, inspired by looking, was astonishing. He realised that, since light was a traveller just like himself, if he and it travelled at the same speed of light, the light coming from the clock face to his eyes at, say, 8 a.m., would never be updated to 8.01, 8.02, etc. In other words, it would always look as if it was eight o'clock. Compared to the people window shopping around the Zytglogge, time would stand still for him. Inside the trolley car travelling at the speed of light, like the *Millennium Falcon* in *Star Wars*, he would of course age as normal, and if he had a bunch of flowers in his hand they would wilt as normal, but time would be different for him and the window shoppers.

This seemed absurd and contrary to all the evidence, but the young Einstein took it further. He came up with a remarkable formulation which related the speed of light to the energy and mass of an object. Light speed = energy and mass, in some relationship.

As the speed of light on the left is a constant, then the energy and mass of an object, for example a tram in Bern, would also somehow have to remain the same. But as the tram sped up, its energy increased. Did this mean that its mass had to decrease?

Call the speed of light 'c', mass 'm' and energy 'E' and you get an equation something like:

$$c = E/m$$

. . . in which, in order to remain a constant, energy needs to be divided by mass. This, as it turns out, is almost, but not quite, right. Einstein said that instead of the speed of light, the constant was the speed of light *squared*, like this:

$$c^2 = E/m$$

Or, to rejig it into its most famous form:

$$E = mc^2$$

Light was related to mass and energy? To many who tried to get their heads around this it must have seemed delusional, and it challenged many of the assumptions that scientists like Isaac Newton had made since the Enlightenment – that there were concrete truths out there that could be discovered. Instead, said Einstein, the big things like space and time are relative and vary according to the observer.

It was looking that proved him right. On 29 May 1919 Arthur Eddington photographed stars during a solar eclipse, when they can be better seen. The images showed that those close to the Sun seemed to be nearer to it than they really are because the light from them had been bent slightly by the Sun's massive gravitational pull. Light was behaving like mass.

Though all these things are only measurable at large distances and great speeds, Einstein made the twentieth century think differently about looking and

its relationship to other things. Looking was temporal like never before. It was unfrozen. In his book *Vision and Painting*, the American art historian and theorist Norman Bryson wrote, 'the gaze of the painter arrests the flux of phenomena, contemplates the visual field from a vantage point outside the mobility of duration, in an eternal moment of disclosed presence'. Painters would rethink this in the light of Einstein. If Copernicus, way back in the late 1400s and early 1500s, had helped dethrone the human gaze by saying, after some others, that the Earth was not the centre of the world, Einstein had, so to speak, empathised with a beam of light by imagining how it would see. Human eyes were still linked to human brains as before, but we had an increased sense that what we were seeing was time.

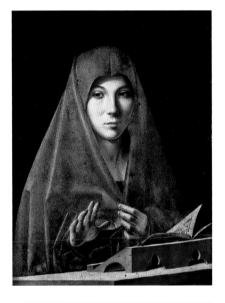

All images of movement implicitly show us time: the black and white frame enlargement from the film about Verdun does, and the painting and chronophotograph of cyclists both do. The next painting does not seem to want to show movement – there is no blur in the sitter's hand and no flicker in her eyes, for example – but it is about time. She is saying halt. Do nothing. Stop movement. And yet there is still movement – time moves. Our attention is drawn to it by the removal of everything else.

We sense the pause, the seconds pass, perhaps the tick of a clock. A moment of silence takes place because she has asked it to. Our response is perhaps to feel calm, or pay attention to the present a little more.

This next painting pushes time further. In it, time is not as an event, but a relationship. The man in the black hat holds his hand out, like the woman in blue above, as if to say *Pause a moment*. He and his two friends are grouped in a semicircle as if they are talking, but their faces are not animated and their eyes do not even quite meet: their conversation has stopped for a moment of contemplation, or consideration of elsewhere.

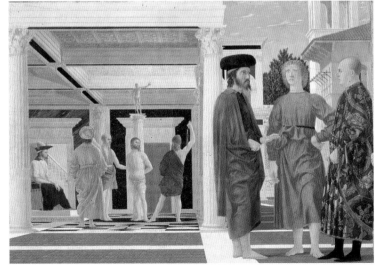

That elsewhere is behind them. On the left of the panel, Jesus Christ is being whipped. Such a violent and presumably noisy event should surely catch their attention, but it does not do so because it is in the past. The men on the right are well dressed in the fashions of the day (1463–64), but the flagellation is taking place a millennium and half earlier. Both events happen in the same place, a town or city with classical buildings, tiled floors and – as we can see from the receding roofs on the left and right – a single perspective. The space is one, but the time is two. Our eyes start on the right but, as they move leftwards, across the central column and the cream line of tiles on the ground which continues it visually, they time travel, backwards, to an atrocity. It is unclear who the men on the right are, and it is possible that the artist Piero della Francesca, by depicting the flagellation, was referring to some suffering or martyrdom that the contemporary men have witnessed, but it is the time warp that startles. Viewed from the early twentieth century, when photography and cinema were still afresh with their thrilling ability to present a moment, Piero's binary time is like a whale beneath the still surface of the picture.

It reminds us that in looking, our eyes can shift between time periods. Not only can they, they often do. When we look at the face of someone we have known for a long time we see their younger self. Film-makers have looked for inventive ways of showing this. A key example of such looking anachronism also occurs in John Sayles's *Lone Star*. A county sheriff in Texas in the 1990s reluctantly investigates what lies behind the discovery of a skeleton from the 1950s. It belongs to a previous sheriff, corrupt and racist. The film moves between now and then, the present and the past. Such flashbacks are commonplace, but in *Lone Star* they do not flash and are not really even back. Sayles explains:

> I used theatrical transitions so that there would be this feeling [that] there wasn't a big seam between the past and the present . . . Basically, you get a background for your tight shot from 1996, you pan away, and when you pan back to where the guy telling the story was, it's somebody completely different, and it's 1957. There's not a cut or a dissolve. I wanted to reinforce the feeling that what's going on *now* is totally connected to the past. It's almost not like a memory – you don't hear the harp playing. It's *there*.

This is precisely Piero's technique in the flagellation painting. To put it in an Einsteinian way, in both *The Flagellation of Christ* and *Lone Star* the space-time is one. It does not split. History in Texas and Italy is so burdensome that it is not even history. At one point in Sayles's film the history teacher says 'What are we seeing here?' In *Lone Star* and *The Flagellation*, we are seeing time, another kind of sliced eyeball deluge.

We will return to this idea of visible time towards the end of our story, when we look at two images of Ingrid Bergman, but for now we should note that Einstein's ideas did not only change the way we looked at time. In the early twentieth century the sublime re-entered looking. As we have seen, for Burke and Rousseau the Alps were sublime, but $E = mc^2$ meant that to calculate the energy of even the simple things in this book – the seaweed and shell that we saw in childhood, the tears that Falconetti as Jeanne d'Arc sheds, the Nike running blade, Newton's falling apple, Chaplin's Hitler balloon, Marnie's yellow handbag, Andy Murray's tennis ball – is to multiply their mass by the speed of light squared. These relatively ordinary things are bombs, in that their constituent atoms contain vast amounts of energy. In the 400s and 300s BCE, the Greek philosopher Democritus came up with the idea that matter was atomic; John Dalton described atoms as tiny, hard and spherical; at the end of the 1800s, J.J. Thomson discovered electrons; in 1911 Ernest Rutherford countered that atoms had a small positively charged nucleus. A picture of the atomic world was emerging. Then came the German Max Planck and the dyslexic, visual Dane Niels Bohr.

Planck read Einstein's accounts of his new ideas, published in 1905. In Brussels in 1911 Einstein met Planck. They became friends, Planck offered Einstein (twenty years his junior) a professorship and Planck came up with a new idea, quantum theory. Its relevance for looking is that it describes the laws of the tiny atomic world, a rock pool with its own rules. Where Newton's apple falls smoothly through space, in the atomic rock pool things move in a more stepped way. Niels Bohr made headway in visualising this. He made his students walk as they talked.

Eye movement stimulates brain processing. Like others before him, he noticed that when elements are heated each burns with its own colour. Using Planck's and Einstein's quantum ideas, he said that the colour comes when an electron releases energy as it 'falls' from its orbit around an atom's nucleus. But it does not fall like an apple falls, or a meteor falls, glowing as it does so. It jumps down from an outer shell to an inner shell, releasing a quantifiable amount of energy with each jump. The study of these emitted colours is spectroscopy; their emission has been compared to stained-glass windows.

To Bohr's fireworks add Brownian motion, and we understand more about the rock pool. In 1827 Scottish scientist Robert Brown noticed that, if they were small enough, pollen particles did not just float in water, they zigzagged, as if charged with manic energy. This lithograph illustrates the sort of path they take.

Again in 1905 Einstein argued that they moved that way because they were colliding with individual, discrete things – water molecules. In 1908, the French physicist Jean Baptiste Perrin proved that Einstein was right. In a few years, a series of new theories about the material world had emerged. They were either inspired or confirmed by looking, but they were, too, compellingly visual. Precisely because the quantum world could not be seen, like the gods of old it inspired visual thinking and visual metaphors, a deluge of imagery, a sliced eyeball. Temporal, discontinuous, colourful and sublimely powerful, the atom became the most unseen imagined thing of the century. It had life, like a rock pool has life. Its beauty was hyphenated with its terrifying potential for misuse, later demonstrated in Hiroshima and Nagasaki.

Atomic and quantum physics drew attention to the idea of the microcosm, the small enclosure which miniaturises the world. Zoos were microcosms, and so were paintings. A series by Vincent Van Gogh, who died in 1890 but whose work was not widely seen and whose insights were not properly understood until the early twentieth century, demonstrates how paintings can be microcosms.

In a world so large and complex, visual containment – the restriction of x-, y- and z-axis – is appealing, like a distillation. From May 1889, for a year, Van Gogh painted and drew a restricted, contained world – this garden at the Saint-Paul asylum in Saint-Rémy, France, which he could see from the window of his bedroom.

Back then it was a wheat field. Here it is in the rain, striated like it is being dragged behind a motorbike, or is under the sea, but at other times it is buttercup yellow, or the wall is purple blue, or the clouds are like cotton wool, or it is sepia in a pen and ink sketch.

Van Gogh had specific therapeutic needs in this period, and no doubt the focus on one place over many weathers, seasons and times

gave him some semblance of control over the external and threatening world. Looked at together, from now, the Saint-Rémy paintings of this field have a meditative intensity. They are microcosmic, atomic almost. Obsessive in what they exclude, they reassure that the world is somehow knowable and that, despite being lashed by rain and baked by sunshine, there is an underlying solidity to the field and the wall. They are paintings of the gaze rather than the glance, as microcosmic looking usually is. They can be seen as conservative, in that they are not the product of a centrifugal imagination or wanderlust. These are not the world view of the grand tourist or the fur trader frontierist in America. They are devotional, hermetic, the sign of someone steadying himself visually.

Micro and atomic looking appeared throughout the twentieth century. From the 1930s onwards scientists not only imagined what electrons looked like, but they looked with them. Visible

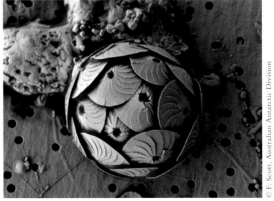

light was far too big and bulky to 'see' the atomic world (it was like trying to put your hand through the eye of a needle), but if you fired electrons at tiny things they were small enough to bounce back from them, like a pin screen, to show a micro-jungle of organisms, surfaces, textures and contours. This, for example, is a marine alga covered in calcite scales. Nothing quite like it had been seen before.

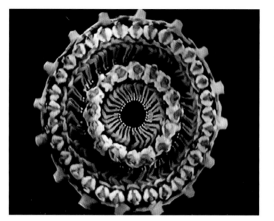

The rock pool was full of such geometric, architectural *jolie laide* objects, and it is hard not to see a visual link between the alga and this image from the Hollywood musical *42nd Street*, made in 1933, the same year in which an electron microscope first showed us more detail than life could.

In the film the individual elements are not the scales of an aquatic sub-creature, but women filmed from above, sitting and leaning backwards in two concentric circles, their legs to one side.

To see this image on the big screen was bewildering. It was large, but the women were small and so kaleidoscopically arranged that they were not discernible as individuals. It was macro and micro, the Hollywood dream world and the quantum world. A beautiful, almost biological thing, and also a dehumanising and abstracting one, an example of what would become known as the male gaze, a unidirectional look that expressed the power of men, their desire, their objectifying instincts and their psychological distance. Looking at the Alps and the Rockies made people feel small, like ants. Looking at algae made us feel like giants, like the Alps.

Just two years before Van Gogh had gone to Saint-Paul, Georges-Pierre Seurat painted this, *The Bridge at Courbevoie*, which, in its use of tiny dots to create a picture, is relevant to our atomic age and demonstrates some of the pleasures of looking at fine detail.

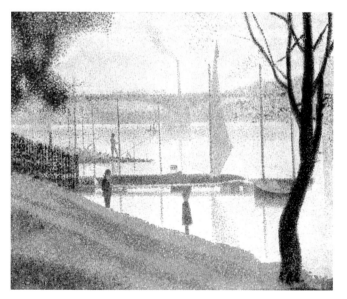

It has the flatness of Cézanne's *Route Tournante*, but instead of the latter's choppy sea surface, Seurat's scene looks like it has been broken up by something, perhaps an electron microscope. Light is particles, and he seemed to know it. He atomised looking, using theories of colour which are less relevant here than is his molecular surface. He believed that a painter should work, in part, like a scientist, and seemed so fascinated by the microcellular nature of matter (it is as if it is snowing in this picture) that

he removes most things that are more expressive, or wayward. So, for example, the people seem still, and the seventeen verticals are like tent poles in the motionless, muggy air.

Gertrude Stein, in her book on Picasso, wrote that 'Seurat's eyes then began to tremble at what his eyes were seeing, he began to doubt if in looking he could see.' The British artist Bridget Riley copied *The Bridge at Courbevoie*, then took Seurat's atomising instincts further, patterning her canvases into weaving or gridding or plaiting abstractions.

The twentieth century is full of microcosms and atomised looking, but three more examples must suffice. The Bengali director Satyajit Ray, whose *Devi* we looked at when we considered eyes in cinema, made *The Music Room* in 1958. The film tells of an ageing landlord in the 1920s, a man of the 1800s whose life and fortune are trickling away. He lives in a crumbling mansion, smokes the hookah as his drowsy afternoons dissolve into evenings, and does not know what month it is. At the centre of his palace is a music room, and at the centre of it is a grand chandelier, lit by candles. Below it the last, elegiac dance that he will ever witness takes place. The audience goes home and he is left to toast the empty room, its pictures and mirrors echoing the Gallery of Mirrors in Versailles. He goes to toast a painting of an ancestor, but, spotting a spider on it, turns away, and in doing so glances into his whisky glass. In

an instant he sees this, the reflection of the chandelier, and is taken aback. It is so small, a microcosm, a symbol of his fading grandeur. And he notices that its candles are slowly extinguishing, as if the oxygen in the room is being replaced with some new gas that will not keep the candles lit, or him alive.

A new day is dawning, so the light is not needed. He has caught sight of how small he is, of his end of days, and there is no going back from that.

Satyajit Ray was well aware of the tradition of miniaturism in Mughal painting, which is amongst the greatest art of tiny looking, of the microcosm. The third Mughal emperor, Akbar, whose conquesting look out onto the Deccan plateau

we considered in Chapter 6, is one of the most pictured people in such painting. In this one, a half a millennium older than Ray's film, Akbar sits and watches women dance, as Ray's landlord did. Above is a lantern, like the landlord's chandelier.

Influenced by Islamic art, and often intended to be incorporated into manuscripts, thousands of such images were produced in Akbar's time alone. All of them afford the pleasures of small-scale looking, of the confined space, of intricacy, of intimacy. The architecture in this one is elaborate – platforms, columns, screens, Mughal-arched doorways – but the painting is small, and will have taken perhaps a month to complete. The paper was often imported, rubbed with an egg-shaped agate stone, primed with white paint, painted with brushes of kitten or squirrel hair, using lenses and spectacles where necessary to do the finest details. The saffron yellow probably came from Kashmiri crocuses. Painters in the ateliers were paid the same as soldiers. The techniques predate the miniaturism of Vermeer, but aim to create jewel-coloured micro worlds which impressed not for their grandeur but their finery. It comes as no surprise that there are many erotic images amongst the Mughal miniature paintings, because they are intimate and can be properly viewed by only one person at a time. The microcosm is often looked at in private. It is seldom shared looking.

Ray's feudal man's microcosm is a moment, but our final example of contained-world looking unfolds over nearly six hours. In 1986 the Iranian filmmaker Abbas Kiarostami made a film, *Where Is the Friend's House?*, in Koker in northern Iran. It was about a young boy trying to return his friend's schoolbook, which he had accidently taken. Three years later, a devastating earthquake in the Koker killed 50,000 people, including many of the non-professional actors Kiarostami had used. The woman who played the granny in the film was cut in half by the destruction.

Kiarostami was horrified, so went back to Koker, in particular to find the boy who had played his lead. He filmed his trip, using an actor to play himself, and locals who experienced the earthquake to play versions of themselves. In the

resulting film, *And Life Goes On* (1992) he looks for the boy actor but, more than that, shows that the flow of life is unstoppable, even when tragedy strikes. One of the crew of the second film was a tea boy called Hossein. During the shoot he told Kiarostami a story – that he got married just five days after the earthquake. The director liked Hossein and was so intrigued by his story that he put him in the second film, acting with a local girl who would play his wife. During the shooting of that small scene in the second film, Hossein fell in love with the local girl. Kiarostami was so intrigued by his predicament that, two years later, he made a third film – *Through the Olive Trees* – which was almost entirely about the making of that small scene in *And Life Goes On*. Here is one of the many moments in the third film. Hossein is on the right, playing himself in the second film (in which he was playing himself). The local girl is on the left, playing the moment where she, acting as Hossein's future wife, is told by him that he loves her.

The description of this trilogy of films makes it sound as if they squeeze the joy and love out of the situations, but in fact they amplify them. The whole of the third film is about the very moment in the second film when that love emerged. We feel that each film zooms in on a part of the previous one, to reveal details like an electron microscope reveals details. The trilogy shows us more than is visible to the naked eye. It is Seurat cinema, Einstein cinema, fascinated by fine grain and convinced that there is something almost sacred in the everyday, the microcosm, the village and a thing that took place on a blue-painted balcony in that village, with pots of geraniums, and a film crew looking on. This image from

the film would make a great Mughal miniature. In an unexpected way it sums up atomic looking – the pleasure of staring into the rock pool, of seeing worlds within worlds.

As the twentieth century proceeded the atomic world continued to create new types of looking, or new things to be seen. The central image of the atomic era was a bomb's mushroom cloud. The explosion in Unit 4 of Chernobyl's nuclear reactor in 1986 led, within a few years, to this religious painting being installed in the village of Chernobyl's Orthodox church. Pious witness bearers to a religious revelation wear radiation protection masks.

And on the French–Swiss border, the largest machine in the world is trying to see the smallest things in the world. The man in this image gives a sense of the scale of CERN's 27-kilometre-long Large Hadron Collider.

In it, hydrogen protons are accelerated to 99.9999 per cent of the speed of light, as if they were Einstein's tram in his thought experiment. They are sent in opposite directions so that they will smash into each other. They can rotate for perhaps ten hours, travelling the distance of the outer reaches of the solar system and back, and when they smash into each other the temperature of the Big Flash is created. The ultimate aim is to try to see things like dark matter, first postulated in 1922, which is thought to represent a quarter of the total energy mass of the universe. In a way the CERN scientists are doing what Galileo did that night on the roof in Venice. At CERN headquarters there is a Nataraja sculpture of Lord Shiva dancing the world into existence. Einstein was like Shiva. He brought new worlds into existence, worlds that were visualised. He split the eyeball.

TUTANKHAMUN

At 2 p.m. on 26 November 1922 a man made a hole in the top left of a doorway. He lit candles and saw, within, something that no one had seen for more than 4,000 years. 'So gorgeous was the sight that met our eyes,' he wrote. The world agreed. Another twentieth-century visual deluge ensued.

Inside the room, the man – English archaeologist Howard Carter, who had been a sickly child and who was an excellent drawer and painter – and his team found, amongst almost six thousand items, a coffin. When they opened it they found another inside. Inside that was a third and then, inside the third, they found a fourth made of pure gold. They lifted the lid and saw that it was full of black pitch. In this image Carter scrapes away that pitch to find the mummy of a minor teenage semi-god, the son of Akhenaten, whom we heard about in Chapter 4.

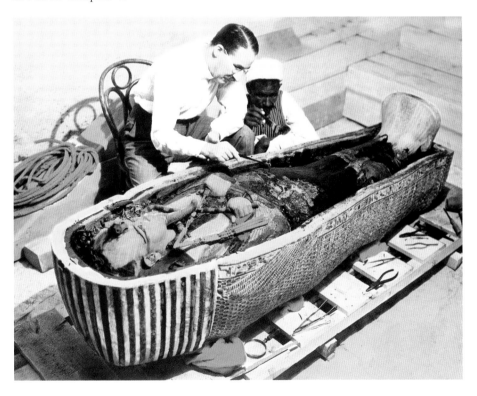

As he opened the coffins inside coffins, did his hands shake? He used a magnifying glass (seen in the bottom of the photograph) and various tweezers and pliers. Tutankhamun wore a gold headpiece with horizontal stripes. He had a long, stylised beard, exaggerated and childlike facial features, eyes of quartz and jewellery

and costuming of lapis lazuli. The Austrian psychoanalyst Sigmund Freud enters our story here, as he can help us understand the power of this moment. Freud dreamt of Rome before he had ever gone there. Did we dream of something like Tutankhamun's casket within caskets before Carter saw it? Egypt had started to fascinate Europeans in the previous century. Napoleon entered Egypt in 1798; the Suez Canal was completed in 1869; Britain occupied the country from 1882; European cities imported ancient obelisks and statuary; the British novelist Amilia Edwards funded the archaeological adventures of Flinders Petrie, who found great ancient stelae and remarkable portrait paintings; most of all, Christians yearned to find proof of the biblical story of the Exodus: Egypt was a mix of religious myth and colonial opportunity, plunder, history, aesthetics and oriental escape.

The discovery of Tutankhamun brought all this to the boil. In the photograph Carter is peeling off the layers of time. Elite Europe had, since the Renaissance, been obsessed by classical Greece and Rome. Iran had mythologised Darius and Xerxes, kings of their Achaemenid Empire. At the dawn of modern India's consciousness was the time of Akbar. What lay under that black pitch predated all that. As we have seen, human beings have often been attracted to decaying things, but this stuff had not decayed. It was a malfunction in the space-time continuum. It closed the psychological distance between early twentieth-century Europe and Africa from millennia before.

This image from the Hollywood film *Planet of the Apes* helps us understand the power of what Carter saw. In the future, people walking along a beach come across the half-buried remains of the Statue of Liberty.

Their and our imaginations immediately fire. Is New York over? What catastrophic event has led to this giant statue being left, forgotten? Has everyone who knew what it meant gone? Maybe there was no catastrophe; maybe things just petered out. The present order is the disorder of the future. We look at the statue and feel intense nostalgia for the life of New York, which is no longer alive. Flick our eyes back to King Tut and, though none of us lived in his cities in his time, we feel nostalgia for something so grand (and, it eventually dawns on us, so exploitative) that it could produce this. The people who crafted this mask had many religious beliefs that we do not share, but their ancient eyes saw beauty in ways that overlap with ours. It is as if they are buried in our collective unconscious. 'Freudianism is an explicit and thematised archaeology,' wrote Paul Ricoeur in *Freud and Philosophy*, to suggest that the unconscious is something that is unearthed. King Tut was unearthed, and so, in *Planet of the Apes*, was the Statue of Liberty. Like a dream, the looking Carter was doing was potent, associative and layered. In the era of Einstein, seeing Tutankhamun was like time travel. In his book *Civilisation and Its Discontents*, Freud wrote, 'In mental life, nothing which has been formed can perish – everything is somehow preserved and in suitable circumstances . . . can be brought to light.'

That is a theme of this book. From her earliest glimpses of blurred, monochrome shapes, a child absorbs and embeds images. They often become invisible to us – they are forgotten – but they have helped shape how we see, what we expect from seeing, and what we project onto seeing.

Seeing Tutankhamun was an extraordinary reveal, a pulling back of the curtain to show something so puissant that it created shock waves in visual culture. The world's media covered the subject. An exhibition of items from the tomb was the most popular in the British Museum's history. Eight million people saw the exhibition in New York's Metropolitan Museum of Art. In 1932 Universal Studios launched a series of mummy movies which were fuelled by the rumours that Tutankhamun's grave had been cursed.

Perhaps more revealing is this artwork from just one year after Carter's discovery. German artist Kurt Schwitters had just started using wood and other materials, and combining them with painted surfaces and patterns to create montages which would be greatly influential.

Schwitters absorbed events in the news into his art, and this untitled work seems to register the discoveries in Egypt like a barometer. In the background is a pink pyramid; just to its right is a stylised, blazing sun. More abstractly, the grey verticals look like sentinels, their 'heads' turned entirely sideways, like the heads in Egyptian friezes and paintings. The colours are warm and desert-like, except for the block of black which seems to be underground, perhaps an echo of the dark tomb that had lain undisturbed for thousands of years. Schwitters had not visited Egypt in person, but it had clearly entered his unconscious.

The discovery of Tutankhamun was the most famous archaeological find of the century, but others displayed a similar pattern. On 24 July 1911 the American historian Hiram Bingham was led by local farmers to a vast, long-overgrown Inca city, Machu Picchu. It was seen regularly by the small number of people who lived near it, but to the outside world it looked like a mysterious temple-eyrie, vertiginously stepped and positioned with such aspects that it must have been one of the greatest looking cities in the world.

On 12 September 1940, in southwestern France, a dog called Robot fell into a hole in the ground. Four teenage boys went in to rescue it. One of them shone a torch into the darkness and discovered cave paintings, six hundred of them in all: animals in packs or alone, locking horns, outlined in black or blocked-in in shades of rust, earth and umber. The animals in the Lascaux caves ran or reeled, and seemed to flicker by firelight. They had been painted at least 15,000 years previously, a fact that is easier heard than imagined. In 1974 farmers in Shaanxi province in China who were digging a well broke into a tomb complex said to represent the universe. Seven hundred thousand workers built it and sculpted its more than seven thousand terracotta warriors and horses, which stood guarding the body of China's first emperor, Shi Huangdi. It is said that a hundred rivers were simulated in the burial complex, using mercury instead of water.

Each of these break-ins discovered under- or overground worlds, extraordinary visual caverns in which history had stopped. The eyeball had been sliced open. Time, previously unseen worlds and historical periods came flooding out. But this was only the beginning of the twentieth-century's visual deluge.

CHAPTER 14

THE SLICED EYEBALL OF THE EARLY TWENTIETH CENTURY, PART 2: *PROTEST, MODERNISMS, SKYSCRAPERS AND ADVERTISING*

MICROCOSMS, time, cinema and Tutankhamun: the looking in the early decades of the twentieth century was already complex, but as the century continued, looking grew to a deluge both outwards and inwards.

Let's turn to outward looking first, and particularly the issue of protest. There has been protest through much of human history. Its purpose is to discomfit power in order to bring about change that usually, but not always, benefits the protestor. We have already looked at two of the great protest movements in Europe, the Protestant Reformation and the French Revolution. Both attempted to scrub their culture's imagery of what they saw as its decorative and elitist excesses.

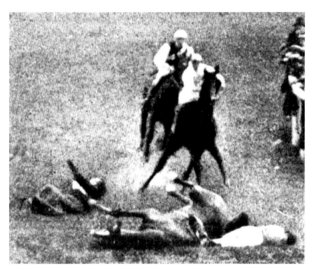

In the era of photography, however, protest tends to produce new imagery rather than remove or replace old. This grainy enlargement of archive footage from 4 June 1913 was one of the most compelling image creations of the early twentieth century.

At first we see the galloping horse trying to change its running course to its left to avoid the fallen one in front of it. It is a simple, dynamic shape, like the drawings of the animals on the cave in Lascaux. Our eyes then drop to the fallen rider at the bottom, bright and contained, like he is protecting his head. Then we look leftwards.

There we see what looks like a woman, her left arm reaching out, her knees bending, her head off the ground as if she is screaming. She probably is screaming because the horse has just trampled her. Her agony is inward, but the reason that this image exists is the opposite of that. She walked in front of the horse probably to attach to it a banner in support of the Women's Social and Political Union, which was campaigning for women's equality and voting rights. Police used newspapers to try to stop the flow of blood from her head. The woman, forty-year-old Emily Wilding Davison, died four days later. She is like a charcoal sketch in this image which captures her protest and sacrifice, but the moment was the culmination of a life of protest. Born into a northern English family, she studied at Oxford University, where she got first-class honours in her exams but did not graduate because women were not allowed to. She was imprisoned nine times and, on hunger strike, brutally force-fed. Tens of thousands of people came out to look at her funeral in London, a brilliantly controlled visual spectacle in which her coffin,

draped in fringed satin, was pulled by four horses. Her fellow suffragettes wore white, and dark sashes and arm bands. They held single white irises, flags or wreaths, and, at moments of stasis, stood at the four corners of the cortège, as if it was on a catafalque. 'Deeds, not words', it says on her headstone. The suffragettes were amongst the best visual thinkers of their times. In the same year that Davison tragically died, an exhibition of new European art introduced post-Impressionism and Cubism – which we are about to look at – to New York. These image innovators changed art, but Davison and the suffragettes changed lives. They were radically outwards. They wanted to send visual messages outwards, via film, photography and newspapers, into the world. They lobbed visual bombs.

There is a line of people waiting behind protestors, waiting for their life to change. There was a line of millions behind this man bending down, Mahatma Gandhi. Like the suffragettes, he and his fellow protestors wore white – the colour of purity which sings out in a black and white image, the colour of the brightest light, of the unified rainbow, of cleanliness, of extreme heat and snow cold, of the hair of old age and of that most everyday thing, salt. In the image, Gandhi picks up some salt from a beach in Dandi in west India, to where he had walked from Ahmedabad, a distance of 240 miles. The mud on the way felt like velvet under foot, he said. When he began, he had 78 fellow walkers. By the time this photo was taken, on 6 April 1930, perhaps 100,000 had seen what they called the 'white flowing river' of people, and many of those had joined.

In 1882 Britain had made it illegal for Indians to collect or make salt, even though it could be found on shores and despite the fact that, because of heat sweat, the population had to consume plenty of it. At first Gandhi's political backers thought that salt was too lowly an issue to contest, but he saw its symbolism and knew that the protest had to be seen. He sent imagery outwards, into orbit. He told the world's media about the protest; three newsreel crews filmed its climax, the *New York Times* carried front-page articles, and *Time* magazine made Gandhi Man of the Year. As a result, millions

of Indians followed his non-violent protest and produced salt – because they had seen him doing it, and could see the simple rightness of his action. It would take another seventeen years for Britain to leave India, but the orbiting imagery of and ideas behind the Salt March inspired the American activist Martin Luther King.

Seven years after the Salt March, in the Basque country on 26 April 1937, at the request of Spain's future dictator Francisco Franco, German and Italian aeroplanes dropped bombs on the old square of Gernika. It was market day, but people took to their shelters and there were few casualties. When the planes left, the people re-emerged and went on with their spring day. Forty-five minutes later a squadron came, bombed for three hours and shot the civilian townspeople as they ran, screaming, into their fields: 1,654 died and half that number were injured. Most of the town's men were away, fighting in the Spanish Civil War, so most of the casualties were women and children. Thousands of them fled. On 1 May

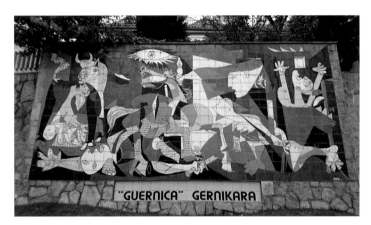

Pablo Picasso read an account of the bombing and sketched what would become this, one of the great works of visual protest, an outwardly projected SOS completed in thirty-five days, using a type of matt black-and-white house paint. Here we see it recreated in tiles in the town of Gernika itself, on a hill on its northern side, where some of the victims fled.

It is like someone has switched the electric light on in a dark room, to expose a pyramid of horrors. The outstretched hand of the dying soldier at the far left perfectly balances the outstretched foot of the women leaning into the atrocity light on the far right. Between them lies a *Raft of the Medusa* stack of limbs and body parts. Three people wail directly upwards to the invisible sky. Fingers, toes and tongues seem in spasm, as if they have been electrocuted. Nature has been banished – the press photos showed mostly charred rubble, in black and white.

The scene is a moment, but it has a before, during and after: the two women who lunge in from the right are on the

verge of discovery, the screaming people are in the midst of agony, whilst the bull on the left seems bewildered or numbed by what he has seen. There is almost no z-axis in *Guernica*. Everything is compressed, thinned, flattened, like Gernika was flattened. Between the tiles of the version in Gernika, wildflowers grow.

Another public artwork in Gernika echoes this. The great Basque sculptor Eduardo Chillida's *Our Father's House* is a large curved concrete structure, through a leaf-shaped hole in which can be seen the trees that symbolise the heart of Gernika and the Basque country, and the sky from which the bombers came.

This eighth-century CE manuscript illumination by the Spanish monk St Beatus of Liébana shows a moment from the Book of Revelation. It is not known whether Picasso knew the artwork, but it is very possible, and there are remarkable visual similarities. The face of the supine man at the bottom, the upward screams, the horses with their tongues out, the flatness, the position of the small bird in both images. Picasso wanted his picture to be a blast on the trumpet. Beatus's book illustration is just such a blast. Image-makers have always wanted to scream in this way.

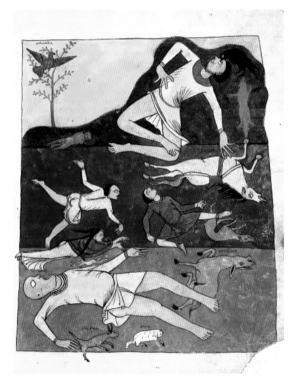

Earlier we looked at monuments, and in one way *Guernica* was a monument, but it did not name the dead or date. Its purpose was not to record details so that they would be remembered. It is better considered a work of protest, because the Spanish Civil War was still ongoing. It was first exhibited in July 1937, after which the war continued for twenty-one months. It stared Franco and his allies in the face, when it toured the world, and said *Look what they are doing, look what they have done*.

Looking played a key role in many of the subsequent twentieth-century protest movements. On 28 August 1963, for the hundredth anniversary of the signing of the Emancipation Proclamation, a quarter of a million Americans joined the March on Washington for Freedom and Jobs. At its climax, Martin Luther King Jr. gave his famous speech, 'I Have a Dream', which made this a landmark in verbal history, but the imagery also became iconic. Photographs taken from the Lincoln Memorial show a sea of people gathered around the beautiful reflecting pool in which the double of the distant Washington Monument obelisk could be seen. The image was grand, symmetrical and serene, as ordered as the gardens of Versailles, and a reclamation of federal grandeur.

Four decades after the bombing of Gernika, in the neighbouring country Portugal, a military coup against the country's right-wing dictatorship brought citizens onto the streets in support of change. One of their main gathering points was the capital city's flower market. It was spring (25 April – the bombing of Gernika was on 26 April), so red carnations were in season.

The protestors, and some of the military, bought the flowers, wore them and inserted them into gun barrels. By this stage, the media was cacophonous. News imagery was everywhere. To be noticed, to get your protest out there, to be centrifugal, you needed to come up with imagery that would cut through, that would orbit, that would have escape velocity. Television crews hungry for images filmed the red carnations, broadcast them, and so more people used them as symbols of the moment, of the socialist challenge to the right-wing government (socialism's colour was red) and of the defiance of might. Gandhi's white said *We object to how we are being governed*; Portugal's red said the same. The Carnation Revolution led to Portugal belatedly shedding its colonies.

Staying in the later twentieth century, protest continued to be optical. In 1980 the Georgian film-maker Tengiz Abuladze already had award-winning films under his belt, but a car accident convinced him that it was now or never to realise a gestating, dangerous, production, *Repentance*. It was based on a true story that had taken place in the west of the country about a man who had been wrongfully imprisoned. On his release he found the grave of the recently deceased man who had jailed him, dug up the coffin and stood the body up against a wall. Abuladze's film imagines a 1930s-style dictator called Varlam, who sends an artist to the labour camps because of his 'individualism' – strong echoes of Stalin. Years later, in the first image opposite, we see that the artist's daughter has had Varlam's body dug up. He is hauled over to a vista, a cityscape of Soviet buildings. In the next image we see him propped up against a

tree. The symbolism was clear and potent: the memory of Stalin's dictatorship should not be buried. It should be there, on streets and in parks, visible and repulsive, like a rotting corpse.

Not only was *Repentance* great art, it was one of the most influential artworks ever made. The most powerful man in Georgia, Eduard Shevardnadze, encouraged its production. Later, whilst in the politburo, he showed it to the reformist general secretary of the Communist Party of the Soviet Union, Mikhail Gorbachev. Gorbachev said 'History must be seen for what it is', and encouraged the film's screening. As a result it was seen by millions, and helped the process of perestroika, which weakened the Communist government of the Soviet Union.

The same struggle – to shake off the oppressive aspects of the Soviet Union – led to another work of optical protest, the Baltic Way. In this image from 23 August 1989, old and young, and a high proportion of women, link hands along a road, as far as the eye can see. Even with binoculars a looker could not have spied the end of the line, because it ran for over 400 miles and involved an estimated two million people.

The Baltic Way was a human chain from Tallinn to Vilnius whose purpose was to draw attention to the fact that the Soviets and Nazis had, in 1939, planned a post-war division of Europe, in which the Baltic states would fall under the control of the former. This is indeed what happened, and the line of people, fifty years after the pact, was the same kind of externalisation as the dead body in *Repentance*. It made visible an iniquity. It externalised. It questioned the legality of the pact. Just over a year later the Soviet authorities accepted that the secret agreement had been illegal.

In China at the same time, a TV series was, arguably, the biggest single protest event ever, yet few people outside China have heard of it. The show had an audience of 600 million and its bold message was part of a chain reaction which led to one of the most publicised human rights violations of our times, the Tiananmen Square massacre, which we will look at in a moment.

Exactly one year before the events of June 1989 in Beijing, the polemical documentary *Heshang* created the greatest controversy in China's then thirty-year broadcasting history. It argued that the country's self-image of national greatness was wrong. It advocated a full-scale adoption of 'Western ideas'.

The left-hand image below, the series' title shot, shows the 3,400-mile long Yellow River, the central symbol of the films. The series used that image to argue that world civilisations can be divided into yellow, soil-based, backward cultures, and blue, sea-based, progressive cultures.

More specifically, *Heshang* said that China failed to capitalise on its great inventions, such as pen and ink, and used the yellow/blue division (the colour combination we looked at in Chapter 1) to explain why the Industrial Revolution did not happen in China. The country needed to wake up and undergo a profound cultural renewal.

Billed as a search for a modern China and conceived of as contemporary

political commentary, *Heshang* argued that the Yellow River, 'cradle of civilisation', had long imposed on Chinese culture a land-locked conformism, a uniform Confucian ideology which isolated the country from global economics. Construction of the Great Wall, argued the film, had further isolated China.

Heshang had a powerful verbal commentary, but combined it with a complex mosaic montage of archive footage. Its signature image was the aerial shot, the visual overview that takes flight from the soil and culture in which, the argument went, China had been too deeply embedded. Other visual symbols of Chinese-ness were interrogated. The Great Wall was an isolationist and arrogant exercise in self-delusion, and the dragon was a slippery symbol of introversion. *Heshang* was a manifesto for outwardness.

The impact was extraordinary. More than half of the Chinese population saw *Heshang*. The broadcaster received thousands of letters of congratulation. All the national newspapers serialised its script, some on the front page. The series was understood by intellectuals, workers, students and peasants alike. Seven books were instantly written about it. Summer camps were organised to discuss it.

But soon signs emerged that the *Heshang* phenomenon was ruffling feathers. It had been too visible. After its first broadcast it was banned. The government propaganda department belatedly concluded that *Heshang* was 'unpatriotic' and 'anti-Communist' and should not be re-run. Its producers were arrested or fled. It scared the hell out of the Chinese authorities. Its aesthetic and historical boldness brought debate about the future of China to every street corner. It added substantially to the momentum of pro-democracy student movements. But the tanks were readying. A film had pushed too far. The idealistic minds of protestors and modernisers, whom Premier Deng Xiaoping called 'the scum of the Chinese nation', had been too taken with its arguments.

The Tiananmen Square massacre, in which between two hundred and a thousand people, mostly students, were killed by the People's Liberation Army, was the result of increasing tension between protestors and the Chinese government. Mao Zedong's death in 1976 ended a period of doctrinal clamp-down. His successor, Deng, ushered in economic reform and talked of material prosperity. In practice this meant some prices were kept low whilst others rocketed. The worst aspects of capitalism – bribery, job insecurity, greed, inflation, and short-termism – came to the fore. If citizens were to endure these, they – especially students and intellectuals – wanted the benefits of a Westernised system. The Party dug its heels in, so people went on hunger

strike. The most famous image from the standoff in the outside world is a still unidentified student standing resolutely in front of government tanks.

His protest is remarkable, but the photograph is shot on an extreme long lens, from on high. Compare it to the kind of shot that is below. One of the hunger strikers has collapsed after three days without food. A man in a plain Maoist top carries him. The carrier is thin, as if he has been on hunger strike too. We are at ground level; the angle is wide, and we see deep into the crowd. The second shot is less detached than the first, more on the ground, less symbolic and more descriptive of individual emotions.

Stories of the hunger strikes moved ordinary Chinese. Hundreds of thousands of them headed towards the square. Soviet president Mikhail Gorbachev was coming to China for a grand welcoming event in Tiananmen Square, the first Sino-Soviet summit in three decades, but the strikers refused to be cleared away. The Chinese government was embarrassed, and so moved the reception away from the line of sight of the protestors. Eventually the army opened fire. Foreign media, who had been there to cover the summit, got their cameras out.

What had been in the head of the protestor in the moments before he collapsed? He will have wanted the mainstream media in China to report his criticisms of the regime accurately. He will have wanted freedom to demonstrate, reform in education (including increased funding) to equip students for the new China. He will have wanted transparency about the salaries of the elite. He will have realised that Confucian conformism had kept citizens docile. And he will probably have seen *Heshang*.

How different will his thoughts, or those of Emily Davison, have been from those of this Syrian man, the last of our protestors, who is standing in a refugee camp on the Greece–Macedonia border in March 2016?

His face is tired. A woman walks behind him. Clothes are drying on a fence, recently built to keep refugees away from the train tracks, which head north, into Macedonia. He has written his message on a piece of ripped cardboard in imperfect English, and stands for hours with it, in silence. It is hard to think of a simpler, more lo-fi example of outwardness. The man's life is hampered. He wants to tell the world. So he writes his thoughts on a piece of cardboard and hopes to be seen, photographed, filmed, tweeted. The image cuts. He could be holding Picasso's *Guernica*. He and the others who have gone before him could hold hands in a line as

long as the eye can see. Like Davison, Picasso, the people in Washington, the carnation revolutionaries, the Baltic silent protestors, Abuladze, the makers of *Heshang* and the Tiananmen hunger strikers, he is externalising injustice. The latter is a lack, an absence; protestors make things to draw attention to the absence.

MODERNISMS

Drawing attention to absence is what many of the great modernist artists of the early twentieth century did. The question here is whether, like the protestors, the painters had centrifugal imaginations which spiralled outwards, or was the process of modern art in these years the opposite of that?

Let's start with a religious Russian, the painter Wassily Kandinsky, who, whilst growing up, saw many icon paintings. As we saw in Chapter 4, the eyes of such paintings often look slightly off-centre, over the viewer's shoulder, to another, metaphysical world. Kandinsky painted that other world. He believed that the apocalypse was coming and, as a follower of the then fashionable idea of theosophy – that the material world would be replaced by the spirit world – he felt that his paintings were prophetic. In this 1913 canvas we can perhaps see several things – a volcano or a Tower of Babel?

The colours are radiant, as in a sunburst. It seems that waves well around the mountain and that, in the top right, there might be figures in the sky. Though the picture is just a few steps away from abstraction, Kandinsky appears to be painting the apocalypse, some future Big Flash that is tumultuous, stormy, but also ancient like a cave painting. Our eyes swirl around it, finding suns and perhaps animals as they do, then are carried off into what could be a brooding sky or a roaring sea. To say this is to think of J.M.W. Turner's great seascapes, equally tangerine, solar and occluded.

Was Kandinsky doing the same thing as the protestors? On the surface, no. They had a material, social message to export, where *Small Pleasures* cannot hope to change the world in the same way. And yet, for both, the everyday world is

deficient, lacking in justice or grace, so the painter holds up an image and says *Here is what we are looking for.*

Other art movements had a more complex relationship with outwardness. There was no TV back in the early twentieth century, but art was an image binge. That country bumpkin Paul Cézanne had paintings shown in Paris in 1904, 1905, 1906 and 1907, and his awkward optics, mannequin people and colour sensations began to seem not only another route through the Himalayas, but weirdly redolent of the atomic age. Pablo Picasso said 'Cézanne's influence gradually flooded everything.' After seeing the 1906 show he painted this, *Les Demoiselles d'Avignon*, which looks like a theatrical backdrop, a work of sewing

as much as painting. It has blank bits and is surfacy, like Cézanne's *Route Tournante*. Its subject – five women and a bowl of fruit – is far more recognisable than Kandinsky's apocalypse, but it feels like we have happened upon those women, as if we are Titian's Actaeon discovering Diana, and that they are not only startled but at a moment of transition. The faces of the two women in the middle are reasonably conventionally drawn (for Picasso at least), but the woman's face on the left is dark-ening, as if halfway between Jekyll and Hyde, and the two on the right are fully transitioned into mask-women – *Doctor Who* creatures, almost. Their planar, enshadowed heads have been transformed by the fact that in summer 1907 Picasso had gone to the ethnographic museum in Paris. He famously saw African art there and was struck by its carving, geometrics and abstraction, the kind of ancient abstract looking that we saw in Chapter 4.

These white French women, probably prostitutes, were turning into Africans from the dream time – shamans perhaps, or figures in whom bogeymen seem to dwell, or what Carl Jung called animas, the balancing part of the collective unconscious. But it was not only the women who were *in medias res*. The space was too. How could we see the woman on the right's body from the back, but her head from the front? Had she spun round, *Exorcist*-style, or has the painter imagined that he had walked around her, seeing her from several angles, then

presented them all at once? We might be reminded of Egyptian sculpture, in which the body is often seen straight on but the head is turned ninety degrees sideways to show as clearly as possible the contours of both. The fruit on the table in Picasso's picture is seen almost from above. Considering multiple angles suddenly makes us wonder if we are not looking at five women, but one seen in five different poses, as in the pages of a sketch book. And the blue background is formed of pizza slices like the women's arms. As in Cézanne's painting of his wife, the brushstrokes do not vary between animate and inanimate things.

Working as a tag team with his friend Georges Braque, Picasso was obliterating the old idea that an image is seen from a single point of view. *Les Demoiselles d'Avignon* has no single, strong vanishing point. It is as if he walked around the women (or woman) as he painted, the result a collage of angular, blocky shapes, shark fins that cut through the picture surface. The new style came to be known as Cubism. It lent itself to objects and people more than landscapes, so musical instruments, jugs, newspapers, playing cards, bottles and faces – the stuff you see in cafés – became its main subject.

Fourteen years before the *Demoiselles* the Norwegian artist Edvard Munch also painted a human being with a mask-like face against a backcloth-like background.

As already mentioned, *The Scream*'s shocking oranges, reminiscent of Kandinsky's apocalyptic tangerine sky, were in part derived from a volcanic eruption. But it also looks like its foreground character has just seen or heard something awful. It covers its ears and howls. Did the two people that have just passed reveal some hurtful betrayal? The figure is painted as an attenuated dark smear, its head a skeleton. But the world around it is equally liquid, boiled, saturated. The bridge and landscape have come to look like what the character feels inside.

The shard-like qualities of the *Demoiselles* and the visual communion between character and setting are echoed in this film image from 1919.

The *Demoiselles* painting looked like a backcloth, as does the room here. There is a light but it is casting few shadows. Instead, they are boldly painted on. The style, Expressionism, existed in literature, theatre and architecture, and, in contrast to Impressionism, which was about receiving visual stimuli, Expressionism was about producing it. The very word tells us that it was about outwardness. It attempted to show us how the world looked or felt from the point of view of the main character. His or her mental state travelled from inside outwards, to 'infect' the world, transforming its buildings, landscapes, perspectives and every aspect of how it looked. In this case the man sitting up in the box, his face painted like the room, is Cesare, a somnambulist circus performer. The man in the hat is Dr Caligari, his mysterious mentor. In the story the former certainly has mental health problems. Eventually it is revealed that Dr Caligari is probably psychotic, so the asymmetry of their world – the left wall slopes more than the right, the window is like an eye, it seems both light and dark – is a projection of their inner states.

As we have seen that all looking involves, in a way, projection, then this could be thought of as a great image about how anyone, not just a mentally ill person, looks. It is not so simple, however, in that a plot revelation at the end of the movie shows that the apparently sane person who has told us the story of Cesare and the doctor is, himself, in a psychiatric unit, so perhaps the externalised mental state is his.

Vincent Van Gogh's psychiatric problems produced images similar to *The Cabinet of Dr Caligari* – images which are outward expressions of inner states. Both are related to the ideas of Freud, which help explain innovative visual culture in the early twentieth century as much as those of Albert Einstein. Protest

was a great externalising visual force; Freud was, in a way, too. He said that we have inside us a preverbal world of images, desires and fears, the door to which is locked. This great sculpture by Henry Moore, *The Helmet*, seems to visualise Freud's ideas. The outer skull is like a shell in which an aperture reveals an internal, interlocked structure.

The internal one seems childlike, infantile, protected, or kept in the dark. Moore's sculpture predates the image next to it by decades, yet they both suggest something buried, unseen, dark and troubling.

Darth Vader, the dark father, was authority and paternity gone hideously wrong, the thing to rebel against, but also the thing that lurked within. Freud said that to imprison the things that lurked within caused mental stress and hysteria. His psychoanalytic theories unlocked the door in order to release us from the anguish of their unacknowledged power. He once had a dream about this paint-

ing, Arnold Böcklin's *Isle of the Dead* (itself a painting of a dream). One of the most popular images of the late 1800s and early 1900s (and Adolf Hitler's favourite image), it gives a haunted sense of Freud's own project.

The rocky crescent island is like the human skull, like Darth Vader; contained within are the dark cypress trees of the unconscious. In our section on Tutankhamun we heard that Freud dreamt of Rome. Archaeology interested him. It unearthed buried things;

ruins could symbolise repressed desires and fears. In this painting the trees seem to be growing in ruins, sheltered by them; they are fertile, far away, an island to be visited. The water is flat, the boat glides forwards, ill met by moonlight, the standing figure in white is approaching, drifting into, the harbour of death or, perhaps, her own unconscious. It is almost as if there is a movie projector on the boat, and the island is a cinema screen.

The paradox is that Freud, the stoker of the fire of twentieth-century looking, was a verbalist. He saw word puns and slips of the tongue as escapees from the prison of the unconscious – signs of what his patient really felt. A parapraxis was an unintended verbal incursion into what someone was saying that revealed what they really felt. Part of his life's work was to make the visual – dreams – verbal, because to do so was to defuse their bomb. Push this idea as far as it goes and you could say that the great European trauma of these years – the First World War – was an appalling parapraxis, a symbolic eruption of terror which revealed the gastric depths that lay below the surface of the continent's cultured image of itself.

Disgust at the First World War was visualised, in neutral Switzerland and elsewhere, from 1915, by new anti-art provocateurs and satirists, the Dadaists. After Gallipoli, after Ypres, after Verdun, the visible world should not remain the same, they felt. It should be upended like an apple cart. Everyday society should register the trauma like a seismograph needle registers an earthquake. In the 1920s a group of artists, painters, eroticists, writers and printers took Sigmund Freud at his word and, again partly spurred by the horrors of the First World War, became some of the most ardent externalisers in human history. Surrealism was officially launched by André Breton's *Surrealist Manifesto* of 1924, itself a document

about words, but a lot of the energy of Surrealism was used to depict the preverbal world of desire and fear – the prison, the island – rather than the post-verbal world of recovery. In showing on the outside what could not be looked at on the inside, by ignoring retinal activity, they revolutionised looking.

Take this remarkable late Surrealist image. *Voltage* is by the American artist Dorothea Tanning, who lived into the twenty-first century and who said she learnt how to paint by gazing at paintings.

A topless woman's head seems to have disappeared. Her hair is still in place but

plaits into a rope which enters her left breast via what seems to be a metal lock or handle. Her right hand holds a corkscrew, attached to which are two eyes – quite possibly her own. If they are, then she is doing that thing that dreamers do, having an out-of-body experience. Externalising looking. She is seeing herself as a lover might, her nudity adding to the sense of display, perhaps of narcissism. Certainly there are visual loops here that swirl us around the picture like a roller coaster: the white scarf encircles her torso; the gold hair echoes its vortex; and the line of the hair, right arm and then eyes is a third arc. None of the lines take our eyes outside the picture frame. Even the sea-like background contains our seeing. The hugging self, the fairground of the self, is the subject.

Tanning did not really mention a possible source for her image, but the ancestor of the naked lady is St Lucy of Syracuse (CE 283–304), about whom we know almost nothing. By the early 1400s the story was told that before she died for the Christian cause, her eyes were gouged out. Hence this image by Francesco del Cossa.

The eyes on the stalk are remarkably similar to those in *Voltage*, and the fifteenth-century image has a white cloth and golden hair too, but the differences jump out. St Lucy has her own eyes – maybe this is her premonition of her fate – and she looks modestly downwards. The external eyes look at – and seem to accuse – us, so there is morality here. Tanning's picture has the opposite intent – to reveal rather than condemn. Lucy had a cause in mind – the still nascent Christian church – whereas Tanning's woman is lost in herself. When Lucy's body was buried, her eyes had returned to their sockets. Her looking was intact, so perhaps del Cossa's painting is of her after she died. She is the patron saint of blindness and is often depicted carrying her eyes, sometimes on a plate. If Catholic imagery tended towards the Baroque, it was sometimes, also, surreal. The intensity of the pious experience is perhaps similar to that of the dream experience, with the ecstatic state as their intersection.

Tanning married the German painter Max Ernst, one of many painters who contributed to the Surrealist dreamscape. Some of its earliest elements were established by Greek Italian Giorgio de Chirico. The dreamscape, the uncanny valley, was a place of sharp shadows and cerulean light. De Chirico lived in Turin for a short time and loved the plunging perspectives and repeated columns of its colonnades, such as this one.

They were rabbit holes to mysterious places, and his paintings are full of them. Where Renaissance painting usually had single vanishing points, however, de Chirico's pictures had many, each colonnade and building tilting towards a different windmill. Crisply painted in themselves – no flickering impressionism for de Chirico – their perspectives nonetheless contradicted each other. You could not get around the city he presented, because it folded in on itself like the film *Inception*. There was almost something Cubist about this, and the dreamscape had its first element –

spatial incongruity. As if to emphasise how much this was about looking, here is de Chirico's 1918 painting *Two Heads*. The one on the left has been stripped of vision, whilst the red one on the right has eyes of tunnels, like those on railway lines or the streets of Turin. The light in this world is as we see it – the heads cast shadows, but what is the angled board between them, and why the rivets on the face? They are rapt, perhaps even alarmed – one half hiding, one on the march into the crisp white light.

The poster boy of Surrealism was the self-mythologising, outwardly directed, exhibitionist, moustachioed, media-savvy Spaniard Salvador Dalí, the co-director of *Un Chien Andalou*, whose eye-slicing image we used to begin our look at the twentieth century. His visual signature is the melting or drooping object – clocks, body parts, etc. – the echo of Einstein, perhaps, or impotence, or the dissolution of the hard outer world into the softer inner one. If de Chirico gave the dreamscape sharp colonnades, Dalí gave it evanescence. In this painting, *Impressions d'Afrique*, he is on the left (there are lovely preparatory self-portraits), half hidden by his canvas, looking at, and reaching out into, the world. His eye is in shadow but we can see that it is alert and somewhat fearful. It is taking in so much that his hand seems to be saying *Stop*.

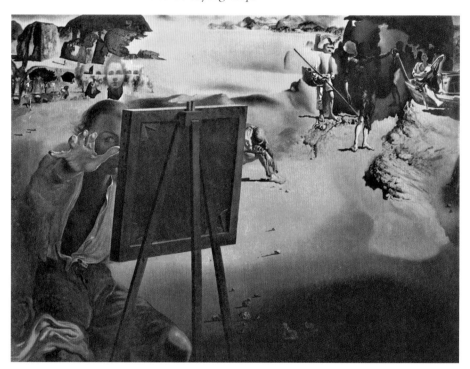

The picture says much about looking because the backdrop is like a back projection, a phantasmagorical amalgam of what he has seen, what images are in his head, his *optique*. Right above him is his wife, but her eyes are also caves carved in white stone. Around her are people, rocks and what looks like a bird's wing, all illogically set in a dusty street scene, like that seen by our imagined Indian man hunkered down at a Kolkata crossroads in Chapter 3. On the right of the canvas, an anguished seated man has dropped his head, and on the far right four barefoot figures pose and merge with the landscape. Towards the end of the

story of looking, we will see connections between *Impressions d'Afrique* and one of the most famous of Spanish paintings, *Las Meninas*.

Dalí probably did not go to Africa, but positions his chessmen on its deserts and dunes. He makes the dreamscape Saharan, almost empty, a hot static place where things are hard to discern, and trick the eye. The phenomenon of the mirage is well known in such places, of course – the heat of the ground refracts the light from, for example, the sky near the horizon, making the ground below the horizon look shimmering and aquatic. In very cold temperatures the opposite – a superior mirage – happens, so that things below the horizon look like they are above it. And then there is heat shimmer, the way the landscape beyond a bonfire flickers if you look at it through the space just above the flames. Dalí was not interested in the kinetic aspect of such imagery, but again and again he painted bravura sections of canvas where the same brushstrokes looked like two things – his wife's eyes and caves, for example – and our brains, not being able to settle on one, switched to and fro. These were looking puns: unexpected connections between two things, such as a corkscrew and a pair of eyes. They played with space-time and were cattle-prod metaphors. Surrealism liked such jolts. It made other looking seem bland, constrained and bourgeois. Later in the twentieth century, after the United States dropped bombs called 'Little Boy' and 'Fat Man' (did the Surrealists have a hand in naming these?) on Hiroshima and Nagasaki, resulting in the deaths of nearly a quarter of a million people, an enraged creature called Godzilla entered popular Japanese cinema, trampling on urban dreams. He was Little Boy and Fat Man by other means, but also a symbol of what had lain dormant. The bombs had split open the surface and a creature from the *huis clos* of fear was let loose. Rendered outwards. Godzilla would soon be interpreted in environmental terms, but he was one of the century's best examples of the unconscious visualised. The dreamscape had a monster.

In many Dalí paintings the setting has oceanic as well as desert qualities. Yves Tanguy, Dalí's senior by four years, made the Surrealist dreamscape more aquatic still. Born at the Ministry of Naval Affairs in central Paris, and briefly in the navy himself, Tanguy's visual imagination explored extra-planetary seabeds. In this picture, *Shadow Country*, we have the lighting of de Chirico, the object placement of Dalí plus the contours of marine biology.

Tanguy had no training as an artist, but saw a de Chirico painting and was so fascinated that he took up painting himself. If Freud's psychoanalysis was a bit like fishing – you drop your line down into the deep, and hope to catch something that you can reel up into consciousness – then the seven lines in *Shadow Country* might be imagined as routes upwards to the surface, where everyday life happens.

Surrealism encouraged unexpected connections and noticed latent material, so here is the place to mention an event from April 1912, the heyday of de Chirico and Picasso, which fascinated the imagination of the twentieth century and whose shadow lies behind the last few paragraphs. About 1,500 people died in the incident, which turned one of the most visual things of the early twentieth century into an absence. The *Titanic* ocean liner was a floating society, stratified along capitalist lines. It was one of the biggest things ever built – an act of hubris, a horizontal skyscraper. Its image system involves the crisp clear moonlight, a probable optical illusion, a sea monster of a kind and the ocean floor. British historian Tim Maltin has studied the weather data from the evening of the tragedy and found that the conditions were right for a superior mirage, so the horizon would have looked higher than it is and might have rendered distant objects less visible or even invisible, until they were a mile away.

Freud talked of representing a thing by its opposite, so instead of showing the liner, let's show its opposite, and the thing that perhaps caused its demise.

Earlier in this book we considered the unseen. Here we have the unmentioned and the unseen. We can almost see the ghost shape of the thing that this iceberg brought to an end. This is a haunted image.

Our final Surrealist was more interested in looking than the others, and introduced a dramatic time of day to the movement's dreamscape: uneasy dusk. Earlier in our story we looked at Magritte's famous painting of an eye, with a sky where the sclera (white) is. That was a good introduction to him, because his paintings are full of seeing and framed vistas: windows, mirrors, tunnels, easels, doorways. His late painting *Blood Will Tell* summarises his approach.

Like Vermeer, he frames the image with a curtain to give us a sense that what we are seeing has

been veiled and is suddenly on show. The curtains edge what lies behind them, like many apertures in his work do. The frame is a border between the realms of the ordinary and the extraordinary. Immediately inside the curtains is a tree with two doors in its trunk which are open and reveal a house with its lights on, and a white sphere. The sphere is typical of Magritte. Unlike Picasso and Braque, who broke objects down into planes and angles, Magritte's objects, and there are many of them (apples, a pipe, fish, bowler hats, umbrellas, trees), are immensely solid and sometimes fill a room. It is as if life is what in the Renaissance was called a 'cabinet of curiosities', a piece of furniture that displays objects of fascination.

Behind the tree, stretching out into the distance, is a landscape similar to Leonardo's in the *Mona Lisa*. An uncanny element is that we can see stars but the sky is blue rather than black. This and the house lights being on conjure the threshold moment of the day that Magritte found so evocative, when day is not quite done and night is not quite complete. The painting perhaps gets to the nub of Surrealist outness. The further we go in that direction, the more we tunnel inwards.

There is a border to be crossed to get into the dreamscape, a border between day and night, a framed border. One of the most famous Surrealist film-makers, Jean Cocteau, regularly emphasised this. Overleaf, in his *The Blood of a Poet*, whose title echoes Magritte's *Blood Will Tell*, a poet wants to cross into the realm of the fantastic, where new types of imagery lie and new modes of seeing take place. He finds a framed mirror. But like the frames in so many Magrittes, and like the *trompe l'oeils* in Dalí, and like the writing of Freud, the mirror is a pun.

It is also water, and the poet plunges in. Perhaps we can see the water as an eyeball, split and ready to be explored.

Turn to modernist literature of the early twentieth century and something different happened to the kind of outness we have seen in Surrealism. In the nineteenth century the looking trend in writing was towards naturalism. Now avant-garde writers emphasised looking as part of fleeting or fragmented consciousness. They externalised the motions of the mind. There had been hints of such modernism before its heyday in the early twentieth century. Dublin-born Bram Stoker's visit to Whitby in 1890 led him to have a typically late-Romantic experience. He saw the ruined Whitby Abbey, skeletal and decaying since its sack at the time of the Protestant Reformation, and its form, elegy, sadness and poetics, mixed with eastern European stories he had heard, led him to write the novel *Dracula*. Not modernist writing in itself, its genesis was, in that the form of an old building was translated into prose, almost like synaesthesia.

In his vast *In Search of Lost Time* (1913–27), Marcel Proust seemed drawn to urban speed, social scanning, the new visuality of life and cinema. People of the time experienced existence less through prayer in churches, or meditating, and more through the kinetic boogie-woogie of modern life. Like some latter-day Galileo, Proust looked at life as if through a telescope, from his bed, landing on the optics of gesture and costume, then panning outwards. In the first pages of the book, half-awakeness is compared to a kaleidoscope. A room in Doncières is described as an 'optical centre'. Monocles and prisms recur. Marcel's looking at church steeples from a moving carriage creates shifting perspectives and echoes a famous moving observation of a church steeple which altered our understanding of space-time. In *The Guermantes Way*, Proust writes:

To succeed thus in gaining recognition, the original painter or the original writer proceeds on the lines of the oculist. The course of treatment they give us by their painting or by their prose is not always pleasant. When it is at an end the practitioner says to us: 'Now look!' And, lo and behold, the world around us . . . appears to us entirely different from the old world, but perfectly clear. Women pass in the street, different from those we formerly saw, because they are Renoirs, those Renoirs we persistently refused to see as women.

The painter and writer is 'on the lines of the oculist', but that is the broader trend in Western, urban life. Reality has been displaced by its representation; the cart is before the horse. The outside leads the inside.

Love in *In Search of Lost Time* is like an optical illusion, though it also allows Marcel to see his hero Gilberte beyond the normal spectrum, in 'infrared'. Proust oscillates between the revelations of looking and its deceptions, or binaries. The latter is clear in this passage:

A man who is in the habit of smiling in the glass at his handsome face and stalwart figure, if you show him their radiograph, will have, face to face with that rosary of bones, labelled as being the image of himself, the same suspicion of error as the visitor to an art gallery who, on coming to the portrait of a girl, reads in his catalogue: 'Dromedary resting.'

Canny Marcel is having his visual cake and eating it. He deploys the new looking technologies as metaphors yet seems to see them as redolent of surface. In *On Photography*, critic Susan Sontag claims that 'whenever Proust mentions photographs, he does so disparagingly'. Besotted by the new types of looking, like so many hipsters and modernists of his age, Proust seems to doubt the pleasure he desires from them. His phrase 'rosary of bones' equivocates. Maybe the man who looks in the mirror at his handsome face is seeing Munch's *The Scream*, or Picasso's *Demoiselles*, or even the *Titanic*'s iceberg? The visual deluge of the new, optical twentieth century was exhilarating, but was it to be decried?

Sontag's fellow American Henry James wrote a remarkable book which seems, here, to enter this fray. In *The Sacred Fount* an unnamed narrator observes the behaviour of guests at an English country house and, from his observations, speculates about their sexual relationships. Like Marcel, he is a peeper, but he is a detective too, which reminds us that detection is one of the first things we do as lookers (see the image of the woman eating something, perhaps in a cinema, in Chapter 2). At the start of Part IX of *The Scared Fount* the narrator says:

I shall never forget the impressions of that evening, nor the way, in particular, the immediate effect of some of them was to merge the light of my extravagant perceptions in a glamour much more diffused. I remember feeling seriously warned, while dinner lasted, not to yield further to my idle habit of reading into mere human things an interest so much deeper than mere human things were in general prepared to supply . . . We existed, all of us together, to be handsome and happy, to be really what we looked . . .

James's novel is not wholly admired; some complain that nothing happens in it, but nothing happens when you people-watch in a train station or, rather, nothing deterministic happens. There is no prearranged plot. James's book asked a more sober question than Proust's: how far can you get if you start from the outside, from 'immediate impressions'?

The English novelist Virginia Woolf answered it. As if to take the looking in *The Sacred Fount* to its logical conclusion, in 1930 Woolf wrote an essay called 'Street Haunting'. It is explicitly about having nothing to do, and so, Woolf invents a goal – in this case the buying of a pencil. Woolf does not need a pencil but she does want a pretext to head out into London at dusk one autumn evening, and look. As we saw in Chapter 12 early in her essay she writes:

The eye is not a miner, not a diver, not a seeker after buried treasure. It floats us smoothly down a stream; resting, pausing, the brain sleeps perhaps as it looks.

. . . thus challenging the premise of this book that looking nourishes our lives. Luckily, as she sees people and imagines their inner lives, she questions her scepticism about depth looking, writing as Leonardo drew, or Copernicus thought. First she affirms the beauty of seeing, saying that:

On a winter's night like this, when nature has been at pains to polish and preen herself, [the eye] brings back the prettiest trophies, breaks off little lumps of emerald and coral as if the whole earth were made of precious stone.

Already she is affirming looking more than Proust does. It brings back trophies. Then, looking at people apparently living on the streets in central London (which reminds us of the photograph of two women crossing the Dublin bridge), Woolf writes this:

At such sights the nerves of the spine seem to stand erect; a sudden flare is brandished in our eyes; a question is asked which is never answered. Often enough these derelicts choose to lie not a stone's throw from theatres, within hearing of barrel organs, almost, as night draws on, within touch of the sequined cloaks and bright legs of diners and dancers. They lie close to those shop windows where commerce offers to a world of old women laid on doorsteps, of blind men, of hobbling dwarfs, sofas which are supported by the gilt necks of proud swans; tables inlaid with baskets of many coloured fruit; sideboards paved with green marble the better to support the weight of boars' heads; and carpets so softened with age that their carnations have almost vanished in a pale green sea.

Passing, glimpsing, everything seems accidentally but miraculously sprinkled with beauty.

This passage is evidence of the power of writing, of course, but of looking too. *A sudden flare is brandished in our eyes.* The flare creates the words. Woolf's eye is not just drifting, enjoying or surfing. It is working. It notices discontinuities in the street scene and evaluates them morally.

She is also deeply aware of the role expectation plays in looking. Her novel *To the Lighthouse* dramatises this role, addressing the idea that looking involves the projection of preconceived ideas and sights. At the start of Woolf's novel a six-year-old, James, wants to go and see a lighthouse on the Isle of Skye, but his father refuses. Ten years later, he finally gets there:

James looked at the Lighthouse. He could see the whitewashed rocks; the tower, stark and straight; he could see that it was barred with black and white; he could see windows in it; he could even see the washing spread on the rocks to dry. So that was the Lighthouse, was it?

No, the other was also the Lighthouse. For nothing was simply one thing. The other was the Lighthouse too. It was sometimes hardly to be seen across the bay. In the evening one looked up and saw the eye opening and shutting and the light seemed to reach them in that airy sunny garden where they sat.

James realises that he is seeing two things, the physical structure and its relationship to his expectations, his decade-long desire to see it. Several times before in the story of looking we have seen that looking is not just a present-tense event: it folds into the present memories and expectations, the past and the future – a theme we will consider further when we explore looking and time. In

this chapter in our story, Woolf's lighthouse is a great outward thing, a beacon or projector, a warner.

Like Woolf, French novelist and film-maker Alain Robbe-Grillet downgraded plot in favour of what was called 'chosiste' passages – sections about things. In his novel *The Erasers* he described objects not because they were relevant to the story but because they were not, and so had a weight of their own. They were narratively inert, so came alive as things outside causation or psychology. Things to be seen. In Jean-Paul Sartre's *Nausea* those things weighed more. Its protagonist Antoine is the opposite of Woolf's street haunter. Where she is sucked in by the faces of the people she looks at, he sees people in the town where he lives (Bouville, which resembles Le Havre in the north of France), but feels no such pull. Unlike in Proust, where looking is exciting but to be queried, or in 'Street Haunting', where to look is to think, evaluate and live, looking for Sartre's Antoine is at first inert. Like Robbe-Grillet, Sartre describes the thingness of things, but then Antoine has a realisation. In a celebrated scene he looks at a tree's roots:

> All at once the veil is torn away, I have understood, I have *seen* . . . The roots of the chestnut tree sank into the ground just beneath my bench . . . If anyone had asked me what existence was, I would have answered in good faith, that it was nothing, simply an empty form added to things from the outside, without changing anything in their nature. And then all at once, there it was, clear as day: existence had suddenly unveiled itself . . . it was the dough out of which things were made; this root was kneaded into existence. Or rather the root, the park gates, the bench, the patches of grass, all that had vanished: the diversity of things, their individuality, was only an appearance, a veneer. This veneer had melted, leaving soft, monstrous lumps, in disorder – naked, with a frightful and obscene nakedness.
>
> . . . The chestnut tree pressed itself against my eyes. Green blight covered it halfway up; the bark, black and swollen, looked like boiled leather . . . I realized there was no mean between non-existence and this swooning abundance. If you existed, you had to exist to excess, to the point of moldiness, bloatedness, obscenity. In another world, circles, musical themes keep their pure and rigid lines. But existence is a yielding . . . *Superfluous*, the chestnut tree there, in front of me, a little to the left.

Philosophers have had a field day with Sartre's novel, and this scene in particular. It has several relevancies for us. It is a looking-born epiphany, an offspring of Newton's tree. It realises that looking can be like flooding – the excess and bloatedness. Later Sartre would expand on his distinction between being and

nothingness; here he seems overwhelmed – nauseated – by the realisation that deductive looking, or seeing the essence of something, is an unnecessary compulsion. Antoine is no more significant than the roots of the chestnut tree, yet he continually makes the thought error of assuming that he is. The Surrealists were hurling dreams and the unconscious outwards, into the world. Great writers such as Proust, Woolf and Sartre were using what was seen as a spur to doubt or think, or a shock to self. The outer world sent missiles inwards, and then they exploded. In both cases looking was helping the artists find their place in the world. Looking was a GPS system by which they navigated.

SKYSCRAPERS

There were other new ways, in the early twentieth century, of seeing where you were and what your bailiwick was. As those writers sat in cafés they watched the cities around them, as if in time lapse, grow. If the twentieth century was a visual splurge, if it was – to continue our metaphor – an eyeball sliced open, then how do the big twentieth-century cities fit into this?

The main thing to note is that they grew upwards. Tall buildings were a signature of the age. But they were not brand new. New York's Empire State Building, the product of modern engineering, building materials and economics, could not have been built much before its time, but the idea of a tall building long predates it. The Tower of Babel was a mythical soaring structure and, remarkably, in the real world, this ten-storey Ethiopian structure was built around CE 300.

Inhabitable buildings in Ethiopia at this time were no more than two or three storeys high, but this massive grave marker, complete with ground floor door and lock, and stacked floors and windows above, is a stone sketch of the tall buildings that would mark the twentieth century. In the nineteenth century the Eiffel Tower was a sculptural beacon which showed how iron could be used to support a massive structure, but had little function beyond that of a sublime viewing platform. It helped Parisians

see their place in the world. Soon afterwards Russian modernists experimented with similar constructions, but it was in America that the skyscraper really rose. Each was out on a limb, out-scaled, soaring, bigger than life. Were they external-isations of something, like the paintings of Tanguy and Dalí were?

The conditions for skyscrapers were ripe. The last time the USA featured in our story it was its westwards horizontal that caught the eye. This time it is its verticality. Chicago led the way. In 1871 a fire destroyed a third of the city, an estimated twenty-eight miles of streets. Two years later, aged just seventeen, a gifted, idealistic young architect, Louis Sullivan, moved to the city to help with its reconstruction. Soon he was talking height. His short, classic essay 'The Tall Office Building Artistically Considered' was a call to arms: 'The architects of this land and generation are now brought face to face with something new under the sun, – namely . . . a demand for the erection of tall office buildings.' In one short paragraph, he summarised why they were being built:

> offices are necessary for the transaction of business; the invention and perfec-tion of the high-speed elevator make vertical travel, that was once tedious and painful, now easy and comfortable; development of steel manufactures has shown the way to safe, rigid, economical constructions rising to a great height; continued growth of population in the great cities, consequent congestion of centers and rise in value of ground, stimulate an increase in number of stories.

The rush was on. In 1885 the Home Insurance Building in Chicago became the world's first modern skyscraper. Four years later New York's first tall building opened. Also in 1889 Chicago's Tacoma Building was the world's first with a completely steel framework. These buildings were engineered but, as Sullivan was at pains to point out, they were also aesthetic, imagined, almost moral things. In his famous essay he asked:

> How shall we impart to this sterile pile, this crude, harsh, brutal agglomeration, this stark, staring exclamation of eternal strife, the graciousness of those higher forms of sensibility and culture that rest on the lower and fiercer passions? How shall we proclaim from the dizzy height of this strange, weird, modern house-top the peaceful evangel of sentiment, of beauty, the cult of a higher life?

Sensibility, beauty and the higher life: this Victorian language sought to make early twentieth-century building be about something. This could be Virginia Woolf writing. Look at an image like this and it is hard not to think that the ingre-dients of New York or Chicago were height, capitalism, engineering, Cubism and

Freud: Cubism for the boxiness, and Freud because such buildings seemed, in part, like externalisations of sexual psychology. Men liked their penises and wanted to make the world look like them.

This view of the Empire State Building is square-on, beautiful, functional, an ideal angle that does not distort, a mid-height shot of a mid-city wonder. The users of this and other commercial buildings were white-collar workers – salarymen and stenographers. Their office windows gave them splendid aerial views of the city's Cubist grid.

Non-users had more angular, less central visual experiences. In this shot from the last act of the film *Force of Evil*, a statue of George Washington, the first president of the USA, in real life a six-foot-tall surveyor, surveys a crevice-canyon on Wall Street that dwarfs the character at the bottom.

The tall buildings seem like extrusions, rectilinear eruption or stalagmites, outward bursts. They exclude light. There is submersion here; the sense of scale in Manhattan is like an Yves Tanguy painting, like the Romantics' desire to be dwarfed by the Alps. Wall Street is one of the central boulevards of the money world, of course, and so if we see capitalism here, we might also see the tiny man degraded or disparaged. The shot externalises the inequalities of capitalism – masters of the universe tower over slaves of the market.

Of course the non-users of tall buildings also look up at them, to see something like this, another type of crevice.

At the bottom of this photograph is the Chrysler Building, completed in 1930, less than a year before the Empire State. Opposite it, a glass structure becomes its viewing platform, looking glass and echo chamber. The sky that was so large for the young Yves Klein has now become rationed. You pay to see, live or eat in places where you can see the sky in New York. Unlike on balloon rides, the looking that is done around tall buildings is sliced. Again, this looking is immersive, aquatic, like the mosque in Esfahan. Tall buildings began, perhaps, as an outward,

upward impulse, but stack enough of them together and stand amongst them and you are inside something. Outwardness disappears.

Seen from a distance, and at night, tall buildings take on other properties. Woody Allen's film *Manhattan* opens with wide black-and-white shots of the skyline of Manhattan. Even the idea of a skyline was newish. New York's, with its forest of verticals, lent itself to a horizontal composition, like a Chinese scroll. Allen films fireworks over it and, at night, without colour, it is hard to see where the burning magnesium ends and the internally lit steel skeletons begin.

No wonder that tall buildings created their own image systems. In the *Batman* #4 comic book, the title character's home city, which resembled a noirish downtown Manhattan, was called Gotham. In thousands of subsequent comics, films, TV shows, and here in this video game, part of the *Arkham* series, Batman is a looker. He stands on, or swoops between, tall buildings to observe

his prey, a vigilante of the era when capitalism has gone wrong and the law is dying, dead or a joke.

Outside and above the city, Batman is seeing his place in it, or lack of place in it. He is like Proust looking at France — fascinated but vaguely repulsed. This image is similar to *Wanderer above the Sea of Fog* in Chapter 1.

We see the back of a man. He looks out into the mist, the z-axis. As we cannot see his face, we cannot read his exact emotions, which makes him, and the scene, gnomic. Galileo stood on the roof of St Mark's in Venice to survey the moons of Jupiter. Tall buildings afford looking, not so much outwards from the citadel, but inwards and downwards, into the thing we have built, its circuitry and grid. Parkour, the recent urban exploration activity, often involves people climbing tall buildings to see what it is like up there, to transgress, to excite, to reclaim, and to challenge the fact that their summits are where the penthouses and rotating restaurants of the rich are.

High looking in modern cities like Dubai has such a premium on it that tallness becomes a sign of social status. You go high to show off or break in – how can you break in to height? – or, perhaps, to escape and die.

Within three years of the Empire State and the Chrysler being built, audiences saw a beleaguered beast climb the former and look at the latter. He was America's Godzilla, an overseer from the dreamscape who died for our sins.

King Kong did not climb to the skyline of New York to admire its modernism or become king of the world. He wanted to escape, to get out of the gutter and away from his tormentors. He did not hate people, but they hated him. His was another kind of early twentieth-century outwardness. The great cities festered. Above, the air was clearer.

ADVERTISING

The city of New York that King Kong climbed above, up to its treetops, was studded with another type of visualisation: advertising. Signs for goods and services had been used since ancient times, but industrialisation and photography created a chain reaction. Around $200 million was spent on advertising in the USA in 1880. This increased to $3 billion in 1920. Stories were told about cars, tobacco, soap and food. The storytellers were the creatives at agencies like J. Walter Thompson, a company that started in America then expanded to the UK (in 1899) and then to Africa and Asia.

Were they propagandists, these creatives? Propaganda and advertising both try to make us believe in something, to spend money on something, to devote time to something. Both use beauty and heroism in their imagery to create desire and invoke myth. Both should be held to account when they tell lies – hence the Advertising Standards Authority in the UK.

One difference between them is scale. Propaganda has a tendency to the epic, the big or national message. Adverts are usually smaller things: haikus and intimate smithereens. In the Western world advertising exists in even the smallest places in our lives – on the back of the aeroplane seat in front of us, in the post-mark on our letters, in frames within frames on our mobile phones. They work well in peripheral vision. They abhor a vacuum, get everywhere and are impertinent, stubborn and aesthetic. In places of high population density, like Hong Kong, they are clustered and jostle for a place in our visible urban landscape. They grow out from buildings and reach across streets, creating Cubist arches of logos, colours, opening-time information and location.

In places where it is assumed that people will drive rather than walk, advertisements are spread out, and line the roads like frames of a film, like rows of dominos – visual, verbal, sequential and competitive.

Adverts did not just add to an already chaotic visual scene in the twentieth century, they replaced things, like the sky in Hong Kong. As they are attractive or garish, they take up time that was previously spent looking at other things. They are speedy. They expect only to be glanced at, and so must deliver their message or emotion quickly, hence their great economy, their puns, *trompe l'oeil* or instant hit of desire. John Berger writes that 'publicity is always about the future buyer. It offers him an image of himself made glamorous by the product or opportunity it is trying to sell. The image then makes him envious of himself as he might be.' Advertising tells us that we will be transformed. It is the Cinderella myth. Even in a printed magazine, where you can look at only two pages at a time, advertisements present story blasts of glamour and envy. In this one for Chesterfield cigarettes no one in the image is smoking. Instead there is an instant hit of emotion.

A healthy, happy, well-groomed, middle-class, enviable white daughter (or is she a wife?) and son smile into the camera, pleased because they have a birthday present for their dad that they know he will love. He is behind the image, he is the receiver of it, of their look, of their love, of their pleasure, as are we. The shot is taken at the height of the eyeline of the boy, so Dad is probably sitting down, in his favourite arm chair. His feet, wearing slippers, could be peeping into the bottom of the shot.

A utopian nuclear family, centred on the man, is evoked here. Hollywood actors Ronald Reagan and Humphrey Bogart endorsed Chesterfield, and the product appears in Bogart's classic movie *To Have and Have Not* and, later, the films *Reservoir Dogs* and *True Romance*. The Coen brothers and Jim Jarmusch use Chesterfields in their movies, and they are mentioned in the James Bond book *Goldfinger*. Clouds of maleness and existentialism swirl around Chesterfields. An estimated 100 million people died of smoking-related illnesses in the twentieth century, more than the combined amount

from both world wars. Advertising was one of the great extrusions of the time. It was the sheen of capitalism, it was desire, fear and hunger made manifest, and so these myriad persuaders that pockmarked the twentieth century like the tommy guns of the First World War are perhaps a culmination of the outwardness that this chapter has charted.

FASHION

Or maybe fashion is. If this chapter's theme has been externalisation, of rendering optical hidden things, of the visual deluge of the split eyeball, then clothes, as an outer skin, are the most obvious example of all. We have seen a lot of clothes in this book: Cleopatra's golden eagle headdress and gown; the *Mona Lisa*'s dark velvet tunic; the knee-length frock coat of Caspar David Friedrich's man who looks out over the misty hilltops; the togas of the apostles at Duccio's *Last Supper*; the Madonna's blue and gold cape in Leonardo's painting; Kim Novak's fitted grey suit in blue shadows in Hitchcock's film *Vertigo*; the uniforms of the dying men at Verdun; the yellow and blue top and skirt worn by Picasso's woman with her back to us; the lace, braid and damask on the dresses of Europa and her sisters; Frida Kahlo's frilly pink full-length gown; the woven hat and braiding of the North Carolina shaman woman; the yellow Chinese tunic from the Silk Road; the grand overcoats of the explorers and Crusaders; the mud-covered garments in the war scene in Welles's film *Chimes at Midnight*; the billowing, gathered robe of the ecstatic St Teresa; the Dutch clothes in the Vermeer picture; Groucho Marx's nightshirt; Jack Lemmon's dress and hairband in *Some Like It Hot*; Dietrich's luscious clothes as Queen Christina; the body jewels of King Xerxes in *300*; the working women's aprons in the Taiping picture; the frock coat of the man with the umbrella on the streets of Paris; the headscarf of the peasant lady looking at a light bulb for the first time; the kimonos of the geishas; the stiff red dress of Madame Cézanne; Marnie's yellow handbag; Luke Skywalker's white belted robe; the shorts of the high jumper and footballers; the blue headscarf of the woman with her hand out who pauses time; the masks of the Chernobyl men; King Tutankhamun's headdress; Gandhi's white *khadi*; the utilitarian green jacket of the guy on Tiananmen Square; the black shrouds of Cesare and Caligari; Batman's cape; and the prim upper-middle-class clothes of the cigarette kids.

Each of these outfits is a precipitate, a sign of social standing, or role, or a visualisation of something internal or symbolic. To show the range of visual meaning at play, let's allocate one word to each of the garments: regal, demure, enlightened, pious, elemental, restrained, combative, sorrowful, privileged, performative, timeless, oriental, European, abject, exalted, performative, childlike, transgendered,

overdetermined, camp, labouring, bourgeois, Slavic, costumed, domestic, Freudian, ascetic, sporting, veiling, atomic, pharaonic, restrained, basic, Gothic and conservative. Exhibit these outfits in a design gallery and you have a history of how clothes are visualised.

Let's end this chapter with an archetypal image of these years, a photograph by André Kertész of people in the Café Dome in Paris in 1925. This is the sort of picture we expect to see of the 1920s, and yes, Paris was an extraordinary cultural centre – and exporter of ideas – around this time. *Un Chien Andalou* was premiered, André Breton had a new novel published, Braque was doing some of his best work, dancer Josephine Baker was all the rage, Le Corbusier was dreaming of a new type of city, and Cole Porter wrote 'Let's Do It'. But of course many things were happening around the world in these years that such an image cannot even hint at. To name a few: the French government devalued the franc, the Soviet Union declared war on its richer peasants, Turkey secularised, Chiang Kai-shek captured Beijing, the Mexican president was assassinated, Alexander Fleming discovered penicillin, and a new cartoon character called Mickey Mouse was born.

That is all out of frame, out of sight, but what is in sight? More than thirty people, in close proximity, the café terrace spilling out onto the street. They chat, smoke, read newspapers and books, serve customers or walk on the pavement. Very few of them are looking idly. What we perhaps notice most is their second skins, their clothes. Where in previous centuries hair was big and made a statement, here it is hidden under women's cloche hats.

Just five years previously, in 1920, Antek Cierplikowski had popularised the bob. The two women in the foreground wear tailored jackets in plane fabrics – few patterns, nothing too decorative or floral or Belle Époque. In 1921 Coco Chanel had opened one of the world's first fashion boutiques and had loosened women's clothing by liberating them from the constraints of the bustier and the corset silhouette. None of the women in this photo is using clothes to emphasise the curves of her body. If anything, the men's

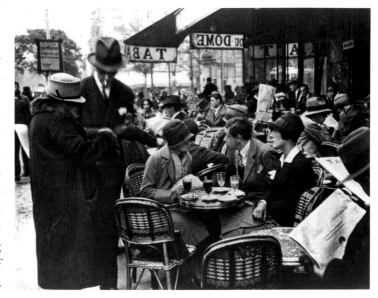

clothes do more structural work, their suit jackets broadening shoulders. All the men wear ties, and most have hats and breast pocket handkerchiefs. To modern eyes this looks dressed up, but in the history of fashion this was a noticeably casual way for the middle classes to dress. Versailles was just down the road, but no one was trying to get into its court, its Gallery of Mirrors. If anything, the terrace café was the new Gallery of Mirrors, the place of gossip, disputation and exchange. Ernest Hemingway hung out in this café, as did Kandinsky and Picasso. So did Vladimir Lenin, who had shaken up Russia and died four years before this photo was taken; so did Simone de Beauvoir, who completed her degree in 1928 and who would shake up the educated, Western, urban world too, in a rather different way. Kertész's photograph is a great image of outwards, the outwardness of clothes, but also of the terrace café. It is a summation of Europe in these years, a continent with the sound of distant drums.

CHAPTER 15

THE TWENTIETH CENTURY LOSING ITS REALNESS?:
MOTORWAYS, WAR, TV, CELEBRITY AND WANT SEE

WHAT to say about the rest of the twentieth century? The eyeball continued to disgorge. Imagery became so prevalent that, as in the case of advertising, it started to replace non-visual experience. If, in his great novel, Marcel Proust sensed that the image technologies were beginning to replace or elbow out non-visual things, would the escalation of imagery in the middle and late twentieth century take this further? In German there is a word – *Entwirklichung* – for the feeling that reality is losing its realness. As looking technologies, advertising, media and travel proliferated in the twentieth century, the word postmodern came to be used for the way imagery referred less to the real world and more to other imagery. Would reality lose its realness in this way in this century? This chapter will look at a disparate range of things – motorways, the Second World War, the atom bomb, TV, LSD and what Hollywood called want see – but its central question will be whether all these things made our grip on the material world around us any less secure.

MOTORWAYS

Let's start with an innovation that captures these discrepant times. The Crusaders and the conquistadors travelled to acquire, steal or enslave. The grand tourists wanted to broaden their minds, and show off when they got back home. The railways made passenger travel a tracking shot. They were new modes of hypnotic looking which sped up the supply lines of arterial capitalism. Following from these, why were motorways built, and what looking did they afford?

The idea for super-fast roads first became popular in Germany in the 1920s, and was echoed in the UK soon afterwards. City living and industrialisation had detached people from the more rural experiences of their parents and grandparents. Arts and Crafts and folkloric movements in architecture and design had

made the countryside a source of inspiration, and a key part of the mythology of nation. It is sometimes said that the German autobahns were built for military transport, but this is not really so, as rail was a cheaper way to move combat equipment and personnel; instead, the rise of car ownership and motorways allowed middle-class nuclear families to become mobile and explore the countryside as a place of leisure.

Construction started in the early 1930s. The main idea, as this image shows,

was to make the driver experience flowing and constant. Unlike many previous rural roads, there are no sharp bends here, nor steep hills.

Motorways ploughed through the land, bulldozing where they needed to. Even the replanted land on either side, according to the Institute of Landscape Architects in the UK, had to be unarresting: more ornamental and intricate landscaping would disrupt or fragment the continuous, unfolding panorama that the driver and passengers would see through the movie frame of their windscreen. Such detail would make motorway looking too jerky. In a still photograph this landscape looks empty, but speed shortens the gaps between things. This has been called the 'landscape of speed'.

America, far more spread out than Europe, made the idea of the motorway its own. President Eisenhower had seen Germany's autobahns whilst commanding the Allied forces in the Second World War, and the Dwight D. Eisenhower National System of Interstate and Defense Highways was sanctioned by the Federal Aid Highway Act of 1956. The z-axis had been part of the national imagination since the decades of the gold rush. In the twentieth century freeways reinvigorated the frontier myth. The open road became a place where you could drive into the distance, alone, losing yourself or unravelling, escaping rules or falling in love. Bonnie and Clyde, Thelma and Louise. Unpaved routes took your eye to the blue-shifted mountains on the horizon, where you could only previously get to if you had time and did not mind a bumpy ride. Paving and suspension meant that those yonder blue hills were more accessible. Motorways were yellow brick roads to take you towards the rainbow.

Rock music and drive-time radio made motorways a sonic experience, but gliding where the speed limit was fifty-five miles per hour gave Americans the sense that they were living a hundred years earlier, outside the law, defectors from modernity and the built world.

This was the poetics of motorway looking. The politics was that people often had to drive long distances for work. The car commute on the parkways of the big cities and the turnpikes of New Jersey made cars intermediate rooms between home and work, places from where you saw the same streets, underpasses, exits, signage, advertising and vistas that you had seen a hundred times before on your daily journey. Far from taking you out of yourself, the road or motorway drive or bus journey was a visual routine that took you past other more or less prosperous lives, a paradoxical prison.

In Britain, leisure drivers used Shell Guide books to find places to visit, the Shell in question being the Dutch American petro-giant. Cars begat motorways begat more cars begat the need for fuel. In ancient times oil came from olives, but subterranean seepage created tar pits. Was there more of such black gold, what the Japanese called 'burning water', down there? Lots. Wells were drilled in China in the 300s CE; the first commercially successful one began in Scotland in 1851. With the hindsight of global warming and oil dependency, it can be said that petroleum – this soup of long-dead plankton and algae, transformed from base metal into gold by heat, pressure and time – should never have been seen. It should have been kept in the ground, but it was not, and unearthing this alchemical resource affected what we see.

Oil was found in Persia – halfway between Europe and Asia on the horizontal, and Arabia and Russia on the vertical – in 1908. It came out of the centre of the world, like the runny yolk of an egg. It was transported by pipeline and

tanker to petro-addicts like America and Europe. In the 1970s oil revenue jumped from $23 billion to over $140 billion. Gulf cities boomed. When it was burnt it darkened the sky, like a Turner painting of the early Industrial Revolution, as in this still from German film-maker Werner Herzog's *Lessons of Darkness*.

Neo-romantic Herzog saw the beauty in this image, its foreground swirl, its reduced colour

palette, as if painted by one of those pre-Cézanne artists who layered their canvases with bitumen (also known as asphalt). Bitumen has a relatively high sulphur content and, when burnt, its atmospheric effect is sulphurous, like hell.

The relationship between oil and hell was political too. In the nineteenth century the Suez Canal, which was dug along the isthmus between the Mediterranean and Red Seas, had spurred world trade and the colonial ambitions of European powers. It had 'corrected' or speeded up continental drift, and opened a window – a looking tunnel – between Europe and the East, rather like the Dzungarian Gate. By the mid twentieth century the colonial era was coming to an end, but the canal found a new use. In 1955 half of what it carried was oil, including nearly two-thirds of what Europe consumed. In 1956 Britain, France and Israel misguidedly invaded Egypt to regain control of the canal, to ensure the continued flow of oil. Addicts will do anything for their next fix.

As petro-lust increased, new drilling and refining facilities were built. What would they look like? This image from the 1920s is of an Iranian one, in Abadan.

As the French film-maker Chris Marker pointed out, it resembled one of the most famous things in Iran's history, the ruins of Persepolis.

پالایشگاه آبادان – سالهای دهه ۱۳۰۰

Iranian Historical Photographs Gallery | www.fouman.com

The similarity eased the Abadan drilling plant into what could be called the Persian visual lexicon. Offshore drilling led to the construction of new architectural-engineering objects, rigs that looked like stalking *Star Wars* fighting machines. Back on land, vast refineries were circuits of circulation of crude source materials and separated products.

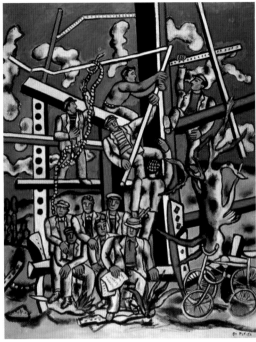

If there was something Freudian about the hauling to the surface of buried material, refineries were a second spin of the surreal wheel. They looked like the pipe paintings of Fernand Léger and, in their turn, seem to have influenced the look of new buildings, such as Paris's Centre Pompidou.

So the harvesting, processing and transport of oil, as well as other power sources, created new image systems which spread beyond the petro-world itself, as well as new, polluted environmental effects. Reactions to the latter added an unexpected entry into the book of visual protest. In 2003 the founders of the international movement World Naked Bike Ride encouraged people to take off

their clothes and cycle around cities to highlight the environmental dangers of vehicle emissions and the need for more planning of road sharing between cars and cyclists, as well as other issues such as the right to be naked in public.

Like the suffragettes, they were creating striking, photographable, media-friendly images to go into battle with some of the most prolific image-makers of the twentieth century: the petrochemical industries and car manufacturers.

So how do these images of motorways and refineries relate to the question of whether reality was losing its realness in these decades? As we have seen, oil structures could look like ruined cities or Surrealist paintings, and, at night, lit Christmas trees. They contributed to the growing surrealism of the twentieth century because they looked nothing like the effect they had: polluting the planet. There was a disconnect between form and politics. Maybe disconnect is a way into the 'losing' bit of losing realness. In her book *Rural Modernity, Everyday Life and Visual Culture*, Rosemary Shirley writes that a road is a 'super-modern non-place'. The speed of motorway driving was certainly super-modern, and their architecture did indeed create in-between places of reduced social specifics. Perhaps they were not non-places – underpasses and concrete junctions have their own aesthetics, as a writer like J.G. Ballard clearly showed. But there was a reduction of placeness. Motorways were more materially hard than, say, the villages that drivers previously had to navigate, but they were socially softer, or more blurred. They were social *sfumato*, smokescreens. They made our grip on the world less secure. Shirley is right in another way, in that the car itself was a non – or reduced – place. The glass in its screen kept out the wind, the strongest indicator of how fast you are going. Motorways and cars reduced our sensory response to the places through which we were travelling, a sign of what was to come.

THE SECOND WORLD WAR

What was to come was horrific – the most material thing of the twentieth century. The Second World War has been more written about than any event in recent history, and we have considered looking in war in general in a previous chapter, but let's turn to seven remarkable images that reveal aspects of its seeing.

Adolf Hitler passionately believed in autobahn construction, but in most other ways he was anti-modern. The rise of European cities had led to cosmopolitanism, which, in Nazi parlance, was code for Jewishness or socialism. Both were degenerate, genetic malformations, and so we arrive at a scene like this, a show of *Entartete Kunst* (Degenerate Art) probably in Munich in 1937. People line up, two deep, in the rain.

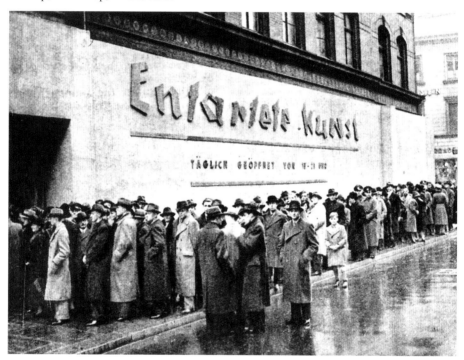

350

The title takes up the whole wall, screaming in expressionist lettering like the titles of *The Cabinet of Dr Caligari*.

Caligari externalised the internal mental illness of its characters; *Entartete Kunst* said to the people in line – two million saw the show in Munich alone, so it was of the

order of the Great Exhibition – *You are sane, but come inside and see what insanity looks like.*

What did they see inside? Africanised images like *Les Demoiselles d'Avignon*, elongated faces, paintings or sculptures of people with big noses, protruding buttocks, stumpy legs – in other words non-idealised, non-Aryan bodies. 'What you are seeing here,' said Adolf Ziegler, President of the Reich Culture Chamber, in 1937, 'are the crippled products of madness, impertinence, and lack of talent . . . I would need several freight trains to clear our galleries of this rubbish . . . This will happen soon.' Freight trains were subsequently used for other purposes. In Berlin, in March 1939, the Degenerate Art Commission burnt over three thousand paintings and drawings. Degenerate art was unreal, said the Nazis, a distortion of or attack on Aryan, healthy, unified minds and bodies. So, in their terms, it was a rally for reality. In truth, its Möbius-strip thinking had twisted modernism's honest attempt to say that human beings are misshapen, panicked, fragmented or alienated. What was outside the museum was degenerate. Inside were portrayals of the true nature of consciousness, post-Freud, Cubism and Virginia Woolf. Degenerate art was generate. It was a reality-seeking missile.

Our next image is a photograph of a German street on or just after 10 November 1938. Its composition is similar to that of the Paris Dome café photograph in the previous chapter, but instead of café society spilling out onto the pavement, we have broken glass. The shop was owned by Jewish people. It was one of 7,500 Jewish businesses, 1,000 synagogues and many cemeteries that were vandalised on the nights of 9 and 10 November.

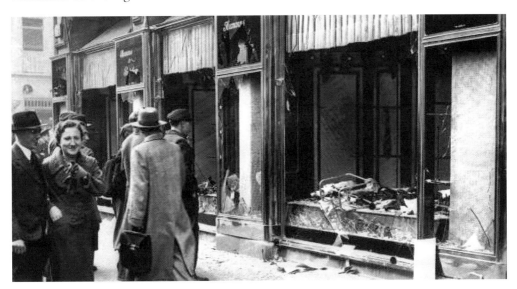

The attacks were an escalation of the German state's assaults on Jewish people's rights and freedoms after Adolf Hitler became chancellor in January 1933. The culmination of those assaults would be a hell of deportation trains, gas chambers and incineration ovens, an industrialised obscenity that the Nazis were canny enough mostly to prevent being photographed. But the organised mob riots across Germany on 9 and 10 November were intended to be seen. In our photograph, the man and woman on the left share a joke as they pass by, unlooking. Those closer to the shop stand and stare, like they did at the human zoo. The attacks took place under cover of darkness, but were there for all to see, in the centre of cities, the next morning. The pogrom was called, by the Nazis themselves, Kristallnacht (Crystal Night), as if there was something beautiful or poetic in the smashing into smithereens of windows. The brittle tinkle of the breakages was the aesthetic starting point of other, deadlier, offensives. You smash before you grab, deport, rob, strip, starve and then murder. Crystal Night is too pretty a phrase to describe what had happened. It robbed the aggression of some of its realness.

And, after you murder, you try to tidy up the evidence. The Nazis were great at covering their tracks, at using euphemism and keeping their scarcely imaginable plan to extinguish the Jews out of sight, but not always. Here, the citizens of the cultured town of Weimar, where Goethe lived and wrote some of his best work, have been driven the eleven kilometres to the concentration camp of Buchenwald. The war is over, Germany has been defeated and, morally outraged

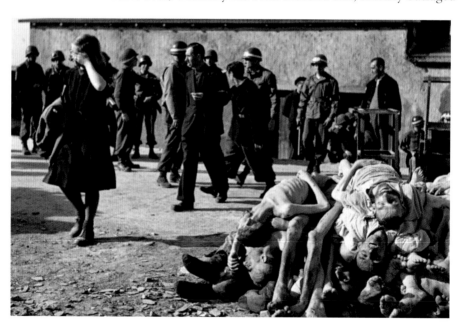

and determined to denazify, the Allies are requiring the bourgeoisie of Weimar to look at the atrocities that have been committed in their name, with their collusion. The woman on the left walks by the pile of bodies and not only turns her head away, but covers her eyes too – a double action to stop her seeing some of the 56,000 people who were worked or starved to death, or experimented upon, or shot or hung.

The two men behind her look away too. Looking here provides visual evidence. Seeing the bodies is intended to be such a horrific jolt that it outweighs the years of anti-Semitic propaganda that the Weimarians will have been fed. As in the photo of the women walking across the bridge in Dublin, keeping their distance from the homeless woman sitting on the ground, our eyes move across this image, right to left, then right again, then left again, traversing savagery and denial, victim and perpetrator, reality and ideology, naked and clothed, static and mobile, spectacle and audience, display and promenade. This dynamism shocks us. The bodies are like an awful projection of what the people of Weimar did not bother to consider or care about. Reality had lost its realness in the inverted German thinking of the early decades of the twentieth century. It had become veiled. This photograph drew back the veil.

Towards the end of the Second World War the bombing of Hiroshima and Nagasaki was a reality check, a counter to those who would idealise the atomic age or the human condition. The bombs' code names – Little Boy and Fat Man – infantilised the terror, but photographs of burnt bodies, quaking children and shadows where people once were countered this verbal euphemism. Looking provided evidence of the atrocity, and proof that atomic bombs escalated destruction. Like the Weimarians walking past the pile of bodies, the Allies seeing newsreel footage and still images of Hiroshima and Nagasaki (which was often censored or sanitised) had to confront their consciences. Looking was not making us lose our grip on reality. It was tethering us to it.

Our fourth image is so fuzzy that it is hard to make out. It is a frame grab from a moment filmed on 23 December 1948. An American soldier, on the right, has just put a dark hood over the head of a sixty-three-year-old man, who we see between the two parallel bars. The man is General Hideki Tojo, a ruthless former prime minister of Japan who committed war crimes in Asia and ordered the bombing of Pearl Harbor.

At the moment of his arrest he shot himself in the chest, on a charcoal cross

he had drawn that was meant to mark the position of his heart. But he did not die, and a US sergeant gave him blood so that he could stand trial. It was one of the longest trials on record. The general was filmed expressionless, occasionally smiling. Deferent Japan, which had recently seen two of its cities destroyed like never before, now watched as one of its symbolic fathers was punished like a child. This Japanese supremacist was seen to be anything but supreme. Filming him with a bag over his head, as he drops on a rope, was a violation of propriety, it could be said, but the ideological swirl of the Second World War had given birth to such an atrocity that tough, ugly looking was necessary. The fact that all human beings have equal rights had been a casualty of war. Seeing Hideki Tojo die was shocking for the floating world, but contributed to the modernisation of Japan. Seeing his execution made the world more real.

When the war ended the victors wanted to punish the vanquished, set an example for history and recoup some of their costs. They were no longer unified in opposition to fascism and Nazism so, as the war tide ebbed, their differences were exposed. At the heart of Germany the city of Berlin was carved up by the winners according to those differences. How do you split a city, whose bits are as interconnected as the piping in an oil refinery? How do you disassemble a thing like Babylon? They learnt as they did it. Subway trains whistled through stations housed in another sector. Waste water and sewage were pumped up, over or around areas not owned by those who produced it. And a wall was built. Quite a wall. It encircled West Berlin,

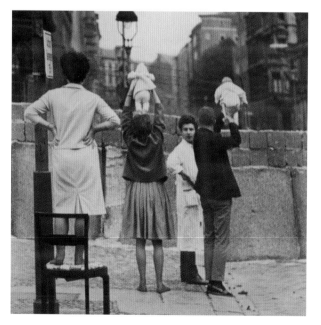

making it an island in the sea of the Communist East. It was a versatile performer, the Berlin Wall, equally at ease with ideological, social and symbolic division, but it also stopped people looking. It was a veil.

In this famous image it is still being built; the veil is being drawn. It has reached head height. If you were smaller, you needed to stand on a chair. The other side is disappearing out of sight, and so parents hold babies above their heads, to be seen by family and friends on the other side.

The babies themselves see, of course, but will have no memory of that. The wall stood for twenty-eight years. As the poet Robert Frost wrote, 'Something there is

that doesn't love a wall'. The scene is like those at airport departure lounges where you get one last glimpse of your daughter before she takes a long-haul flight somewhere, to start a new life. Was reality losing its realness in Berlin when this photo was taken? Most definitely. People on both sides of the wall became symbols of, and pawns in, the Cold War, a big, hyper-militarised, paranoid story full of lies. What you could not see became fake, stereotyped, other and the enemy.

Our sixth image went some way to undo the forged, counterfeit realities of war. Nine years after the start of the construction of the Berlin Wall, something visual happened that helped bring it down. Whilst in Warsaw, German Chancellor Willy Brandt laid a wreath at the monument to those who died in the Nazi Warsaw Ghetto. After doing so, apparently unplanned, he fell to his knees. In his memoir he wrote, 'I did what people do when words fail.' He spoke of the German crimes, but here he embodied repentance by lowering his body, adopting a position of prayer and submission.

To kneel before something is to say *You are greater than I am* or, at least, *I am no greater than you*. As chancellor, of course, he was not just a man. He represented Germany, so in this image Germany genuflects. We can see at least ten camera people, and numerous bystanders, looking at him, as the person holding the camera for this picture did. Everyone's eyes look at Brandt, whose own are

downcast. After the Berlin Wall fell, Poland's ambassador to Germany, Janusz Reiter, said 'If you open your eyes wider, the year 1970 was the turning point in Polish–German relations in the political sense.' The reproduction of this photo meant that people around the world could see it. In particular, Jewish people could see it. It was one of the great visual apologies of the century. It helped change the world.

Our seventh and final look at the Second World War is the most mysterious. In 1894 a new building was unveiled in Berlin to house the German parliament. In 1933 it suffered an arson attack which showed, claimed Hitler, that the government was imperilled, and led to the establishment of the Nazi regime. It was damaged in the war and remained a pockmarked shell in the decade thereafter. Then, in 1995, the artists Christo and Jeanne-Claude wrapped the Reichstag in aluminium-covered polypropylene, for two weeks. Five million people came to see it. It looked like the iceberg that sank the *Titanic*, or a Cubist cloud, or one of the people whose faces are covered in Magritte's paintings.

The wrapping of the Reichstag is significant in the history of looking, because it has elements of Surrealism and theatre. The building symbolised several stages in German history. To wrap it made it seem like those stages, many of which were unedifying, had been hidden, suppressed and consigned to the unconscious. For a fortnight, nationalism and Nazism were behind the veil. But then they were unveiled, and the element of theatre became clear. Like the

curtains we saw in the paintings by Vermeer, Titian and Cézanne, the unwrapping of the Reichstag was a reveal, a restart to looking, which is why it chimed with the reunification of Germany. Germany was restarting, so the argument went, so it was appropriate to package it up, then open the package on Christmas morning. There was ambiguity in the wrapping, then. It seemed to play along with the official version of history, that a new era had begun, yet its Surrealism suggested that the building stood for the nightmare of the recent German past. It was a symbol of not looking, of averting your eyes, like those Weimarians did. The wrapped Reichstag was deeply ambiguous about looking.

REALNESS ELSEWHERE IN THE TWENTIETH CENTURY: LSD, DNA, TV AND CELEBRITY

If an earlier sense of what reality is was being assailed in the twentieth century, the assailants were far more diverse than art modernisms, car travel and war. Most internally, and in a way that undermined David Hume's ideas about perception, the agent was lysergic acid diethylamide. First made in Switzerland in 1938, and first taken in 1943, it started to have its effect at the century's midpoint. LSD was the great new pupil dilator of those years.

Users talk about the degree to which a drug is visual. LSD showed that the visual cortex of the brain needed relatively little stimulation to produce fireworks. Enhanced by it, an everyday thing had rainbows. Tripping expanded visual experience. It was alchemical in that it made something remarkable out of something not. We knew before LSD that looking involved projection, but the chromatic and expressionist potential of the visual cortex was now unleashed. It made Kandinskys. Pre-LSD, and outwith the ritualistic use of naturally occurring psychoactive materials in ancient cultures, it was ticking over. Not only did LSD increase the colour, fringing and movement of certain objects (effects which scared many users), it created new seen things. It was a hallucinogen.

Advocates said that it opened the doors of perception, that it made us marvel at the physical world and sense existence in a way that is less filtered through ego. In terms of looking, it was ambiguous. Its visual distortions were often beautiful, like a Sonia Delaunay painting, but they were lies. Under the influence of LSD the brain became a charlatan. It danced the seven veils. Its molten dream was untethered and onanistic. If you did not have a bad trip it was fun, and the photo album of your life colour shifted, but its main cultural influence was in music. The Beatles' *Sgt. Pepper's Lonely Hearts Club Band* and Jimi Hendrix's *Are You Experienced*, for example, fed the emergence of a counter-culture which sought to deprogramme social conditioning and challenge Western capitalist values.

Another three-letter molecular acronym of these years was partially discovered through looking. Scientists had come to believe that we inherit physical and mental characteristics from our parents and ancestors as a result of the chemistry of the tiny nuclei of our cells. But what happened in those nuclei? What were the ingredients and how were they configured? It was not possible to look into them directly, with the naked eye, yet the great discoveries about deoxyribonucleic acid (DNA) were feats of looking.

One of the key lookers was thirty-year-old English mineralogist Rosalind Franklin. For some time she had been X-raying coal and carbons. Then, on the suggestion of a colleague, she X-rayed DNA, from many angles and over a long period of time. One of her images – photograph 51 – was this one:

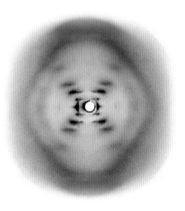

To a non-expert it is just a whirring blur, but a twenty-two-year-old American scientist, James Watson, was shown it in Cambridge in 1953. In his own words, 'the instant I saw it, my mouth fell open and my pulse began to race'. A key debate amongst biochemists until then was how many chemical chains existed in DNA, which had previously been postulated by a Swiss chemist, Friedrich Miescher, in 1869. Franklin's image convinced Watson that there were two, and that they wound around each other. It is as if Franklin had photographed a spiral staircase from above.

Looking had solved part of the mystery of DNA, but not all. What about, to continue the metaphor, the rungs of the spiralling ladder? And how do the various sub-elements – sugars and phosphates – fit together? Watson was working with a thirty-five-year-old British former physicist, Francis Crick, at the time and, like architects, they decided to try to visualise the structure using models.

In this image they have made cardboard cut-outs of adenine (A), thymine (T), and cytosine (C), and are trying to ascertain how they connect, like trying different pieces in a jigsaw to see which ones fit. They then replicated these in metal and wire.

Beyond that they built 3D stick-and-ball models of the spiralling staircase. The

structure of DNA was too complex to visualise mentally only. They had to *see* it, again like architects. There was something of the children's toy about their imagery, but its simplicity enabled them to think clearly. When they finally published their results a new era in human understanding began. The treads of the ladder were split in two, as in this illustration, to show pairs of thymine and adenine, and cytosine and guanine. Sugar and phosphate group chains form the edges of each spiral.

Arguably one of the greatest realities of all had been understood in a better way than ever before. DNA contained genes which instructed our bodies on how to grow. They were messages in bottles sent from one generation to the next. Many of a person's physical and behavioural characteristics were encoded in those messages.

If some of the other looking of the twentieth century distanced people from the nature of existence, the DNA discoveries did the opposite. Crick and Watson were given Nobel prizes. Franklin was not even nominated.

TV

Art, psychology, transport, war, drugs, DNA: already the story of looking in the twentieth century had many characters and plot lines. Then, enter stage left, one of the biggest characters of all. At first glance television was a smaller, more boring cinema in your living room, but it was, initially, different in essence. Where film was time and space travel (you saw things on screen that had happened previously, elsewhere), TV – since it was at first live – was only a space travel medium. Viewers saw something that was happening elsewhere, but at the same time. It was farawayness, an encounter between outside and home thereness. 'Television' means seeing from far away. A clunkier version of it – 'televivavision' – captures better its superhero ability.

Within decades it began to settle in people's lives – a flickering fireplace, a distracting, movable feast, a domestic window on the world. It was a narrative, performative campfire, a language that was not always well spoken. Manufacturers of things turned it into a shop widow for those things, a retail outlet for the new stuff of the twentieth century – roll-on deodorant, Mars bars, sports cars. It took to advertising – and advertising took to it – with alacrity. Toothpastes sponsored dramas in a combination straight out of Surrealism. The new medium was great

at certain things: its long timelines meant that in gardening programmes you could see tomatoes planted, then, months later, see them redden. Talk shows were, visually, close-ups of heads (the TV screen was shaped like a head) and two shots of eyelined people, like the Mexican sculpture of a man and youth near the beginning of this book. In children's programmes puppets on strings, and then animations, became popular. Colour TV was particularly good at snooker. A close-up of the white cue ball hitting the pink; happiness is a cigar called Hamlet; a woman called Angie on *EastEnders* is telling her embattled husband, Den, that she is dying; a man walking on the Moon; President Gamal Abdel Nasser of Egypt announcing on TV that Egypt has lost the Sinai Desert in the Six-Day War; a female puppet pig with a feather boa and a raging ego; a presenter sitting in front of, and then playing with, gorillas in the wild. There was brilliance in these visuals – elsewhere, fetishistic, close up, democratic.

The writer Raymond Williams argued that a key element of TV was flow. Yes, you could watch it and iron your clothes at the same time, so the sound of television was important, but it was a visual conveyer belt. Things were always passing by its rectangle. It was like railway travel, but the opposite. It moved, you did not, whereas on a train ride the landscape stayed where it was and you moved. In this image, for example, two South African women and a child in the Red Hill settlement near Cape Town watch the wedding of Britain's Prince William and Kate Middleton.

Their living conditions are basic, their electricity unreliable, their clothing as functional and affordable as the royals' are not, but they have stopped whatever they were doing because the circus has come to town, to their screen. The dramatic, fantastic, exotic elsewhere is attracting them and creating that looking arc that forms around a TV screen.

Had this flow an impact on our question of realness? Yes. The real was wildly imperfect (two world wars showed that) and needed rearranging (which the Surrealists and others had a go at) but TV's conveyer belt made it seem dreamlike. It kept going. One minute Angie is dying, then there is an earthquake in Armenia, then the snooker's on, then the Berlin Wall is down. Flow flattens. You cannot take your eyes off it, but it reduces amplitude.

Raymond Williams had one particular concern about television. Before it, he said, drama was something that people saw occasionally. On TV they saw it every day – in prestige costume fiction, crime series, soap operas and the like. He saw this increase as unique in human history and felt that it changed the real. Much more of the time of a frequent TV watcher was spent looking at fictional worlds – half as much as they spent working or sleeping. Life became a stage, a *telenovela*. Spoken references, social information, role models and psychological attachments were TV drama influenced. People always had performed selves, but, felt Williams, the difference in degree became a difference in kind. TV, for heavy viewers, was replacing the real.

And, because it was powerful, states were very interested in it. Governments almost everywhere have tried to influence what their populations saw on TV. In India, for example, the government appoints all the board members of Prasar Bharati, the country's biggest public broadcasting organisation, which controls the main TV network, Doordarshan.

In South Africa TV was not allowed until 1976. Albert Hertzog, the country's minister for sports and telegraphs, called it 'the devil's own box', which would show foreign films where races mixed, and whose 'advertising would make [black] Africans dissatisfied with their lot'. Prime Minister Verwoerd said that, 'like atomic bombs', TV is a modern thing that is not desirable. In America in 2004 CBS was fined $550,000 for broadcasting, for one second, Janet Jackson's right breast, a fragment of TV history that, according to the Guinness book of records, became the most searched-for item in internet history. The scale of the fine led other networks to curtail forceful material: NBC discontinued its yearly broadcast of Steven Spielberg's *Saving Private Ryan* on Veterans Day.

CELEBRITY

And TV created a new star system. Newsreaders, weather forecasters and game show hosts filmed in close-up stared into the camera lens, which made it look like they were addressing not millions of people, but us. The eye contact was intense, like that of the boy and the goat in the Tarkovsky film. Sometimes we saw as much of them as we did our own families. We knew the people in the box could not look at us, but it seemed as if they could. If they did not look directly into the lens, the effect was sometimes more intense still; we were in their rooms, observing their lives and loves, and they did not even know it. We were flies on the wall, or the invisible man.

Visible stardom had been enhanced by cinema. By the early twentieth century looking at famous people had become so commonplace that it had started to replace other things that we did with our time. We looked up, to people like V.I. Lenin. Often filmed from below, making great speeches, his stardom took the form of a paterfamilias, a leader, storyteller and interpreter of history (and our place within it). His insights and arguments were so central to the Soviet Union that when he died (in 1924, aged fifty-three), he had to remain visible. It is claimed that the authorities wanted to bury him, but they received 10,000 telegrams from citizens saying that they should not. Do we believe this? Certainly, like Tutankhamun, or like a Christian saint, his body was preserved. It was on display for decades in a modernist red granite pyramid mausoleum in central Moscow. People queued to see him. Expectation built as you got close. In the flesh, he seemed to glow like

alabaster. The whitened skin gave him a divinity of sorts. A shock, then, to see this image of him from more recent times, undergoing one of his eighteen-month retreatments. He is being immersed in a bath of potassium acetate and glycerol, and will be there for a month.

The scene is almost like a Frida Kahlo self-portrait. The gash in his belly, through which his intestines will have been removed, is like a Caesarean. His genitals are covered. His skin is

like tobacco, but is bleached regularly to stop it discolouring too much, and to prevent fungus forming. Knowledge of the height to which he flew in the world of idolatry makes a glance at this picture, in its abject stiffness, all the more compelling. Though many of his ideas, or their implementations, have been discredited, the scale of his fame and impact seems to be the thing that prevents him being quietly interred with his family. This is the opposite of the dug-up body in Abuladze's film *Repentance*. Lenin is being preserved by the authorities to draw attention to what was good about his reign.

Celebrities are service providers. They render things that we are instinctively drawn to, or want, or think we want. Lenin sold leadership and a place in the world. This woman reminds us of another aspect of fame – what could be called its shamanism.

Oum Kalthoum was one of the most famous people of the twentieth century, a colossus like Elvis Presley. Born in Egypt in 1904 (or possibly 1898), she was dubbed 'The Planet of the East', as if she was a world unto herself. Four million people attended her funeral.

Here she poses, or has been posed, in front of the Sphinx in Giza. Her head is at the same angle, her shaded eyes (she was famous for her sunglasses) prevent us from reading her emotions, so we almost insert the Sphinx's eyes into Oum's dark sockets. We can see confidence in her face, but nothing much else.

On stage, she sang songs that lasted forty-five minutes or more. They were trancey, structured like a maze, hypnotic and ritualistic. She seemed to connect her audience to ancient or timeless aspects of life – passionate, oneiric and archetypal. Her style of singing dates from before the time of Islam, and would have been heard on battlefields and at weddings. Her most famous song, 'Enta Omri', begins with an emotive couplet about looking:

> Your eyes took me back to my days that are gone
> Whatever I saw before my eyes saw you was a wasted life

In other words, her looking life restarted when she first saw her lover. To see Oum Kalthoum sing was to be part of a collective unconscious. This image draws a line back from her to ancient Egypt. It is like she is dreaming the Sphinx, or remembering it. Looking at this allows people to imagine themselves as part of the same lineage.

Even more famous than Kalthoum in the twentieth century was Amitabh Bachchan, the greatest star of Hindi cinema, the king of movie kings, whose first name means 'the light that will never die'. Born in 1942 to a cultured Indian family, he has 215 film and TV credits; some of his movies played in cinemas for years; his face appears in advertising across India; he was a politician for a period; he presented the country's version of *Who Wants to Be a Millionaire*; and his musical style influenced how Indian men dance. In this still from his film *Silsila*, in which he plays a poet and romantic, he has baby qualities: the protruding lip, the crying eyes. The redness of those eyes reminds us of Marina Abramović crying when she looked into the eyes of art lovers in New York.

That is the next thing about looking and stardom – its proximity. The physical and emotional closeness of this image encourages empathy and identification. It allows the viewer to get their sadness out. When the looked-at is as famous as Bachchan, and has done many interviews, and his private life has been in the papers, to look at his face is, for many people, to feel like it is their face. Their consciousness is behind those crying eyes. The aesthetics of the image, and its availability, help create the illusion. Looking as surrogacy, again.

Through much of the 1970s Bachchan played angry young men. India had fought another war with Pakistan, its population topped 500 million, there were food shortages, the economy struggled and the international liberation wave of the late 1960s crashed on the country's shores. The government's response to these events was authoritarian – press and judicial freedoms were curtailed – and young people were enraged. In the movies Bachchan embodied that rage. His characters' physicality and facial expressions made it visible. Like the Surrealists, he unearthed feelings that were repressed. If the government abjured what was happening in the real world, his stardom, by force of its personality and momentum, evinced it. He was a splurge, a split eyeball. There was sex in this too. Like Sharmila Tagore and many of the other stars of Indian cinema, Bachchan was beautiful. There was no actual sex in Hindi cinema of those days, but there was masses of desire. The films were inflated with it, like hot air balloons. Fame and desire propelled each other upwards. Audiences saw their heroes desperate to have sex but not doing so. The erotic energy seemed to aerate the style of the films. The musicality, colour, swirl and scale were a kind of pregnancy.

Bollywood is often said to be masala cinema, referring to its mix of ingredients: epic storylines, family saga, romance, comedy, dance sequences, tragedy and action. Celebrity, it became clear, is just such a masala: of heroism, shamanism, empathy, catharsis, erotics and gossip. Perhaps something else too. The political writer George Monbiot says that celebrity is a mask worn by corporate capitalism to humanise it, to draw us to it like babies to their mothers' faces. He goes further, quoting anthropologist Grant McCracken to show that celebrities take up far more space in the culture than previously – actors received 17 per cent of cultural attention in the US in 1910, but 37 per cent a century later. The twentieth century's hall of fame was, in some ways, like an expanding version of the picture galleries of other centuries. Those masala ingredients have, after all, long been part of our human make-up. What was new was television's (and eventually other devices') delivery of them into our homes, and the hyper-fictive quality of the TV age that Raymond Williams cared about. And, again coming back to the question of this chapter, did reality lose some realness as a result? The short answer is a careful no. In Europe, the Enlightenment of Diderot, Hume and Rousseau had been a splendid, long-overdue clear-out of superstition, magic and potions, but it had thrown the baby out with the bathwater. It had over-rationalised the human condition, and emphasised science, the material and the measurable over the wanton id. The masala of twentieth-century celebrity, delivered on platters by television and cinema, returned irrationality and desire to the human banquet, as well as degrees of alienation and passivity. As such it restored a *degree* of reality to our lives. We were naturally more preoccupied by sex, beauty,

narcissism, power, hubris and death than the rationalists of the Enlightenment liked to believe we were.

In the 1970s a film about a Great White shark showed how particularly potent was our attraction to the last item on that list – death – and so a two-word phrase entered the story of looking.

WANT SEE

If scientific and Enlightenment looking was about curiously discovering things about the material world, Hollywood's rethink in the 1970s was a reminder of more compulsive types of looking. Near the beginning of our story we considered the awakening sexual desire of teenagers, and how looking at bodies, and genitals, was compelling, often coupled with fear. The crowds who thronged to the Paris Morgue were driven by a similar compulsion. '*Morguer*' in French means to stare disdainfully. That compulsion was, in Hollywood, called want see.

The pruning of 'wanting to see' to just two words, two syllables, is brutal but effective. It focused the minds of those who were in the business of appealing directly to things in our psyches. This image, from Steven Spielberg's film *Jaws*, hardly needs to be identified.

Before it, Hollywood's fortunes were on the slide, but after it and images of the Devil in *The Exorcist*, the era of the blockbuster was born – people queued around the block. Crucial to the idea of want see is that it does not give you new visual information about something that you had never previously imagined.

Instead, it is (an often horrific) confirmation of what you had long imagined. When we swim in the sea, somewhere in our minds is that question of whether there is something below us, some malevolent leviathan as powerful as the swell, which could prey on us. *Jaws* pictured just this, and the human remains of those who have been eaten by that leviathan.

Lest we think that the Hollywood blockbusters invented such desires, here is John Singleton Copley's *Watson and the Shark* of 1778, which prefigures *The Raft of the Medusa*, almost exactly two centuries earlier.

The shark is in the same position, and rearing out of the waves in the same way. Shallow staging means that the naked man in the painting and the actor in the film still appear to be on the same picture plane, and a similar size in relation to the shark. They are overboard. Bait for the beast.

An image from another Spielberg film gives us a clearer sense of want see. Here, in *Jurassic Park*, actor Laura Dern has glimpsed a dinosuar. She is so shocked that her jaw drops

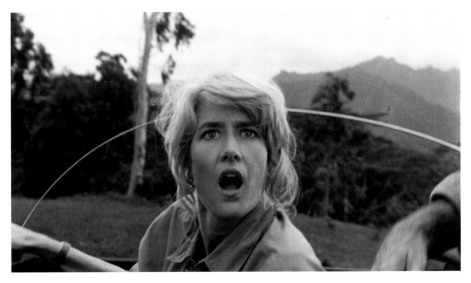

open and her eyes widen. Her face gets bigger, more moonlike, as if reflecting light from the sun.

It is like she has just seen Godzilla or an atom bomb or Lenin or Oum Kalthoum or the double helix or Buchenwald. Want see is the reaction shot to the split eyeball of the twentieth century, its not so objective correlative. It undermines the polite idea that human beings are civilised and self-improving. It explains why traffic slows as it flows past road traffic accidents. It kicks in when reality is losing its realness. It hurls up psychic materials as a memento mori to our socialised, evolved selves. More associated with Thanatos than Eros it shows that consciousness is fascinated with its own demise.

To say this is to evoke two final images in this chapter, both from the country that invented the phrase want see, America. *Jaws*, *The Exorcist* and *Jurassic Park* were entertainments, and so, playful and escapist to varying degrees, but want see is a neat and disturbing label for the more real shocks of recent decades. Take, for example, this long-suppressed moment from the famous Zapruder film of the assassination of American president John F. Kennedy. The footage was widely shown soon after the shooting on 22 November 1963, and became fetishised thereafter, but this particular frame was considered too much. The bullet's impact has an effect like scattering orange powder, or a balloon bursting, but what was so shocking was that this was part of the president's head exploding.

A section of his brain, the seat of his consciousness, a thing that had thus far never seen the light of day, a metonym for America's consciousness, as the president is such a symbol of the nation, was, instantly, seeing the light of day in the most violent way imaginable. A horrifying enlightenment.

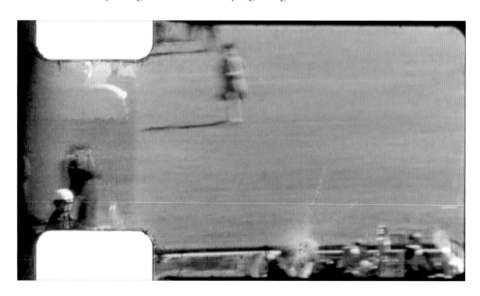

Much of the discussion of what happened in America on that day has mythic properties. Commentators said that 'Camelot' was over, that an idealised era had died. The Zapruder footage was incontrovertible, shocking visual imagery that stormed the citadel of progressive America's imagined self. It overturned the madrigal and stopped the mead drinkers in their tracks. Their jaws dropped open. In seeing the frozen or slo-moed frames, they had gazed at the Tyrannosaurus Rex, the Godzilla, the proof that consciousness is only a few pounds of mince.

That is the ultimate reality check. For all its entertainments, blandishments, reality TV programmes, mendacious advertising, hidden persuaders and political elisions, the twentieth century was a reality check. It served up a series of visual shocks which, like the Surrealists and Dadaists, showed life by detonating its surface.

The most famous of these shocks came soon after the century had turned. It has already fed *curiositas* for more than fifteen years. As this image shows, it was a hard and soft thing.

Beautifully lit, curling clouds, like those in Baroque paintings which elevate the Virgin Mary to heaven and are filled with cherubs, billow out from something hard, linear and monumental, a grid-lattice world. That world is almost Zen-like in its graphic simplicity. Nothing so straight could have grown in nature and, as if to compensate for all that lovely order, the cauliflower clouds extrude like lichen. What a pleasing visual contrast. What formal harmony.

What a shame, then, that we are looking at a mass grave coming into existence. What a shame that there are body parts and the myriad smithereens of

offices, coffee machines, handbags and lunches in the lichen. Television again ushered these platters into the banquet. They were beamed live, and then re-run and re-run, as if their repetition would dislodge the disbelief. But looping in the media does not undo looping in your head, and so, 9/11 was spoken of in almost aesthetic terms. The then president of the United States, George W. Bush, said 'these acts shatter steel, but they cannot dent the steel of American resolve' – that metaphor again (in a country that had pared its steel production to the bone). Flying two planes into the World Trade Center was an effective way of making America's jaw drop. The people at the top table had been listening to the madrigal and drinking their mead, oblivious to the humiliation of the Middle East and the sophisticated culture of one of the world's biggest religions, Islam. Not any more. On 9/11 the bombers – whose aggression was rejected by nearly all Muslims – castrated the US. On TV. For the world to see. How's that for humiliation? The often mentioned irony was that Hollywood had regularly depicted the destruction of great cities and buildings. CGI technology had allowed film-makers to imagine such disorder in hyperrealism. Tall buildings will eventually fall. Potential energy will eventually be converted. Entropy will have its way, and so, when Louis Sullivan started imagining and building beautiful, high structures, their demise became something we imagined and wanted to see. The more elegant and gravity-defying the buildings were, the more we foresaw their unlovely end. Hold an egg in your hand and its perfection and frailty make you want to crush it. Hollywood, and the twentieth century, were alive to the desire to crush, to see something unfeasible destroyed.

CHAPTER 16

THE TWENTY-FIRST CENTURY AND EVERYWHERE: *SKYPE, SURVEILLANCE, VIRTUAL AND AUGMENTED REALITIES*

'Whether we gain or not by this habit of profuse communication it is not for us to say.'

— *Virginia Woolf,* Jacob's Room

WHAT if want see went wild? Is that what has happened in the twenty-first century? Has looking flooded everything else, so much so that we need sandbags to keep the tide out? Has the split eyeball become a torrent?

SURVEILLANCE

The short answer is yes, largely because of state and private company surveillance in the twenty-first century.

Surveillance did not start here, of course. The gathering of people in cities allowed them to be watched. Palaces and state buildings from India to the Ottoman Empire to the Americas have, for millennia, been built with hidden observation niches. In 1792 the *Comité de surveillance* was set up in France, to peep on people and gather evidence for their arrest. In the UK in 1844 the government opened so many private letters in the 'national interest' that, according to William McCullagh Torrens, there was a 'paroxysm of national anger'. In the 1910s the UK's suffragettes were secretly photographed. In the First and Second World Wars soldiers' letters home were read and sometimes censored. In the 1960s and '70s closed circuit television – images beamed to one central destination rather than broadcast to many places – was installed on transport routes and at soccer matches. In 1973 Times Square in New York had surveillance technology installed. But in the twenty-first century, technology allowed mass observation like never before. There are about thirty million surveillance cameras in the United States, nearly one for every ten people. In the world there are perhaps one hundred million. Car number plate recognition is becoming commonplace. Face recognition technology is advancing. Global satellite locat-

ing systems such as the USA's GPS, China's BeiDou-2tf, Russia's GONLASS and so forth, allow anyone with a compatible mobile phone or other device to locate themselves (and be located) to within a few metres. The device needs to be visible to four satellites (the USA's GPS has thirty-one), and relies neither on internet or phone reception.

The eyes are in the sky like never before. Religious people believe that their gods look down on them, but now millions of glass orbs containing cameras that look like Dalek eyes or HAL 9000, the sentient computer in *2001: A Space Odyssey*, do look down.

It is the 'sur' in surveillance which gives it its direction and scale. It is from above, this peeping. The powerful are looking at the powerless. Surveillance stalks us like Picasso stalked a still life. It sees us from all angles. The combined image is Cubist, or like the eye of a fly. In this image from Andrea Arnold's film *Red Road*, Kate Dickie plays a CCTV security officer watching thirty live feeds from blocks of flats in Glasgow.

The residents are working class, near the bottom of the social ladder, and being watched by those with vested interests from higher up. The flats themselves were amongst the tallest residential ones in Europe, so the looking down dynamic is, in one sense, reversed. The film is less interested in the Orwellian social monitoring afforded by CCTV than in something more psycho-sexual and, eventually, personal. Dickie's character sees, on one of her screens, a man she recognises having sex. She watches like a voyeur, and uses the information gleaned from all those screens to get into the man's apartment, have sex with him, and then accuse him of rape – all to avenge a tragic event that happened years previously. The film reminds us that CCTV cameras often point to places – car parks, underpasses – where people think they are not being watched and where they, therefore, can be sexual or violent. Dickie's monitoring is compulsive, and overwrought – qualities that apply to state monitoring too.

The American former CIA employee Edward Snowden would agree that the monitoring practices of the USA and other states have transitioned from their rational security justifications into something more irrational and compulsive. Some of the documents he leaked revealed the extent of the Five Eyes

intelligence-gathering alliance in the Anglophone world, in which the US, Canada, the UK, Australia and New Zealand cooperate in gathering and sharing information in ways that are ungoverned by law. Ungoverned is the key word. Surveillance fascinates those who do it. They cannot stop themselves from transgressing. Call it the aesthetics or erotics of the peephole or the Paris Morgue. In the world of surveillance the split eyeball has indeed become a deluge.

Not everything about the new, wild, twenty-first century looking technologies is retrograde. Look at the following map. At a guess we might say that the red lines are bird migration paths or shipping routes, but they are sub-aquatic highways of cables laid between continents and countries.

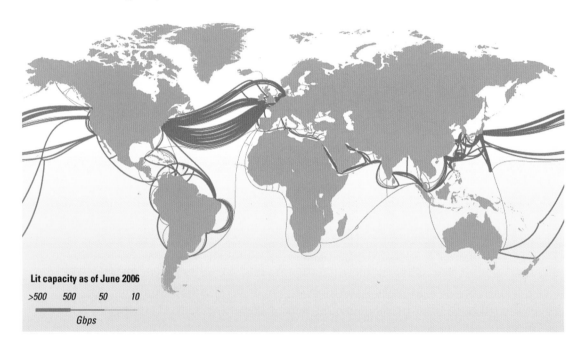

Before the twenty-first century, copper wires telecommunicated spoken and visual information, but such wiring was vulnerable to electromagnetic interference and decay. What could replace copper? It had for some time been known that uncoloured human hairs could carry light shone down them, but of course our map does not show intercontinental hair connections. Instead, a substance that comprises 10 per cent of the Earth's surface, silicon dioxide – silica – has been attenuated into micrometre-thick strands which act like light tubes, channelling it at great speed and across vast distances with minimal denaturing. At first such fibre optics provided point-light sources in awkward places – hence its use in dentistry more than a century ago. Then, with the increasing purification of

the materials, and more bundling, the cables became astonishing global light arteries; one fibre could carry thousands of television channels and millions of phone calls.

Light, that bit of the electromagnetic spectrum which humans can see, did the carrying. It was the postal system of the twenty-first century. The looking medium transported much of what was being shown, said, thought, sold and dreamt. This was a previously unimaginable triumph of light. Most things in human culture, and nearly everything modern, now relied on it. This was multitudinous and bordering on the unimaginable. Pictures from anywhere that had been photographed could be called up within seconds. The internet company Google undertook a looking Domesday Book on a vast scale. It tried to photograph many of the public spaces on earth and stitched them together into Google Earth.

Satellites in the sky photographed from above, vehicles fitted with 360-degree cameras drove the world's streets, taking pictures of them. They did not ask permission, and so had to blur car registration plates and things that seemed private. Given that it was a Western company, Western places were captured in more detail – though not places that claimed to be sensitive for security or other reasons. Google Earth's previous incarnation, EarthViewer 3D, was produced by Keyhole, Inc., which was funded by Sony and the CIA's In-Q-Tel.

As with CCTV, then, it was necessary to ask who was doing the photographing and why, and how all this super-looking would be used. What if they captured the moment of a crime, or something that looked like a crime, or was considered a crime in one country but not in another? Classified places were blurred, but who gets to decide what is classified? It was important to query the illusion of all-seeing, but doing so did not make it less new or less thrilling.

And then looking went further. The images we saw on Google Earth had already been photographed, but soon the thereness and nowness that had excited TV viewers in the twentieth century became massively extended. Webcams removed many of the limits on human seeing. Previously, if your family or friends moved away from home, they moved out of view. Your only ways of seeing them were time-delayed – through still photographs, for example. Their visual present tense was entirely unavailable to you.

No more. In the internet age you could see them walking down the beach at Santa Monica, California, by clicking onto the family's web page. You were no longer California dreaming, or at least not in the same way. You were California seeing. The new technologies lessened what in German is called *Fernweh* – literally 'distance pain' – and also *Heimweh*, 'home pain', or longing for home.

Then such seeing became less limited still. Yet more impediments to what could be called all-looking were removed. Your friend did not have to walk past a

webcam there for you to see her here. She could take her phone out of her pocket and make a video call to you, from where she was and what she was seeing, and you would see it too. Person-to-person, distance, simultaneous seeing was revelatory. It removed some of the pain of migration. It enhanced distance learning and intercontinental co-working. It slowed or even reversed the clustering of people doing the same jobs. If you lived on Cape Breton or the island of Skye, you could design a book jacket for a Paris publisher by doing regular visual meetings with them from where you were rather than where they were. If you were exiled from Iran, you could talk to your grandparents there. If you were a gay teenager growing up in a place that did not welcome you, you could see and talk to others who did.

Face to face was transformed and extended. Eye contact conjoined with space travel. This was a new frontier in looking. It was most certainly looking, but not as we knew it. There were downsides. Nostalgists lamented the loss of distance – the epic, isolating aspect of travel. If you had internet, you could no longer be far away; hereness can be oppressive. And your conversation with your Iranian granny could be monitored. Also, like most technologies, Skype and the like could be exploited by predators and abusers, but none of these things undermines the blaze, the effulgence, of twenty-first-century distance looking. Skype enhanced life.

Or did it? All this dispersal raised the question of what was happening to our consciousnesses in the twenty-first century. Did they still reside in our brains, in our bodies, or did the fact that we could see so many other places live mean that we were partly in those places? Or had we downloaded our consciousness onto our smartphone? What was Skype doing to our psyches?

The anxiety behind such questions is palpable, and is the theme of this chapter. Are we doing too much looking, or is the looking that we are doing replacing other forms of living which are more natural or enriching? New discoveries about neuroplasticity suggest that young people who have used smartphones from their pre-teens, and who, because of those fibre optic cables and satellites, have a diminished sense of elsewhere, are having their brains changed. If true, this is perhaps concerning, but it is probably too early to tell, and the concerned should ensure that they are not indulging in millennia-old looking-phobia. Yes, there is a deluge; yes, we are seeing in more ways than ever before, but is this a change in kind? Are our consciousnesses undermined or enhanced by seeing so much?

If a difference in kind has occurred, let's pause for a moment and look back through our story to find where it happened, or the moment before looking got worse. Those who saw the almost live TV feed of Apollo 11 landing on the surface of the Moon on 20 July 1969 certainly had less imagery in their lives than

we do, but the visual shock of looking live at those events was surely as great as any in the era of Skype. The Moon landing led to thinkpieces in newspapers about how it further decentred the Earth and the God-shaped hole in traditional thinking. Looking at it was seeing a new frontier. If our minds have been fundamentally altered by looking, the change took place at least as far back as that Moon landing.

So let's wind the clock back further, to Paris in the late 1800s and that well-dressed couple walking the boulevards. As we saw, they were hypnotised by the new capitalism, the society of the spectacle. Their eyes were darting between objects to buy, the increasing pace of street life, the new fashions and social displays. Soon there would be the shock of cinema. Can we say that their minds were less bewildered by looking than ours are, or that they felt less of a dispersal as a result of looking than we do? Yes, what they were seeing was all in the city through which they walked, but what a world that city was, and how those objects for sale spoke of elsewhere, and what a universe the Exposition Universelle of 1867 conjured. Were the minds of its millions of visitors healthier, because less invaded by imagery, than ours? Again, the answer is, surely, no.

So we must go further back still. Let's try much further, to that walk we took through the Ishtar Gate in Babylon in 570 BCE. Surely consciousness was simpler then, or less pulled in different directions by visual stimulation? Again the answer is no. The lapis lazuli, the hundreds of lions, the visual throng, the merchants and worshippers led us to come up with the word 'vabel' to describe visual confusion and looking overload. New to such a world, the visitor would be mesmerised, scared perhaps, and certainly unable to encompass everything she was seeing. So, again, even this far back in human history we must conclude that looking was fragmenting self.

How far back, then, do we need to go? What about the Mexican clay sculpture of the man and the youth looking into each other's eyes? It was the moment when we considered eye contact, but even there, as we saw, looking into the eyes of another had the momentary, wrenching effect of self-loss. Suddenly, as if by lightning, we are in their world, looking at us. The rawness and uncontrollability of their glance cattle-prods us.

Let's conclude, then, that looking has always been a shock and that Skype and Google Earth are differences of degree, not kind, from what went before. Yes, they are wondrous and disturbing. Things were gained and lost at the moment of their invention. Some old ways of being died and new ways were born.

VR AND AR

Then, in this new century of retreating looking frontiers, came virtual reality. As the technology currently stands, the user excludes the real world with a headset which allows them to see, in its place, three-dimensional images, which move with their head movements.

Unlike cinema or theatre, the user substantially controls the angle from which he sees. VR did away with the framing of windows, paintings and films. It therefore gave a feeling of being immersed in the place you are seeing. Nearly every looking experience described in this book, particularly those related to space, can be rethought with VR. Objects afford fewer possibilities with this new technology, but VR is good at the poetics of space, and what could be called the sublime of space. It dynamises the x-, y- and z-axis in such a way that it sometimes causes motion sickness. It is as if the virtuality is a steroid.

As with any new technology, the key question is to what is it applied? No surprise here. VR lends itself well to shooting games, porn and travelogues. Early adopters – both creators and audience – step into its world, and what first occurs to them is its potential for self-loss. VR can make you feel that you are in the Serengeti at dusk, or in a Syrian refugee camp, or in a room with your sexual ideal. Its potential for pleasure and empathy became apparent at the same time. Chris Milk and Gabo Arora's *Clouds Over Sidra* is centred on a twelve-year-old Syrian girl, Sidra, who lives in the vast Za'atari refugee camp in adjacent Jordan. Their VR documentary allows us to enter a migrant city, a symbol of the greatest

crisis of the twenty-first century, and look around for ourselves. We follow Sidra and see her 360-degree life. There have been many film documentaries on the same subject, but in each the viewer is outside, looking into the camp through a window, the frame of the camera shots. *Clouds Over Sidra* is, in a new sense, frameless. Our senses tell us that we are there in ways no other art form or mode of journalism has previously made possible. At the time of writing, VR is the next big thing. It seems likely that its technology will be improved, its headsets will become less clunky, it will look less like a novelty. It will seamlessly merge into social and personal spaces and become a place of advertising, learning, escaping and desiring.

Augmented Reality – AR – is more interesting still. A pre-twenty-first-century game, Pokémon, was its bridgehead. Pokémon Go used satnav technology to overlay a fictive, childish world onto the real world.

The overlay was not so heavy or dominant that, like VR, it replaced your circumstances. Instead, it worked with those circumstances, spicing them up a bit and inserting fairy/elf/leprechaun creatures into it for your delectation. AR allows you to look twice, or at two things at once, two trains running. Stretch this a lot and you get Cézanne's double looking, at a mountain and his brush-strokes at the same time. In Pokémon Go your phone is a revealer. You have to look down to your phone, from the world, to see the characters. Its success was such a sugar rush that parks, churches, industrial estates, public buildings, monuments and the like all had to develop a policy towards it.

Is Pokémon Go too much looking? Will its gaming offspring make it impossible to distinguish between what we see normally, in the way humans have seen since the beginning of the species – light from a real object converging on our retinas – from more manipulated types of looking? The answer to the first question is no, and the second is yes. Just as cinema is no longer photochemical, so looking is no longer indexical or evidential. In the digital age we see lots of things that are not really there. This, however, is not apocalyptic. As we will see at the end of this book, seeing weathers every storm.

To remind ourselves of this, let's slip the leash of the digital world and see, in this twenty-first century which it seems to define, if it really does so.

CHAPTER 17

THE UNSEEN; LOOKING BACK; LOOKING AND DYING; BEING LOOKED AT

'It is not easy to keep eyes open, to welcome the gaze that seeks us out. But surely for criticism, as for the whole enterprise of understanding, we must say: "Look, so that you may be looked at in return."'

– *Jean Starobinski*, The Living Eye

WHAT old types of looking prevail in the digital world? Almost all looking, actually. In the twenty-first century men like our Bengali one hunkered at the crossroads in Chapter 3 still look as he did. Newcomers to bustling cities are still overwhelmed. Staring at the sky feels the same as it did to Yves Klein. Teenagers look at their acne and still cringe. Seeing your mother's arthritic fingers is still saddening. Watching your lover sleeping is abiding. Now that we have worked through the sheen of new looking, the technology and burnish, the glister and neo-dazzle, it is time to start to wrap up this story by looking at these offline things and, also, what could be called the edges of looking.

THE UNSEEN

Let's start with what we do not see. The word unseen has appeared aplenty in this book: in reference to Akhenaten's religion, Leonardo and Vasari, the Enlightenment, the sublime, cities, the atomic world, Freud and the sinking *Titanic*. It has popped up like a buoy, insistently inviting itself into this story of the seen, but as we draw to the close we should give this assertive gatecrasher its due.

There are things that were not seen for some reason, that cannot be seen, and that have been kept out of sight. In Asian art, for example, one of the most powerful ideas is the suggestion of something by its absence. A pen and ink artist will

purposefully leave out key details so that the viewer's eyes will add them. 'Figures, even though painted without eyes, must seem to look,' writes Roger de Piles in *The Principles of Painting*, '. . . without ears [they] must seem to listen.' In Japanese flower arranging, a similar evocation takes place. The spaces between the branches, stems, leaves and petals are as expressive as the material things – mu (無), the void, which we first encountered on the grave of film-maker Yasujiro Ozu.

Look specifically for the unseen, and it appears in many places. Here is a Greenpeace diptych, the same location photographed decades apart.

The unseen in the second image is the glacier in the first. It is gone because of global warming. Those who deny that CO_2 levels have risen because of human and industrial activity say that the burden of proof is on the consensus of climatologists, and that an absence

does not infer causation. But this image of loss speaks a thousand words, and points, in its calm, panoramic, beautiful way, to the calamity to come.

Things have been kept out of sight for creative and political reasons. This is an image from German film-maker Werner Herzog's film *The White Diamond*. In his trademark deadpan voice-over, he tells us that the locals who live near these Kaieteur Falls in Guyana say that there are great treasures behind them.

Birds swarm and then fly underneath the torrent, as if to see the trove. Herzog has his cameraman lowered on a rope so that the latter can film the jewels. He tells us that he was successful in doing so but the result was too beautiful to show. He is playing with our expectations, of course. He is teasing us by withholding from our sight what he calls the ecstatic truth and – we must assume – there is no Aladdin's cave back there. Herzog would rather believe and assert the myth because, although it is factually dead, it is imaginatively alive. He plants these non-seen things in his films like bombs in a minefield, so that they detonate when we approach them.

Many other artists have played with concealment as a way to tantalise. Guy-Manuel de Homem-Christo and Thomas Bangalter, better known as Daft Punk, have, since the turn of the century, mostly appeared in public wearing helmets to obscure their faces.

This reflects some aspects of their music – its synth-electro elements, which emphasise futurism and robotics. The disco-elation in many of their tracks might be expected to be visualised in more human terms – do we not want to see the face of an ecstatic dancer? – but the helmets modernise the image and pleasure. Their polished chrome and gold reflect surfaces and grid lighting. They are deadpan bling. They dazzle and deflect. Electronic

dance music toys with the thought that euphoria can come from dervish, feverish repetition and self-loss. Masking their faces, de Homem-Christo and Bangalter suggest the escapism of such loss, its perfection and, perhaps, a touch of menace.

The most morally serious unseens in history have been those where crimes committed were covered up. This Allied photograph of the Nazi extermination camp Auschwitz-Birkenau was obviously taken from the air.

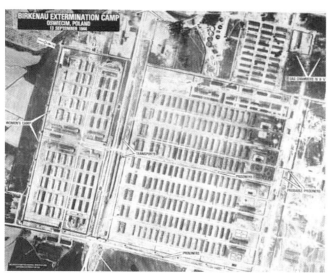

For such a large complex of transport, administration, sorting, storage, medical, living, working, gassing and cremation buildings, it is remarkable how few photographs exist of it from the time of its operation. The Nazis wanted to keep its function secret, and so policed photography ruthlessly. About one million people – the population of a medium-sized city – were murdered in this former Upper Silesian forest in just a few years. Such boundless abjection was highly visible – the constantly arriving trains; the bewildered, terrified people; their corralling within the camp; their repellent murder and then the burning of their bodies – and, of course, was massively seen by more than a million human beings. But most of those million were its victims, and so the images died with them. The gas chambers were demolished by the fleeing Nazis, who perhaps hoped that, since their crimes were at the outer edge of what is humanly imaginable, if they could not be seen then they might be thought of as unreal.

Away from the history of the unseen is its psychology. Take this brown and black speckled image. It is from an experiment recounted in *The Change from Visible to Invisible: A Study of Optical Transitions* by G.A. Kaplan.

In the experiment subjects were shown two abstractly patterned, adjacent sheets of

paper. The experimenters successively cut a slice of the second and repositioned it against the first. You cannot see the join in the image, but imagine that there is one, somewhere in the middle. As it is successively cut, the right half of the image gets smaller. Observers watched each iteration, but not one of those observers thought that the right half was getting smaller; all of them believed that it was *sliding under* the left, as the moon might disappear behind clouds. As James Gibson says in his book *The Ecological Approach to Visual Perception* (1986), 'Deletion always caused the perception of covering . . . the surface going out of sight was never seen to go out of existence.'

The conclusion to draw from such a simple experiment is that we are hard-wired to believe that things do not disappear. Giving the choice between believing that something is no longer there or that it has slid under something that is there, we will choose the latter. This optical illusion of once seen never forgotten has a metaphysical dimension. It is hard, and painful, for us to accept that when a loved one dies their consciousness disappears, so, instead, we comfort ourselves with the belief that it slides behind, or goes to an adjacent room, or to heaven. The supernatural, Santa, ghosts and reincarnation are all related to this persistence of vision, this after-image. Our looking is haunted by what we once saw.

LOOKING BACK

One of the things we once most saw was our younger self. In early childhood in the modern world, most small children will have seen themselves in the mirror. It will have struck them that they are an object in the world, like a bed or a car. For most of them it will have been hard to have absorbed this fact – we do not feel like a car or a bed – and so they will have lived their lives with a working assumption that they have a self.

In this image, a man looks at himself. He is fifty-one. The warm light above his head, out of frame, makes faint shadows in, and so emphasises, the wrinkles on his forehead and under his eyes. His skin has lost elasticity. It is bigger than it needs to be to cover what lies beneath and flex when he laughs, which he is not doing here. There is grey in his curls, his nose is big from

drinking and his mouth neither smiles nor frowns. It shows acceptance of what he sees. After five decades on earth, his face is what it is.

He sees in it a man who has outlived much that he loved: Rembrandt van Rijn saw three children die within weeks of their birth, and his wife of eight years die in 1642, fifteen years earlier. Her loss was so long ago that perhaps he can no longer recall her face. By contrast his is still available for his inspection, maybe too much so. If only he could see his a bit less and hers a bit more. He sees a man who, a year before he painted the image, was publicly humiliated through bankruptcy. His pride came before a fall. He sees what is not there – whom he loved and what he lost. And he sees what is there. Compare his self-portrait to the brown dots experiment and we realise that, in laying before himself his wrinkles and ageing, the artist is trying to be true to what he sees and what is there, perhaps to distract himself from what is not there, or as a counter-balance to it. He does not want to make the mistake of believing that it has slipped behind, or into the next room. He is too good a looker for that, too interested in evidence.

Then take this woman, Ingrid Bergman. In the first image she is sixty-three. She is acting in a film, *Autumn Sonata*, which was made by her namesake Ingmar Bergman, whose movie *Persona* we saw earlier in this book. Bergman is playing a concert pianist, Charlotte, who has a difficult relationship with her daughter, Eva. Eva plays the piano too, but Charlotte's perfectionism makes her judge her daughter's inferior playing.

Bergman is framed in close-up in this image. She looks left, out of frame, to the thing that moves her to tears. It is a classical composition which allows the audience to look at her emotions.

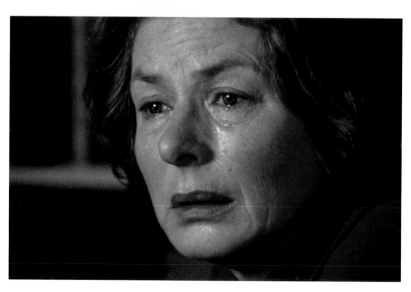

Then look at this image, also of Ingrid Bergman, but thirty-six years earlier.

The film is *Casablanca*, one of the most famous ever made. *Autumn Sonata* is a psychologically realistic drama; *Casablanca* is more romantic, otherworldly, and mythic almost. The lighting in the second image is softer. Its beautiful grisailles make our eyes notice the slashes of red in the eyes and on the lips of the previous image. But, most of all, we notice that the composi-

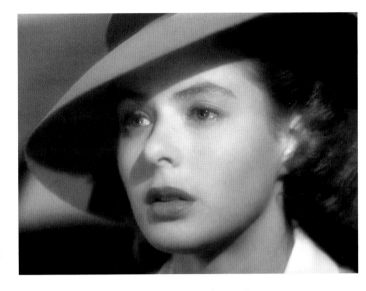

tion is identical. It is as if Ingmar Bergman was trying to recreate the earlier, more utopian frame, perhaps, in his harsh manner, to show what happens as a face ages. What would Ingrid think when she looked back from 1978, when *Autumn Sonata* was made, to her younger self in 1942? Like Rembrandt, she would see what had changed. What she had gained and lost. She would see thirty-six years of looking. She might think *What those eyes have seen.* 'It is our duration which thinks, sees, feels,' wrote French theorist Paul Virilio in *The Vision Machine*. Bergman was brought up in the dark winters of Sweden but then became a movie star in California's constant sunlight-floodlight. She would see a woman glamorised by Hollywood – made up and lit with great skill. She would know what that woman in 1942 had not known – that Auschwitz happened, that she would become a pariah because she had an extramarital affair, that she would reject the Hollywood glamour machine to a degree, to act in more realistic films. Perhaps it is only now that she is old that she can see herself young. Perhaps she would only know that she has been happy because she has seen herself sad. She would see a photo album of her lifetime. She would see the story of her looking. It is as if she had been on Apollo 8 and is now looking at the Earth from the Moon. And late looking is often comparing. When we look at these two images we are moved, because we see either our own ageing in them, or we see time, or disappointment or resignation. The first image is as beautiful as the second – its browns and reds are as satisfying as the colour scheme in Rembrandt's self-portrait; the lines around Bergman's mouth and eyes, and the shapes of her eyebrows, make a pattern more complex than the smooth contours of her younger face. But we cannot help seeing a decline of

sorts in the *Autumn Sonata* shot, especially if we know that Bergman would die, four years later, of breast cancer.

The word decline is like a bell that tolls. It reminds us that we should think about the decline in looking. With age, the eye muscles that shape the retina lose strength, and the lens stiffens. Our eyes cannot focus light as well, and so the world is blurred again, as it was when we were first born. In much of the world spectacles are not freely available, and so, ageing people must simply accept the new lack of sharpness. In the UK before the National Health Service, those who could not afford glasses improvised. As late as the beginning of the twentieth century, for example, some people used the bottom of a broken milk bottle as a crude lens to help them read small print. Also, in older people, macular degeneration causes the middle of the visual field to blur and darken. As our looking centres the human face, this can lead to a failure to recognise loved ones and see eye contact. When such foveal vision declines, sufferers must learn to use the edges of their eyes. An estimated twenty-three

million people around the world are affected.

Whilst still in his teens, the Spanish painter Diego Velázquez painted this beautiful image of an older lady whose eyesight seems to have declined.

She is not looking at the eggs she is cooking and she appears to be trying to find the pot to stir its contents with the spoon. To add to our sense that she is blind, the boy in the picture lets his glance drift, its slackness a sign that he knows it will not be engaged by her. Rather than give us a sense of what the world might look like through her faded sight, the painter does the opposite. He surrounds her with an arc of material, hyper-visualised, touchable things – a white porcelain jug, a red onion, a metal mortar and pestle, the earthenware cooking pot, the shiny one below it, the gourd and decanter that the boy holds, the boy himself, and then the basket and rag: the dozen circular things seem to remind us of what she cannot see, or perhaps the way they are laid out like satellites orbiting her means that they are projections of her inner eye.

Projections, again – one of the main subplots in this book's story. Here is a particularly telling one. It is from a French film, *Three Colours: Blue*, written and directed by Krzysztof Kieślowski.

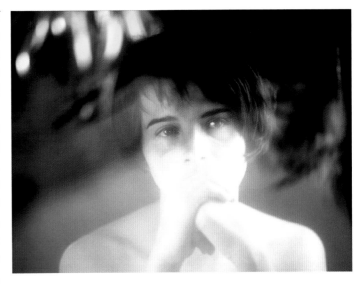

In it we see a woman whose musician husband and their child have been killed in a car accident. She is paralysed by grief, so much so that nothing from the outside world can penetrate her cocoon. But bars of her husband's music seem to cut through, and, in this image, so do banks of blue light. The light and the music often coincide in their ingress, as if they are the same thing. They are hallucinations, and also her sputtering attempts to come back to life, like a car engine turning over several times before it finally engages. Kieślowski uses the blue light to visualise such intrusions. Sometimes the light is a hurtful reminder of the trauma, at other times it is a visitation, an annunciation from another realm. He makes us see her grief.

What we do not see in the film are the dead bodies of her husband or child. Looking at the dead is a contested thing. Some cultures encourage it; others put corpses out of sight as quickly as possible. The picture of my grandmother on the locked phone in the introduction to this book was taken surreptitiously. Perhaps it was indecorous to take it, an invasion of her dignity? When a person dies naturally, they often deflate slightly. Their blood pressure drops and so their skin cleaves closer to their bones. Their corpse can look shocking when suddenly deprived of the inflation of the cardiovascular system. The image does not just slip between the pages of the photo album of our lifetime, and theirs. 'I want to remember them alive,' say those who do not wish to see dead bodies, and there is wisdom in that: the final dead image can be so wrenching that it obscures all the living ones. The potency is always there. The United States government released a photograph of President Obama and his team watching al-Qaeda founder Osama Bin Laden being killed in Abbottabad, Pakistan by American Special Forces, but – unlike those of other assassinated leaders General Hideki Tojo or Saddam Hussein – did not show either the moment of his death or his corpse. To have done so would have inflamed his followers, it was said. The aim was to remove his sting.

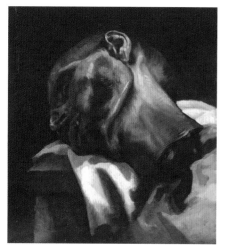

Maybe a sting is what looking at a dead body feels like. Did Théodore Géricault, who created *The Raft of the Medusa*, feel a sting, a sudden heat and pain, when he painted this study, *Head of a Guillotined Man*, in around 1818?

Probably not, for gruesome reasons. The man was a thief who had died in an insane asylum. Géricault had borrowed the head, probably from the Hôpital Beaujon morgue in Paris, taken it home, painted it whilst it was still fresh, then stored it under his bed or in his attic, until it changed colour. In this, later, image, it is green, but in earlier versions it has not yet decomposed.

Perhaps his initial reaction at seeing the severed head (which had not, in fact, been guillotined) was a sting, but he went beyond the jolt and fear, to treat the head like Cézanne treated an apple, or even his own wife's head – a material thing, an object on a cloth on a table that catches the indifferent light from the top left. Géricault was in his twenties when he painted these images (and would himself be dead by the age of just thirty-two), and he seems to have been unperturbed by them. He joked with his neighbours when they complained of the smell of the rotting flesh. He knew that many would feel an instinctive revulsion when they saw the head of the thief, or his paintings of it, but he seemed to want to separate that revulsion, that reflex, from the act of looking. He wanted to remove the sting or stigma.

In the context of our story, Géricault's aim is fascinating. The distaste his neighbours felt was the ultimate projection. Their instincts told them to be afraid – they might catch a disease from the rotting flesh, or beheading made them think of violence and so they wanted to escape – and so they wanted to look away. The implications and associations of the body part were telling them that they should not be looking at it. He wanted them to stop projecting, to remove the association.

But he was fighting a losing battle. Watch what happens when we are selectively told things about the opposite image.

When we hear that it is a sculpture of an artist's sleeping father, we see night-time calm in it, and feel the care with which the artist has curved his dad's cheeks and chin. But it is not that. When we hear that it a death mask of the same artist's father, we see less craft and more sorrow. But it is not quite that either. In fact, this is a death mask of Napoleon Bonaparte. A mould of his face and head was made, either in plaster or wax, about thirty-six hours after he died on 7 May 1821. It is said that Napoleon's assistant stole part of the mould, but casts were made from it, and so were other moulds, so the versions of his face that exist in bronze or marble are once or twice removed. The remove reduces the sting, perhaps – the mask is unlikely to have directly touched the thing that touched his face – but when we look at it we project onto it what we know about his passion, power, love life, hubris, increasing cruelty and influence, for good and bad. The thinness of those cheeks and the pointiness of the nose surprise us – we would expect something more robust from someone so robust – but his blood had stopped pumping, and powerful people never look like their power. We think *Is that all that he was? Is that what he was reduced to?* After the atomic bomb in Hiroshima, shadows could be seen on the stones where people once where, where complex cardiovascular systems once worked, where consciousnesses once dwelled. The shadows, the death mask, the blue light – all are inadequate indicators of what once had been; they direct our thoughts backwards to the person and forwards to *mu* (無), emptiness, the void.

BEING LOOKED AT

Our story started with a child being born and opening her eyes. It ends with fading sight and dying. Or it almost ends that way. The funerary, the crypt, are as far as we can go in that direction. The guided tour of the visible world is complete. But before we conclude, before we evaluate our story and ask what it meant, let's consider the counterpoint to looking – being looked at. In our section on eye contact – looking at the goat in the Tarkovsky film, and Marina Abramović in New York, for example – we saw how electrifying it can be to stare into another's eyes. But there is more to being looked at than eye contact. Our whole bodies can be seen. 'Look, so that you may be looked at in return,' wrote Jean Starobinski at the beginning of this chapter, sounding as if his advice could be useful. And indeed it can. Being looked at is the way out of the void.

To see how, consider this, one of the most famous paintings in the art world.

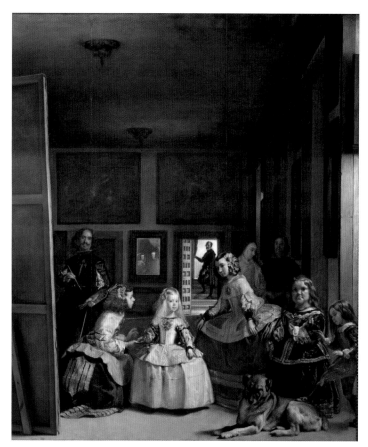

At first glance it is a group portrait of children and a dog, with adults looking on. Then we clock the painter on the left and we wonder what he is looking at and rendering on such a large canvas. His subject is a visual magnet as it draws not only his attention, but that of six other people in the painting. Scanning for clues, being the looking detective, we eventually see the mirror in the background and, in it, the king and queen – ghosts in this remarkable machine. A curtain of red in the reflection echoes the red of the girls' bows, the boy's trousers and the cross on the painter's tunic.

Almost everyone, then, is looking at the king and queen. This is what it is like to be famous. We assume that a painting is seen from the painter's perspective, but this one is not. To complicate things, what we see in the distance might be a reflection of the painting of the king and queen, rather than themselves, but whichever, their look structures the room and creates a centre of visual gravity. The painter, Diego Velázquez, does an extraordinary volte-face by putting the viewer at this centre of gravity. Doing so is politically ambiguous. By letting us stand in the shoes of Philip IV and his wife in 1656, he allows us to feel the attraction of being a monarch, or the lack of privacy of being a monarch (you are always 'on'), or the painting can be seen as a portrait of vanity seen from inside the vanity. As the king and queen are barely visible, the picture fails to tell us how they feel about being looked at. If it gives them a thrill, they are on the exhibitionist spectrum. If they dislike it, they feel invaded by being looked at.

Las Meninas has fascinated artists. Pablo Picasso reworked it several times, making it look like a harlequin image or *Guernica*. The power of the original derives from its visual complexity and the way it shows that looking can be

invasive and violent. The king and queen are freaks in a world where most people are not regal. They are excluded from the everyday. The irony is that the global everyday excludes most people some of the time, because they are poor, black, disabled, disfigured or sexually different. In our section on the human zoo we saw the dispiriting ways in which black Africans were displayed like animals.

But there is a far richer aspect of being looked at. In this moment from the film *Under the Skin*, for example, Adam Pearson plays a character who has been invited into the van of a beautiful woman, and who reaches out to touch her.

Pearson has neurofibromatosis, which means that excessive body tissue grows on certain parts of his body, mostly his face. He is far from the social norms of beautiful and, throughout his life, has had adverse reactions from children and adults. Being looked at will often have been hurtful, and so, it would be unsurprising if Pearson and his character did not want to be in the limelight. In the film, however, the woman, played by Scarlett Johansson, is an alien whose sense of what a body is, as well as what beauty is, is radically different to what most humans think. The result is that she is neither attracted to nor repelled by Pearson's character. In the image she leans towards him, lifts her chin and seems to be about to smile.

In the story she is a killer with superhuman powers, so it could be said that she is being nice to him in order to murder him, but *Under the Skin*'s looking regime is far more complicated than that. It completely rethinks the looking economy, its power and control. Men are used to gazing at women, but here, as in Claire Denis's *Beau Travail*, the spotlight is turned on them. They love it, in part because they do not know how powerful she is. It is a relief, especially if you

have been told all your life that you are ugly. Being the object of the gaze is so thrilling that some of the men follow the alien into a void-like world of tar, and to their certain death. After years of looking, leering, gazing, hustling and coming on to women, it is entrancing for them to be come on to.

Being looked at goes beyond desire, however. If you are a white person from the Western world and travel to the black world, and especially if you have blond hair, you are looked at in a way that you might not have felt before. If you are straight and go to a gay club, something similar happens. You feel the polarities shift. You are looked at and estranged. You begin to understand the power you took for granted. You take an imaginative leap. Stopping looking, then, need not be a kind of death. It can be a joy, a recovery, a submission, as acceptance. By being looked at you know more about the world. You discover, in the phrase we encountered in relation to the z-axis, 'the rapture of self-loss'. As Roland Barthes wrote in *Camera Lucida*, 'I instantly make another body for myself. I transform myself in advance, into an image.'

CONCLUSION

'Who would believe that so small a space could contain the images of all the universe?'

– *Leonardo da Vinci*, on the human eye

'Would the pictures coming into a dark room [a camera obscura] but stay there, and lie so orderly as to be found upon occasion, it would very much resemble the understanding of a man, in reference to all objects of sight, and the ideas of them.'

– *John Locke*, An Essay Concerning Human Understanding (1690)

IN my head, the subtitle of this book was 'a guided tour of the visible world' and I hope you have a sense of having been taken places. When I started writing I also imagined the book as a photo album of a lifetime. I hoped that, as we turned the pages, we would see ourselves and our species grow up. It has taken me 123,000 words to realise that that is not quite right. 'A lifetime' is OK, as I have tried to structure this book a bit like a life. We have seen the wax and wane in looking that happens during someone's life – how their sight is fuzzy, then agog, then expanding, then declining. And 'a photo album' is not bad, in that it is a

succession of images, the sort of thing that the mums and dads of people of my generation got out when relatives visited, or after a few drinks, to show Polaroid snaps of them and their parents when they were small. The images in those old photo albums were few and precious; they came unstuck and had see-through crinkly paper to protect them from the light. If they were from the 1970s, those images would have yellowed. If you came from a poor country, you perhaps had no images at all.

Paul Cézanne's *optique* was not as external as a photo album that you showed your friends, of course. It was his inner eye, the things he had seen, how he had learnt from them or become enriched by them, or outraged or fearful. His return to Aix-en-Provence after a stint in fancy Paris was, for example, a push-pull. He wanted to get back to the things he had seen (and felt, heard, eaten, smelt and so forth) in the south of France, and wanted to escape the things he had seen (and felt, heard, eaten, smelt and so forth) in the metropolis. So a photo album is perhaps too linear and sequential a metaphor for *l'optique*. Maybe it would be better to see it as this, the *Reliquary of St Faith* in the church of Sainte-Foy (St Faith) in Conques, which was completed in the twelfth century.

Conques is about 170 miles northwest of Aix, but I can find no record of Cézanne having been in the medieval village. No matter. The reliquary tells us more about how we look than a photo album does. Behind the square door in its chest are housed

relics from the life of a young woman who is said to have been put to death by a red-hot poker wielded by the Romans in the late 200s CE. The body of the statue is made of yew. The head is likely to be taken from a fifth-century CE portrait of a Roman dignitary – which is why it does not much look like a girl or young woman. The gold on the body is from the 900s CE. A hundred years or so later, a crown and the throne were added, to suggest that she was now regal and in heaven. Sometime later the jewels on her knees and thighs, and those around her neck, were added. Centuries later the chest cavity was inserted, and only in the last two hundred years were her feet replaced – they had been worn away by worshippers, who thronged to see the reliquary, desperate to touch it.

The reliquary is garish, filigreed, festooned, hieratic, fascinating and, for some, absurd. But it is a great emblem of accrual. It started with some wood and became layered, extended, encrusted, extruded. The additions were not added on linearly. They come one on top of the other. That is how looking happens. Each thing that we see, each visual experience that has an impact, is overlaid by the successive ones. I first went to Berlin in 1989, when it was still Communist. Having not previously been in the non-capitalist world, I was visually astonished by the lack of advertising, the brown colour palette, the brutalist architecture, the cars, the lighting, the lack of retail, the clothes and the plunging perspectives of Karl-Marx-Allee. I have been back to Berlin about a dozen times. In each subsequent visit it had become more like Western, capitalist cities. I had only half a roll of film on my first visit, so the photos are few, but I notice that my visual recall of it is being buried under the new layers, like the relics of St Faith embedded in the staring, garish gold Roman god that houses them and belies them. When he went to Brazil for the last time, Charles Darwin wrote that he 'stopped again and again to gaze on such beauties, & tried to fix for ever in my mind, an impression which at the time I knew must sooner or later fade away'. Multiply my Berlin experiences and Darwin's by many thousands, and you get our looking lives. They are reliquaries.

This sounds elegiac or nostalgic, and I certainly wish I could recall with more clarity my 1989 trip to Berlin, but it is actually a product of the unstoppable efficiency of looking. Those of us who can are perpetually looking. We are always assessing the visual scene for danger, beauty, things we have seen before and things we have never seen. During the course of writing this book I have visited the refugee camps in Calais and the Greek–Macedonian border. I grew up in a low-temperature war in Belfast, was in Sarajevo during the siege, have filmed in Iraq during its war, and have visited the slums of Mumbai, but some of what I saw in the camps made me feel like I had opened a trapdoor, below which were living conditions that I had not experienced before. I filmed and photographed

these places, but if those recordings disappear I will have my memories of what I saw. They too will fade and become overlaid, especially if I return to those places.

As well as the waxing and waning looking that an individual does in the course of her life, we have looked at visual moments in human history in this book. Braid our personal looking and our species' looking and you get the story of looking. It starts at birth. We look outwards. At the fuzzy world around us, then at our guardians, then at our homes and societies. Our story of looking continues as we see sexually, explore cities, contemplate abstractions like god, travel, trade and conquest. Videodromes of various sorts were built around looking. The 1700s were a kind of picture gallery. We have seen how scientists looked at the physical world with their naked eyes, and then looking devices – telescopes, X-ray machines, electron microscopes and so on. We have explored how painting, photography, film, TV and VR have become surrogate lookers. Tall buildings and aeroplanes added height to how we looked. And then digital removed many of the barriers of – and the things that define – human looking. It was as if we were so desperate to see more places and inaccessible things (others' bodies, that homicidal shark, the Devil, dinosaurs, California, etc.) that we kept pushing looking as far as it would go, without any sense of whether there were limits. The story of looking has been a story of expansion. Our eyes have not much evolved in the last 10,000 years, but the things to see have massively increased in number and our ways of seeing have stretched what we mean by seeing.

This book has been an account of what we saw, and how, but along the way it has had misgivings. The later chapters were built around metaphors such as the panopticon and the split eyeball. I said that looking has become a deluge. This book is relevant because it is written at the time of that deluge, of looking technologies and digital's defiance of the real. And there is no sign of the technologies and their defiance abating. What do we think of that? Looking back across our story, can we evaluate looking? Can we say that it has, overall, been good or bad? Or that it was once good and now is not? Perhaps these questions are too simple, but let's try to answer them in good faith, and see what conclusions we draw.

Let's imagine a sliding scale. On its extreme left are the most negative, socially or psychologically harmful aspects of looking; on the extreme right are the most positive or useful. In between, as we move rightwards, the types of looking we encounter become more valuable, enriching, revealing, imaginative, thoughtful or fun. As we move leftwards, they become untrue, divisive, controlling or anti-democratic. Let's start on the left. Who do we find there? St Augustine, Martin Luther and the Taliban, surely: those who saw immorality in the act of looking. What do we find on this anti-ocular side? Visual propaganda – looking

with images – is certainly there, and so are human zoos. Let's put the gaze of the slave trader and child pornographer there too.

Beyond these extremes, little else belongs at this edge. Move halfway between this far edge and the neutral centre of our scale and you get the ambiguously negative aspects of looking. Here we can add the looking that is done in conquest, for example. It had some noble anthropological ambitions, but, overall, was exploitative and thieving. Here also is surveillance. It prevents some crime but in its scale it is itself a crime. Also at home at this ambiguously negative spot is visual advertising. It is not wholly bad, but clutters the Western world and worships wealth, exclusivity, narrow definitions of beauty and materialism. Let's also plant car visual culture and oil dependency here. Cars liberated some people but they have contributed to global warming, pollution and obesity. Here too belongs our visual relationship with death. Its ambulance-chasing aspects, the slowing down to have a ghoulish look at road traffic accidents and the flocking to the Paris Morgue are mostly ignoble. Of course we should see death for what it is, but, for the most part, as a species, we are bad at looking at it. And to death add visual celebrity culture. Again it has positive aspects – it affords identification and catharsis, and externalises our desiring, Freudian ways – but, overall, its potency has given it too much power. It visually hypnotises. As to individuals, let's put at least one great artist, Marcel Proust, in this ambiguously negative locale. He was fascinated by looking, and wrote about it brilliantly, but had many misgivings.

Now let's march to the dead centre of our evaluative scale, the place for those aspects of the story of looking which seem entirely balanced between positive and negative. We find a bizarre range of things here: the Baroque, for example, is here because it produced sublime art yet was coercive, propagandistic and discouraging of thought – a potent cocktail. And the sublime itself is dead centre because, whilst it winningly gives us a sense of our smallness and the scale and immanence of our planet, it too can be used to overpower and demean – for example in the Nuremberg rallies. Still in the middle we find visual psychoactive drugs such as LSD. They expand what we have seen, but what they reveal is pointless visual rapture. Then, in another unexpected juxtaposition, we come to an artwork like the wrapped Reichstag. Fascinating and beautiful, it was politically naive in that it suggested a new start, a reboot of German political history. And also in this central position is a biggie – the concept of visual evidence itself. Once, the idea of looking as proof – the impulse of the doubting Thomas, 'unless I see with my own eyes, I will not believe' – would have been further to the right. In the digital age, however, when almost any image can be doctored, few things can be entirely proven with

a photograph. Some would locate visual evidence on the negative side, but the role that mobile phone footage has played in the exposure of police brutality in the USA, the Ukrainian Maidan movement, and protest more generally means that the idea has not been lost.

Move further right and the good times come. A lot of the story of looking is ambiguously positive. Looking at bodies, for example, gives us great pleasure. It is not in the wholly positive far right position because the erotics of looking can become compulsive, damaging or predatory. Cities too are here. Their visual density excites, as does the intersection of myriad lives lived. Like bodies, cities too would be in the most positive position on our scale if it was not for the people exploited in them, their homelessness, their crowding and the anxieties that such close living produces. Let's also put in this populous, enjoyable position photography, cinema and TV. The creative potential and achievements of each are obvious. Their philosophical implications are fascinating. Their weakness is their innate ability to underestimate or sanitise the dreadful. They cannot really show what war is like. As representations, they cannot truly capture the full amplitude of, for example, human suffering. I would add to them electric light. It extended living into the evening, made it easier for people with fading eyesight to live their lives, and made public places safer and more navigable. Light bulbs' downsides are few, but they exist: light pollution, the failure to see the stars in cities and the unatmospheric flatness of most industrial and some retail illumination – but this last thing is a quibble. Also ambiguously positive are visual memorials. Grieving or aggrieved people on the whole benefit from being able to point to something in the world that bears witness to their grief. At times, of course, such memorials can become propaganda, or they can appropriate the loss with malign intent.

Let's also put in this place some much reproved aspects of our present century, such as Facebook and selfies. Yes, they are ubiquitous, often banal and worse, but it is too easy to overlook how liberating and affirming the effects of the first can be, and selfies are mainly a sign of how fascinated we are with seeing ourselves in groups and in the world. Much of human looking is in this ambiguously positive category.

Finally we come to the wholly positive aspects of looking. They are great in number, but how's this for a heterodox selection of joys: colour; landscape; Leonardo da Vinci's notebooks; people-watching; the faces of those you love; protest; Galileo; David Hume; the Bauhaus; visual comedy; the films of Larisa Shepitko and Claire Denis; electron microscopes; and Skype? I am not sure that I have seen a list like that in the world. Jocund and skippy, it could run for pages, and you could add scores of items to it. And, of course, some would dispute items

on it. For example, a politically conservative person might not agree that protest is wholly positive.

It would be wrong to end our story on the most positive case for looking, however. It has too many weaknesses for that. To conclude here would be too optimistic about our relationship with the visual world. A more considered evaluation takes one step backwards along our scale, to ambiguously good. It is there, I think, that we find Paul Cézanne. His dogged determination to paint out of doors and his repetition of certain subjects, such as apples, show his hungry commitment to looking. His appetite for it did not wane. It nourished him. And yet, as we saw with his painting *Route Tournante*, he also was sceptical about what he immediately saw. He mixed new visual impressions with other considerations. Some of them were purely painterly and to do with what was happening on the surface of his canvas, but others were things that looking alone cannot tell you. Hence our sense of him – and all of us – as a projector. *L'optique* is, I would say, an expression of qualified joy. My own position is the same as Cézanne's. I am passionate about looking, but not blind to its faults. Looking has been ambiguously good for our species. It has substantially enhanced our lives.

It is tempting to finish there, but mention of the word 'species' points to one hitherto unexplored area of current scientific research. It could have come at the beginning of our story, but instead it is at the end.

We have considered what is seen between these two images, a person's birth and their death.

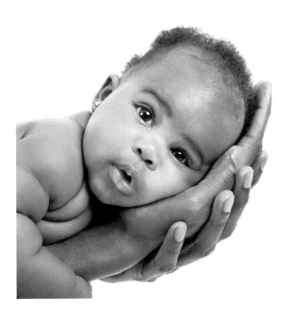
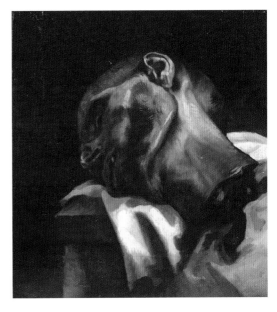

Does all the accrued looking that happened during their life disappear when they die? Does the reliquary disappear? The obvious answer is yes, but is it the right answer? The French biologist Jean-Baptiste Lamarck might have disagreed. In 1809, exactly fifty years before Charles Darwin's *On the Origin of Species*, he published *Philosophie Zoologique*. He argued that our immediate environments affect our biology, using, for example, the fact that moles are blind because they do not need to see. So far, so uncontroversial. But then he wrote in *Philosophie Zoologique*:

> All the acquisitions . . . wrought by nature on individuals, through the influence of the environment in which their race has long been placed . . . are preserved by reproduction to the new individuals which arise.

In other words, we can inherit the biological changes that our parents underwent in their lifetimes. This does not stretch modern credulity much either, but it was challenged by many of his successors. Evolution worked in deep time, not as rapidly as mother to daughter. Lamarckism subsequently fell out of favour, but has revived in recent years. In 2013 Brian Dias and Kerry Ressler of the Emory University School of Medicine in Georgia, USA, and others published the results of studies of mice. They had made male mice associate the smell of cherry blossom with slight electric shocks. The mice therefore came to fear the smell. They then inseminated female mice with the sperm of fearful males. The mice that were subsequently born were also afraid of the smell of cherry blossom. Memory, therefore, can be genetically transmitted from parent to child. The mechanism is not yet fully understood – it is thought that micro ribonucleic acid modifications could play a part – but it has been found to work from the female mouse too: the information is passed via her egg.

Add to this a study published on 28 September 2015 by Nicholas Shakeshaft and Robert Plomin which shows that our ability to recognise faces, for example, is a skill transmitted by genes that are not the same as those by which we inherit other abilities. If we are particularly good at recognising faces, it is likely to be a specific inheritance from recent ancestors rather than a species-wide legacy. Add to this the wider and more obvious fact that the baby in the above image does not need to be taught by her parents to be afraid if she sees a lion coming running at her and roaring, and you get indications that aspects of looking are, or could be, handed down in her cells.

If we accept this, the implication is clear: when she is born, a child already knows some profound things about seeing. Looking has, in a sense, already happened to her and for her, and lies dormant, ready to be activated. Does that mean that when she sees the sky, trees, other people, emotions, spaces, animals,

bodies, homes, tools, crowds, sunsets and ailments, that she is looking, in part, through ancestral eyes? That she has already seen these things? Déjà vu. Is the reliquary already barnacled?

A note of caution must be struck here. Researchers believe that smell is more genetically transmittable than sight. But what, then, about archetypes – ancient cultural ideas and symbols? The child sees the sea and feels an attraction to it, not just because it is vast and powerful. Though humans originated in the savannah of Africa, their encounters with other seas have been so lasting and powerful that the sea seems to have become a secondary natural influence on the species. And what about forests and trees, one of which was the starting point of this book? Many cultures have myths and fables about trees. The forest as harbour and harbinger; the place where the beasts live; the climbing place; the darkness where our unconscious can surface like a vampire surfaces; that incongruous forest in Arnold Böcklin's painting that both Freud and Hitler liked; a forest as a cloudscape, a microcosm; and as a Gothic city or cathedral vaulted upwards. Carl Gustav Jung defined his idea of the collective uncon-scious as 'the mind of our unknown ancestors, their way of thinking and feeling, their way of experiencing life and the world, gods and men'. He is clearly talking about ancient imprinting, and was not specifically discussing the visible world, but there are elements in his thinking that are relevant to the story of looking. In 'The Structure of the Psyche', referring to people having dreams about snakes, he wrote 'The snake-motif was certainly not an individ-ual acquisition of the dreamer, for snake-dreams are very common even among city-dwellers who have probably never seen a real snake.' In the era of TV, of course, everyone has seen a snake, and even in Jung's day most people will have read about snakes in literature, so his point is debatable. One of Jung's key archetypes is the Tree of Life, which he finds in most cultures and of which he says, 'the branches up above are the kingdom of the heavens; the roots below form the kingdom of the earth, the nether world; and the trunk is the world axis round which the whole world revolves'. Christmas trees derive from arche-typal German firs, the baubles and lights symbolising the Moon, Sun and stars hung on the branches of the Cosmic Tree.

Though we are unlikely to be able to inherit the visual equivalent of a mouse's fear of cherry blossom, is it not very possible that we have inherited some of the innate responses to the visual world which interested Jung? The story of our looking starts before our birth and continues after our death. Images are in there somewhere, as deep time imprints at least. Suddenly the dead image of my dead granny on my dead phone seems less dead after all. Her looking continues – through me.

Often books end with a further reading section, but this one has a further action section, which is very short and of just two parts. The first is a single word.

Look.

The second is a suggestion: if this photo album, this gallery tour, has inspired you, make images unlike any we have seen before.

The tree outside my flat, seen in different seasons and weathers, and other trees that I have seen whilst making this book: in Chernobyl; the 'Goethe tree' in Buchenwald concentration camp; trees along a Belfast peace wall; a leaf from the Austrian Alps; trees on the island of Skye; and tree painted around 30–20 BCE for the Villa of Livia near Rome.

ACKNOWLEDGEMENTS

At one of our dinners in Edinburgh, when we talk over each other, I mentioned the idea for this book to my friend, the publisher Jamie Byng. He almost at once said that he was interested in it, and I think I probably punched the air. It has been a pleasure to be in his solar system.

At school my art teacher, Heather McKelvey, gave me books on Cézanne, taught me to look as I drew and, I suspect, has been whispering in my ear for longer than I realise. Sean Quinn, who was in the class she taught, helped me see and mended my life in a way for which I will be forever grateful. At university Rosemary Muir Wright and Professor Paul Stirton taught me art history from opposite directions and Professors John Izod and Grahame Smith nurtured my love of cinema. Grahame and Professor Angela Smith gave me great advice in my sections on literature, as did my friend and producer Adam Dawtrey. Timo Langer has edited all my feature films and, so, my seeing has been enriched by his. Professor Gerry McCormac was generous with his time and knowledge about physics. Professor Ruth Jonathan has lived like few people I know, and gave valuable, detailed advice on the manuscript. And Jim Hickey made key suggestions for my short section on music.

Caroline Chignell at PBJ Management has been so generous with her time that it embarrasses me. Not only with this book have her knowledge and plain speaking enhanced my work. If you have met her you will know what I mean. Jenny Todd at Canongate has been a delight to work with. Francis Bickmore has improved this book more than anyone else, and I think I would cut off my finger for him if he asked. I can see why so many authors would want him as their editor, and am delighted that I got him. Thanks are due to Megan Reid, Rona Williamson, Rafi Romaya, Kate Oliver and Anna Frame at Canongate, and Gavin Peebles for his elegant typesetting.

I would like to thank whoever it will be, in the future, who finds a way of inserting a layer of graphene at the back of our retinas and improves our looking in ways that I can only imagine. They will make human looking so far seem like just a prologue. In that prologue, to the person at whom I have looked most in the world – GLM – I would like to say that there is no place, thing, vista, moment or person I would rather see.

Mark Cousins
Edinburgh
2017

IMAGE CREDITS

All copyrighted images are credited below. Unless otherwise indicated here, images are in the public domain.

While every effort has been made to contact copyright holders of images, the author and publishers would be grateful for information about any images where they have been unable to trace them, and would be glad to make amendments to further editions.

INTRODUCTION
Tree at dawn © Mark Cousins
Paul Cézanne letter to Émile Bernard, 1905 © The Samuel Courtauld Trust, The Courtauld Gallery, London
Basalt statue of Cleopatra VII horn of plenty (51–30 b.c.) © State Hermitage Museum, St. Petersburg, Russia/De Agostini Picture Library/S. Vannini/Bridgeman Images
Cleopatra, Joseph L. Mankiewicz, Rouben Mamoulian, Twentieth Century Fox Film Corporation; MCL Films S.A; Walwa Films S.A., USA-Switzerland-UK, 1963
Phone © Mark Cousins

CHAPTER 1
African American Baby Girl on Parent's Hands © Flashon Studio/Dreamstime.com
Blurred grass © Mark Cousins
Persona, Ingmar Bergman, Svensk Filmindustri, Sweden, 1966
The Divine Lady, Frank Lloyd, First National Pictures, Warner Bros., 1929
Mona Lisa, Leonardo da Vinci, 1503–06, Musée du Louvre, Paris
Seascape with a Sailing Boat and a Ship, J.M.W Turner, c.1825–30, Tate Modern, London
Ugetsu Monogatari, Kenji Mizoguchi, Daiei Studios, Japan, 1953
Wanderer Above the Sea of Fog, Caspar David Friedrich, 1818, Kunsthalle Hamburg, Hamburg, Germany
Little Sparta © Mark Cousins
*Ms.Sup.Pers.*1113. fol. 66v The Camp of Genghis Khan (c.1162–1227) from a book by Rashid al-Din, Persian School, (14th century) © Bibliotheque Nationale, Paris, France/ Bridgeman Images
The Last Supper, Duccio Di Buoninsegna, Museo dell'Opera del Duomo, Siena
Vista © Mark Cousins
The Virgin of the Rocks, Leonardo da Vinci, 1483–1486, Musée du Louvre, Paris
Geometric pattern of the Jameh Mosque of Isfahan, Iran © Flavijus/Dreamstime.com
Azurite and Malachite © Janaeken/Dreamstime.com
Colour Wheel, Johann Wolfgang von Goethe, *Theory of Colours*, 1809 Goethe House, Frankfurt, Germany
Hero, Zhang Yimou, Beijing New Picture Film Co., China Film Co-Production Corporation, Elite Group Enterprises, Sil-Metropole Organisation, Zhang Yimou Studio, Hong Kong, China, 2002
Vertigo, Alfred Hitchcock, Alfred J Hitchcock Productions, Paramount Pictures, USA, 1958
Les Parapluies de Cherbourg, Jacques Demy, Parc Film, Madeleine Films, Beta Film, France, 1965
Sea x2 © Mark Cousins

CHAPTER 2

The False Mirror, René Magritte, 1929, © 2017 C. Herscovici, Brussels/Artists Rights Society (ARS), New York, USA

Ivan's Childhood, Andrei Tarkovsky, Mosfilm, Trete Tvorcheskoe Obedinenie, USSR, 1962

Marina Abramović: The Artist is Present, Matthew Akers, Jeff Dupre, Show of Force, AVRO Close Up, Dakota Group, USA, 2012

Late Autumn, Yasujirō Ozu, Shôchiku Eiga, Japan, 1960

Piccadilly, E.A. Dupont, British International Pictures, UK, 1929

Verdun, souvenirs d'histoire, Léon Poirier, Cinematheque de Toulouse, France, 1931

The Cyclist, Natalia Goncharova, 1913, The Russian Museum, St. Petersburg

The 'Huastec Adolescent', believed to represent a young priest of the god Quetzalcoatl or perhaps the god himself © Werner Forman Archive/Bridgeman Images

Landscapes x8 © Mark Cousins

The First Movie, Mark Cousins, CONNECT film, Screen Siren Pictures, UK-Canada, 2009

Mère et enfant (Mother and Child), Pablo Picasso, 1902 © Succession Picasso/DACS, London, 2015

Osaka Elegy, Kenji Mizoguchi, Daiichi Eiga, Japan, 1936

Figurine of a woman crying © Werner Forman Archive/Bridgeman Images

The Lamentation of Christ, c.1305 (fresco), Giotto di Bondone © Scrovegni (Arena) Chapel, Padua, Italy/Bridgeman Images

Silver-plated iron mask, from the necropolis in Homs, Syria. Phoenician civilisation, II millennium BC © De Agostini Picture Library/Bridgeman Images

The Passion of Joan of Arc, Carl Theodor Dreyer, Société générale des films, France, 1928

Susanna and the Elders, c.1620 (oil on copper panel), Ottavio Mario Leoni © Detroit Institute of Arts, USA/Bridgeman Images

Susanna and the Elders, Artemisia Gentileschi, 1610, Pommersfelden, Germany

Homeless, Dublin, Ireland © Peter Macdiarmid/Getty Images

Taxi Driver, Martin Scorsese, Columbia Pictures Corporation, Bill/Phillips, Italo/Judeo Productions, USA, 1976

Fragment of a Kongo nkisi nkondi (wood), Congolese School, (19th century) © Tropenmuseum, Amsterdam, The Netherlands/Photo: © Heini Schneebeli/Bridgeman Images

CHAPTER 3

The Chess Game, Sofonisba Anguissola, 1555, National Museum in Poznań, Poland

The Desperate Man, Gustave Courbet, 1845, Private Collection

Self Portrait, Albert Dürer, 1500, Alte Pinaothek, Munich

Self Portrait, c.1910 (w/c & pencil on buff paper), Egon Schiele, Private Collection. Photo: © Christie's Images/Bridgeman Images

Self Portrait on the Borderline Between Mexico and the United States, 1932, Tate Modern, London

Mirror, Andrei Tarkovsky, Mosfilm, USSR, 1975

Unswept Floor, *'Asàrotos òikos'*, 5–6th Century, Gregoriane Profano Museum, the Vatican

Early Summer, Yasujiro Ozu, Shôchiku Eiga, Japan, 1951

Bedroom at Arles, Vincent van Gogh, 1888, Musée d'Orsay, Paris

Bowl decorated with a geometric pattern, Style I, from Susa, Iran, 3100–3000 BC (terracotta), Mesopotamian © Louvre, Paris, France/Bridgeman Images

St Ninian's Brooch © National Museum of Scotland

Wooden Vessel. Photo: Stuart Humphreys © Australian Museum

Eye glasses © Yodke67/Dreamstime.com

Tea Infuser and strainer, made by the Bauhaus Metal Workshop, Weimar, 1924 (silver with ebony), Marianne Brandt, Private Collection. Photo: © The Fine Art Society, London, UK/Bridgeman Images

Sputnik 1, 1957 © AFP

CHAPTER 4

Statue of David. Firenze, Italy © Alfonsodetomas/Dreamstime.com

To Have and Have Not, Howard Hawks, Warner Bros, USA, 1944

Romeo + Juliet, Baz Luhrmann, Bazmark Films, Twentieth Century Fox Film Corporation, USA, 1996

Diana and her Nymphs discovered by Actaeon (after Titian) © Knole, Kent, UK/National Trust Photographic Library/Bridgeman Images

Le Déjeuner sur l'herbe, Édouard Manet, 1863, Musée d'Orsay, Paris

The Origin of the World, 1866 (oil on canvas), Gustave Courbet © Musée d'Orsay, Paris, France/Bridgeman Images

Beau Travail, Claire Denis, S.M. Films, Tanaïs Productions, France, 1999

Sky x2 © Mark Cousins

Stone head from steel statue © De Agostini Picture Library/Bridgeman Images

Mother and Child on the Beach, Jean-Baptiste-Camille Corot, 1860, Philadelphia Museum of Art, Pennsylvania

Relief depicting the Aten giving life and prosperity to Amenophis IV (Akhenaten) (c.1352–1336 BC) his wife, Nefertiti and three of their daughters, from Tell el-Amarna, New Kingdom, c.1375–1354 BC (limestone) © Agyptisches Museum, Berlin, Germany/Bridgeman Images

La Tourette x2 © Mark Cousins

The Holy Face (panel), Russian School, (13th century) © Andrei Rublev Museum, Moscow, Russia/Bridgeman Images

Tokyo Story, Yasujirō Ozu, Shôchiku Eiga, Japan, 1960

Snow White and the Seven Dwarfs, William Cottrell, David Hand, Wilfred Jackson, Larry Morey, Perce Pearce, Ben Sharpsteen, Walt Disney Productions, USA, 1937

Shiva © Mark Cousins

Iran/Persia: A map or diagram showing the Ka'ba or Kaaba at the heart of the Masjid al-Haram in Mecca. From a 16th century Persian manuscript of poetry by Lari Mohyi (1527) © Pictures from History/Bridgeman Images

2001: A Space Odyssey, Stanley Kubrick, Metro-Goldwyn-Mayer, Stanley Kubrick Productions, UK-USA, 1968

Man of Sorrows (oil on canvas), William Dyce © Private Collection/Bridgeman Images

Hupa: Female Shaman. A portrait of the principal female shaman of the Hupa, North America. Photographed by Edward S. Curtis, c.1923. Photo © Granger/Bridgeman Images

CHAPTER 5

The Watts Towers, Simon Rodia National Park, Los Angeles © Bridgeman Images

Interiors of the Mezquita, the church mosque, in Cordoba © Nicole Ciscato/Dreamstime.com

Interior of the Notre Dame de Paris in Paris, France © Scaliger/Dreamstime.com

Cottage © Mark Cousins

Philip Johnson's Glass House, reprinted courtesy of Robin Hill

Chinese *yingbi* © Mark Cousins

Kailisa Temple © Mark Cousins

Ellora Caves near Aurangabad, Maharashtra state in India © Saiko3p/Dreamstime.com

Ishtar Gate, Neo-Babylonian c575 BC: restored glazed brick © Pergamon Museum/ Universal History Archive/UIG/Bridgeman Images

A lion from the Gate of Ishtar, Babylon © Chris Hill/Dreamstime.com

Intolerance: Love's Struggle Throughout the Ages, D.W. Griffith, Triangle Film Corporation, Wark Producing, USA, 1916

Gladiator, Ridley Scott, DreamWorks, Universal Pictures, Scott Free Productions, Mill Film, C&L, Dawliz, Red Wagon Entertainment, USA-UK, 2000

Abbasid Baghdad © Jean Soutif/Look at Sciences/Science Photo Library

Anatomy of the Eye, Al-Mutadibi (fl.1170–99) © Egyptian National Library, Cairo, Egypt/ Bridgeman Images

Iran – Esfahan (Isfahan) – Maydan-e Emam. Royal Mosque Masjed-e Emam © De Agostini Picture Library/W. Buss/Bridgeman Images

Pale Flower, Masahiro Shinoda, Bungei Production Ninjin Club, Japan, 1964

Metropolis, Fritz Lang, Universum Film (UFA), Germany, 1927

Presidential Palace of Astana Kazakhstan © Cosmopol/Dreamstime.com

Pripyat, Ukraine © Pripyat.com

Pripyat, Ukraine © Mark Cousins

Destruction of Babylon © The University of Manchester Library

CHAPTER 6

Dzungarian Gate, NASA

Emperor's Semiformal Court Robe, Chinese School (18th century) © Saint Louis Art Museum, Missouri, USA/Gift of Mrs. Ralph F. Bixby/Bridgeman Images

Agra Red Fort, India, Uttar Pradesh © Olena Serditova/Dreamstime.com

A barefoot ancient Christian army marches round besieged Jerusalem (colour litho), Tom Lovell © National Geographic Creative/Bridgeman Images

The Discovery of the True Cross and St. Helena, c.1740 (oil on canvas) © Gallerie dell'Accademia, Venice, Italy/Cameraphoto Arte Venezia/Bridgeman Images

Sainte Chapelle (Holy Chapel), Île de la Cité, Paris © Francoisroux/Dreamstime.com

Mounted Crusaders fighting against the Saracens in c.1185, from Le Roman de Godefroi de Bouillon (vellum), French School, (14th century) © Bibliothèque Nationale, Paris, France/Bridgeman Images

Portrait of a Man, Said to be Christopher Columbus (c.1446–1506), 1519 (oil on canvas) © Metropolitan Museum of Art, New York, USA/Bridgeman Images

Christopher Columbus lands in the New World in 1492 and is greeted by Taino Indians © Private Collection/Peter Newark American Pictures/Bridgeman Images

The Arrival of Cortés, Diego Rivera, 1951, Palacio Nacional de Mexico, Mexico City

Breastplate representing the god of death, Mictlantecuhtli, from Tomb 7, Monte Alban, Mixtec, c.1300–1450 (gold), Pre-Columbian © Museo Regional de Oaxaca, Mexico/ Bridgeman Images

The New World, Terrence Malick, New Line Cinema, Sunflower Productions, Sarah Green Film, First Foot Films, The Virginia Company LLC, USA–UK, 2005

World Map in Mercator Projection © Intrepix/Dreamstime.com

World Map in Mollweide Projection © Intrepix/Dreamstime.com

Throne of Blood, Akira Kurosawa, Toho Company, Kurosawa Production Co., Japan, 1957

Chimes at Midnight, Orson Welles, Alpine Films, Internacional Films, Switzerland-France-Spain, 1965

Come and See, Elem Klimov, Belarusfilm, Mosfilm, USSR, 1985
Department of Defense, *Gulf War Target Camera Image*, 1990–91

CHAPTER 7

El Caracol, the Stars Observatory ruins facade in the Maya archaeological site of Chichen
 Itza, Yucatan Peninsula, Mexico © Alexandre Fagundes De Fagundes/Dreamstime.
 com
Shen Kuo © Mark Cousins
The Human Foetus in the Womb, facsimile copy (pen & ink on paper) © Bibliothèque des Arts
 Décoratifs, Paris, France/Archives Charmet/Bridgeman Images
Fictional 15th century depiction of the birth of Julius Caesar, Unknown c. 1473–1476 ©
 British Library
Chung Kuo, Cina, Michelangelo Antonioni, RAI Radiotelevisione Italiana
Anatomical theatre, built 1594–95, Italian School, (16th century) © University of Padua,
 Italy/Bridgeman Images
Trial of Galileo, 1633 (oil on canvas), Italian School, (17th century) © Private Collection/
 Bridgeman Images
Io, NASA
The birthplace of Isaac Newton, Woolsthorpe Manor and the famous apple tree © Tim@
 awe/Dreamstime.com
Biston betularia © Natural History Museum, London, UK/Bridgeman Images

CHAPTER 8

Isenheim Altarpiece, Matthias Grünewald, 1512–1516, Unterlinden Museum, Alsace, France
Kuya-Shonin (Saint Kuya) Kosho, Rokuharamitsuji Temple, Kyoto, Japan
St Martin's Cathedral, Utrecht © Mark Cousins
Thessaloniki © Mark Cousins
The Entry of St Ignatius into Paradise, Andrea Pozzo, 1694, Sant'Ignazio Church, Rome
The Ecstasy of St Teresa of Avila, 1647–1652, Gian Lorenzo Bernini, Santa Maria della
 Vittoria, Rome, Italy © De Agostini Picture Library/G. Nimatallah/Bridgeman Images
The Entombment of Christ, Michelangelo Merisi da Caravaggio, 1602–1604, Pinacoteca
 Vaticana, Vatican City
The Art of Painting, Johannes Vermeer, 1665–1668, Kunsthistorisches Museum, Vienna
Rustem Pasha Mosque in the foreground and the Suleymaniye Mosque, an Ottoman
 imperial mosque on the Third Hill of Istanbul © Ira Block/National Geographic
 Creative/Bridgeman Images
Old Decorative Tiles, Rustem Pasha Mosque, Turkey, Istanbul © Riccardo Sala/Alamy
 Stock Photo
Galerie des Glaces (Hall of Mirrors) 1678, Château de Versailles, France © Peter Willi/
 Bridgeman Images

CHAPTER 9

Happy Company (Allegra compagnia), Bartolomeo Passerotti, Ca. 1577 © Private Collection/
 Mondadori Portfolio/Electa/Antonio Guerra/Bridgeman Images
Punch (Pulcinella) and Pasquale Terremoto, puppets from the Maria Imperatrice Guarattelle
 theatre, Naples, Italy © De Agostini Picture Library/L. Romano/Bridgeman Images
Italian and French Comedians Playing in Farces, 1670, Comedie Francaise, Paris, France ©
 Archives Charmet/Bridgeman Images

Robert Gallinowski and Joerg Gudzuhn in a scene of *Tartuffe* (by Moliere), Deutsches
Theater, Kammerspiele, Berlin-Mitte © Markwaters/Dreamstime.com
La Surprise de l'amour, Pierre de Marivaux, 1722
Playtime, Jacques Tati, Specta Films, Jolly Film, France-Italy, 1967
Monsieur Hulot's Holiday, Jacques Tati, Discina Film, Cady Films, Specta Films, France,
1953
The Great Dictator, Charles Chaplin, Charles Chaplin Productions, USA, 1940
Stop! Look! And Hasten! Chuck Jones, Warner Bros., USA, 1954
Duck Soup, Leo McCarey, Paramount Pictures, USA, 1933
Some Like It Hot, Billy Wilder, Mirisch Company, United Artists, USA, 1959
Taj Mahal Palace, India © Sergeychernov/Dreamstime.com
Statue at Treptower Park, Berlin © Daniel Novoa/Dreamstime.com
Soviet War Memorial in Treptower Park, Berlin, Germany © Demerzel21/Dreamstime.
com
McGurk's Bar, Ireland © Mark Cousins
Tuol Sleng Genocide Museum, Phnom Penh, Cambodia © Thegrimfandango/
Dreamstime.com
Taj Mahal at sunrise, India © Steve Allen/Dreamstime.com

CHAPTER 10
Gallery of Views of Ancient Rome, 1758, Louvre, Paris, France © Bridgeman Images
Camera Obscura illustration from the *Encyclopedie* by Denis Diderot © Private Collection/
Archives Charmet/Bridgeman Images
The Scarlet Empress, Josef von Sternberg, Paramount Pictures, USA, 1934
Tricolore rosette, French School (18th century) © Musee de la Ville de Paris, Musee
Carnavalet, Paris, France/Bridgeman Images
The Death of Marat, Jacques-Louis David, 1793, Royal Museums of Fine Arts of Belgium,
Brussels, Belgium
About Schmidt, Alexander Payne, New Line Cinema, USA, 2002
Triumph of the Will, Leni Riefenstahl, Reichsparteitag-Film, Germany, 1935
Worker and Kolkhoz Woman (Woker and Collective Farmer), Moscow, Russia © Scaliger/
Dreamstime.com
Strike, Sergei Eisenstein, Lenfilm, USSR, 1925
300, Zack Snyder, Legendary Pictures, Virtual Studios, Atmosphere Pictures, Hollywood
Gang Productions, USA, 2006
Dudley, Worcester (w/c on paper), Joseph Mallord William Turner © Lady Lever Art Gallery,
National Museums Liverpool/Bridgeman Images
1700 drawing of Byrd plantation, Virginia
Brookes slave ship, 1788
Civil War CDV of Gordon (slave) at the Baton Rouge Union camp during his medical
examination, 1863
A Subtlety, Kara Walker, 2014. Photo © Jason Wyche. Courtesy of Creative Time
God the Geometer, Anon., 1220–1230, Austrian National Library, Vienna, Austria
8½, Federico Fellini, Cineriz, Francinex, Italy, 1963
Thessaloniki from above © Mark Cousins
The Earth as seen from space: NASA
North by Northwest, Alfred Hitchcock, Metro-Goldwyn-Mayer, USA, 1959

CHAPTER 11

The Raft of the Medusa, Théodore Géricault, 1818–1819, Musée du Louvre, Paris, France

Mountains © Mark Cousins

The forest of pines (ink on paper), Hasegawa Tohaku © Tokyo National Museum, Japan/ Bridgeman Images

Fenster am Oybin im Mondschein, Carl Gustav Carus, 1825–1828, Museum Georg Schäfer, Bavaria, Germany

Western Trail, The Rockies (oil on paper), Albert Bierstadt © Private Collection/Bridgeman Images

Red River, Howard Hawks, United Artists, USA, 1948

The Searchers, John Ford, C.V. Whitney Pictures, Warner Bros, USA, 1956

Indian viewing railroad from top of Palisades, 435 miles from Sacramento, Alfred A. Hart, 1916–1908, Golden State Photographic Gallery, California

Study of a Negro Man, c.1891 (charcoal & pastel on cream laid paper), Henry Ossawa Tanner © Detroit Institute of Arts, USA/Founders Society Purchase/Bridgeman Images

The Passage of the Andes (oil on canvas), Augusto Ballerini, 1817 © Private Collection/ Index/Bridgeman Images

Railway © Mark Cousins

Once Upon a Time in the West, Sergio Leone, Rafran Cinematografica, Finanzia San Marco, Paramount Pictures, Italy, 1968

The Return after Three Days, c.1865, Julia Margaret Cameron © Private Collection/The Stapleton Collection/Bridgeman Images

The Way It Looks from the Stern Seat (albumen silver print from glass negative), Seneca Ray Stoddard © Museum of Fine Arts, Houston, Texas, USA/Museum purchase funded by Cindi Blakely in honor of Robert T. Blakely at 'One Great Night in November, 2001'/ Bridgeman Images

Harold Whittles hearing sound for the first time, Jack Bradley, 1974

Chronophotography: Dismounting a bicycle, Étienne-Jules Marey, late 1890s

North Korea, 2011 © Damir Sagolj/Reuters

Songs from the Second Floor, Roy Andersson, Filmproduktion AB, Sveriges Television AB, Stockholm, Danmarks Radio, Köpenhamn, Norsk Rikskringkasting, Oslo, Arte France Cinéma, Issy-les-Moulineaux, Société Parisienne de Production, Paris, Essential Filmproduktion GmbH, Berlin, Easy Film A/S, København, Zweites Deutsches Fernsehen (ZDF), Mainz, La Sept/Arte, Paris, Sweden–Norway–Denmark, 2000

CHAPTER 12

Narcissus, c.1500 (wool & silk), French School, (16th century) © Museum of Fine Arts, Boston, Massachusetts, USA/Charles Potter Kling Fund/Bridgeman Images

A Clockwork Orange, Stanley Kubrick, Polaris Productions, Hawk Films, UK, 1971

Sketch for *Paris, a Rainy Day*, 1877 (oil on canvas), Gustave Caillebotte © Musée Marmottan Monet, Paris, France/Bridgeman Images

Washington Street, Indianapolis at Dusk (oil on canvas), Theodor Groll © Indianapolis Museum of Art, USA/Bridgeman Images

Russian peasants getting electricity for the first time, 1920

The Horse Fair, Rosa Bonheur, 1852–55, Gift of Cornelius Vanderbilt, 1888, The Met Fifth Avenue, New York, USA

Portrait of the courtesan Hanaogi of the Ogiya, Nihonbashi, Edo, the start of the Tokaido/ Nakasendo. From Keisei dochu sugoroku, *A Tokaido Board Game of Courtesans*. Keisai Eisen © Pictures from History/Bridgeman Images

The Courtesan, Vincent van Gogh, 1887, Van Gogh Museum, Amsterdam, The Netherlands

Ink and colours on paper, Xu Gu, Chinese Paintings Collection, Berkeley Art Museum, Univeristy of California, Berkeley, USA

Impression, Sunrise, Claude Monet, 1872, Musée Marmottan Monet, Paris, France

Route Tournante (Turning Road), Paul Cézanne, c.1905 © The Samuel Courtauld Trust, The Courtauld Gallery, London

Landscape with the Nymph Egeria (oil on panel), Claude Lorrain (Claude Gellee) © Museo di Capodimonte, Naples, Italy/Bridgeman Images

Madame Cézanne in a Red Dress, 1888–90 (oil on canvas), Paul Cézanne © Metropolitan Museum of Art, New York, USA/Bridgeman Images

Portrait of Madame Cézanne after Cézanne, Juan Gris, 1916, Leonard A. Lauder Cubist Collection, Gift of Leonard A. Lauder, The Met Fifth Avenue, New York, USA

Crane design, Tawaraya Sōtatsu and Hon'ami Kōetsu, Seventeenth Century, Kyoto National Museum, Japan

The Kiss in the Tunnel, George Albert Smith, George Albert Smith Films, 1899

2001: A Space Odyssey, Stanley Kubrick, Metro-Goldwyn-Mayer, Stanley Kubrick Productions, UK-USA, 1968

Sphynx © Mark Cousins

Marnie, Alfred Hitchcock, Universal Pictures, Alfred J. Hitchcock Productions, Geoffrey Stanley, USA, 1964

Devi (The Goddess), Satyajit Ray, Satyajit Ray Productions, India, 1960

Rien que les heures (Nothing But Time), Alberto Cavalcanti, Néo Films, France, 1926

Man with a Movie Camera, Dziga Vertov, VUFKU, USSR, 1929

Star Wars IV – A New Hope, George Lucas, Lucasfilm, Twentieth Century Fox Film Corporation, USA, 1977

The Ascent, Larisa Shepitko, Trete Tvorcheskoe Obedinenie, Mosfilm, USSR, 1977

*La Noire de . . .,*Ousmane Sembene, Filmi Domirev, Les Actualités Françaises, Senegal, 1966

Birth, Jonathan Glazer, New Line Cinema Fine Line Features, Lou Yi Inc., Academy Films, March Entertainment, UK/France/Germany/USA, 2004

Olympic Stadium, Athens, Greece (19th century) © Private Collection/Look and Learn/Elgar Collection/Bridgeman Images

Charles Dumas winning the gold medal for the High Jump at the 1956 Melbourne Olympics © Private Collection/Bridgeman Images

Football match Germany – Protectorate of Bohemia and Moravia in Berlin in 1939 © SZ Photo/Scherl/Bridgeman Images

Hand mit Ringen (Hand with Rings), Wilhelm Röntgen, 1895, Physik Institut, University of Freiburg, Germany

CHAPTER 13

Un Chien Andalou, Luis Buñuel, Les Grands Films Classiques (France), France, 1929

Bern, Zeitglockenturm © United Archives/Carl Simon/Bridgeman Images

The Annunciation, Antonello da Messina, 1474, Galleria Regionale della Sicilia, Sicily, Italy

The Flagellation of Christ, c.1463–4 (tempera on panel), Piero della Francesco © Galleria Nazionale delle Marche, Urbino, Italy/Bridgeman Images

Brownian motion (litho), English School, (20th century) © Private Collection/Look and Learn/Bridgeman Images

The scenic garden at Monastery Saint-Paul de Mausole, Saint-Remy-de-Provence, France © Evgeniy Fesenko/Dreamstime.com

Enclosed Wheat Field in the Rain, Vincent van Gogh, 1889, Philadelphia Museum of Art, Philadelphia, USA

42nd Street, Lloyd Bacon, Warner Bros., USA, 1933

The Bridge at Courbevoie, Georges Seurat, 1886–87, The Courtauld Institute of Art, London, UK

The Music Room, Satyajit Ray, Arora, India, 1958

Dancing girls taken from Baz Bahadur's palace at Malwa, performing a Kathak dance before Akbar, from the 'Akbarnama', Mughal, 1561 (gouache on paper), Indian School, (16th century)© Victoria & Albert Museum, London, UK/Bridgeman Images

Through the Olive Trees, Abbas Kiarostami, Abbas Kiarostami Productions, CiBy 2000, Farabi Cinema Foundation, Iran, 1994

Chernobyl © Mark Cousins

View of the CMS detector in the surface hall at Cessy. Image via CERN

English archaeologist Howard Carter (1873–1939) and an Egyptian assistant examining the sarcophagus of King Tutankhamun (20th century) © Private Collection/Leemage/Bridgeman Images

Planet of the Apes, Franklin J. Schaffner, APJAC Productions, Twentieth Century Fox Film Corporation, USA, 1968

Untitled, c.1923–5 (oil, wood relief, plywood), Kurt Schwitters © National Galleries of Scotland, Edinburgh/Bridgeman Images

CHAPTER 14

Emily Davison killed at 1913 Derby, British Pathe, UK ,1913

Salt March, Dandi, South Gujarat, 1930

Guernica in situ x2 © Mark Cousins

Our Father's House © Mark Cousins

Saint-Sever Codex, Beatus of Liébana, 1038, Bibliothèque Nationale de France, Paris, France

Repentance, Tengiz Abuladze, Qartuli Pilmi, Qartuli Telepilmi, Sovexportfilm, USSR, 1984

Protesters hold hands along the Baltic Way, a demonstration stretching across three countries, Latvijas Okupacijas Muzejs, 1939

Heshang (River Elegy), Xia Jun., CCTV, China, 1988

Tiananmen Square protests, 1989 © Jeff Widener/AP Photo

Tiananmen Square protests, 1989 © Sadayuki Mikami/AP Photo

Protestor © Mark Cousins

Small Pleasures, Wassily Kandinsky, 1913 © Solomon R. Guggenheim Museum, New York, USA/Bridgeman Images

Les Demoiselles d'Avignon, Pablo Picasso, 1907, Museum of Modern Art, New York City, USA

The Scream, Edvard Munch, 1893, National Gallery, Oslo, Norway

The Cabinet of Dr. Caligari, Robert Wiene, Decla-Bioscop AG, Germany, 1920

Star Wars IV – A New Hope, George Lucas, Lucasfilm, Twentieth Century Fox Film Corporation, USA, 1977

The Isle of the Dead, 1880 (oil on canvas), Arnold Bocklin © Kunstmuseum, Basel, Switzerland/Peter Willi/Bridgeman Images

Voltage, Dorothea Tanning, 1942

St Lucy, c. 1473–74 (tempera on panel), Francesco del Cossa © National Gallery of Art, Washington DC, USA/Bridgeman Images

Colonade © Mark Cousins

Two Heads, Giorgio de Chirico, 1918, Rome, Italy

Impressions d'Afrique, Salvador Dali, 1938, Museum Boijmans, Rotterdam, The Netherlands

Gojira (Godzilla), Ishirô Honda, Toho Film (Eiga) Co. Ltd., Japan, 1954

Shadow Country, 1927 (oil on canvas), Yves Tanguy © Detroit Institute of Arts, USA/Gift of Lydia Winston Malbin/Bridgeman Images

La Voix du Sang (Blood Will Tell), Rene Magritte, 1947–1948

Le Sang d'un poète (The Blood of a Poet), Jean Cocteau, Vicomte de Noailles, France, 1932

The Obelisk of Axum © Zaramira/Dreamstime.com

Empire State Building, New York City, USA © Venemama/Dreamstime.com

Force of Evil, Abraham Polonsky, Enterprise Productions, Roberts Pictures Inc., USA, 1948

Chrysler building, New York City © Pod666/Dreamstime.com

Manhattan, Woody Allen, Jack Rollins & Charles H. Joffe Productions, USA, 1978

Batman: Arkham Origins, Eric Holmes, Benoit Richer, WB Games Montréal, Warner Bros. Interactive Entertainment, USA-Canada, 2013

King Kong, Merian C. Cooper, Ernest B. Schoedsack, RKO Radio Pictures, USA, 1933

Hong Kong street scene © Iclicuclic/Dreamstime.com

Café du Dôme, Paris, 1928 (silver gelatin print), Andre Kertesz © The Israel Museum, Jerusalem, Israel/The Noel and Harriette Levine Collection/Bridgeman Images

CHAPTER 15

Lessons of Darkness, Werner Herzog, Canal+, Première, Werner Herzog Filmproduktion, France-UK-Germany, 1992

1920 Abadan Refinery, Iranian Historical Photographs Gallery

Persepolis © Mark Cousins

Engineers, fuel and oil © Christian Lagereek/Dreamstime.com

Etude pour 'Les constructeurs': L'équipe au repos (Study for 'The Constructors': The Team at Rest), Fernand Léger © ADAGP, Paris and DACS, National Galleries of Scotland

The Pompidou Cultural Centre in Paris, France © Jan Kranendonk/Dreamstime.com

World Naked Bike Ride, Brighton, 2014

Entartete Kunst (Degenerate Art), Munich 1937

The Cabinet of Dr. Caligari, Robert Wiene, Decla-Bioscop AG, Germany, 1920

Residents of West Berlin showing their children to their grandparents who reside on the Eastern side, 1961

Warsaw Ghetto monument © Ullstein bilderdienst, Berlin

Dem Deutschen Volke, Jörg Daniel Hissen, Wolfram Hissen, Arte, Estwest, Ex Nihilo, Zweites Deutsches Fernsehen (ZDF), France-Germany, 1996

Discovery of DNA, 1953 © James Watson, Francis Crick/Cavendish Physics Lab, University of Cambridge

DNA helix strand © Martine De Graaf/Dreamstime.com

Watching the royal wedding, Redhill informal shack settlement outside Cape Town, South Africa, 2011

Silsila, Yash Chopra, Yash Raj Films, India, 1981

Jaws, Steven Spielberg, Zanuck/Brown Productions, Universal Pictures, USA, 1975

Watson and the Shark, John Singleton Copley, 1788, Museum of Fine Arts, Boston, USA

Jurassic Park, Steven Spielberg, Universal Pictures, Amblin Entertainment, USA, 1993
Zapruder Film, Abraham Zapruder, Sixth Floor Museum, Texas School Book Depository, USA, 1963
9/11 South Tower © Gulnara Samoilova/AP Photo

CHAPTER 16
Security cameras © Suljo/Dreamstime.com
Red Road, Andrea Arnold, Advanced Party Scheme, BBC Films, Glasgow Film Office, Scottish Screen, Sigma Films, UK Film Council, Verve Pictures, Zentropa Entertainments, Zoma Films Ltd., UK-Denmark, 2006
Sub-aquatic optic cables © PriMetrica, Inc, 2006
Virtual Reality headset © Andreaobzerova/Dreamstime.com
Pokemon Go © Lee Chee Keong/Dreamstime.com

CHAPTER 17
Iceberg © Greenpeace International
The White Diamond, Werner Herzog, Marco Polo Film AG, NDR Naturfilm, NHK, BBC Storyville, Mitteldeutsche, Medienförderung (MDM), Germany-Japan-UK, 2004
Daft Punk Unchained, Hervé Martin-Delpierre, BBC Worldwide Productions, France-USA, 2016
Aerial reconnaissance photographs of Auschwitz showing Auschwitz II (Birkenau) taken by the U.S. Air Force, 1944–1945
The Change from Visible to Invisible: A Study of Optical Transitions, G.A. Kaplan, 1969
Self-Portrait, aged 51, Rembrandt van Rijn, c.1657, Bridgewater Collection Loan, 1945, Scottish National Gallery, Edinburgh, UK
Autumn Sonata, Ingmar Bergman, Personafilm, Filmédis, Incorporated Television Company, Suede Film, France-West Germany-Sweden-UK, 1978
Casablanca, Michael Curtiz, Warner Bros., USA, 1942
An Old Woman Cooking Eggs, Diego Velazquez, 1618, Purchased with the aid of the Art Fund and a Treasury Grant 1955, National Galleries of Scotland, Edinburgh, UK
Three Colours: Blue, Krzysztof Kieslowski, MK2 Productions, CED Productions, France 3 Cinéma, CAB Productions, Zespol Filmowy "Tor", Canal+ , Centre National de la Cinématographie, Fonds Eurimages du Conseil de l'Europe, France-Poland-Switzerland, 1993
Head of a Guillotined Man, Théodore Géricault, 1818/1819, Art Institute Chicago, Chicago, USA
Death mask of Napoleon Bonaparte (1769–1821), French School (19th century) © Musée de l'Armée, Paris, France/Bridgeman Images
Las Meninas, Diego Velázquez, 1656, Museo del Prado, Madrid
Under the Skin, Jonathan Glazer, FilmFour/Nick Wechsler Productions, UK, 2013

CONCLUSION
Reliquary Stature of Sainte-Foy (Saint Faith), Sainte-Foy, Conques
Trees x15 © Mark Cousins

INDEX

Abadan 347
Abbasid Empire 104
Abbottabad (Pakistan) 389
Abelard and Eloise 77
abolitionists 207
Aboriginals (Australia) 39, 69, 188–9
About Schmidt (film) 198
Abramović, Marina 41, 42, 50, 58, 364
abstract 81–91, 136
Abuladze, Tengiz 310, 363
Academy of Arts (Iran) 203
Achaemenid Empire 302
Actaeon 77–8, 79
acupuncture 144
advertising 338–40
Advertising Standards Agency (UK) 338
Aegimius (Greek poem) 256–7
affinity 38
Afghanistan 27, 119, 138
Africa 40, 79, 131, 206–8, 302, 324–5, 338, 403
African Americans 129, 235
African babies 14–15, 21, 26
aggression 57, 58
 violence 288, 292, 308, 312, 313
 war 118, 132–6, 138, 188
Agincourt 132
Agra Fort 121
agricultural revolution 50
Aisha bint Abi Bakr (wife of Muhammad) 159
Aix-en-Provence 268, 273, 396
Akbar, Emperor 122, 130, 181, 297–8, 302
Akhenaten, pharaoh (aka Amenhotep IV) 83–4, 85, 89, 301
Alaskan mother and child (photograph) 234
Albert, Prince 131
Alexandria 6
Algeria 34, 218, 262
Algonquin 188
al-Haram mosque 88
Alhazen (Moon crater) 140
Allen, Woody 336
Alps 189, 211, 221–3, 335, 405
al-Qaeda 389

Amenhotep IV, pharaoh 83–4, 85, 89, 301
America *see* North America; United States of America (USA)
American Civil War 238
American Indians 30, 233–4, 240
American Special Forces 389
An Essay Concerning Human Understanding (Locke) 395
And Life Goes On (film) 299
Andersson, Roy 245
Anguissola, Europa 60–1, 64, 340
Anguissola, Sofonisba 60, 64
ankh 61
Apollo 8 212, 387
Apollo 11 376
Arab–Byzantine wars 132
arches 95, 96
Archimedes 139
Ardèche (France) 111
Are You Experienced (album) 357
Argentina 236–7
Aristotle 105, 173, 226
Arkham video games 336
Armenia 361
Arnheim, Rudolf 83
Arnold, Andrea 373
Arora, Gabo 378
Art Journal 247
The Ascent (film) 279–80
Asia 28, 69, 98, 108, 121, 126, 338, 353
Assyria 96
Astana 109–10
atom bombs 353
atomic looking 289–300
Atsuta, Yûharu 66
Aufforderungscharakter (prompt character) 68
augmented reality (AR) 379–80
Auschwitz–Birkenau 384, 387
Australia 38, 39, 374
Australian carrying tray 69–70, 72
Austria 188, 237, 405
Austro-Hungarian Empire 63
autobahns 344–5
Autumn Sonata (film) 386–8

Avicenna (Ibn Sina) 155
'Axis of Evil' speech 203
Aztecs 128, 129, 142
azurite 28, 30, 31

Baartman, Sarah 228
babies 14–17, 21, 26, 30, 35, 38–9, 135
 birth 143–4
Babylon 101–3, 109, 111–12
Bacall, Lauren 75–6, 78, 79, 85
Bachchan, Amitabh 364–5
Bach, Johann Sebastian 188
Bachelard, Gaston 65
Bacon, Francis 45, 79, 137, 138, 147, 155
Baghdad 7, 104–6, 140
Baker, Josephine 341
Ballard, J.G. 349
Ballerini, Augusto 236
Baltic states 312
Baltic Way 311–12
Bangalter, Thomas 383–4
Barbara (French singer) 225
Barker, Clive 88
Barnum, P.T. 227
Baroque 162–5, 168, 172, 194, 198–9, 322, 399
Barthes, Roland 162, 242, 246, 280, 289, 394
Basque country 308–9
Basra (Iraq) 140
Batman #4 (comic book) 336, 340
Baudelaire, Charles 108, 261
Bauhaus 70–1
The Beatles 357
Beau Travail (film) 80, 393
Beethoven, Ludwig van 188
Beijing 341
Beitler, Lawrence 225
Belfast 183, 397, 405
Belgium 218, 239
Belorussia 134
Benjamin, Walter 261–2
Berger, John 25, 78, 268, 339
Bergman, Ingmar 15–16, 386
Bergman, Ingrid 293, 386–7
Berlin 183, 351, 354, 356, 397
Berlin Wall 354–6, 361
Bern (Switzerland) 289–90
Bernard, Émile 4, 271, 272
Bernays, Edward 199

Bernini, Gian Lorenzo 163–4, 165, 234
Beuys, Joseph 64
Bible 27, 91, 127, 147, 241, 302, 309
bichrome 28
Bierstadt, Albert 230, 232, 236
Big Bang 14
Big Flash 14, 300, 316
Bin Laden, Osama 389
Bindusara, Emperor 143
Bingham, Hiram 304
'A Bird came down the Walk' (Dickinson) 254–5
birth 143–4
Birth (film) 281
Biwa, Lake 20
Black Country 204
The Black Girl (film) 280–1
Black Sea 218
black square 88–9
Bleak House (Dickens) 258
bleeding hand sculpture 183, 186
blindness 8, 39, 388
The Blood of a Poet (film) 327–8
Blood Will Tell (Magritte) 327
blue 26–8, 30–3, 35, 165, 196, 312
Böcklin, Arnold 320, 403
bodies 74–80, 389–90
body language 51, 52, 174
Bogart, Humphrey 76, 339
Bohr, Niels 293
Bolívar, Simón 236
Bollywood 276, 365
Bonaparte, Napoleon 218, 220, 237, 264
Bonheur, Rosa 265
Book of Revelation 309
The Book of the Ten Treatises of the Eye (Hunayn) 105
Borneo 30
Boston News Weekly 188
Botticelli, Sandro 74
Bow Wow Wow (band) 78
Bowie, David 64, 225
Bradley, Jack 243
Brahmins 185
Brandenburg Concertos (Bach) 188
Brandt, Chancellor Willy 355
Brandt, Marianne 71, 72

Braque, Georges 318, 327, 341
Brasilia 107
Braveheart (film) 28
Brazil 107, 206, 397
Breton, André 321, 341
The Bridge at Courbevoie (Seurat) 296–7
Bristol 208
Britain 28, 118–19, 205, 208, 218, 238, 302, 307, 308
 see also United Kingdom (UK)
Britannia Receiving the Riches of the East (relief carving) 205
British Empire 205
British Museum 303
Brontë, Charlotte 247
Bronze Age 61
bronze-orange 35
Brookes (slave ship lithograph) 206–7
Brooklyn 208
Brown, Robert 293
Brussels 293
Bryson, Norman 291
Buchenwald concentration camp 352, 405
Bunker, Chang 227
Bunker, Eng 227
Buñuel, Luis 288
Burgess, Anthony 260
Burke, Edmund 220–1
Burks, Robert 33
Burton, Richard 223
Bush, President George W. 203, 370
Byron, Lord 223

'cabinet of curiosities' 327
The Cabinet of Dr Caligari (film) 350
Caesar, Julius 28, 118–19, 130, 192
Caesarean section 143–4
Café Dome (Paris) 341
Calais, refugee camp 397
California 6, 95, 233, 387
Calvin, John 160
Cambodia 184
Cambridge 358
Camera Lucida (Barthes) 246, 394
Cameron, Prime Minister David 2
Cameron, Julia Margaret 241–3, 246
Campanile 138, 145, 146

Campbell, Joseph 22
Canada 239, 374
Canaletto 188
Candyman (film) 88
Cao Xueqin 251
capitalism 50
car number plate recognition 372
Caracol observatory 139
Caravaggio, Michelangelo Merisi da 84, 163–4, 197, 234
Caribbean 127
Carnation Revolution 310
Carter, Howard 301–3
Carus, Carl Gustav 222–3, 226
Casablanca (Film) 387
Cassel, Lieutenant F.L. 134
Catherine the Great 192–4, 214
Catholic Church 146–7, 158–9, 161, 163, 175
Caucasus 28
Cauvin, Jehan (aka John Calvin) 160
Cavalcanti, Alberto 277
'Cavalry Crossing a Ford' (Whitman) 254
CBS (Columbia Broadcast System) 361
celebrity 362–6
Celtic brooch 69
censorship 372
Central America 130
Central Asia 119
Central Pacific Railroad 234, 239
Centre Pompidou (Paris) 348
CERN (European Organisation for Nuclear Research) 300
Cervantes, Miguel de 252
Cézanne, Marie-Hortense 271–2, 279, 340
Cézanne, Paul 4–7, 9, 251, 268–73, 285–6, 296, 317, 357, 390, 396, 401
CGI (computer-generated imagery) technology 370
Chacabuco 237
Chanel, Coco 341
The Change from Visible to Invisible: A Study of Optical Transitions (Kaplan) 384–5
Chaplin, Charlie 178, 179
Charlemagne 220
Charon (Pluto moon) 213

Chauvet caves 111
Cherbourg 34
Chernobyl (Ukraine) 110, 239, 300, 340, 405
Cherokee Nation 233
Chesterfield cigarettes 339
Chiang Kai-shek 341
Chicago 334
Chien Andalou, Un (film) 288, 324, 341
Childe Harold's Pilgrimage (Byron) 223
children, developing 25, 47–50, 50–1, 60, 63, 68, 385
Chile 184, 236–7
Chillida, Eduardo 309
Chimborazo (Ecuador) 151
Chimes at Midnight (film) 133–4, 340
China 27, 30, 68, 94–121 *passim*, 141, 143, 186, 191, 218, 238–9, 251, 312–15, 346
chlorophyll 26
chosiste 332
Christianity 52, 55, 69, 86, 102–24 *passim*, 146–7, 159–60, 188, 214, 238, 241, 302, 322
Christina, Queen 340
Christo and Jeanne-Claude 356
chromatic circle 31–2
chromium oxide green 268
chronophotography 244
Chrysler Building 336, 337
Chung Kuo: Cina (film) 144
CIA (Central Intelligence Agency) 373, 375
Cierplikowski, Antek 341
Cincinnati 188
Cinderella myth 339
'cine-eye' 278
cinema 2, 273–82, 364–5
The Cinematic Apparatus (Comolli) 245, 249
cinnabar 138
Civilisation and Its Discontents (Freud) 303
Clarke, Arthur C. 89
classicism 166, 194, 196, 271
Cleopatra 5–6, 9, 26, 27, 35, 192, 198, 340
A Clockwork Orange (Burgess) 260
A Clockwork Orange (film) 260
Clouds Over Sidra (film) 378–9

cluster judges 103
cobalt blue 27, 28
cobalt violet 268
Cocteau, Jean 327
Coen brothers 339
Cohen, Leonard 225
collective unconscious 403
Colosseum 103–4, 189, 226, 282
colour wheel 31–5, 49
coloured shadows 33
Columbus (Christoforo Colombo) 126–8, 235–6
Come and See (film) 134–5
Comédie-Française 172–5, 181
comedy, visual 172–80, 185, 188
Comité de surveillance 372
commedia dell'arte 172, 173–8, 181, 186
commerce 120
Communist Party of the Soviet Union 311
Comolli, Jean-Louis 245, 249, 250
concrete, types of 108
Confessions (Rousseau) 221
Confucius 238, 313, 315
Congolese *nkongi* 58
Congress (US) 232–3, 237
connections 38–9
conquests 118–31
conquistadors 128, 130–2, 136, 139, 145, 183, 344
Constable, John 269–70
Constantine, Emperor 124
Constantinople 126, 165, 239
construction 94–100
Cook, Captain 149
Copernicus, Nicolaus 55, 146, 213, 291
Copley, John Singleton 367
copper 138
Corday, Charlotte 197
Cordoba 95
Corot, Jean-Baptiste-Camille 83
Cortés, Hernando 128
Cosmic Tree 403
cosmopolitanism 350
Cossa, Francesco del 322
cotton (white gold) 206
Counter Reformation 162
Courbet, Gustave 62, 78–9, 243, 266, 267
Courtauld Institute (London) 268

Courtesan or Oiran (after Keisai Eisen) (Van Gogh) 266
Cranach the Elder, Lucas 160
Crick, Francis 358–9
Crimean War 133
crown jewels, British 131
Crusades 123–6, 130, 198, 340, 344
Crystal Palace (London) 246–7, 282
Cubism 201, 307, 318, 323, 334–5, 338, 351, 373
The Cyclist (Goncharova) 46, 244, 261

da Vinci, Leonardo 18, 28–33 *passim*, 49, 74, 81, 134, 142–3, 165, 285, 327, 395
Dadaists 321, 369
Daesh 161
'Daffodils' (Wordsworth) 223
Daft Punk 383
Daily Courant (newspaper) 188
Dakar 94
Dalí, Salvador 288, 324–5, 326, 327, 334
Dalton, John 293
dancing 281
Dandi (India) 307
danger 226
Dante 257
 Dante and Beatrice 77
Daoist 141
Darius 302
Dark Ages 105, 147
dark wine colour 35
D'Arlandes, Marquis 209
Darwin, Charles 151–3, 218, 397, 402
David, Jacques-Louis 197, 198–9
David and Goliath 74, 75
David (Michelangelo) 74–6, 78, 79, 85, 100, 158, 197
Davids, K. 283
Davison, Emily Wilding 306–7, 315
Day of Judgement 62
de Chirico, Giorgio 145, 323, 324, 326
de Homem-Christo, Guy-Manuel 383–4
de las Casas, Bartolomé 127
de Montserrat, Antoni 122
De Niro, Robert 57–8
de Piles, Roger 382
dead bodies 389–90

Paris morgue 219, 228–9, 366, 374, 390, 399
death 172, 246, 281–2
 memorials 180–6
Debord, Guy 262
Defoe, Daniel 189
degenerate art 351
Degenerate Art Commission (Germany) 351
Le Dejeuner sur l'herbe (Manet) 266
del Giocondo, Lisa 18, 21
Delacroix, Eugène 267
Delaunay, Sonia 357
Deleuze, Gilles 6–7
Democritus 293
Les Demoiselles d'Avignon (Picasso) 317–19, 351
Demy, Jacques 34
Deng Xiaoping, Premier 313
Denis, Claire 80, 393
Deposition or *The Entombment of Christ* (Caravaggio) 163–4, 197, 234
Dern, Laura 367
Descartes 6
design 68–72
desire 74–80
The Desperate Man (Courbet) 62
destruction 111–13
detection 44–5
developing child 25, 47–50, 50–1, 60, 63, 68, 385
Devi/The Goddess (film) 276–7, 297
devil 87
Diana, (goddess) 77–8
Diana and Actaeon (Titian) 77–8
Dias, Brian 402
Dickens, Charles 3, 257–8
Dickinson, Emily 254–5
Diderot, Denis 191–2, 195, 221, 365
Dietrich, Marlene 75, 193, 340
Diop, Mbissine Thérèse 281
The Disasters of War (Goya) 133
Discourses (Rousseau) 195
The Discovery of the Mind: The Greek Origins of European Thought (Snell) 27
distance 21, 26, 32, 43, 375
Divine Comedy (Dante) 257
The Divine Lady (film) 17
DNA (deoxyribonucleic acid) 358–9
Doctor Who (TV) 317

Dome café (Paris) 351
Domesday Book 206
Domino 208
Don Quixote (Cervantes) 251
Doncières 328
Donen, Stanley 281
Doordarshan 361
Double Indemnity (film) 17
double looking 379
Doyle, Christopher 33
Dracula (Stoker) 328
Dream Pool Essays (Shen Kuo) 142
Dream of the Red Chamber (Cao Xueqin) 251
Dreyer, Carl Theodor 53
Dubai 337
Dublin 56
Duccio 24, 340
Duck Soup (film) 179
Dudley (Worcester) 204, 220
Dudley Castle 204
Dumas, Charles 283
Dupin, Amantine-Lucile-Aurore 252
Dupont, E.A. 44
Dürer, Albrecht 62, 63, 64, 129, 226
Dutch East India Company 164
Dwight D. Eisenhower National System of Interstate and Defense Highways 345
Dyce, William 90
Dylan, Bob 225
dyslexia 122
Dzungarian Gate 119–20, 347

Eagleman, David 39
Early Summer (film) 66
Earth 146, 149, 212–13, 374, 377, 387
earthshine 50
East Africa 30
East India Company 205
EastEnders (TV) 360
Eastern Mongolia 119
The Ecological Approach to Visual Perception (Gibson) 385
The Ecstasy of St Teresa of Avila (Bernini) 163
Eddington, Arthur 290
Edison, Thomas 264
L'Education sentimentale (Flaubert) 252
Edwards, Amilia 302

Egypt 8, 26–30 *passim*, 61, 68, 83, 95–6, 208, 302, 304, 318, 347, 360, 363
Eiffel Tower 263, 333
8½ (film) 210
Einstein, Albert 224, 290–294, 300
Eisenhower, President Dwight D. 345
Eisenstein, Sergei 201–2
El Dorado 205
11 September 2001 113, 369–70
Eliot, George 39
Emami mosque (Esfahan) 106–7
Emancipation Proclamation 310
Emerson, Ralph Waldo 246, 253–4, 267, 272
Emory University School of Medicine (Georgia) 402
emotion 50–8
empathy 55–6
Empire State Building 333, 335, 336, 337
empiricism 155, 190
encyclopedias 191–2
Encyclopédie (Diderot) 191–2
'engineering consent' 199
England 28, 203–4, 208, 228, 239, 258, 274
English Channel 118
Enlightenment (le siècle des Lumières) 192, 194–5, 214, 218, 220–1, 223, 226, 228, 290, 365–6
'Enta Omri' (song) 364
Entartete Kunst (Degenerate Art show) 350
The Entombment of Christ or *Deposition* (Caravaggio) 163–4, 197, 234
The Entry of St Ignatius into Paradise (fresco) 163, 168
Entwirklichung 344
envoy eyes 121
The Erasers (Robbe-Grillet) 332
Ernst, Max 323
Eros 368
erotic looking 80, 81
Esfahan 106–7, 214
Ethiopia 333
Euphrates River 101
Europe 69, 94, 118, 131, 149, 161, 208, 220, 302, 346–7, 365

Evein, Bernard 34
evidence, looking as 138
evil 87, 335
 'Axis of Evil' speech 203
 evil eye 91
The Exorcist (film) 366, 368
*The Exploitation of the Works of
 Nature* (Yingxing) 191
Exposition Universelle (1867)
 377
Expressionism 319, 350, 357
Exsurge Domine (Vatican
 document) 160
eye contact 38–42, 58
eye movement desensitising
 and reprocessing (EMDR)
 studies 240
Eye of Ra 87
eyelines 38, 41, 98
eye-lock 39–40

face recognition technology
 372
Facebook 3
Falconetti, René Jeanne 53
The False Mirror (Magritte) 38
Farrell, Colin 130, 131
fashion 340–2
'Fat Man' (bomb) 325, 353
fear 40, 58
Federal Aid Highway Act
 (1956) 345
female gaze 80
Fenton, Roger 133
Ferdinand of Spain, King 127
Fernweh (distance pain) 375
Ferris wheel 210
Fête de Lumières (Lyons) 84
fight or flight 76, 207
films 2, 273–82, 364–5
Fingal's cave 225, 226
Finlay, Ian Hamilton 23, 35
'The First Time Ever I Saw
 Your Face' (song) 226
First World War 321, 340, 372
Five Eyes intelligence-gather-
 ing alliance 373–4
Flack, Roberta 226
Flag Act (1818) 237
The Flagellation of Christ
 (Francesca) 291–2
flags, sculptures of lowered
 182–3
Flaubert, Gustave 251
Flavian Amphitheatre (Rome)
 103
Fleming, Alexander 341

fleur-de-lys 195
flight 209–14
Florence 74, 78, 79
flying buttresses 96
focus 14–21
foot binding 238
'The Forbidden' (Barker) 88
Forbidden City (Beijing) 98
Force of Evil (film) 335
Ford, John 232
Fordist system 205
Forster, E.M. 37, 50
42nd Street (musical) 296
Forum 189
France 34, 78, 84, 160, 168,
 174–5, 188–99 *passim*, 208,
 218–39 *passim*, 251, 261,
 304, 341, 347, 372
Francesca, Piero della 292
Franco, General Francisco 308,
 309
*Frankenstein: or, The Modern
 Prometheus* (Shelley) 223–4
Frankfurt 31
Franklin, Rosalind 358–9
French Revolution 161, 169,
 180, 192, 194–8, 201, 203,
 224, 226, 306
'frenzy of the visible' 250
Freud, Sigmund 63, 302–3,
 319–21, 326–7, 335, 348,
 351, 403
Freud and Philosophy (Ricoeur)
 303
Friedrich, Caspar David 21,
 66, 340
Frost, Robert 41, 354
Futurists 46, 89, 100, 244, 260,
 273, 383

Galen 142
Galileo Galilei 138, 145–8, 300
Gallery of Mirrors (Versailles)
 168–9, 297, 342
Gallese, Vittorio 55
Gandhi, Mahatma 307, 310,
 340
gas lamps 263–4
Gaul 30, 118
Geneva 160, 195
Gentileschi, Artemisia 54–5,
 56
Georgia 233
Géricault, Théodore 219, 220,
 390
Germany 39, 43, 189, 200,
 237, 239, 344–5, 352–7

Nazi regime 39, 79, 134,
 182–3, 200, 312, 350–2,
 354–6, 384
Ghengis Khan 122
ghost images 16, 20–1
Giacometti, Alberto 268, 270
'giant rhubarb' (gunnera) 94–5
Gibson, James 385
Gibson, Mel 28
Giotto 52
Gladiator (film) 103
Glasgow 208
Glass, Philip 225
glass 97
Glass House (Connecticut)
 97–8
Glazer, Jonathan 281
Glennon, Bert 193
global satellite location systems
 372
Gobi Desert 119
Godard, Agnès 80
Goethe, Johann Wolfgang von
 31–5, 49, 151, 189, 225,
 352
'Goethe' tree (Buchenwald)
 405
gold 128–31, 139, 163, 233,
 236, 345, 397
 white (cotton) 206
Goldfinger (Fleming) 339
Gombrich, E.H. 39, 43, 269
Goncharova, Natalia 46, 244,
 261
Google 375
Google Earth 375, 377
Gooley, Tristan 204
gopuram (decorated tower) 99
Gorbachev, President Mikhail
 311, 315
Gordon (slave) 207
Gota Canal 263
Gould, Freddy 241
Goya, Fransisco 133
grand tours 188–91, 192, 223
Grant, Cary 173
Gray, Gilda 44
Great Exhibition (London
 1851) 247, 263, 282
Great Expectations (Dickens) 3,
 258
Great Wall of China 313
Greece 27, 87, 95, 139, 172,
 202, 211, 282, 302, 315,
 397
 Greek myths 255–6
green 32, 35, 138

Greenpeace diptych 382
grief 172, 185, 186, 276, 389
Griffith, Corinne 17, 18
Griffith, D.W. 102
Grimm, Jacob 87
Grimm, Wilhelm 87
Gris, Juan 272–3
Groll, Theodor 263
Grünewald, Matthias 158–9, 161
The Guermantes Way (Proust)
 328–9
Guernica 7, 308, 310
Guernica (Picasso) 308–9, 392
guillotine 197
Gulf War 136, 199
gunnera (giant rhubarb) 94–5
Gutenberg press 160

haft rangi tiles 106
Hagenbeck, Carl 227
Han Chinese 238
Handel, George Frideric 188
Happy Company (Passerotti)
 172–3
Hardouin-Mansart, Jules 168
Hargreaves, James 204
Hart, Alfred 234
Harun al-Rashid, Caliph
 104–5
Hawks, Howard 76
Head of a Guillotined Man
 (Géricault) 390
Hebrew language 27
Die Hebriden (Mendelssohn)
 225
Helena (mother of
 Constantine) 124
The Helmet (Moore) 320
Hemingway, Ernest 342
Hendrix, Jimi 357
henna 104
Henry Ford clinic 63
Hermitage 194
Hero (film) 32–3
'Heroes' (song) 225
Herschel, William 286
Hertzog, Albert 361
Herzog, Werner 346, 383
heshang (film) 312–13, 315
Hewlett–Packard 120
The Hidden Persuaders (Packard)
 199
Hillier, Mary 241, 246
Hindi cinema 276–7, 364–5
Hinduism 27, 88, 185, 229,
 278

Hiroshima 294, 325, 353, 391
Hitchcock, Alfred 33, 102,
 213–14, 276, 340
Hitler, Adolf 79, 178, 179,
 200, 320, 352, 356, 403
Hobbes, Thomas 174
Hockney, David 242
Hogarth, William 188
Holland 160, 225
Holiday, Billie 225
Hollywood 366–7, 370, 387
Holmes, Sherlock 44
Holocaust 274
Holy Land 123, 130
home 64–7
Home Insurance Building
 (Chicago) 334
Homer 27, 28, 31, 35
Homestead Act (1862) 232
Homs 53
Hon'ami Kōetsu 274
Hong Kong 238, 338–9
Hong Xiuquan 238
Hôpital Beaujon morgue 390
Hopkins, Gerard Manley
 252–3
horror 218–19
The Horse Fair (Bonheur) 265
Hossein (tea boy) 299
hot air balloons 209
Houssaye, Arsène 261
Howards End (Forster) 37
Humboldt von, Alexander
 151
Hume, David 190–1, 192, 195,
 202, 224, 357, 365
humility 55
Hunayn ibn Ishaq 105, 112,
 140
Hundred Years War 132
Hupa, North Carolinian 90–1
Hussein, President Saddam
 199, 389
Hven island 148
Hybridity branches 153
hypnotic looking 344

'I Have a Dream' speech 310
Ibn al-Haytham 140, 141, 270
Ibn Sina (Avicenna) 155
Ibsen, Henrik 255
Icarus 210
iconoclasm 161
Ignatius of Loyola 162, 164
illuminated manuscripts 70
illumination, types of 263–4
Il-sung, Kim 245

imagery 159–61, 162, 164,
 194, 199, 205, 207, 220,
 310
impersonation 179
Impression: Sunrise (Monet) 268
Impressionism 188, 261,
 265–73
impressions 190, 192, 202, 206
Impressions d'Afrique (Dalí) 324,
 325
'in order to convince' 201, 202
Inca city 304
Inception (film) 323
India 28, 61, 87, 121–2, 127,
 130, 186, 188, 226, 239,
 276, 302, 307–8, 361,
 364–5
Indian Ocean 121
Indian Removal Act (1830)
 233
indigo 28
Indo–Gangetic plain 122
Industrial Revolution 152,
 153, 203–5, 220, 226, 312,
 346
industrialisation 50, 71
Institute of Landscape
 Architects (UK) 345
Intolerance (film) 102
Io 148–9
Iran 30–2, 68–70, 72, 77, 87,
 203, 302, 347
 see also Persia
Iraq 105, 140, 199
Ireland 56, 229
Iron Age sculpture 82–3
Isabella of Spain, Queen 127
Isenheim Altarpiece (Grünewald)
 158
Ishtar 101, 108
Ishtar Gate (Babylon) 101, 108,
 118, 198, 377
Islam 86, 88, 95, 107, 123,
 159, 161, 167, 298, 370
Islamic African states 206
Isle of the Dead (Böcklin) 320
Israel 347
Istanbul 166
Italy 18, 31, 70, 74, 166, 186,
 189, 237, 239
 Renaissance 18, 75, 80, 189
Ivan's Childhood (film) 40, 41,
 42
iwan (pointed-arch entrance)
 106
Iznik tiles 167

Jackson, Janet 361
Jacobins 161
Jacob's Room (Woolf) 371
Jahan, Shah 130
Jamaica 207
James, Henry 258, 329–30
Japan 27, 112, 132, 159, 189,
 266–7, 274, 325, 354
Jarmusch, Jim 339
Java, volcanic eruption 112
Jaws (film) 366–8
Jean Charles (African crew)
 219
Jeanne d'Arc 53
Jeanne-Claude, Christo and
 356
Jerusalem 123–4, 126, 130
Jesuits 122, 162, 188, 191–2,
 252
Jesuits: A Multibiography
 (Lacouture) 162
Jesus Christ 25, 52, 62, 85, 90,
 122–5, 158, 163–4, 197,
 292
Jewish culture 27, 103, 147,
 350–2, 356
Jin Ping Mei (The Golden Lotus)
 (anon) 251
Johansson, Scarlett 393
John Paul II, Pope 149
Johnson, Philip 97–8
Jones, Chuck 178
Journal of Motor Behaviour
 (Davids) 283
Julie, or the New Heloise
 (Rousseau) 13
Jung, Carl Gustav 317, 403
Jupiter 149
 moons of 146, 148
Jurassic Park (film) 367–8

Ka'bah (Mecca) 88–9
Kabbalah 30
Kahlo, Frida (Carmen Rivera)
 63–4, 128, 340, 362
Kaieteur Falls (Guyana) 383
Kailasa temple (Ellora) 98–100,
 167
Kaiser, H.G. 234
Kalf, Willem 65
Kalthoum, Oum 363–4
Kanagawa, treaty of (1854) 266
Kandinsky, Wassily 316, 317,
 318, 342, 357
Kaplan, G.A. 384
Karl-Marx-Allee (Berlin) 397
Kazakhstan 109

Keisai Eisen 266–7
Kelly, Gene 281
Kennedy, President John F. 368
Kepler, Johannes 147
Kertész, André 341, 342
Khmer Rouge 184
Khomyakov, Mikhail
 Stepanovich 71–2
Kiarostami, Abbas 298–9
Kidman, Nicole 281
Kieślowski, Krzysztof 389
King, Martin Luther 308
King Jr, Martin Luther 310
King Kong (film) 337
Klein, Yves 26–7, 35, 38,
 81–2, 84, 107, 336, 382
Klimov, Elem 135
Klingemann, Karl 225
Kodak Brownie cameras 288
Koestler, Arthur 147, 149
Koffka, Kurt 68
Koh–i–Noor diamond 130–1,
 247
Koker (Iran) 298
Kolkata 61
Kopernik, Mikolaj (Nicolaus
 Copernicus) 55, 146, 213,
 291
Koran 106–7
Kosho 159–60
Krakatoa eruption 112, 113
Kristallnacht (Crystal Night)
 352
Kublai Khan 130
Kubrick, Stanley 89, 260, 274
Kurosawa, Akira 132
Kuwait 199
Kuya 159

La Malinche 129
La Spezia (Italy) 82–3
La Tourette priory 67, 68,
 84–5
labour, cheap 94
Lacouture, Jean 162
Lamarck, Jean-Baptiste 402
Lancelot and Guinevere 77
landowners 50
Landscape with the Nymph Egeria
 (Lorrain) 269–70
'landscape of speed' 345
Lang, Fritz 109
Lanzmann, Claude 274
Laocoön sculpture 189
lapis lazuli 27, 28
Las Vegas 110
Lascaux caves 27, 304, 306

The Last of the Mohicans (LP) 78
Last Supper (Duccio) 24, 340
Latin American Memorial 183, 186
laughter 172–3
Laurel and Hardy 173
Layla and Majnun 77
Le Corbusier 67, 68, 84, 88, 341
Le Havre 268
Le Nôtre, André 169
'le sauce' 265, 267, 270
Le Vasseur, Thérèse 195
Leaves of Grass (Whitman) 254
Lebanon 223
Léger, Fernand 348
Lemmon, Jack 179–80, 340
Lenin, Vladimir 8, 342, 362–3
lenses 165
Leone, Sergio 240
Leoni, Ottavio Mario 54, 56
Lessons of Darkness (film) 346
'Let Me Die in My Footsteps' (song) 225
'Let's Do It' (song) 341
Letter on the Blind (Diderot) 191
Lewis-Jones, Huw 191
light, speed of 149, 290
light bulbs 264
Lin, Maya 183
Lincoln Memorial 310
lingam (phallus of Shiva) 100
Lippershey, Hans 138
Lisbon 112
literature 250–60
'Little Boy' (bomb) 325, 353
Little Snow-White (Grimm) 87
Liverpool 206, 208
The Living Eye (Starobinski) 7, 381
Locke, John 395
London 28, 188, 204, 205, 235, 306, 330
Lone Star (film) 292
'the look' 75
look of love image 17–18
'look where I am' impulse 3
Lorrain, Claude 269–71
Los Angeles 94, 95
Louis IX of France, King 125
Louis XIV of France, King (Sun King) 168, 175, 196, 209
Louis XVI of France, King 196
Louisiana 207, 230
Louvre 169
love 17–18, 39, 62, 281

Lovell, Tom 123
LSD (lysergic acid diethyla-mide) 357, 399
Ludwig, Anna Bertha 285–6
Luhrmann, Baz 76–7
lumen and *lux* 84–5, 164
lust 80
Luther, Martin 155, 159, 160, 176, 199, 398
Lyons 84

Macbeth (Shakespeare) 132–3
Machu Picchu 304
McCracken, Grant 365
Macedonia 315, 397
McGurk, Paddy 183–4, 186
Magellan, Ferdinand 211
Magritte, René 38, 223, 245, 327
Mahabharata (poem) 276
Maidan movement (Ukraine) 400
Maintenon, Madame de 169
Malay Archipelago 152
male gaze 78
Malevich, Kazimir 89
Malick, Terrence 130
Maltin, Tim 326
Man with a Movie Camera (film) 278
Manchester 204
Manchu Chinese 238
Mandela, President Nelson 2, 228
Manet, Édouard 65, 78, 79, 266
Manhattan 113, 335
Manhattan (film) 336
Manila 94
Mantegna 25
manufacturing techniques 71
Mao Zedong, Chairman 8, 186, 313, 314
Marat, Jean-Paul 197–9
March on Washington for Freedom and Jobs 310
Marco Polo 130
Marduk, temple of 102
Marey, Étienne-Jules 244, 261, 273–4
'Marianne' 195, 201, 219
Marina Abramovic: The Artist Is Present (film) 41
Marion (Indiana) 225
Marivaux, Pierre de 176
Mark Antony 6
Marker, Chris 347

Marnie (film) 276
Martin (son of Cortés) 129
Marx, Groucho 179, 340
Marx, Harpo 179
Marx, Karl 247
masquerade 179
Matterhorn 223
Max, Arthur 103
Mayans 52, 139
mazes 176–7
Mecca 88
Mediterranean 28, 55, 118
Medusa (ship) 218–19
Meeropol, Abel 225
'the meeting eyes of love' 39
Meischer, Friedrich 358
Meissonier, Jean-Louis-Ernest 267
melanin 26
Melville, Herman 257
memorials 180–6
Mendeleev, Dmitri 153–4
Mendelssohn, Fanny 225
Mendelssohn, Felix 224–5, 226
Las Meninas (Velázquez) 325, 392
Mercator, Gerardus 131
mercury 138
Merian, Maria Sibylla 191
Merleau-Ponty, Maurice 7
Meso–America 129–30
Metropolis (film) 109
Metropolitan Museum of Art (New York) 303
Mexican sculpture 39–42, 47, 52, 234, 377
Mexico 63–4, 128, 198, 341
Mexico City 94
Mezquita (Córdoba) 95–6, 167
Michelangelo 60, 74, 76, 100, 158, 166
Mickey Mouse (cartoon) 341
microcosm 289–300
Mictlantecuhtli (god of the dead) 129
Middle Ages 24, 28, 69, 84, 118, 122, 142
Middle East 27, 87, 161, 223, 370
Milan 26
Milk, Chris 378
miniaturism 133, 255, 297–8, 300
minimalism, visual 169
Ministry of Naval Affairs (Paris) 326

mirage 325
Mirror (film) 64
mirror images 61, 62, 87–8, 385
Mississippi 230
Mississippi River 229, 231, 233
Miyagawa, Kazuo 20
Mizoguchi, Kenji 19, 51, 52, 165, 220
Möbius-strip thinking 351
Moby-Dick (Melville) 257
Moctezuma 128
modernisms 316–33
Molière 174–6, 179, 186
Mona Lisa (da Vinci) 18, 28, 75, 327, 340
monasteries 67
Monbiot, George 365
Monet, Claude 268
Mongols 112
Mongol–Turks 122
Montefalco, Sister Clare of 142
Montgolfier, Joseph-Michel 209–11
Moon 50, 55, 138, 205, 212–13, 387
 craters 140, 155
 landing 376–7
Moore, Henry 83, 320
Morguer (stare disdainfully) 366
Morocco 30
Moscow 94, 201, 218, 362
Moses 159, 160
Motherland (sculpture) 182
motorways 344–9
movement 42–7
movies 2, 273–82, 364–5
Mozart, Wolfgang Amadeus 188
Mughal Empire 122, 133, 181, 185, 188
 art 297–8, 300
Muhammad, Prophet 88, 159–60
Mukhina, Vera 201
Mumbai 94, 397
Mumtaz Mahal 181, 186
Munch, Edvard 112, 130, 318
Munich 350
Museum of Mankind (Paris) 228
Museum of Modern Art (New York) 41
music 224–6
The Music Room (film) 297
Muslims 125, 161, 370

Muybridge, Eadweard 225, 244

Nabokov, Vladimir 252
Nagasaki 294, 325, 353
Nana (Zola) 250–1
Nanking 238
'Nantes' (song) 225
Naples 178
Napoleon Bonaparte 218, 220, 237, 264, 302, 390–1
Napoleon III 262
Narcissus 255–7
NASA (National Aeronautics and Space Administration) 148
Nasser, President Gamal Abdel 360
Nataraja sculpture 300
National Academy of Design 235
National Health Service (NHS) 388
Nationalism 235–9
Native Americans 30, 233–4, 240
'Natural History of Massachusetts' (Thoreau) 253
naturalism 251–5, 257, 273
Nausea (Sartre) 332
nazars 87
Nazi regime 39, 79, 134, 182–3, 200, 312, 350–2, 354–6, 384
NBC (National Broadcasting Company) 361
Nefertiti 83
neon lighting 264
Nero, Emperor 111
Netherlands 164–5
New Jersey 264, 346
New World 205, 206
The New World (film) 130
New York 41, 50, 113, 303, 307, 333–4, 336–8, 364, 372
New York Times (newspaper) 307
New Zealand 374
Newton, Isaac 149–51, 192, 290, 293
Niagara Falls 247
Nice 26
Nicholson, Jack 198
Nicodemus 164
Niemeyer, Oscar 183, 186
Nieuwerkerke, Émilien de 266

Nike 72
Nikko (Japan) 181
Nile, River 223
9/11 113, 369–70
nkongi 58
Nobel prize 359
nomadic people 50
North Africa 87
North America 94, 131, 188, 206, 229–35, 253–4, 285, 295, 372
see also United States of America (USA)
North by Northwest (film) 213–14
North Carolina 90
North Korea 245
North Sea 35
Northern Ireland 183
Notre Dame (Paris) 96, 98, 106, 111, 124, 220
Novak, Kim 340
Nubians 227
nuns, Italian 142
Nuremberg 399
Nykvist, Sven 16

Obama, President Barack 2–3, 389
Obama, Michelle 2–3
observation 139, 141, 146
The Odyssey (Homer) 28, 31
oil 346–9
Olympic Games 7, 282
Once Upon a Time in the West (film) 240
One Thousand and One Nights 105
'only connect' 50
Opium Wars 238
l'optique (inner eye) 4–5, 142, 191, 268, 324, 396, 401
orange 32
On the Origin of Species (Darwin) 152, 218, 402
The Origin of War (Orlan) 79
The Origin of the World (Courbet) 79
Orlan 80
Orpheus and Eurydice 256
Orthodox Church 193
Osaka Elegy (film) 51–2
Oslo 112
Össur 72
Othello (Shakespeare) 58
Ottoman Empire 161, 165–8, 172, 181, 188, 218, 237

Our Father's House (Chillida) 309
Oxbridge colleges 208
Oxford University 306
Ozu, Yasujiro 43, 66–7, 86, 382

Packard, Vance 199
Paestum temples 95
Pakistan 365
Palacio Nacional (Mexico City) 129
Pale Flower (film) 107–8
Palestine 123
Palmyra 161
Panini, Giovanni 189
Panoptes, Argus 256–7
Pantheon (Rome) 84, 108, 189
Paolozzi, Eduardo 129
Paradiso (Dante) 257
Les Parapluies de Cherbourg (film) 34
Paris 51, 148, 174, 196, 209, 212, 239, 265, 277, 317, 333, 340, 348, 377, 396
morgue 219, 228–9, 366, 374, 390, 399
Paris Salon 235
Paris World Fair (1937) 201
Paris Street: Rainy Day (Caillebotte) 261
Parkour (urban activity) 337
Parthenon 95
Das Passengen-Werk (Benjamin) 261
Passerotti, Bartolomeo 172
Pearl Harbour 353
Pearson, Adam 393
'pencil of nature' 242
Pennsylvania 207
people-watching 61, 67
People's Liberation Army 313
Percy, Henry 134
Pergamon Museum (Berlin) 101
Perigueux 288
Perrin, Jean Baptiste 294
Persepolis 203, 347
Persia, Shah of 130
Persia 24, 30, 88, 138, 181, 188, 202, 346–7
Persian Gulf 346
Persona (film) 15
Pestalozzi, Johann Heinrich 224
Petrie, Flinders 302
'phantom ride' 274

Philip IV of Spain, King 392
Philosophical Dictionary (Voltaire) 5
A Philosophical Enquiry into the Origin of Our Ideas of the Sublime and Beautiful (Burke) 220
Philosophie Zoologique (Lamarck) 402
Phnom Penh 184
photography 2, 241–7
On Photography (Sontag) 329
Photoshopping 199
Picasso, Pablo 7, 51–2, 165, 233, 297, 308, 317–18, 326–7, 340, 342, 392
Piccadilly (London) 228
Pictish design 69, 70, 72
Pilâtre de Rozier, Jean-François 209
pilgrimage 123
The Pillars of Society (Ibsen) 255
pince-nez 70
Pinochet, Augusto 184
Pissarro, Camille 272
Planck, Max 293
Planet of the Apes (film) 302
Plato 105
Playtime (film) 176–7
plein air 273
Pliny 121
Pliny the Elder 121
Plomin, Robert 402
Pluto 213
pneuma (circulatory air) 105
The Poetics of Space (Bachelard) 65
Pokémon Go 379–80
Poland 44
Pollock, Jackson 107
Pompeii 44, 110, 189
porcelain, Chinese 104, 112
Porter, Cole 341
Portrait of a Lady (James) 258–60
Portugal 226, 310
post-Impressionism 307
Pozzo, Andrea 162–3
Prasar Bharati 361
The Prelude (Wordsworth) 223
Presley, Elvis 363
Principles of Gestalt Psychology (Koffka) 68
The Principles of Painting (de Piles) 382
Pripyat 110–11, 222
Processional Way (Babylon) 101

projections 131, 212, 273, 319, 324, 331, 353, 357, 388–90
propaganda 198–203, 338, 353, 398–9
Propaganda (Bernays) 199
protest 237, 306–16, 319
Protestantism 159, 161–4, 168–9, 173, 306, 328
Proust, Marcel 328–9, 330, 344
Psychiatric problems 319
punishment 260
purple 28, 32

Qing dynasty 238
Quakers 207
qualitative judgements 190
quantum physics 293–4
Quebec 188

Rabier, Jean 34
The Raft of the Medusa (Géricault) 218–19, 308, 367, 390
railroads 239–41
rainbows 33
Raphael 7
'the rapture of self-loss' 22
Ray, Satyajit 277, 297–8
Rayleigh scattering 26
reading 250
 glasses 70
Reagan, Ronald 339
realistic light 84
red 43, 196, 310
 red block 88
Red River (film) 231–2
Red Road (film) 373
refineries (oil) 348–9
Reformation 149, 159, 163, 306, 328
 Counter 162
refugee camps 397
Regent's Park (London) 226
Reichstag, wrapping of 356–7, 399
Reinertsen, Sarah 72
Reiter, Janusz 356
Reliquary of St Faith 396–7
Rembrandt van Rijn 62, 385–6, 387
Renaissance 24, 81, 302, 323, 327
 Italian 18, 75, 80, 189
Repentance (film) 310–11, 312, 363
Rerberg, Georgi 65

Reservoir Dogs (film) 339
resistance 235–9
Ressler, Kerry 402
The Return after Three Days (Cameron) 241, 242
The Revolution of the Heavenly Orbs (Kopernik) 55
rhubarb 94–5
Richter, Gerhard 20
Ricoeur, Paul 303
Riefenstahl, Leni 79, 200–1
Riley, Bridget 297
Rio Negro 152
rituals 168
Rivera, Carmen (Frida Kahlo) 63–4, 128, 340, 362
Rivera, Diego 128–9, 198
Rizzolatti, Giacomo 55
Robbe-Grillet, Alain 332
Robot (dog) 304
rock formations, geometric 94
Rocky Mountains 230
Rococo 194
Rodia, Simon 95
Rodionov, Aleksei 135
Roman Empire 6, 28, 65, 95, 103, 108, 118–19, 122, 189, 397
Les Romanciers naturalistes (Zola) 251
Romanticism 220–6, 228, 229, 253, 267, 335
Rome 103–4, 111, 159, 173, 189, 302
Rømer, Ole Christensen 148–9
Röntgen, Wilhelm Conrad 285–6
rosettes (cockades) 196
rosewater 104
Rostam 143
Rousseau, Jean-Jacques 13, 112, 194, 195, 197, 221–2, 365
Route Tournante (Cézanne) 268–73, 296, 317, 401
Rudaba, Princess 143
Rural Modernity, Everyday Life and Visual Culture (Shirley) 349
Russia 85–6, 90, 188, 192–3, 334, 342
 Russian Revolution 202
Russian Ark (film) 194
Rüstem Pasha mosque 167
Rutherford, Ernest 293

Sacramento (California) 233–4, 240
The Sacred Fount (James) 329–30
sacred light 84–5
saffron yellow 298
Sagolj, Damir 245
St Augustine 138, 142, 159, 398
St Beatus of Liébana 112, 309
Saint-Lazare hospital-prison (Paris) 51
St Lucy of Syracuse 322
St Martin's Cathedral (Utrecht) 160
St Ninian's brooch 68
St Paul 211
Saint-Paul asylum (Saint-Rémy) 294, 296
St Petersburg 192, 194
Saint-Rémy (France) 294–5
St Teresa 164, 234, 340
Sainte-Foy church (Conques) 396
Sainte–Chapelle (Paris) 125, 131
Salon des Refusés 266
Salt March 307–8
San Martín, José de 236–7
Sand, George (aka Amantine-Lucile-Aurore Dupin) 252
sans-culottes 195, 197
Santoro, Rodrigo 202–3
São Paolo 183
Sarajevo 397
Sartre, Jean-Paul 332–3
Saving Private Ryan (film) 361
Sayles, John 292
Scandinavia 189, 255
Schiele, Egon 62–3, 64
The School of Athens (Raphael) 7
Schwitters, Kurt 303–4
scientific looking 138, 141, 188
Scotland 22–3, 69, 90, 96–7, 223, 224–5, 346
Scott, Ridley 103
Scott, Walter 223
The Scream (Munch) 112, 130, 318
Scrovegni Chapel (Padua) 52, 158
In Search of Lost Time (Proust) 328, 329
The Searchers (film) 232

Seascape with a Sailing Boat and a Ship (Turner) 18–19
Second World War 34, 39, 44, 280, 344–5, 350–7, 372
Seeing is Believing: The Politics of the Visual (Stoneman) 199
segregation 208
Seitz, John F. 17
self-portraits 61–3
Self-Portrait (Rembrandt) 385–6, 387
selfie photographs 2, 3
Sembène, Ousmane 280
Senegal 219
Les Sept Viellards (Baudelaire) 261
Seurat, Georges-Pierre 296–7
Seven Years War 194
sexuality 63
 sexualised looking 80
sfumato 18, 49, 61, 205, 241, 349
Sgt Pepper's Lonely Hearts Club Band (album) 357
Shaanxi province (China) 304
Shadow Country (Tanguy) 326
In the Shadow of the Glen (Synge) 119
shadows 34, 102, 272
Shakeshaft, Nicholas 402
Shakespeare, William 58, 132–3, 172, 185
shaman 90–1, 363
Shell Guide books (UK) 346
Shelley, Mary 223
Shen Kuo 141–5
Shepitko, Larisa 279–80
Shevardnadze, Eduard 311
Shi Huangdi, (Emperor) 304
shikara (rising tower) 99
Shinoda, Masahiro 108
Shipp, Thomas 225
Shirley, Rosemary 349
Shiva, Lord 88, 98, 100, 300
Shrewsbury, Battle of (1403) 133, 136
Sibelius, Jean 225
Siberia 153
Sicily, King of 139
silk 120–1, 126, 163, 165
Silk Route (Road) 28, 94, 104, 120, 126, 136, 340
Silsila (film) 364
silver 35
The Simpsons (TV) 198
Sinan, Mimar 166–7, 181
Singin' in the Rain (film) 281

Sino-Japanese war 132
Sino-Soviet summit 315
Situationists 262
Six-Day War 360
Skye, Isle of 405
Skype 376–7
skyscrapers 333–7
'slapstick' comedy 173
slavery 206–8, 219, 235
sliced eyeball 304, 324
Small Pleasures (Kandinsky) 316
smartphones 3
Smith, Abram 225
Smith, Captain John 205
Smith, George Albert 274
Snell, Bruno 27
Snow White and the Seven Dwarfs (film) 87
Snowden, Edward 373
The Social Contract (Rousseau) 195
social structures 61
socialism 350
Socrates 6
softness, visual 17
solitude 220, 221
Some Like It Hot (film) 179–80, 340
Somerset vs Stewart 207–8
Somme, Battle of the (1916) 134
Songs from the Second Floor (film) 245
Sontag, Susan 7, 246, 329
South Africa 228, 361
South America 131, 132, 236–7
Southern Deccan Plateau 122, 130
Soviet Union 71, 183, 201–2, 278, 310–12, 341, 362
space 21–5
Space Odyssey novels (Clarke) 89
Spain 111, 127, 236, 308
Spanish Civil War 308, 309
Spartans 202
spectacle 168
speech deprivation experiments 122
Speke, John Hanning 223
Sphinx (Giza) 275, 276, 363, 364
spices 102, 126, 164
Spielberg, Steven 361, 366, 367
spirits, bad 98

split eyeball 2, 300, 340, 365, 368, 372, 374, 398
sport 282–6
Sputnik 1 71–2
Staffa 224
Stalin, Joseph 310–11
Stanhope, Lady Hester 223
Star Wars (film) 78, 278–9, 290, 347
Starobinski, Jean 7, 381, 391
The Starry Messenger (Galileo) 146
The Starry Night (Van Gogh) 32
Statue of Liberty 195, 201, 302–3
statue storm 160
steel 97
Stein, Gertrude 297
Sternberg von Josef 193
Stettin (Prussia) 192
Stockholm 4
Stoddard, Seneca Ray 242–3
Stoker, Bram 328
Stoneman, Rod 199
'Strange Fruit' (song) 225
'Street Haunting' (Woolf) 249, 330, 332
Strike (film) 201–2
The Structure of the Psyche (Jung) 403
Study of a Negro Man (Tanner) 235
Stukeley, William 150
A Subtlety (Walker) 208
Sudan 227
'sudden glory' 174
Suez Canal 263, 302, 347
suffragettes 306–7, 349, 372
Sufism 107
sugar sculpture 208
Suleiman the Magnificent 166, 168
Süleymaniye mosque 167
Sullivan, Louis 334, 370
Sun 50, 55, 83–4, 149, 290
Sung Ti 81
Sunset Boulevard (Film) 17
La Surprise de l'amour (Marivaux) 176
Surrealism 145, 245, 321–8, 357, 361, 365, 369
Surrealist Manifesto (Breton) 321
surrogacy 364
surveillance 372–7
Susanna and the Elders (Leoni) 54
'Suzanne' (song) 225

Sweden 188, 263, 387
Switzerland 224, 289–90, 321, 357
Synge, J.M. 119
Syrian mask 53

Tacoma Building (Chicago) 334
Tagore, Sharmila 365
Tahiti 149
Taíno Indians 127–8
Taiping Rebellion 218, 238–9, 340
Taj Mahal 121–2, 130, 172, 181, 185–6
Talbot, William Henry Fox 242
Taliban 398
'The Tall Office Building Artistically Considered' (Sullivan) 334
Tallinn 312
Tamaudun (Okinawa) 181
Tanguy, Yves 326, 334, 335
Tanner, Henry Ossawa 235
Tanning, Dorothea 321–3
tapestry of Narcissus 256, 257
Tarkovsky, Andrei 40, 41, 64, 65–7, 85, 362
Tarr, Béla 119
Tartuffe (Molière) 174, 175–6
Tate galleries 208
Tati, Jacques 176–7
Tawaraya Sōtatsu 274
Taxi driver (film) 57
tea 205
teapot (Bauhaus) 70–1
tears 52–4, 58, 172, 276, 364, 386
memorials 180–6
Trail of Tears 233
technology, war and 136
teenagers 74–7, 79–80, 81
Tehran 106
telescopes 138, 145–6, 149
television (TV) 2, 359–61
Tenochtitlan 128
Thanatos 368
Theory of Colours (Goethe) 31–2, 33
Thermopylae 132, 202
Theroux, Alexander 30
Thessaloniki 161, 211
thinking, visual 83, 143
Thompson, J. Walter 338
Thomson, J.J. 293
Thoreau, Henry David 253

Thorning-Schmidt, Prime Minister Helle 2–3
Three Colours: Blue (film) 389
three-dimensional images 378
300 (film) 202–3, 340
Through the Olive Trees (film) 299
Tiananmen Square (Beijing) 186, 312, 313, 315, 340
Tibet 30
Tiepolo 124
Tigris River 104–5, 112
Tigris-Euphrates Delta 101
Time (magazine) 307
timeline 152–3
Times (London newspaper) 263
Times Square (New York) 372
Tinne, Alexandrine 223
Titanic (ocean liner) 219, 326, 329, 356, 382
Titian 77, 357
To Have and Have Not (film) 75, 339
To the Lighthouse (Woolf) 331
tobacco 205
Tohaku, Hasegawa 221–2
Tojo, Prime Minister General Hideki 353–4, 389
Tokyo 108, 109, 112
Tokyo Story (film) 86
Torrens, William McCullagh 372
A Tour Thro' the Whole Island of Great Britain (Defoe) 189
tourists 2–3
grand tours 188–91, 192, 223
Tower of Babel 103, 333
trade 120–1
Trail of Tears 233
'transparent eyeball' 250, 252, 254, 263, 265, 267, 272–3, 278, 286
Transvaal 218
travel 223
Treatise on Painting (da Vinci) 81
Tree of Life (Jung) 403
Treptower Park (Berlin) 182, 183
Triumph of the Will (film) 199
trompe l'oeil 327, 339
True Romance (film) 339
Tuareg nomads 223
Tuol Sleng Genocide Museum (Phnom Penh) 184

'turbid media' 33
Turin 323
The Turin Horse (film) 119
Turkey 126, 341
Turner, J.M.W. 18–19, 31,
 204–5, 220, 267–8, 316
Turrell, James 84
Tutankhamun, King (aka
 Tutankhate) 84, 301–4,
 340
Two Heads (de Chirico) 323
'Two Look at Two' (Frost) 41
2001: A Space Odyssey (film)
 89–90, 274, 372

Ugetsu Monogatari (film) 19,
 220
Ukraine 110, 400
ultramarine blue 165
Umar, Caliph 123
Under the Skin (film) 393
UNESCO (United Nations
 Educational Scientific and
 Cultural Organization) 203
Union Pacific Railroad 239
United Kingdom (UK) 143,
 188, 189, 204, 247,
 338–47 *passim*, 360, 372,
 374, 388
 see also Britain
United States of America
 (USA) 30, 63–4, 143, 178,
 183–203 *passim*, 229–39
 passim, 310, 334–46 *passim*,
 361–74 *passim*, 389, 400
 see also North America
Universal Exposition (Paris
 1867) 261–4, 266
Universal Studios 303
University of Padua 144–5
Unswept Floor (Roman mosaic)
 65
Unter den Linden (Berlin)
 264
Urban VIII, Pope 146
Utah 239

Van Gogh, Vincent 32, 62, 67,
 257, 266–7, 294–6, 319
Vasari, Giorgio 18, 158–9
Vatican 159, 172, 173, 174
Vaughan, Philip 204
Veda 27
Velázquez, Diego 388, 392

Venice 55, 138, 145, 178, 188,
 189
Venus 149
verbal vocabulary 5
Verdal, Suzanne 225
Verdun 45–6, 291, 321, 340
Verdun, souvenirs d'histoire (film)
 45
Vermeer, Johannes 165, 267,
 298, 340, 367
Versailles 168–9, 172, 174,
 194–6, 209, 214, 226
Vertigo (film) 33, 102, 340
Vertov, Dziga 278
Verwoerd, Prime Minister
 Hendrik 361
Vesuvius, Mount 7, 111, 121
Veterans Day (USA) 361
Victoria, Queen 131
Victory over the Sun (opera)
 89
Vienna 210
Vietnam 132, 183, 184
Vikings 69
Villa of Livia (Rome) 405
Vilnius 312
vimana (holiest of chambers)
 100
violence 288, 292, 308, 312, 313
violet 32
The Virgin of the Rocks (da
 Vinci) 28–30, 31
Virginia 205
Virilio, Paul 387
virtual reality (VR) 378–9
Visconti, Tony 225
visible light 84
The Vision Machine (Virilio)
 387
Vision and Painting (Bryson)
 291
Visual Thinking (Arnheim)
 83
visually impaired 8
Vlatades monastery
 (Thessaloniki) 161
vocabulary, visual 5
Voltage (Tanning) 321–2
Voltaire 5, 149–50

Walden (Thoreau) 253
Waldon Pond 253
walkabout 189
Walker, Kara 208

wall piercings 96
Wall Street 335
Wallace, Alfred Russel 151–3
Wallace, William 28
Wanderer above the Sea of Fog
 (Friedrich) 21, 336
'want see' (compulsive looking)
 219, 366–70
war 118, 132–6, 138, 188
Warsaw 355
Warsaw Ghetto 355
Washington, George 335
Washington DC 183, 188
Washington Monument obelisk
 310
*Washington Street, Indianapolis at
 Dusk* (Groll) 263
Water Music (Handel) 188
Watson, James 358–9
Watson and the Shark (Copley)
 367
Watt, James 204
Watts Towers 95
*The Way it Looks from the Stern
 Seat* (Stoddard) 242–3
Wayne, John 234
Ways of Seeing (Berger) 25, 78,
 268
weapon's-eye view 136
Weimar 352–3, 357
Welles, Orson 133, 340
West Africa 80, 206
West Germany 355
West Indies 206, 208
Western genre 25, 233–4, 236
Western Trail, Rockies (Bierstadt)
 230–1
Where Is the Friend's House?
 (film) 298
Whitby Abbey 328
white 185, 307, 310
 white light 33
The White Diamond (film)
 383
White House (Astana) 109
Whitman, Walt 254
Whittles, Harold 243–4, 246
Who Wants to Be a Millionaire
 (TV) 364
Whymper, Edward 223
*William Shakespeare's Romeo +
 Juliet* (film) 76–7, 79
Williams, Raymond 360–1,
 365

Winnicott, D.W. 246
Winter Palace 194
Wittenburg 159
woad 28, 118
Women's Social and Political
 Union 306
wonders of the world 101
Woolf, Virginia 249, 250, 287,
 330–2, 351, 371
Wordsworth, William 151, 223
World Fair, Paris (1937) 201
World Naked Bike Ride 349
World Trade Centre 113, 370
World's Fair (1889) 228
Wright Flyer (aeroplane) 210–11
Wright, Orville 210–11
Wright, Wilbur 210–11
Wu, Emperor 120
Wulf, Andrea 152

x-axis 294, 378
Xerxes I of Persia, King 202–3,
 302, 340
X-rays 285–6
Xu Gu 267–8

y-axis 294, 378
yellow 32, 61, 298, 312
Yellow River 312–13
yingbi walls 98, 120
Yingxing, Song 191
Yokohama 107–8, 112
yoni (divine mother) 100
YouTube 275
Yucatan plateau 139

z (illusion of three-dimensional
 space) 25
z-axis 35, 55–66 *passim*, 96,
 121, 210, 222, 243,
 268–74 *passim*, 294, 309,
 337, 345, 378
z-lessness 24, 26
z-ness 24, 32, 43
Za'atari refugee camp 378–9
Zapruder, Abraham 368–9
Zen Buddhism 69, 369
Zhang Qian 120
Zheng He 121
Ziegler, Adolf 351
Zola, Émile 250–1, 253, 264,
 266, 267, 273
zoos 226–8
Zytglogge tower 289–90